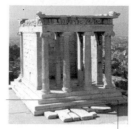

The Acropolis

MATERIALIZING CULTURE
. .

Series Editors: Paul Gilroy, Michael Herzfeld and Danny Miller

Barbara Bender, *Stonehenge: Making Space*

Gen Doy, *Materializing Art History*

Laura Rival (ed.), *The Social Life of Trees: Anthropological Perspectives on Tree Symbolism*

Victor Buchli, *An Archaeology of Socialism*

Marius Kwint, Christopher Breward and Jeremy Aynsley (eds), *Material Memories: Design and Evocation*

Penny Van Esterik, *Materializing Thailand*

Michael Bull, *Sounding Out the City: Personal Stereos and the Management of Everyday Life*

Anne Massey, *Hollywood Beyond the Screen*

Judy Attfield, *Wild Things*

Daniel Miller (ed.), *Car Cultures*

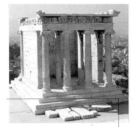

The Acropolis

Global Fame, Local Claim

Eleana Yalouri

Oxford • New York

First published in 2001 by
Berg
Editorial offices:
150 Cowley Road, Oxford, OX4 1JJ, UK
838 Broadway, Third Floor, New York, NY 10003-4812, USA

Berg is the imprint of Oxford International Publishers Ltd.

Library of Congress Cataloging-in-Publication Data

A catalogue record for this book is available from the Library of
Congress.

British Library Cataloguing-in-Publication Data

A catalogue record for this book is available from the British Library.

ISBN 1 85973 590 8 (Cloth)
 1 85973 595 9 (Paper)

Typeset by JS Typesetting, Wellingborough, Northants.
Printed in the United Kingdom by Biddles Ltd, Guildford and
King's Lynn.

Της γιαγιάς μου

Berg Publishers would like to apologise to the author, to readers, and to persons whose names have been misspelled for a series of errors in the printing of Greek letters. In particular, the letter ώ is frequently misspelled as τ, and many intonation marks are missing. This was the result of a software corruption for which the author is in no way responsible, as the proofs did not contain the errors. A full list of the errata is available from the publishers upon request. Please write to enquiry@bergpublishers.com

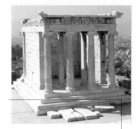

Contents

Acknowledgements ix

List of Figures xiii

Abbreviations xix

Preface 1

1 Introduction 5

2 The Acropolis Past and Present 27

3 Greece Condensed: Materializing National Identity 49

4 Contesting Greek Identity: Between Local and Global 77

5 Consuming Inalienable Wealth 101

6 The Aesthetics of Sacredness 137

7 Conclusions 187

Notes 199

Bibliography 213

Index 231

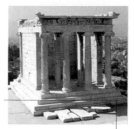

Acknowledgements

My deep gratitude is owed to Charles Stewart and to Chris Tilley for their guidance throughout this project and for opening up intellectual paths since the very beginning of my engagement with this topic. Charles's wide range of interests and the flights of his imagination have always been a source of inspiration. Chris, with his deep theoretical grounding and teaching charisma encouraged me to transcend the constraints of disciplinary boundaries and made me see the productive aspects of 'being undisciplined'.

I thank Michael Herzfeld and Jeremy Tanner for offering me the fulfilling experience of a challenging and genuinely enjoyable overall discussion of my work as well as for all the help they generously gave me.

But there is still an earlier history, and my engagement with this project owes a lot to the support of Yannis Hamilakis, whose collaborations with me have borne fruit in the form of two papers and further inspiration for new ideas presented in this book.

When I began my research in Greece there were various people who talked with me and helped me to start untying 'Ariadne's clue', among them Christos Boulotis, Pavlos Kavouras and Thanasis Kalpaxis. Fanni Konstandinou Alkisti and Angelos Horemis, Evi Touloupa and Ismini Triandi were very kind in giving me access to sources and information I would not have been aware of and would not have had access to otherwise.

I am grateful to the discussion group in Athens for asking the 'right questions', teaching me 'the art of arguing', and above all for the valuable memories.

Chrisy Moutsatsos has been a dear companion during intellectual wanderings throughout the fieldwork period, making my time in Athens pleasurable and meaningful.

Stella Galani has been a teacher and a friend to me at the same time, and throughout these years she has not failed once to show her interest

in my work and to support me in difficult moments. Her presence has marked this work in various ways. She has kept me in touch with Greek debates concerning the Acropolis through her frequent mailings of newspaper clippings along with supportive postcards. Her care and love for people is the best lesson someone being initiated to anthropology could possibly have.

Elia Petridou has been like a sister, a precious and supportive fellow traveller on the difficult road towards the completion of this book and has made the writing-up loneliness less lonely.

Vassiliki Bouki, with her passion for and insights into all things Greek, has often made me think twice about things I always took for granted. Being a 'volcano' of feelings and ideas, she has contributed immeasurably to my deeper acquaintance with and understanding Greek culture.

I thank Apostolis Panayotou for constantly reminding me of the value of friendship and for offering me a comforting shoulder and the catharsis of laughter in moments of 'crisis'; Tasos and Maria Valadorou for their loving presence, their overall support and for providing me with an excellent view to the Acropolis from their house in Theseion; Clio Gougouli for her spirited support and for her close reading and critical response to an earlier draft of the book; Manos Spiridakis for providing tapes to 'keep the spirits up'; Georgios Varouxakis and Argiris Papasiriopoulos for sharing with me his understanding of modern Greek history; Esther Solomon for sharing with me her ideas and for her pointed observations; and all my friends and extended family in Crete, Athens, Cambridge and London who have been an inexhaustible driving force and always there to offer a patient ear when I needed it.

Some of the questions addressed in this book were originally presented at the meetings of the UCL departmental writing-up seminar group run by Mike Rowlands, Danny Miller and Chris Pinney. I have profited greatly from my interaction with them, as well as with the discussion group organized by Chris Tilley at his flat every other Tuesday. I am especially thankful to the first year undergraduate students (2000–2001) of the University of Westminster for giving me the excitement of getting a fresh view of long-worked topics. I thank them all for the intellectual stimulation.

I would like to acknowledge the financial support from the Graduate School of UCL which assisted with the expenses of my fieldwork research, as well as the grants from the Hellenic Foundation, the Royal Anthropological Institute, and G. & S. Theodosiou who allowed me to complete the research.

I am profoundly grateful to the people who willingly talked to me about the Acropolis and shared with me their memories and their beliefs and whom I will not recount here in order to keep their anonymity. Without their contribution this thesis would simply not exist.

No thanks can possibly do justice to the faith my parents have always shown in me and to their unreserved emotional, moral support, the intellectual motivation and their constructive criticism.

Last but not least, I am deeply indebted to Karl Strobl. His presence has marked these pages, which he has thoroughly read and challenged with his square logic. With his patience, humour and good spirit he has always shown to me that it is *the travel* to Ithaca that matters.

I dedicate this book to the sweet memory of my grandmother who passed away while I was writing its very last pages.

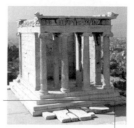

List of Figures

0.1 The Acropolis from the northwest (source: Studio Kontos). xx
0.2 A man dressed up in the folk Greek outfit of τσολιάς before
 the entrance of the Acropolis site (Photo by E. Yalouri). 3
1.1 The National Monument of Scotland on Calton Hill,
 Edinburgh (1822–1829) (Photo by Panayotis Dendrinos). 7
1.2 The Parthenon in Nashville, Tennessee, built on the
 occasion of the international exhibition for the centenary
 celebrations of the foundation of Tennessee (c. 1930)
 (Photo by David J. Coffta). 8
1.3 The Walhalla in Regensburg, Germany, built to symbolize
 the pan-Germanic unity in the period when Napoleon was
 dominating (1842) (Photo by Georg Benke). 9
1.4 Copies of the Erechtheion's Caryatids in the Church of
 St. Pancras, London (1819–1822) (Photo by E. Yalouri). 10
1.5 The newspaper Καθημερινή (21/11/99) reports on Clinton's
 visit to Athens and quotes his words 'we are all Greeks'. 10
2.1 The Parthenon viewed from the northwest (source:
 Studio Kontos). 29
2.2 The eastern façade of the temple of Athena Nike (source:
 Studio Kontos). 30
2.3 Part of the Erechthcion viewed from the southeast
 (source: Studio Kontos). 31
2.4 The bombardment of the Acropolis by Morosini (Fanelli
 1707; source: Gennadeios Library, American School of
 Classical Studies). 33
2.5 Poster of the Greek National Liberation Front (EAM, the
 major resistance organization during the Nazi occupation
 in Greece), with the subtitle 'all on a war footing!' The
 Acropolis features in the background (source:
 Καραχρήστος 1984). 41

2.6 and 2.7 Photographs of British soldiers who camped on the
Acropolis after the outbreak of the Civil War
(Photographs by Dmitri Kessel; source: Kessel 1994). 42

2.8 Political prisoners in Makronisos building a Parthenon
(Rodocanachi 1949; source: Gennadeios Library,
American School of Classical Studies). 43

2.9 The dictator Stylianos Pattakos raises the Greek flag on
the Acropolis (source: Megaloconomou Archive). 45

2.10 and 2.11 Political posters (1970–1974) by G. Aryirakis
against the military dictatorship (source: Καραχρήστος 1984). 46

3.1 A Turkish Muezzin, who preaches on the Parthenon. The
person on the right says 'oh, I can foresee things not
going that well'. Cartoon by Stathis, Τα Νέα (8/8/96). 54

3.2 Εύζωνοι having raised the Greek flag on the Acropolis
(source: Studio Kontos). 59

3.3 The siege of the Acropolis by the Greeks (1827–1833),
highlighting the function of the Acropolis as a fortress
(source: Εθνικό Ιστορικό Μουσείο της Ελλάδας 1966). 60

3.4 Article in the newspaper Έθνος (24/3/97) dedicated to
the act of Glezos and Santas. The title quotes their words
'We took the flag down with our teeth'. 61

3.5 Panhellenic Cultural Movement poster opposing the
governmental decision to send Greek antiquities abroad
for display (source: ΠΑΠΟΚ). 68

3.6 Advertisement of a Greek bank's new branch in Cologne,
Germany (source: Metrolife Εμπορική). 70

3.7 The Greek community of a village in the south of Russia
dances under a framed painting of the Parthenon
(Τα Νέα 13/5/97). 72

3.8 The statue of goddess Athena, sent by the mayor of
Athens, Dimitris Avramopoulos, to the Greeks of Astoria,
New York. The statue was placed in Athens Square Park.
The inscription on the base of the statue says: 'A gift from
the people of Athens, Capital of Greece, to the people of
the city of New York' (photo by E. Yalouri). 74

4.1 Το Βήμα της Κυριακής (14/7/96) comments on Billy Paine's
role in Atlanta's successful application to host the 1996
Olympiad with the words: 'All the backstage with the
dirty money. He is the one who "stole" the 1996
Olympics from us'. 87

4.2 An election leaflet of the *Left Alliance* party (Συνασπισμός),
 circulated before the 1994 European parliamentary
 elections. The party announces its intention to fight for
 the return of the Parthenon marbles by crossing out the
 names 'Elgin marbles' and 'British Museum' and
 substituting for them 'The Parthenon marbles' and 'The
 Acropolis Museum' (Source: Συνασπισμός). 92
5.1 A Second World War poster, part of a campaign calling
 for financial assistance to Greece (source: Σύγχρονα Θέματα,
 1978 (1): 96). 104
5.2 Advertisement of the dairy industry FAGE (source: FAGE). 106
5.3 A newspaper article contrasting the outrage provoked by
 the Coca-Cola advertisement with the indifference that
 Greeks showed for the cover design of an issue of *'Spectator'*,
 showing the Parthenon as a concentration camp (source:
 Το Βήμα της Κυριακής, 30/8/92). 108
5.4 Jane Mansfield posing in the Parthenon (source:
 Megaloconomou archive). 111
5.5 Cartoon by Ilias Makris, commenting on the
 commodification of the Olympics by Coca-Cola (source:
 Καθημερινή, 21/7/96). 116
5.6 Black people displaced under the heavy podium of the
 white Olympic winners in Atlanta. Comment on the
 racist features of the city accommodating the Olympic
 Games of 1996 (source: *Καθημερινή*, 21/7/96). 116
5.7 Front page in the newspaper *Τα Νέα* (7/8/96) dedicated to
 the return of the Olympic winners from Atlanta to Greece.
 The title says 'Hello to you, proud Greeks'. 118
5.8 Cartoon by KYR, after Greece was granted the right to
 host the Olympic games of 2004. One of the figures on
 the right says 'You see, even the νέφος (the pollution-cloud
 hanging over Athens) participates in the celebrations'
 (source: *Ελευθεροτυπία*, 21/9/97). 119
5.9 A newspaper article (*Το Βήμα της Κυριακής*, 16/8/98)
 discussing the impending Calvin Klein show in
 Herodeion. 124
5.10 Cartoons by Mitropoulos, criticizing the ill effects of
 mass tourism. (source: Mitropoulos). 132
5.11 Cartoons by KYR, criticizing the levelling effects of mass
 tourism. In the last cartoon tourists are represented as
 sheep, baaing, and led by the tourist guide/shepherd

into a tourist bus labelled *To Μαντρι* (The sheepfold)
(source: KYR). 133

6.1 The Archbishop of the Greek Orthodox Church of
North America, Iakovos, visiting the Acropolis (source:
Megaloconomou archive). 140

6.2 Three priests in front of the statues of Dioskouroi at the
museum of Delphi (source: N. Kontos). 140

6.3 A modern Greek votive (τάμα) depicting the Pathenon
(source: Nikos Papageorgiou collection). 143

6.4 The little church of Άγιος Γιάννης της Κολόνας (St John of
the Column) in Athens. The Corinthian column belongs
to an earlier temple dedicated to Ianiskos (photo by
E. Yalouri). 144

6.5 The small church of Zoodohos Pigi (source: Studio
Kontos). 145

6.6 A bust of the personification of Athens, crowned by the
Acropolis, in front of the cultural centre of the
municipality of Athens (photo by E. Yalouri). 151

6.7 and 6.8 Photos of main Athenian streets (Eolou, Athinas)
whose axes are aligned to provide a view to the Acropolis
(source: Studio Kontos). 157

6.9 and 6.10 Cartoons by Mitropoulos, using the Acropolis as a
reference to criticize the sorry state of the city of
Athens (source: Mitropoulos). 158

6.11 and 6.12 Cartoons by KYR and Mitropoulos, criticizing
the sorry state of the city of Athens in relation to the
Acropolis (sources: KYR and Mitropoulos respectively). 159

6.13 The dancer Mona Paiva on the Acropolis, photographed
by Nelly in 1927 (source: The Photographic Archive of
the Benaki Museum). 160

6.14 The dancer Nikolska, photographed by Nelly in 1929
(source: The Photographic Archive of the Benaki
Museum). 162

6.15 Inscription at the entrance of the Acropolis site,
forbidding 'improper or advertising pictures, singing
or making loud noises', etc. (photo by E. Yalouri). 163

6.16 Cartoon by Ilias Makris which appeared in *Καθημερινή*
(18/8/98) after an English tourist in Knossos pulled his
pants down in front of the antiquities in order to have a
picture taken. The inscriptions of the columns from the
left are 'Ionic style', 'Doric style', 'Corinthian style', and
'English style'. 163

6.17 Members of the Hymetos movement unravelling a
 banner on the Acropolis (source: *Tα Νέα*, 23/2/99). 173
6.18 Cartoon by Dimitris on the occasion of 'the cleaning' of
 the Parthenon marbles by the BM. It appeared in *Tα Νέα*
 (10/6/98). 181
7.1 Cartoon by Stathis. According to *Καθημερινή* it should be
 interpreted as 'The Man loaded with the mythical time
 that he himself created' (source: *Καθημερινή*, 4/1/00). 189
7.2 The Acropolis under the fireworks of the 2000
 celebrations (source: *Tα Νέα*, 3/6/00). 197

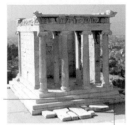

Abbreviations

ASA	Archaeological Society at Athens
BM	British Museum
CAC	Central Archaeological Committee
CK	Calvin Klein
4th GR	4th-year class of a government-run school
5th GR	5th-year class of a government-run school
GTO	Greek Tourist Organisation
6th GR	6th-year class of a government-run school
6th PR	6th-year class of a privately run school

Foreign quotations – whether from written or oral sources – are translated into English by the author (E.Y.), unless the reference itself is already taken from an English translation and cited accordingly. I also provide my own translation of foreign titles in the bibliography.

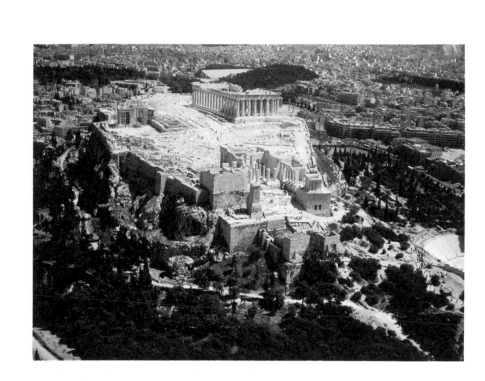

Figure 0.1 The Acropolis from the northwest (source: Studio Kontos).

Preface

In a movie I saw recently, two kids are zapped into the black-and-white world of a 1950s family soap opera. Once in the black-and-white city of *Pleasantville,* the kids start to subvert its rigid values, literally bringing colour to the lives of the inhabitants, turning the movie itself into a coloured one. This idea reminded me of two experiences I had in my student days.

Several years ago I was introduced to an Australian living in London and studying artificial intelligence for his PhD degree. Once he heard that I come from Athens he exclaimed 'I assume Athens is a white city!' 'What do you mean "white"?' I asked him. 'Well,' he confessed smiling, 'I guess I am under the influence of all those images we get about Greece and its classical antiquity, and I expect houses in Athens to be all white and standing on white tall columns.' A few weeks earlier during a casual discussion over one of the college's suppers in Cambridge a Taiwanese student had also displayed interest in my Athenian origin: 'Athens very similar to Taipei,' he said, 'both black and smoggy!' Although both comments were well-intentioned I couldn't help feeling awkward at that time. In hindsight, I might have felt unease because 'white Athens' vividly brought to my mind the Western European stereotype of Greece as 'the ideal land of ancient Greeks', dismissive as it was of anything related to the Greek present. On the other hand, I probably associated 'Black Athens' with the comparatively dark colours in which modern Athens has often been depicted by foreign visitors describing it as a city unbearable to live in.[1] The main problem, however, was that both images did not relate to *my* Athens, which I had been experiencing not as black-and-white, but in colours, full of smells and sounds, and full of life.

I had a similar feeling of awkwardness when a Greek friend was wondering why on earth I had renounced my future as an archaeologist in order to study for a PhD in social anthropology and material culture.

'It is so much more exciting to study archaeology, especially in Greece', she said. When I asked what made her think so, she answered with an extract from Sophocles' Antigone (verses 456–7): 'Ου γαρ τι νυν γε καχθες, αλλ' αει ποτε ζη ταυτα κουδεις οιδεν εξ οτου φανει'. 'The past', she explained, 'is valuable because it has been tested by time, while the present you don't know how long it will last, or if it lasts at all.' I couldn't sympathize with my friend. For me, after all, classical monuments were associated more with sunny Sunday walks in the old city of Athens, rather than with architectural typologies that I had to learn by heart as a student of archaeology. No account of the Acropolis has talked more to me than that of Louis Bertrand (1908), who, one evening in 1906, sitting on a bench on the Acropolis and listening to the noises coming from the city spread out on the foot of the hill, contemplated: 'I believe that the trombone chords, the firework rockets, the noise from night clubs and railways – that confused hubbub of a people which seeks its way and surges out of life – all that glorifies goddess Athena better than all the words of Renan . . .'.

The idea of studying the Acropolis in the present was built up gradually and it was the outcome of a dialectic between personal quests and academic coincidences. While I was an undergraduate student of archaeology in Crete, Michael Herzfeld was writing *A Place in History*, his book on the monuments of the very town where I was living and studying. A mutual friend and local resident, fascinated by Herzfeld's research project, often recounted his work and quests. Another social anthropologist, Yorgos Nikolakakis, who was then lecturing at the University of Crete, was completing his research about the ways in which the archaeological excavation organized by the Department of Archaeology in a mountain village of Rethymno had affected local people's lives. I had participated in those excavations under the direction of the professor of archaeology Thanassis Kalpaxis, who was at that time contributing to archaeology's 'critical self-consciousness' through his two books on archaeology and politics. It was only in my early graduate years that I started seeing these scattered experiences within a wider theorized framework. At the Department of archaeology at Cambridge heated discussions were taking place concerning the political parameters of any archaeological or historical interpretation, and Ian Hodder, one of the leading adherents of 'post-processual archaeology' declaring the loss of archaeology's 'political innocence', taught at the faculty of anthropology and archaeology at Cambridge. Coming from a country where archaeology bears the strong impact of the art-history-oriented German archaeological thought, I was surprised

that anthropology was taught under the same roof as archaeology and that the course on museum studies I attended was emphasizing the socio-politics of heritage rather than the practical ways antiquities need to be displayed. Moreover, it was a new experience for me to see that archaeological conferences such as TAG (Theoretical Archaeological Group) organized sessions discussing issues such as gender or politics.

It took several lectures on social anthropology and material culture, writing up seminars and lengthy readings to bend my clear-cut distinctions between archaeology and anthropology, the past and the present, and to realize that it is not just archaeologists and historians who 'produce' history. The proud old man who dresses up in the folk Greek outfit of tsolias (τσολιάς) and goes up the Acropolis hill to pose in tourist photos (Figure 0.2) makes a claim to historical 'continuity' equally

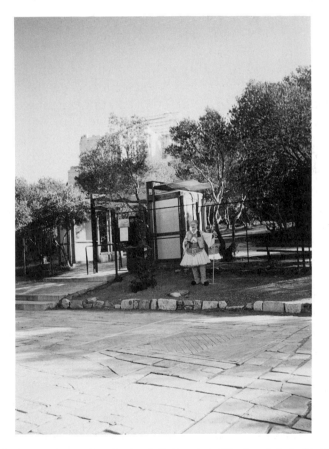

Figure 0.2 A man dressed up in the folk Greek outfit of τσολιάς before the entrance of the Acropolis site (Photo by E. Yalouri).

powerful as that of any Greek folklorist or historian supporting the 'survival' of antiquity in the present. The process of knowledge I have described here would probably be translated in Foucauldian terms as me internalizing the *episteme* of the particular historical moment and in Bourdieu's terms as the 'habitus' of the different environments in Greece or abroad in which I was lucky to be. Those years and places have provided me with a certain lens, a particular way of viewing 'knowledge/truth' (Foucault 1980; 1984). My accounts, therefore, are not less 'constructed' than those of the people I will quote hereafter, and the present work is a product of the very dialectic it explores: The dialectic between the present and the past and the one between the local and the global.

Introduction

Local Present, Global Past

A couple of years ago I took an English friend visiting Athens to a taverna in Plaka, the old town of Athens which lies on the north foot of the Acropolis hill. During lunch I sensed that something was not quite right, as he remained silent during most of the three-course meal. When asked, he replied: 'How can you eat while you're looking at the Acropolis?' I did not understand his question immediately, so he continued: 'I mean how can you do something so trivial when you have *that* so close and so visible?'

I knew that my friend had a classical education, but as we had both attended many courses at University about the fusion of the past and the present, I did not expect him to feel so strongly about us having lunch near the archaeological site. For him, however, the presence of the fifth-century Acropolis was so powerful that it determined the socio-temporal landscape of the wider area and made any modern or everyday interference a 'matter out of place'.

It was not until much later that it occurred to me that my friend's reaction was typical of a more general habit to view the Acropolis in the context of its fifth-century past, detached from its present life. In fact, although the Acropolis often appears in literature, history and archaeological research as a product of high artistic quality and of great social and religious importance within the Athenian society of the fifth century BC, its position in modern Greek society and its role in more recent periods has been very little researched.

The acquaintance of the Western world with classical antiquity developed gradually, first through literary ancient sources, such as Pausanias and Pliny, Roman copies of Greek classical art, some late Hellenistic sculpture, and subsequently through the descriptions of travellers to Greece and designs, such as those made by the British painters James Stuart and Nicholas Revett or the French architect Julien David Le Roy.

5

Goethe sought the land of the Greeks with his soul ('das Land der Griechen mit der Seele suchen'). Although he had never seen Greece, he was so much identified with the classical Greek spirit that another representative of the *Sturm und Drang* movement, Schiller, wrote to him in 1794 (Staiger 1996: 34):

> Since you were born a German, since your Greek spirit was thrown into this Nordic creation, you had no other choice than either becoming yourself a Nordic artist, or substituting for your imagination – with the help of the power of thought – what reality did not offer to it and in this way, as it were, giving birth to a Greece from the inside and in a rational way.

Although Romantic writers questioned the validity of classicist interpretations of ancient Greece, they nevertheless kept Greece as an important source of inspiration, albeit viewed from a different perspective than that of Classicism. It is typical that at the end of the eighteenth century, when Goethe and Schiller were publishing a periodical under the title *Die Propyläen*, the Romantic Schlegel brothers were publishing a periodical under the classicizing title *Athenäum* (Κονταράτος 1994: 42). Shelley, the prominent English Romantic poet, who also had never visited Greece, still felt he loved it so much as to claim, in 1821, that 'We are all Greeks. Our laws, our literature, our religion, our arts have their root in Greece' (Shelley 1934: 447).

Greek classical studies have spread *beyond* Europe, and have become 'the beloved heritage of many people around the world' (Lowenthal 1988).[1] The diffusion of classical culture has made the monuments of classical antiquity the patrimony of a world expanding out of its homeland's borders. Greek antiquities have been systematically and widely used in the name of international values. They do not only feature in museums internationally, but are even copied and have become emblems of cities far away from Greece (Figures 1.1–1.4).[2] Even today, people all over the world, from the author Salman Rushdie[3] to the former president of the United States, Bill Clinton, keep stating that they have a share in Greek heritage or even that they are Greeks (Figure 1.5).

'Heritage' has become an asset of growing value. On the one hand global agencies such as Unesco declare and sponsor 'world heritage sites' promoting them as belonging to all mankind 'irrespective of the territory on which they are located' (http://www.unesco.org/whc/2giff.htm#debut update 1/6/2000), while on the other more and more

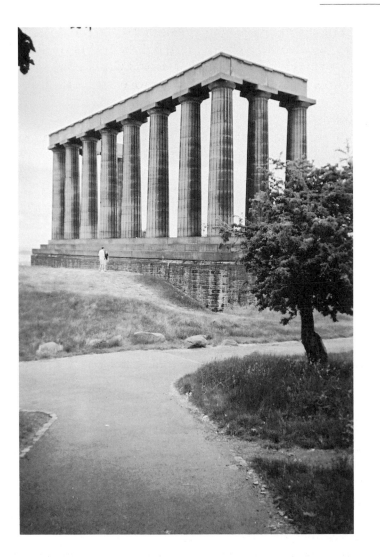

Figure 1.1 The National Monument of Scotland on Calton Hill, Edinburgh (1822–1829) (Photo by Panayotis Dendrinos).

contestations over ownership of national heritage emerge. Discussions involving the politics of heritage are a case in point. Sites or monuments often become enmeshed in conflicts over contested identities and revivals of ethnicity. Issues of ownership and repatriation have increasingly become central in the nations' negotiations of their identities and their claims internationally. Decolonization and multi-culturalism have increased efforts of former colonies to enhance perceptions of their

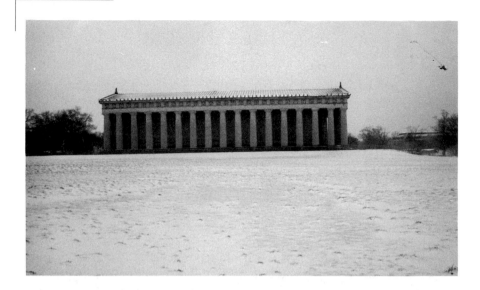

Figure 1.2 The Parthenon in Nashville, Tennessee, built on the occasion of the international exhibition for the centenary celebrations of the foundation of Tennessee (c. 1930) (Photo by David J. Coffta).

identities. Peoples all around the globe manifest their will to control their heritage and the ways in which others represent them. Statements about 'global patrimony' ideals are often met with scepticism today, as they are often associated with an era of conquest when 'heritage belonging to the world' meant 'heritage belonging to the West'. For the eighteenth-century West, the colonized peoples of the rest of the world were considered as condemned to permanent inferiority and 'heritage blindness' (Lowenthal 1998: 243), requiring guidance and help in safeguarding their legacies.

Classical Greek heritage has been 'contested' by 'the world' since well before the establishment of the Greek state in 1830. Once the Greek state was born, the modern Greeks inherited – together with Greek lands – also the title to the ancient Greek heritage. Thus the Athenian Acropolis, 'the corner stone of the Classical Greek era', in becoming a 'world monument', also became the national monument of Greece par excellence. The question is how these two local/national and global meanings of the same monument can co-exist and interrelate and how Greeks cope with this double-faceted aspect of their heritage, especially in an era which on the one hand promotes the idea of a global community and on the other encourages national difference.

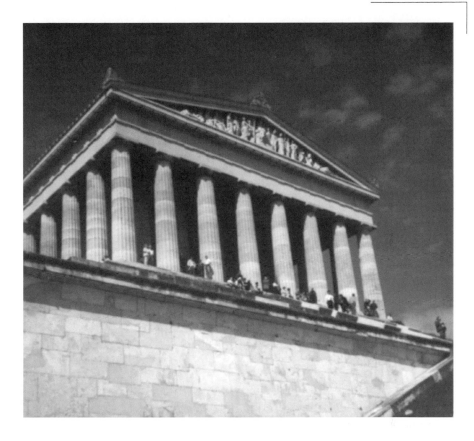

Figure 1.3 The Walhalla in Regensburg, Germany, built to symbolize the pan-Germanic unity in the period when Napoleon was dominating (1842) (Photo by Georg Benke).

In the preface of this work I referred to foreigners' 'black-and-white' perception of Athens and Greek culture in general which is also embraced and reproduced by Greeks themselves. This perception has also informed and, equally, has been informed by discussions about Greek identity.

The travel writer Patrick Leigh Fermor (1966) viewed Greek identity as consisting of a dilemma between two archetypes, the one of 'Hellene' and the other of 'Romios' (Έλληνας, Ρωμιός). From an anthropological perspective, Herzfeld (1982a; 1987) developed this idea further and discussed the dialectic of Greek identity as consisting of two extreme poles: at one end stands 'Hellenism' (Ελληνισμός), which he calls the 'outside' view of Greek culture. This is linked to the idealization of ancient Greeks by Western Europeans, and it constitutes an imported

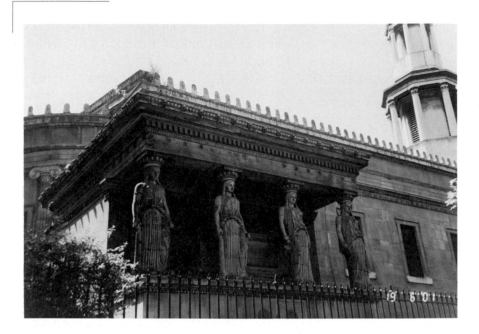

Figure 1.4 Copies of the Erechtheion's Caryatids in the Church of St. Pancras, London (1819–1822) (Photo by E. Yalouri).

Η ΚΑΘΗΜΕΡΙΝΗ

Ημερήσια Πολιτική και Οικονομική Εφημερίδα

ΕΤΟΣ 81ο — ΑΡ. ΦΥΛΛΟΥ 24.337 — ΙΔΡΥΤΗΣ: Γ. Α. ΒΛΑΧΟΣ ΑΘΗΝΑ, ΚΥΡΙΑΚΗ 21 ΝΟΕΜΒΡΙΟΥ 1999 ΔΡΑΧΜΕΣ 300

Κλίντον: «Είμαστε όλοι Έλληνες»

Χρυσό μετάλλιο για τις επιδόσεις της οικονομίας μας

Από τα ελληνοτουρκικά εξαρτάται η πορεία της Αγκυρας προς Ε.Ε.

Figure 1.5 The newspaper *Καθημερινή* (21/11/99) reports on Clinton's visit to Athens and quotes his words 'we are all Greeks'.

view, adopted by the Greeks during the establishment of the Greek state in 1830. At the other end stands 'Romiossini' (Ρωμιοσύνη), which he calls the 'inside' view of Greek culture (1987: 114). This is associated with the history of Greeks as part of the Byzantine and the Ottoman Empires, and is the view modern Greeks feel more at home with. Thus, according to Herzfeld, every Greek is 'torn between two opposing stereotypes': the one of 'Hellenes' (idealized Hellenes of the Classical past) and the other of 'Romii' (Christians of the Byzantine and Ottoman periods) (1987: 41). Herzfeld links these two facets of Greek identity with the paradox of Greece being considered the ancestor of Europe yet presently, as he says, on its margins or its 'periphery'.

The positioning of Greece between 'Europe' or, more generally, 'the West' and 'the Orient' is one that has pervaded discussions – within Greece and outside – of Greek identity since the establishment of the Greek state. Throughout modern Greek history there are times when 'the West' has been associated with ideas of progress and modernization, virtues sought by Greece in its efforts to join the pace of the modern world. Especially during the early days of the new state it was believed that – through Europeanization – Greece could reach out to its past and heritage. At other times, however, 'the West' has acquired negative connotations, as it has been perceived as a foreign presence hostile towards Greece. In these cases 'the West' is often juxtaposed to 'the Orient', which is considered to be the place where the roots of the Greek folk resides, the place which gave birth to the Orthodox Byzantine Empire. On the other hand, 'the Orient' has also been linked with backwardness and the Dark Ages of Turkish occupation (cf. Herzfeld 1987). Thus 'the West' and 'the East' have become loaded with various meanings, according to historical, political, or cultural circumstances, and although they are not static concepts, they do retain some basic associations. 'The West', as the historian Έλλη Σκοπετέα (1992: 12) has suggested, has often been seen as a synonym of 'the modern world' with all its connotations and interpretations. On the other hand, 'the Orient' has been used by Greeks to refer to what Greeks call 'Our Orient' (καθ'ημας Ανατολή), 'the borders of the West with the East from the East's side' (ibid.: 13) or, according to the linguist Μπαμπινιττης (1998), Asia Minor and areas of Hellenism in the Orient, and in general the Orthodox Orient.

As the literary theorist Δημήτρης Τζιόβας (1989: 51–52) notes, until 1922 (when what Greeks call the 'Asia Minor catastrophe' took place) Greek cultural identity was introspective and the main issues for the Greek nation were those of unity and continuity. From 1923 onwards,

Greek cultural identity became extrovert, and the main issue was the differentiation of the Greek from other nations and the projection of its cultural specificity ('Greekness' – Ελληνικότητα). The 'generation of the 1930s', an arts and literature movement, tried to transcend polarities within Greek identity such as Romios and Hellene, traditionalism and modernization, etc., which were the outcomes of such introspective speculation. Representatives of the '1930s generation', such as the literary figures of Seferis and Theotokas, juxtaposed Greek Hellenism (Ελληνικός Ελληνισμός) to European Hellenism (Ευρωπαϊκός Ελληνισμός).

The '1930s generation' used this juxtaposition to describe the interaction of Greek identity with Western Europe. Sixty years later, the social anthropologist Roger Just (1995) adopted the notions of 'local' and 'global' Hellenisms to discuss how Greeks internalize global cultural constructs portraying Greece as the birthplace of history and the cradle of civilization. Just explained how 'Western civilization' imported Hellenism back to the place where it was first born and he illustrated ways in which it was reappropriated on a local level. I would like to explore this local-global relationship further, not just in terms of how the local translates global knowledge and constructions, but in terms of the extensive politics between the two. Moreover, I will try to elaborate on the nature of this local reappropriation in relation to classical Greek heritage. The geographer David Lowenthal (1988) was the first to introduce the problematization of Greek classical heritage as both Greek national and global heritage. He described the preoccupation of the West with the ancient Greek world and how the latter was adopted as Western/global heritage. He also showed how the Greeks, after the establishment of the Greek state, re-evaluated and readopted Greek antiquity as their national heritage.

In this account of research on Greek identity I should also mention the work of the literary theorist Artemis Leontis. In her *Topographies of Hellenism* (1995) she traced the *logos* (discourse) of the Greek *topos* (place), the ways in which the notion of the Greek homeland is constructed through literature. Studying Western travellers' accounts of Greece as well as texts of Greek literature, she illustrates the ways in which notions of Hellenism are produced by Greek and Western European discourses, and she makes a distinction between 'Hellenism' (the concept of Hellenism produced in the West) and 'Neohellenism' (the concept of Hellenism produced in Greece since the establishment of the Greek state).

It becomes evident that the notion of Hellenism has many facets, which led to the distinction of categories such as 'Neohellenism', 'Greek

and European' or 'local' and 'global' Hellenism. I must note, however, that the notion of Hellenism is used in Greece to refer to Greek identity as a whole. Greeks normally use it as shorthand to refer to more than the ancient classical past. For example the Greek word for Greece is 'Hellas' (Ελλάς) and Greeks are called 'Hellenes' (Έλληνες). Thus, 'Hellenes' are not simply the mythical giants of the pre-independence period (Κακριδής 1989) or the pagan Greek ancestors. Hellenism does not denote geographical space or chronological divisions. It declares a unity with common origins, language, religion, habits, and customs in both past and present. It is a concept that refers to the Greek presence as evidenced in terms of ideas, people, cultural values or material objects in both time and space.

Viewing Greek identity through oppositions or partitions such as 'Romios/Hellene', the 'West/the East', or 'Centre/Periphery' puts an emphasis on boundaries and encourages viewing the world as a 'mosaic', a collection of cultures and places, each one having a uniform character occupying a distinct space in the world map (cf. Crang 1999). Such an approach can be a useful tool towards understanding what is in reality a far more complex character of cultures. Perceptions of the West, the East, for example, are not the same everywhere. What is more, a culture may entail features of both the East and the West. By adopting the terms 'local' and 'global' in my work I want to emphasize the dynamic and dialectic character of the 'local-global' nexus. By using these terms, one can understand the processes through which tensions such as 'West and Orient' or 'Hellenism and Romiossini' are bound together for the construction of a strong Greek identity which is negotiated in the international arena. I would like to show that local and global interpretations of Hellenism are mutually defining and that the process of building Greek identity is intimately linked with this interrelation. The 'local' is part of the 'global' and the 'global' consists of many 'locals' (cf. Just 1995), and the use of these terms simply enables us to demonstrate the dynamics between the two. I do not mean to undermine the significant role of perceptions of the West (or Europe) and of the Orient, nor of the features of Romiossini and Hellenism in the understanding and conceptualization of Greek identity. On the contrary, I want to include all these defining elements in this local-global framework.

I must stress that I do not use the terms 'local' and 'global' in order to imply that the relationship of Hellenism with 'the world' is only a product of the 'era of globalization' as witnessed in the last few decades. The roots of a concept of global Hellenism are related to the quest for

the cultural roots of the West from the Enlightenment onwards, rather than the flows of people, information, and capital of the 'modern' (Giddens 1990) or 'postmodern' (Harvey 1989) era. 'Globalization' is believed to be a historical process, which for some (e.g. Robertson 1992: 58–60) predates modernity. Hellenism travelled around well before modernity. However, modernity enhanced Hellenism's circulation around the world. Moreover, it was only when the Greek nation-state was established, that the relationship between local and global Hellenisms originated and it was only then that Greek heritage started to be 'contested' by both 'the world' and the Greek nation-state.

'Globalization' is used today as a term to describe the compression of the world increasingly perceived as one entity, a 'global village'. Globalization, it is feared, will make the world 'a homogeneous global theme park, one McWorld tied together by communications, inform-ation, entertainment and commerce' (Barber 1995: 4, cited in Watson 1997: 78). On the other hand, the intensification and revalidation of national, ethnic and regional identities seem to argue for the opposite. The resurgence of nationalisms, as experienced for example in the former Yugoslavia and the former Soviet Union, tend to indicate that global-ization results in friction and tension, rather than convergence and homogenization. This phenomenon has led Anthony Smith to talk about a 'globalization of nationalism' (1991: 143).

The interplay between the global and the local is a vital issue for people around the world, and has accordingly become a subject of interest within the social sciences. Since the 1980s among anthropologists there has been growing interest in the future of the 'local' in an era of globalization. In this context, the question most frequently raised is whether the local will sustain its cultural specificity or whether it will become assimilated and homogenized in the process of globalization. A number of social theorists (Appadurai 1990; Clifford 1997; Lash and Friedman 1992; Miller 1998; Featherstone 1990) have argued that meanings and values, as they move across borders, become transformed and adapted to local cultures rather than being levelled out.

A series of studies have set out to illustrate the process of objects becoming indigenized by local cultures as they move between peoples. Daniel Miller (1992) has shown how the US soap opera 'The Young and the Restless' became instrumental in creating a 'highly specific sense of Trinidadian culture'. Miller did not interpret systematic watch-ing and discussing the soap opera as a sign of Americanization, but as a means for Trinidadians to produce a local sense of their culture. Miller (1998) has also shown how another American 'global' product, Coca-

Cola, became an ethnic drink in Trinidad, representing Black African identity in contrast to other, red drinks associated with Indian identity.

Research in five different societies in East Asia (Beijing, Hong Kong, Taipei, Seoul, and Japan) (Watson 1997) has demonstrated the variable adaptations of McDonald's to suit distinct local circumstances. It has also shown the major differences in consumption practices across these different localities to the extent that in these places McDonald's is no longer perceived as a foreign enterprise.

O'Hanlon's study (1993) about the Whagi of New Guinea demonstrates how foreign advertisements or products have been used to express issues of particular local character. Other studies have focused on this local-global relationship with regard to tourist art. Steiner (1995) has shown how local peoples internalize foreigners' ideas of traditional art and use them for their own interests, while several other studies investigate the local-global interaction in relation to the transformation of 'primitive art' when it is put in 'civilized places' (e.g. Price 1989; cf. Morphy 1995).

The present work follows the tradition of all these studies of 'recycling' and 'indigenization' of objects, falling into the wider category of 'material culture studies' which aim at demonstrating the dynamic ways in which a material product of culture can reflect identities, practices, and values, and can communicate meanings and influence people's world-views and behaviours.

The interest of anthropology in material culture is as old as the discipline's history, starting with evolutionism. The colonialist encounter with 'primitive man' resulted in a craze of collecting 'traces' of his material culture and in the establishment of major private or public collections to house the specimens.

In the 1920s, when fieldwork was introduced to anthropology as a primary methodological practice, the theoretical approach towards material culture changed. Rather than following an evolutionary scheme, 'things' were now seen as 'tools' in the service of human adaptation to different environments, and research focused on their utilitarian qualities.

After the 1960s, the introduction of structuralism revived the interest in material culture. Levi-Strauss's application of the linguistic theoretical models of Saussure in anthropology revolutionized the study of objects by introducing the idea of 'a language of things'. Things were treated as signs which reflected social relations. This approach, however, was criticized as being static, failing to convey the dynamism of social relations in a historical perspective.[4]

From the 1970s onwards – and as a reaction to the sterile formalism of structuralism – the importance of 'practice' and 'agency' has been emphasized, highlighting how peoples interact with structures (Ortner 1984). This turn has not left the study of material culture uninfluenced. As early as 1986 it was argued that things have social lives, and that from the moment of their production they enter a life-cycle of various phases and social contexts (Appadurai 1986). By tracing the 'cultural biographies' (Kopytoff 1986) of things one could also trace their 'social lives' and the multiple social meanings they acquire in space and time.

Although Appadurai dealt mainly with the 'social life' of commodities, his approach was later applied not only to commodities but to material culture in general. Moreover, more recent studies have emphasized not simply the different social contexts that define the meanings of things, but also on how crucial things themselves are in shaping our identities. Hoskins (1998), for example, in her research in Sumba, Indonesia, showed how biographies of things are interconnected with peoples' biographies and how one can study people by studying things. Being interested in tracing personal life histories and identities, Hoskins found that the only way to do so was by asking people to talk about objects. The latter, conveying memories and experiences, were at the same time becoming the medium for people to construct their identities.

From passive markers of social relations or artefacts satisfying functional needs, things have been recently attributed a much more active and influential role in society. Alfred Gell in his 'theory of agency' (1998) emphasized the mediatory role of objects in social processes by viewing them as 'agents'. Gell explains that defining 'things' as agents does not mean attributing to them minds and intentions – things are not 'self-sufficient' agents in the same sense as people are. The agency of things, however, is manifested in the effects that things have on people's social lives (Gell says things are 'an emanation or manifestation of agency . . ., a mirror, vehicle, or channel of agency, and hence a source of such potent experiences of the "co-presence" of an agent as to make no difference' (ibid.: 20).

In the last two decades there has been a bulk of material-culture studies arguing that objects are not just illustrations of human action but are actually involved in the production of social realities, in the shaping of the norms that people follow and the values that they represent.[5] Objects and persons are linked in a dialectic process whereby they transform or reproduce each other. The way people construct and

make use of their material world has been described as a process of 'objectification' (see Munn 1977; 1986; Miller 1987; cf. Bourdieu 1977; Giddens 1984) in which – by making and using things – people construct and redefine themselves and their roles within a certain social setting.

Sites, or more generally places and landscapes, have often been the object of such research (e.g. Bender 1993b; Tilley 1994; Hirsch and O'Hanlon 1995; Lovell 1998). They have been examined not as mere 'containers of action' (Tilley 1994) but as 'humanized', dynamic sites, witnessing and producing socio-political action not simply reflecting, but also influencing – if not producing – cultural activity. Places constitute the very environment in which people live and act, and they thus contribute to the construction of identities and social relationships.

Another issue that has been stressed in this context is that the spatial cannot be seen divorced from the temporal (Tilley 1994). A place's present meanings are defined by its past, while at the same time present meanings inform this place's past. Places have biographies, histories enriched by consequent layers of meaning produced through human actions and practices and recalled through social and individual memories (ibid).

The present work deals with a landscape marked by the presence of monuments. Here the meeting of space and time becomes even more evident. The Acropolis, a landmark in the landscape of Attica, cannot be fully understood except within its different historical contexts defining its character and investing it with various meanings. In fact, the Greek word for 'monument' is 'μνημείο', a word deriving from the word 'μνήμη', 'memory'. The study of a monument is then of necessity also a study of time and of memory. This work also views the Acropolis as a 'vehicle of agency' which informs the ways Greeks understand their national identity. More specifically, it investigates the way Greeks and the Acropolis are engaged in a dialectic process of objectification, forming, transforming, or reproducing each other. Through the physical presence of the Acropolis, Greeks internalize perceptions of their national identity, and by interacting with and using it, they reproduce or transform the ways they understand and define themselves in an international context.

Tracing the Acropolis

When I arrived in Athens in 1996, I had been away for almost eight years. Although I had been returning for short periods, holidays, and family celebrations, I had not actually lived there during those years.

Thus, my first visit to the Acropolis was not only a return to a place that I had not seen for a long time, but also a return in time: the lazy Sunday walks in the Agora or the Acropolis that always ended up with chocolate feasts in the neoclassical house of my godparents in the old town of Plaka. Their house, lying on the north slope of the Acropolis hill and full of age-old bric-a-brac, Byzantine icons, censers and aged books, gave off a sweet smell of oldness that fused with the oldness of the Parthenon as viewed from the big window of their living room. With the church bells of the Anafiotika (see p. 55) ringing in the background, I remembered listening to my godfather's stories: the 'gold-belted Lady' (Χρυσοζωνούσα) sometimes taking the form of the Virgin Mary and others that of the goddess Athena, the kidnapped Caryatid, and the marbled king – the last Byzantine emperor who turned into marble when the Ottomans conquered Constantinople.

The stories I had heard about the Acropolis at school were of a different kind. The Caryatids, the beautiful girls of my godfather's stories, were turned into fifth-century BC statues and the Acropolis got trapped in factual school textbooks. The school trips to the Acropolis site took the form of another lesson, constantly reminding us that visiting an archaeological site required seriousness and a 'proper' conduct.

While at University we studied even more of the typology of the monuments, and the Acropolis became an endless field of confusing theories contradicting each other as to the monuments' different phases of construction, their architectural and their sculptural styles.

In the summer of 1996, I was about to add a new layer to my previous experiences of the Acropolis. My confusion about my role was not less than that described in accounts of non-Greek anthropologists who were often mistaken for archaeologists while conducting their research in Greece. I was claiming to practice anthropology, and yet I practised archaeology, since I was producing a *logos* about antiquity. Furthermore, I could now feel part of the irony described by Just one year earlier: the reappropriation by local Hellenism of global Hellenism which was itself an earlier appropriation of local Hellenism. Being a Greek who had been exposed to a global knowledge of Hellenism and coming back to Greece to 'study' it through models I had learnt abroad made me a product of the same irony I was coming to study.[6]

At that time the Greek economic situation, which until 1993/1994 was weak and exhibited a large budget deficit, had started to improve, and the hopes of Greece joining the European Monetary Union were becoming more realistic. These developments, however, were too recent to change the defensive attitudes of the majority of Greeks towards

international politics. Although Greece had been a full member of the EU since 1981, in Greek people's minds it played a secondary role in decision-making, because the voting rights in most EU institutions are broadly proportional to each country's population size. Ever since the establishment of the Greek state, foreign powers, especially Britain and the USA, had been interfering with – if not controlling – political developments in the area. Major destructive events in Greek history, such as the "Asia Minor Catastrophe" (1922), the Greek Civil War (1944–1949), the Colonels' Junta (1967–1974), as well as more recent and less disastrous events, such as the Greek-Turkish dispute over the islet of Imia (1996) (see also p. 54), were and still are widely seen as episodes in which foreign powers played a role detrimental to Greece. In the 1990s, the wider area of the Balkans went through wars and turmoil in which new nations gained autonomy and Former Yugoslavia broke apart. During this period Greece, was not just an observer of these developments, but it was actively involved on various levels: it was asked to and tried to play the role of a referee, for example in the conflict between the Serbs and the Croats; it was accused by the Former Yugoslav Republic of Macedonia (FYROM) of having expansionist intentions, while Greece itself felt threatened; it had its boundaries questioned by Turkey; a large number of legal and illegal immigrants, e.g. from Albania, had fled to Greece; the media broadcast, interpreted, or even invented scenarios for upcoming wars; both political and ecclesiastical authorities had officially acknowledged how crucial and unpredictable the situation was, and had adopted a more or less heroic discourse in their agendas. All these parameters added to an already existing feeling of insecurity. Abroad classicism was not as popular as it used to be. Its extensive ideological use for justifying oppressive regimes had taken its toll (cf. Bernal 1987). Classical studies had become less prevalent, as focus had shifted to more practical and economically profitable subjects for education (cf. Σύγχρονα Θέματα 64 (1997)). In Greece discussions about Greek classical heritage loomed as large as ever. The delay of the construction of the new Acropolis Museum, the conservation works on the Acropolis, the restitution of the Parthenon marbles and the Olympic Games, and the question of whether the site of the Acropolis should be open to the public in the summer nights with the full moon were some of the topics discussed vividly and fuelled longstanding Greek self-criticisms, such as the one alleging that modern Greeks are not worthy of their ancestors, or on the contrary that Greeks are trapped in an unquestioning 'ancestor-cult' (προγονολατρεία, προγονοπληξία).[7]

I started my research by visiting the Acropolis, simply watching, or trying to engage in chats with the visitors. The Acropolis, however, seemed to always slip from its site on the top of the hill and to pop up everywhere else in Athens: In archaeology books, school textbooks, newspapers, postcards, cartoons, songs, stories and memories. What is more, it was transformed depending on the angle from which one was looking at it or hearing about it. It looked different from my godparents' window than from the window of the taxi in Patission street, where it served more as a point of measuring how polluted the Athenian atmosphere was each day. It looked different in our school fieldtrips than in our Sunday walks. And as if things were not already complicated enough, there were also the Acropolises that I had met while I was in Britain, in the British Museum, in the etchings featuring colleges' sitting rooms and classicists' offices in Cambridge and in London, or in the stories of people who had visited the site during their summer holidays.

It was becoming more and more clear that if I were to study the Acropolis, I should not study it as a monument anchored and bounded on a particular site, but as one that is mobile and multiply situated. Thus, my objective became to trace the Acropolis' meanings across and within multiple areas of activity within Athens, and eventually my fieldwork took place anywhere in Athens by simply talking to people I met during the course of a day – for example archaeologists, some of whom are involved in works on the Acropolis, tourist guides, left- or right-wing activists, teachers, students, intellectuals, arts people, people living near the Acropolis or far away from it or in other parts of Greece – to learn the ways in which they think about and/or experience the Acropolis. Unusual events or any public debate or new city or state policies affecting the Acropolis were drawn on to generate specific talking points to hinge conversations on.

I found that the anthropological field research into what the Acropolis means to various people, and how these meanings are contested and negotiated in the present, would be helped by pursuing similar questions historically. Past uses and meanings of the Acropolis, discovered through historical research, also threw up questions and ideas I found interesting to discuss with informants, even if only to discover that they are no longer concerned about these matters. I therefore looked at some written sources, covering the period of the nineteenth and twentieth centuries with the aim to unravel some of the meanings that have built up in association with the Acropolis over time and through its use, and to see how they connect to certain social, political and ideological realities.

In a reading of Foucault's ideas and their application in material culture studies, Christopher Tilley (1990) has underlined the importance of discourse in the production of material culture. Discourse for Foucault is not simply a linguistic medium. It also refers to codes and rules that order reality. Discourse, Foucault says, is power linked with knowledge and truth, and it can be crucial in understanding the relation of material culture to social practice. Bearing this in mind, I would now like to draw special attention to some of the sources of discourses discussed in this book.

One of the key areas for the building of attitudes towards and perceptions of the Acropolis and classical antiquity in general is education. All Greeks go through the national educational system, and the Acropolis appears in the curricula of three different grades.[8] National educational systems constitute primary mechanisms through which the idea of the nation-state is established and reproduced. Schools, through the teaching of subjects such as history, language and geography, as well as through other school activities such as national celebrations, field trips, etc., legitimize and reproduce the nation-state's authority and the main principles on which it has been founded (Αβδελά 1997). Χριστίνα Κουλούρη (1988) has shown the role the teaching of history and geography played for the Greek nation-state's self-awareness as early as the second half of the nineteenth century. A more recent work (Φραγκουδάκη and Δραγτνα 1997) has revealed the role the educational system plays in contemporary Greece. According to Αβδελά (1997), this is very centralized, as it not only bases teaching on one and only one book per lesson, but also defines in very strict terms how it is supposed to be taught, thus not allowing much space for the teachers to apply their own educational methods and evaluations.

History lessons in particular play a crucial role in the building of national identity, emphasizing concepts of continuity and homogeneity within the Greek nation. In all history books the Acropolis is assigned to the chapter concerning the classical ages, as a product of the 'Golden Age of Pericles'. In the teachers' handbook provided by the Ministry of Education, the aims of teaching history at school are defined. Among them are 'the realization of Greek continuity' and 'the cultivation of an original patriotic spirit' (Υπουργείο Εθνικής Παιδείας και Θρησκευμάτων 1995–96: 26). In the chapter referring to the teaching of the ancient Greek language, some of the aims are:

[for the students] to understand and experience the values of the ancient Greek civilization; especially to acquire the feeling of their responsibility

as educated [πνευματικοί] people, so that they contribute to the building of a free and democratic life, to the social and cultural [πνευματική] development of the [Greek] people, and to the raising in every aspect of the standard of its life; to understand the uninterrupted continuity and presence of the Greek spirit from the years of Homer until today and its immense contribution to the development of Europe and of humankind in general (ibid.: 44–5).

Throughout this work I will refer to a number of compositions which students in four different grades of primary and secondary schools wrote in class under the topic 'What is the meaning of the Acropolis today? Does it mean anything to you personally? Do you think that the Elgin marbles should come back to Greece?', as well as to the outcome of discussions I had with them and their teachers at their schools.[9] All compositions were written in class. After getting compositions back, I tried to visit the schools and talk to the students, as well as to some teachers and to the proprietor of one of the schools. I am aware that the particular environment under which the students wrote and discussed the role of the Acropolis, as well as the topic of the composition, may have had a significant influence on what they did or did not express. This in itself is, however, a relevant discourse with its own variations, influenced by the educational system and the dominant ideology.

When one looks at the attitudes toward the Acropolis, the first concern is to investigate the attitudes of those who are directly involved in decisions concerning its presentation and preservation, the archaeologists. One year ago Angeliki Kotaridi, an archaeologist of the Archaeological Service, gave an interview to the newspaper *Ta Néa* (10/6/00) about the role of archaeology and archaeologists. Archaeologists, she said, are

> the medium between two worlds. Those who left, the dead, and those of today, the living. The archaeologist must establish a contact relation between these two worlds. He is the one to whom the dead will talk in order to communicate their knowledge, and he will pass it on to the living people.

Archaeology is not only a research enterprise. It is the means which provide the evidence through which the national past is supported and national claims gain credibility and 'scientific justification'. It provides the 'tangible links' of the present to the past, through objects which serve the notion of cultural continuity, and which create and

reinforce the unity of a nation-state in time and space. It therefore participates actively in the political discourse and constructs national identity. In Greece in particular, archaeology and especially classical archaeology has played a decisive role in the state's life, forming the 'patriotic discipline' of the nation.

Many organizations shape archaeological discourse in Greece today. For the purposes of this research, I talked to various archaeologists specializing in classical or prehistoric archaeology, working in academia or in the Archaeological Service,[10] in the Acropolis' or in other local inspectorates (εφορίες – ephorates).[11] As well as the outcome of the conversations I had with them, I also intend to discuss certain issues that are brought up by the Archaeological Society at Athens (Εν Αθήναις Αρχαιολογική Εταιρεία) (hereafter ASA) in its newsletter *ΕΔΑΕ* (from No 19: *Ο Μέντωρ*).[12]

The ASA, established in 1837, is an influential institution involved in the archaeological discourse from the establishment of the Greek state until today.[13] One could say that the Society's work has complemented that of the Greek Archaeological Service in conducting excavations and producing excavation reports as well as other archaeological publications. It consists not only of archaeologists, but also of middle- and upper-middle-class 'friends of antiquity' from various disciplines. Having a long history, the ASA bears and reflects elements of all the phases that gave Greek archaeology the face it has today. It is a private legal entity, but partly sponsored by the state.

I used several other written sources apart from the ASA's newsletter and student compositions. I drew a significant amount of data from a wide range of newspapers covering the period 1987–1997. The issues I was interested in were not just those related to the Acropolis, but also others concerning classical antiquities in general, or discussions about Greekness. For the news of the period 1987–1994 I used the archive of newspaper clippings referring to archaeological issues kept in the Library of the American Archaeological School at Athens. The rest were newspapers that I, or friends, bought on a daily basis, balancing my attention over a wide spectrum of Greek print-media.

It has been noted (Σκοπετέα 1988), that newspapers render the spirit of an age much more efficiently than a book, which is constrained to internal consistency. Each individual newspaper still has a polyphony about – and approach to – current issues. The casual tone of newspaper discourses is more immediate than the elaborately thought-out argumentation of authored books. Newspaper discourse, being addressed to a mass audience, is quite important in shaping and reproducing ideas

and values. Obviously, news does not consist of 'facts' but is an ideological interpretation of events employing a complex set of criteria and mechanisms. As a number of critical linguists have pointed out (e.g. Fowler 1991, Hall 1978, Philo 1983), everyday local or global events are subject to processes of selection and interpretation according to various political, economic and social factors before they eventually become 'news'. In addition, the linguistic features newspapers use, such as typographical choices or devices, styles of writing, and stereotypes, are crucial in the way social realities are constructed. Language is the repository of a vast accumulation of experiences, values and meanings, while at the same time it influences people's thoughts and practices. Thus, far from 'neutrally' reflecting social reality and empirical facts, language intervenes in 'the social construction of reality' (Berger and Luckman, 1976), which makes it an important tool for the study of culture.

My aim was to seek polyphony. However, I found that there was a certain uniformity and consensus in the various newspapers' discourses with regard to the importance of the Acropolis. Trying to find an alternative discourse questioning this opinion, I decided to go through a fortnightly left-wing magazine interested in contemporary political and social issues, *Αντί* (1974–today). Moreover I reviewed two art periodicals, *Επιθετρηση Τέχνης* (1954–1967) and *Ζυγός* (1955–1985).[14] The first one is an intellectual, broadly left-oriented periodical, while the second one is a periodical interested especially in the arts. Finally, I went through *Τα Αθηναϊκά* (1955–today), the periodical of 'the Society of Athenians' (Σύλλογος Αθηναίων), a club of elitistic character in which only people who can trace their family history in Athens back at least one hundred years can be registered. The periodical has an ethnographic character and publishes stories, personal memories, poems, etc., and it aims to preserve memories of old Athens.

Apart from the oral and written material, I also collected visual material from books, the press or archives (the Benaki Museum, the Greek Literature and History Archive (*ΕΛΙΑ*), the Megaloconomou photographic archive, and other personal archives), including photos, political posters, advertisements and cartoons.

My original aim was to present all this material in the form of separate discourses, namely those of the newspapers, of the archaeologists, of the schools, and so on. In the process of dealing with the collected material, however, I found so many similarities between the various discourses, that I finally decided to organize it thematically. For example, I felt very often that in the way people talked the Acropolis

was being transformed into key concepts of the nation, such as the flag, the territory, the history, the national body, etc. This transformation often took the form of metaphors or metonymies, which I found useful to illustrate and analyse the ways in which the Greeks perceive and describe issues of national politics by transferring them into an everyday discourse. Through such tropes, I explored the Acropolis as a condensation site of national identity, and a meeting point of classical and contemporary, diasporic and mainland Hellenisms (Chapter 3). Another recurring issue was the key-role of the Acropolis and the classical heritage in general in negotiations of Greece's position within international politics. In particular, plans for 'exporting' classical antiquities for exhibitions, claims over antiquities' repatriation, and efforts for 'reviving' Greek classical heritage were seen as mechanisms whereby Greece attempts to write its history, name its property and define its place on the world map (Chapter 4). The paradoxical relationship of the local and global meanings of Greek heritage was further illuminated by exploring its role as 'inalienable wealth', threatened by the encroachment of global consumer culture, a contrast that was often used to describe wider ideological relationships between Greece and the 'West' (Chapter 5). Through such juxtapositions the Acropolis was often imbued with sacredness whose purity and aesthetics had to be fiercely protected. Its sacredness, however, served not only as a means of differentiation of the Greek national self in relation to 'the others', but also as an empowering means in the hands of social groups and individuals within Greece who produced and reproduced such concepts of sacredness in their resistance against the state (Chapter 6).

The intention of this book is far from providing a holistic account of the Acropolis' representation, but to show the multiplicity of the faces it acquires in Greece. Thus, the chapters to follow concentrate on some flashpoints which aim to illustrate aspects of the construction, negotiation and transformation of the cultural meanings of the Acropolis and at understanding Greek behaviours, attitudes, and perceptions in regard to the process of defining their identities and their position in a changing world. Although my actual research took place during the years 1996–7, its outcome does not represent a snapshot of Greek society of that particular time. My ties with Greece are much longer than that period. Thus, this book is infiltrated by experiences, readings and memories before and after these years, too.

The Acropolis Past and Present

To fully understand the multiple meanings of the Acropolis today, one should also reflect on how it has participated in different phases of Greek history. Here, therefore, we revisit the history of the Acropolis in the course of Greek history in general, not in order to give a detailed account of the entire Greek history, but to enable us to put people's attitudes and perceptions of the Acropolis into a historical perspective. This chapter thus serves as a reference which will help to capture some basic knowledge of – and emotions about – the past shared by the Greeks.

Early History

In the 'Clouds' by Aristophanes (verses 299–310) the virgins of the chorus sing the following verses when they come down to Athens:

> Come then with me,
> Daughters of Mist, to the land of the free.
> Come to the people whom Pallas hath blest,
> Come to the soil where mysteries rest;
> Come, where the glorified Temple invites
> The pure to partake of its mystical rites:
> Holy the gifts that are brought to the Gods,
> Shrines with festoons and with garlands are crowned,
> Pilgrims resort to the sacred abodes,
> Gorgeous the festivals all the year round.

> (The Loeb Classical Library translation)

These verses were written in 423 BC, nine years after the Parthenon and the Propylaea were built in Athens, and while the Erechtheion was still under construction. In the above verses we can feel the poet's pride and admiration for the buildings and the other works of art in Athens,

which have inspired many subsequent generations and cultures. Although these buildings were the product of the fifth century BC, a happy historical moment in Athens' history, they have deep religious and cultural roots in much earlier times.

The rocky hill of the Acropolis with its natural fortification and springs was settled as early as the Neolithic period (c. 6000–3000 BC). In the early years of Mycenaean period (c. 1600–1100 BC) Athens was a small Mycenaean settlement originally centred around the south and south-east slopes of the hill. By the fourteenth century BC, however, it spread outward from the slopes. It seems that over time the power of the Athenian rulers who dwelled on the summit of the Acropolis had increased significantly and by the late thirteenth and early twelfth centuries they dominated the other settlements of Attica, which were eventually unified – fully or not, we do not know with certainty – under one central administration. The Acropolis thus became gradually an important political centre, protected with strong defensive walls called 'Cyclopean'. The Acropolis, like all other Mycenaean citadels was not only a religious place and royal residence, but also an administrative, commercial and military centre, and a refuge for the population in periods of war (Hurwit 1999: 71–4).

There is little factual knowledge about the place between the eleventh and seventh centuries. What is known, however, is that throughout the eighth century the Acropolis seems to have been the religious centre of the city-state growing in size and power. In those years, the construction of a first temple, built partly on the relics of the Mycenaean palace, is situated. It was dedicated to goddess Athena Polias, protector of the city of Athens, worship of whom increased over those years. By the sixth century Athens had become one of the major centres of Hellenism, and Athena acquired yet more worshippers who flooded the sacred site with rich offerings. Eventually, its eighth-century temple was replaced by a new and bigger one – the so-called 'ancient temple' (αρχαίος νετς). Having been a simple local sanctuary until then, the Acropolis now became a monumental site and a highly visible confirmation that the city's achievements had outranked those of other places in Greece (Hurwit 1999: 85–98).

After their victory against the Persians at the battle of Marathon (490 BC) the Athenians' power increased. As a sign of their gratitude for their goddess's support, they decided to build a new temple dedicated to her. They did not succeed in materializing their goals, however, as the Persians invaded Greece again in 480 BC, occupied Athens, and devastated the hill. Two years later the Athenians, having won the naval

battle against the Persians in Salamis, finally returned to their city only to find their temples and their offerings in ruins. In the years to follow, Athens re-established its dominance within the Greek world and became the head of the 'Anti-Persian Alliance' of the Greek cities founded in Delos, in Apollo's sanctuary. Pericles (c.490–429 BC), the prominent figure who reinforced democracy in Athens, conceived of a major project in order to increase the political and cultural power of Athens within the Greek-speaking world. He planned for a long-term building programme with monuments which would glorify Athens within and beyond Greece. The financial expenses of the project were supported not only by the riches of Athens, but also by the money of the Anti-Persian Alliance's treasury that the Athenians had transferred from Delos to Athens, ostensibly for better safekeeping (Spivey 1997: 234). Pericles' project thus cannot be viewed in isolation from the political manoeuvres of the Athenian hegemony. In fact, Spivey (1997: 234–5) sees it as the Athenian response to the ceremonial and imperial centre that the defeated Persians were creating in Persepolis at that time.

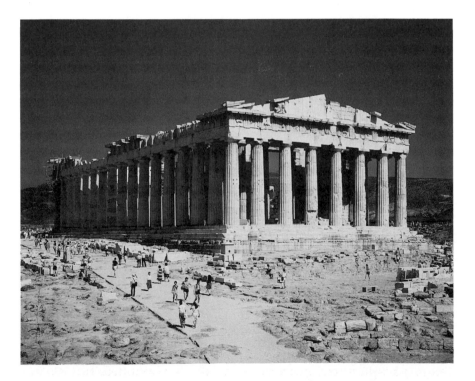

Figure 2.1 The Parthenon viewed from the northwest (source: Studio Kontos).

The first monument of the Periklean project was the Parthenon as we know it today (see Figure 2.1). Its construction by Iktinos and Kallikrates started in 447 and finished in 438 BC, while its decoration by the sculptor Pheidias, head of numerous artists and workers, took until 432. The Parthenon was not just a sacred site but it also stood for the dominant position of Athens in the ancient Greek world. At the same time it was the product of a long history of aesthetic quests, which reached their peak in the Age of Pericles. When the Parthenon was completed in 432 BC, it was already 'ancient', says Plutarch (*c.* AD 46–120, *Life of Pericles* 13, 5) meaning that it enjoyed the respect and the symbolic significance of a monument consecrated through its long-term use. The year 437 was when the building of the Propylaea, the monumental entrance to the Acropolis, began. It was interrupted, however, because of the outbreak of the Peloponnesian War (431 BC) between Athens and Sparta and their respective allies. Pericles died in 429 BC. His project, however, was continued after the peace brokered by Nikias in 421. The temple of Athena Nike was built between the years 425 and 421 (Figure 2.2). In 421 began the construction of the Erechtheion (Figure 2.3), a

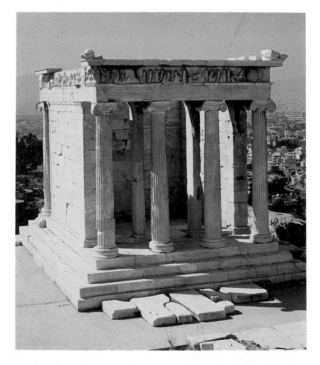

Figure 2.2 The eastern façade of the temple of Athena Nike (source: Studio Kontos).

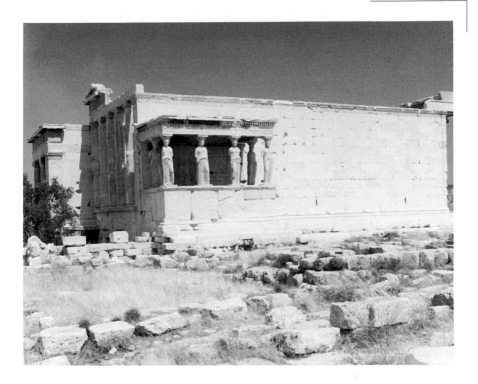

Figure 2.3 Part of the Erechtheion viewed from the southeast (source: Studio Kontos).

temple following architectural lines very unusual in ancient Greek temples. The Erechtheion was the most revered sanctuary of the Acropolis (Μπρούσκαρη 1996: 194). It was dedicated to Athena and Poseidon, the two main deities of Athens, yet it also housed relics of ancient worship, as well as the old sacred statue of Athena. Its construction, however, was interrupted by the Athenian Expedition to Sicily and was finally completed between the years 409 and 406.

Since the beginning of their construction, all these monuments have been continuously enmeshed in negotiations of power and in games of politics, as has the site of the Acropolis itself. While Athens was still under Macedonian hegemony, Alexander the Great dedicated 300 shields to the Parthenon as votive offerings after his victory over the Persians near the river Granicos in 334. Similarly, after he entered Susa, the old Persian capital, he sent two bronze statues stolen by the Persians in 480 back to Athens. Hurwit (1999: 253–4) suggests that, by offering the spoils of his victory, Alexander did not simply pay his respect to

the Panhellenic sanctuary. Instead, he was also trying to remind the Athenians of his powerful presence, stifling their opposition while he was in Asia, and using the Parthenon, a monument representing the Athenian power after the Persian wars, as a monument celebrating his victorious expedition against the same enemies.

Around 304–3 BC one of the successors of Alexander the Great, Demetrios, known as 'the Besieger' (Poliorketes), who had already been deified by the Athenians whom he liberated from the aristocratic regime in 307 BC, declared and materialized his wish to become co-tenant of goddess Athena in the Parthenon in an effort to further enhance his divine standing (Hurwit 1999: 261).

During the Roman occupation the Acropolis was among the very few monuments not stripped of ornaments and offerings for the decoration of Rome's public buildings or villas of Roman officials. However, it was used to legitimize and manifest the power and the authority of the new conquerors. Around 27 BC a small temple dedicated to Rome and Augustus was built on the Acropolis, only 25m away from the Parthenon. Some years later, in 61 BC, a monumental inscription praising Nero as 'the son of God' was placed on the architrave of the east side, while one century later the Roman traveller Pausanias (I, 24.7) reports having seen the statue of Hadrian standing in the Parthenon next to that of goddess Athena (Κορρές 1994: 140).

From the fourth century onwards the ancient world gradually declined as Christianity spread. It is believed that in the sixth century AD, during the reign of the Byzantine emperor Justinian, the Parthenon became a Christian church. In the years to follow, a series of modifications (architectural alterations as well as fresco decorations) took place in order to make the temple appropriate for the new religion (Κορρές 1994: 146–8). Smaller Christian churches were built, in the precincts of the Erechtheion and the Propylaea.

As a result of the Fourth Crusade, the Acropolis became the seat of Frankish conquerors (1204–1456) who installed their palace in the Propylaea, and transformed the Parthenon into a Roman Catholic Church.

After the Ottomans took over Athens in 1456, they transformed the Parthenon into a mosque and added a minaret in its northwest corner (probably around 1460 – Κορρές 1994: 151). The Turkish traveller Evliya Chelebi, writing in 1667, expresses his admiration for the fact that 'there is no such magnificent mosque in the whole atlas of the globe. In civilized countries no sanctuary exists to equal it' (Mackenzie 1992: 13). The Acropolis became the settlement of the Turkish garrison and

the Erechtheion the residence of the Ottoman administrator's harem. In 1687, during the Turkish-Venetian War and faced with the danger of the Venetian army's intrusion, the Ottomans decided to further fortify the Acropolis. They did so by using building material from the temple of Athena Nike, which was demolished for this reason. When the Venetian army, under the leadership of Morosini, finally bombarded the Acropolis the following year, the Parthenon, where the Ottomans had kept their gunpowder, was blown up and the monument was, to a large extent, destroyed (Figure 2.4).

From the eighteenth century, with the resurgence of classicism, more and more Western Europeans visited Greece. The Acropolis became more widely known, but also fell victim to the collectors' zeal (Σιμόπουλος 1993). It was within this spirit that Lord Elgin, taking advantage of both his position as British ambassador to Constantinople and of the political circumstances favourable for Britain, persuaded the Ottoman authorities to issue a *firman* (an official letter of permission) allowing him to '. . . erect scaffolding, to view and draw the buildings and sculptures, to make moulds, to remove obstructions from the monuments,

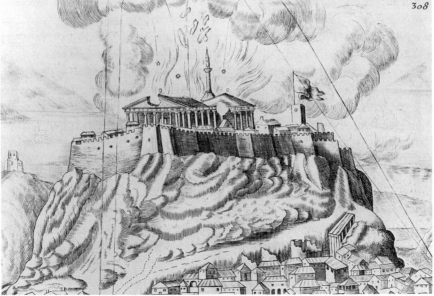

Figure 2.4 The bombardment of the Acropolis by Morosini (Fanelli 1707; source: Gennadeios Library, American School of Classical Studies).

and to conduct excavations, taking away anything of interest which the excavations yielded' (St. Clair 1998: 89).[1] Eventually, the works undertaken on the Acropolis included more than what the firman provided for: More than half of the surviving panels of frieze were sawn off the monument, several metopes and most of the surviving figures of the Parthenon's pediment were removed as well as a Caryatid and a column from the Erechtheion. After an adventurous journey during which a ship loaded with sculptures sank (Hamilakis 1999; Μηλιαράκης 1994[1888]) the artworks finally reached London and were eventually sold to the British government which then presented them to the British Museum. (For more on the moral and legal issues surrounding the Parthenon marbles removal by Lord Elgin, see Γεννάδιος 1930; Hitchens 1987: 24, 37; St Clair 1998.)

National History

The Establishment of the Greek State

During the Greek War of Independence two sieges of the Acropolis took place, the first one by the Greeks against Ottomans (1822–1827) and the second by the Ottomans against Greeks (1827–1833). These devastated the Acropolis' hilltop and seriously damaged the ancient monuments. For three years from 1824 to 1826 the daughters of the fighters of the War of Independence had a school set up for them in the Parthenon (Hitchens 1987: 24). When, after the end of the War of Independence, the Ottomans handed over the Acropolis to the Bavarian garrison in 1833, the German archaeologist Ludwig Ross arrived in Greece to undertake the directorship of the Archaeological Service. In 1832 he found Athens in a state of destruction that reminded him of Thucydides' description (A. 89) of the city after the withdrawal of the Persian troops for the battle in Salamis in 480 BC (Ross 1976 [1863]: 48).

On 18 March 1835 the Acropolis came under the administration of the Greek Archaeological Service, which was established for the conservation and restoration of archaeological works (Κόκκου 1977: 72). In 1837 another archaeological institution, the Archaeological Society at Athens, was founded in order to 'contribute to the recovery, the restoration and the completion of antiquities in Greece' (ibid: 99). Its first meeting was held in the Parthenon, where Iakovos Rizos Neroulos, the first president of the Society, pointed to the ruined buildings and said, 'Gentlemen, these stones, thanks to Pheidias, Praxiteles, Agoracritus

and Myron, are more precious than diamonds or agates: it is to these stones that we owe our political renaissance' (cited in Tsigakou 1981: 11).

Neroulos was very much aware of what he was saying: The *raison d'être* of Greek archaeology, at least in its initial stages, was the justification of Greek national identity. Thus it should not come as a surprise that the first measures for the preservation of classical antiquities were instituted from the very beginning by the new state.

When the question of which city should claim the right to become the capital of the new state arose, the choice was made not so much because of Athens's geographical position, nor for any other practical reasons. It was its name, linked with the glory of the classical world, that was enough to justify such a choice (Πολίτης 1993: 75, 76; McNeal 1991: 60). The European Powers played a major role in shaping the political, ideological and socio-economic framework within which the War of Independence took place. It is not accidental that classical antiquity, which was selected to be the new nation's most prominent heritage, was identified as the epitome of democracy, arts and sciences by the major European Powers who were to support the Greek nation's independence. Classical antiquity had regained its soil in the form of the Greek state, and ancient Greeks had found their 'legitimate descendants' in the face of modern Greeks. The monument epitomizing that glory was the Acropolis. Athens was the city laid at the foot of this site, which had to be restored in its classical form. It was in that context that the architects Kleanthis and Schaubert designed the first urban plan of Athens, which had to be 'equal to the ancient glory and glamour of this city' (Κόκκου 1977: 56). The plan had provided for keeping 'the most important part of the city' (i.e. the area around the Acropolis) free for excavations.[2]

The Acropolis in particular became a subject of special concern. In 1834 Otto, second son of the staunchly philhellenic King of Bavaria, had arrived from that country to take office as king of Greece; the Bavarian architect Karl Friedrich Schinkel suggested a plan according to which a palace should be built for the young king among the classical ruins on the Acropolis. This ambitious idea did not materialise in the end, and the Acropolis was to be preserved as an archaeological site. The symbolic ceremonial opening of the restoration works took place in the summer of 1834 on the Acropolis. The classicist architect Leo von Klenze placed one of the column drums back in its original position and addressed the new king, who was present at the ceremony, with the following words (Tsigakou 1981: 63):

[When the works began] the shadows of those great spirits who until then had suspected their imminent destruction in any stroke of an axe or the sound of the workers' voices, rose from their peaceful tombs and raised their arms above these exalted ruins as if trying to protect them. Thus everything was against our operations. The levers broke, the workers fell ill, the masons believed that the works ought to be suspended. But O!, the blue flag of hope appeared on the distant horizon: the king was coming with his councillors in order to undertake the work of rescue . . . and, as if by a miracle, those gigantic marbles began to obey the masons and harmonize under the sound of the hymns that saluted the king.

Thus, for Klenze, the restoration works on the Acropolis symbolically coincided with the beginning of Otto's task of restoring the modern Greek state itself.

This first period is marked by the efforts of the Greek archaeologists and their Bavarian advisors to free the Acropolis site from any relics representing eras other than the classical one. All later monuments (medieval, Turkish, and early modern) were demolished in the interest of preserving only the monuments of the fifth century BC.

The Revival of the Two-Headed Eagle and the Reconciliation of the Classical and the Byzantine Past

When the Greek state was established, its boundaries excluded large Greek populations. The inability of incorporating all these Greeks in the new state, which had as a consequence the impossibility of identifying the Greek nation with the Greek state, created hopes for the revival of the Byzantine Empire which would include the entire Greek nation. These hopes found their expression in the concept of the 'Great Idea' (Μεγάλη Ιδέα) that marked Greek history during the second half of the nineteenth and the first two decades of the twentieth centuries.[3] Up to that point, Greek history was seen to have only two periods (the classical and the present) with a huge gap between them (Δημαράς 1989: 402). A new three-age scheme appeared where classical antiquity, Byzantium and modern Greece shared in glory and importance. This new scheme was also dictated by several external developments: Europe did not show the same philhellenic attitude any more, so Greeks needed to renovate their cultural orientation in the eyes of Europe; dangers also came from other Balkan ethnicities which were forming their national consciousnesses and claiming part of the Ottoman land. Moreover, in nineteenth century Europe, under the appearance of Romantic

concepts of history, historicism emerged. This viewed the past not as an autonomous entity in the way the Enlightenment had done, but as an inherent part of a living organism, i.e. the nation, which also had a present and a future. Thus, the study of history began to favour periods such as the Greek medieval (Byzantine) era. The need for such an emphasis was felt even more strongly after 1830, when the Austrian historian Fallmerayer questioned whether the modern Greeks were the descendants of the ancient Greeks. His theory, created a strong shift in the worldview of modern Greeks. The gap between the ancient and modern worlds, which Fallmerayer's theory was creating, had to be bridged (Πολίτης 1993).

Konstantinos Paparrigopoulos was the principal Greek historian who theorized this unity, destined to become the basic element of the modern Greek consciousness (ibid.). It was that unity that allowed him to make the comparison between the Parthenon as the representative of classical antiquity, and St Sofia, the Christian church of Constantinople, as the representative of Byzantium, and call them 'half-brothers' (Δημαράς 1970: 144). The archaeological policy also changed around that time. Systematic archaeological excavations were extended beyond the area of the Acropolis, aiming to reveal other 'important' sites highlighting the public life of the fifth century BC, like the cemetery of Kerameikos, the Athenian Agora, and the ancient theatres. It is revealing that in these excavations monuments of later periods were no longer demolished at the excavated sites. The Byzantine past had won a position in the Greek history and had become worthy of preserving and remembering.

Preparing for the Twentieth Century

The 1880s are marked by the premierships of Harilaos Trikoupis, whose principal aim was the modernization of Greece's infrastructure. He sought to strengthen Greece politically and economically before engaging in irredentist adventures. He encouraged industrialization, improved communications through railway construction and the building of the Corinth canal, and modernized the army (Clogg 1992: 69). While the previous period was marked by the affinity to the ancestors and the idea of the nation as being intimately connected to the past, this new era opened up a new ideology which embraced also the future, the modernization and the recovery of the state. However, the onerous terms of the foreign loans for the realization of the above works created long-term debts which finally resulted in the declaration

of the Greek state's bankruptcy in 1893 (Σβορτνος 1994: 104). In 1894, along the spirit of these difficult times, the Greek poet Kostis Palamas, the major representative of the so called 'generation of the '80s' (γενιά του '80), went to the Acropolis on a moonlit night to contemplate 'the times in which reality is so wild and so mean to our country' and lamented 'the heavy sleep to which the Greek Glory has given herself in our days' (Palamas, *Acropolis Esperini* cited in Αργυρίου 1994).[4]

Regarding the site of the Acropolis, this period is marked by the management of the Greek archaeological heritage by Panayotis Kavvadias (1850–1928)[5] who was General Ephor of Antiquities from 1885 to 1922. The interventions that took place in that period coincided with the general climate of economic improvement and modernization introduced by Trikoupis's government. While the restorations of the years 1835–1885 were undertaken by enthusiastic amateur archaeologists who applied empirical and improvised methods, this new period encouraged a 'scientific' approach, whereby the works were supervised by trained, multidisciplinary, and international committees (Mallouchou-Tufano 2000). During the period 1899–1933 Nikolaos Balanos supervised a major restoration project. This was the first systematic project that was undertaken on the Acropolis using modern technological methods. Despite the scientific specifications, however, Balanos's work proved disastrous for the Acropolis' monuments. Balanos wanted to restore the ancient monuments to their lost grandeur, and he proceeded with the relocation of architectural elements, which, however, proved somewhat arbitrary. Thus, his interventions led to the loss of the original structure of the monuments. The iron joints that he used for strengthening provoked oxidation of the marbles, which eventually began to crack and break (Mallouchou-Tufano 1994: 83–4).

The '1930s Generation' and the Regeneration of 'Greekness'

Greece emerged victorious from the Balkan Wars of 1912–13. In 1915, the 'Entente Powers' (Britain, France and Russia) promised important territorial concessions in Asia Minor in their efforts to bring Greece to their side. The realization of the 'Great Idea' seemed to be close. In the aftermath of the First World War, however, Greece found itself involved in a confrontation (1919–1922) with the forces of the nationalist Turkish movement (Νεότουρκοι), who under the leadership of Kemal Atatürk aspired to create an independent and modernized Turkish state. Thus, what was meant to result in the materialization of 'the Greece of the two continents [Europe and Asia] and the five seas [Ionian, Aegean,

Mediterranean, Marmaras, Black Sea]' (Clogg 1992: 97) resulted in a big disaster which has since been known as 'the Asia Minor Catastrophe', and in a vast exchange of populations between the two countries. The collapse of 'the Great Idea' was a blow to Greek identity. In the general climate of disaster and disillusionment, however, there appeared a group of Greek intellectuals and artists with different backgrounds who have become known as the 'generation of the '30s' (γενιά του '30). They felt the need for regeneration and began to contemplate the different paths that Greece had to follow in order to come to terms with the crisis and to rejuvenate itself.

In the early twentieth century Western European artistic and intellectual circles appeared to turn against classical norms. Not only did they push classical paragons aside, but they also often mocked them. The futurist Marinetti, in his manifesto addressed to the young people of Greece, invited them to turn their backs on the Acropolis and wondered ironically: 'If the Parthenon looks nice as it stands on the top of the Acropolis, will it, however, retain its grandeur in the eyes of a Greek pilot who flies at a height of 3000 feet?' (Λυδάκης 1994: 245). An indicative Greek response to these stances expressed by some leading intellectuals and artists of that period can be summed up in the words of Theotokas, a representative of the 'generation of the '30s': 'An aeroplane flying in the Greek sky, over the Parthenon, gives off a new harmony which has not yet been conceived by anyone . . . An aesthetics is being formed genuinely in the air we breathe' (Vitti 1977: 41). In Greece the acquaintance with these new trends does not result in the renunciation of antiquity, but in its reconciliation with modernity. We must note, however, that even in Western Europe classical antiquity still plays a significant role, as for example in the works of Picasso, De Chirico, or even in the work of the militant modernist Le Corbusier (Κονταράτος 1994: 47–8), who restructured classical values on a different basis.

In 1936–1940, within the general climate of fascism in central Europe, the dictatorship of Ioannis Metaxas, known as 'the Third Hellenic Civilization' (a term borrowed from Hitler's Third Reich (Clogg 1992: 119)), was established in Greece implying that the two previous civilizations were the ancient Greek and the Byzantine. During that period, classical antiquity regained its heroic dimensions (Ιωαννίδης 1988). For example, in 1936 Athens celebrated the fortieth anniversary of the revival of the Olympic Games, and a conference was organized in Greece by the International Olympic Committee. A glorious ceremony took place on the Acropolis, including the reciting of Renan's

'Hymn to the Acropolis' and the crowning of the flags of the forty-two countries participating in the revival of the Olympic Games with laurel wreaths. The ceremony on the Acropolis was followed by another one in the Panathenaic Stadium, organized by the Greek Olympic Committee. There, before the eyes of the audience, the Minoan, Classical, Byzantine, and contemporary Hellenisms paraded. The aim was to remind both local and foreign visitors of the historical background of the Olympic Games (Πανόραμα του [20ου] αιτνα).[6]

The Second World War and its Aftermath

At this moment the Acropolis is morally forbidden to us. The Sacred Rock, too, is under foreign occupation and the blue and white flag does not fly alone any more. In fact, I know several Athenians who, out of a feeling of discipline and wounded love, avoid to raise their eyes towards it (Roger Milliex, 1946: 8).[7]

These were the words of Roger Milliex, a French writer and essayist in a lecture he gave in France in the winter of 1942. During the Second World War the Acropolis' function as the symbolic fortress of Athens was accentuated (Figure 2.5). The German occupation of Athens was officially signified by the raising of the German flag on the site and the legendary suicide of the Greek soldier who until that time was guarding the Greek flag on the Acropolis hill. The resistance to the German occupation was manifested in the removal of the flag by two young Greeks (see Chapter 3).

The liberation of Greece from the German occupation in October 1944 was celebrated on the Acropolis, where the Greek flag was hoisted again in the presence of the Greek government and Prime Minister George Papandreou (Papageorgiou-Venetas 1994: 390). However, the end of the Second World War did not bring peace to Greece. A civil war (1946–1949) broke out between ΕΛΑΣ, the National People's Liberation Army forces representing a communist ideology, and the National Army, supported by the right-wing political parties as well as Britain which had been the main ally of Greece in Europe against the Axis powers. When Papandreou's government returned to liberated Athens it was backed up by British soldiers to ensure its safe return and to stifle attempts by the communists to take control. After the outbreak of the civil war some British soldiers camped on the Acropolis to prevent ΕΛΑΣ from occupying an ideal spot from where to open fire. The photographer Dmitri Kessel of *Life* magazine documented the

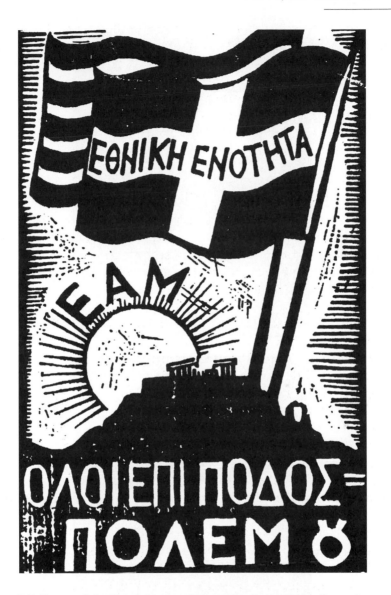

Figure 2.5 Poster of the Greek National Liberation Front (EAM, the major resistance organization during the Nazi occupation in Greece), with the subtitle 'all on a war footing!' The Acropolis features in the background (source: Καραχρήστος 1984).

stay of those soldiers on the Acropolis. 'Guns, binoculars, berets were hanging from the statues', and 'their washed clothes were hung out right below the Parthenon' (Kessel 1994) (Figures 2.6 and 2.7).

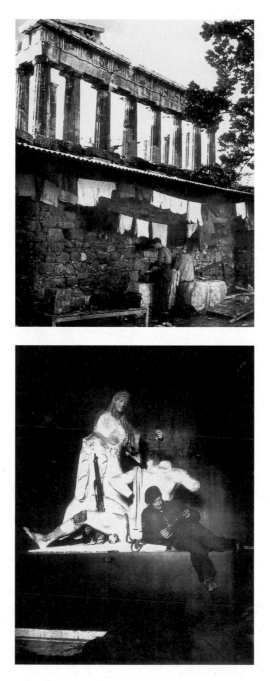

Figures 2.6 and 2.7 Photographs of British soldiers who camped on the Acropolis after the outbreak of the Civil War (Photographs by Dmitri Kessel; source: Kessel 1994).

Between 1946 and 1949 the island of Matronisos, where many thousands of political prisoners were kept, was called 'The new Parthenon' by the authorities (Βαλέτας 1975; cf. Hamilakis and Yalouri 1996; Hamilakis 2000), because the prisoners there were forced to build replicas of the Parthenon (Figure 2.8). They were also forced to build replicas of the Erechtheion (Κουτσίκου 1984: 87) and of St Sofia (Leontis

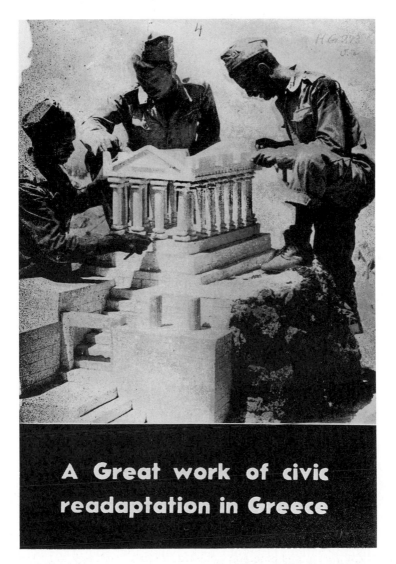

A Great work of civic readaptation in Greece

Figure 2.8 Political prisoners in Makronisos building a Parthenon (Rodocanachi 1949; source: Gennadeios Library, American School of Classical Studies).

1995: 221). Makronisos was also called the 'National Baptismal Font' by governmental officials (ibid.). They considered Makronisos to be the place where 'errant' Greeks would be cleansed of their political sins and helped to reapproach the glorious past spirit from which they had strayed, thus regaining their Greekness (Rodocanachi 1949: 6). Makronisos was perceived as 'a national civilising capital, which has emerged through the struggle of the violent forces of the Slavocommunist darkness against the forces of freedom which were born from the spirit of ancient Greek philosophy' (Photographic Album of Makronisos 1949: 6).

Works carried out on the Acropolis in the 1950s were linked with the developmental and ideological aims of post-war and post-civil-war Greece and correspond to the demands of mass tourism which appeared in Greece at that time (Μαλλούχου-Tufano 2000). Greek tourism, in its initial stages, was conceived in a romantic way. The only intervention in the Acropolis' landscape was the attempt by the architect Dimitris Pikionis to unify morphologically the sites around the Acropolis. Pikionis shaped his perceptions about 'Greekness' during the '1930s generation'. However, he only applied them in the 1950s. Two paths were built on two hills which stand opposite one another, the Acropolis and the Philopappos. The first one gives access to the site of the Acropolis, while the other carries the visitor away from the Acropolis' hill and takes him or her to the levelled hilltop of Philopappos, from where the Acropolis' site can be viewed. Pikionis's plan was the first to define space not with constant reference to the ancient monuments, but in relation to the natural landscape as a whole (Κοτιόνης 1994: 13). Pikionis used decorative elements from earlier Greek traditions and incorporated them in his works on the ancient site, as in the example of the cobbled paths, following traditions from Epirus, or the tiles that he used for the church of St Dimitris Loumbardiaris on the Philoppapos hill. He also incorporated real fragments of either ancient or later traditional pots and sculptures in his landscaping works.

Particular reference should be made to the 'colonels' dictatorship' in Greece between 1967 and 1974 (Figures 2.9–2.11). Like Metaxas' authoritarian regime, the dictatorship's ideology tried to incarnate the 'Helleno-Christian ideal'. Classical art became committed art, manipulated for the interests of the authoritarian ideology. A series of feasts at the Panathenaic Stadium of Athens, organized by the dictators, celebrated the various facets of Greek civilization. Young Greeks dressed up as ancient classical citizens, Byzantine chieftains, Greek soldiers from the Second World War, and folklore figures participated in parades,

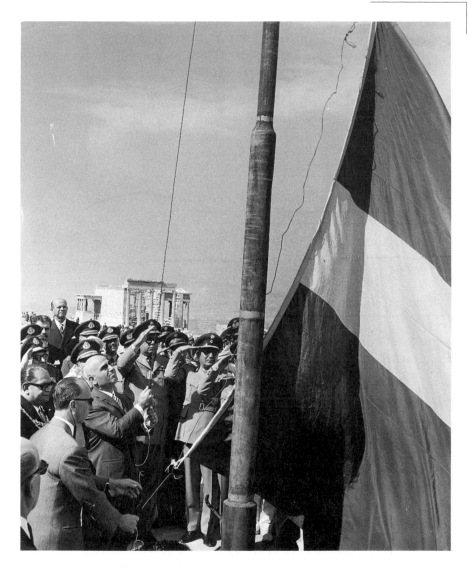

Figure 2.9 The dictator Stylianos Pattakos raises the Greek flag on the Acropolis (source: Megaloconomou Archive).

chariot races and representations of battles. Moreover, from 1970 until 1972 the dictatorship undertook the project (known as 'Το Τάμα') of building a gigantic church equal in glory to St Sofia of Constantinople (Κουτσίκου 1984: 98). The plan was to build the church on Tourkovounia, a hill in northern Athens with a view of the Acropolis, thus competing with the ancient monuments in glory.

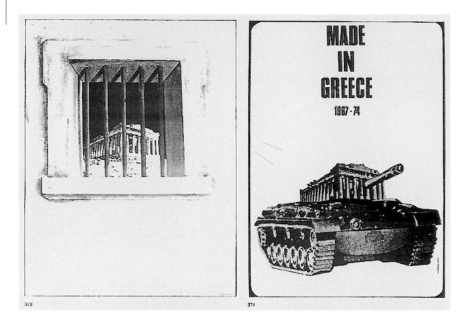

Figures 2.10 and 2.11 Political posters (1970–1974) by G. Aryirakis against the military dictatorship (source: Καραχρήστος 1984).

Towards a Democratic Pluralism

The figure who undertook the task to guide Greece from the junta regime to a pluralist democratic one was Konstantinos Karamanlis, the prime minister of Greece from 1974 until 1980. As early as 1961 the European Community had provided for the possibility of Greece joining the EC in 1984. Karamanlis, however, seeing membership as a guarantor of political stability, decided to push for speedier admission and advertised the whole project with the motto 'Greece belongs in the West'. To this motto, the political opposition of ΠΑΣΟΚ (Panhellenic Socialist Movement), under the leadership of Andreas Papandreou, replied with the slogan 'Greece belongs to the Greeks' (Clogg 1992: 179), presenting the ambition of joining the EC as one that was solely in the interests of a rich and economically powerful minority. When ΠΑΣΟΚ came to government it did not change its rhetoric, which even then was one of national pride and anti-Western (ibid.). It is not a coincidence that during that period ΠΑΣΟΚ introduced free entry to the Acropolis (as well as to all archaeological sites) for all Greeks. ΠΑΣΟΚ is the party that governed Greece for almost the last two decades of the twentieth century, with the exception of three years of government by the right

wing (Νέα Δημοκρατία) between 1989 and 1991. As early as the first ΠΑΣΟΚ government in 1981 the main slogan of the ΠΑΣΟΚ Minister of Culture Melina Merkouri was that 'civilization is Greece's heavy Industry'. In that spirit the campaign for the restitution of the Parthenon (or 'Elgin') marbles featured as a main issue in Merkouri's political endeavour. Disagreements over the legitimacy of Lord Elgin's conduct are as old as the removal of the sculptures from their original site, and the restitution issue has been raised on several occasions by both British and Greek intellectuals. (For a report on British reactions, see Hitchens 1987; for a report on Greek reactions see Κρεμμύδας 1998.) However, it was under Merkouri's public office that it was fervently projected as a 'national issue', supported by all political parties. Along with the claim for the restitution of the Parthenon marbles, the return of the Olympic Games to Greece has been a declared aim ever since. At the same time the design of a new Acropolis Museum, to be built at the foot of the Acropolis, became the subject of an international architectural competition.

The post-war Archaeological Service has been faced with the very difficult problem of how to preserve the Acropolis monuments. The damage has been accelerated by air pollution and acid rain destroying the sculptural details of the Acropolis' artworks. Together with the restoration of democracy in Greece the restoration of the Acropolis was set as an urgent task. In 1975 a preliminary multi-disciplinary committee was set up to investigate the problems created in the Acropolis' monuments due to all the above-mentioned factors. The (permanent) Committee for the Preservation of the Acropolis' Monuments was officially established in 1977. The principal aims have been the containment of the continuing deterioration of the monuments, their further restoration, and the correction of earlier mistakes (Μπούρας 1994: 329–30). In the organization and administration of antiquities in different departments (ephorates) today, the Acropolis is the only monument that commands an ephorate of its own.

In Chapter 1 I referred to the meanings of the Acropolis throughout space, as both a national Greek and international monument representing international values and ideas. In this chapter I referred to the meanings of the Acropolis throughout time and I defined certain periods of major and direct human impact. The Acropolis' site bears a dynamism that is not constrained in its fifth-century BC history, but covers many centuries of historical experience before and after that time up to the present. The site as a pagan sanctuary or Christian or Moslem shrine has accommodated a wide range of cult activities. But it has also

served as an important political, administrative, and military centre representing the influence of different regimes of truth and power and it has been directly involved in politics of a public or private nature from the very beginning of its habitation. This fact makes it a site rich in meanings and dense in values layered throughout history. In the following chapters I will try to unravel some of them while showing how

> time present and time past
> are both perhaps present in time future
> and time future contained in time past

> T.S. Eliot, 'Burnt Norton', *Four Quartets*.

Greece Condensed: Materializing National Identity

Stathis Gourgouris (1993; 1996) has discussed the nation as a social-imaginary institution (cf. Anderson 1991) the work of which is very similar to that of the dream-work as described by Freud. Criticizing previous approaches to the concept of the nation as narration, he emphasizes that national imaginary is more complex than an exclusively discursive formation (1993: 83). Alternatively, he argues, 'the emphasis must shift from nation-as-text to nation-as-dream, which is to say that those texts bearing the nation's mark may ultimately be seen as descriptions of the nation's dream-thoughts, thus figural descriptions . . . of the nation's dream-work' (ibid.).

Jakobson (1975) has pointed out the metonymic and metaphorical character of mechanisms such as 'condensation' and 'displacement', which, according to Freud, define dream-work. The way dream-thoughts are condensed in comparatively brief, laconic dream-contents is similar to the way metonymy 'involves a move from a part to a whole' (Tilley 1999: 5). On the other hand, the way dream-thoughts are displaced by 'distortions of the dream-wish, which exist in the unconscious' is similar to the way a metaphor transfers one term from one system or level of meaning to another (ibid.: 4). If we take Gourgouris's comparison of nation-building to dream-work one step further, we could compare mechanisms such as condensation and displacement with equivalent mechanisms that take place in nation-building. Metaphor and metonymy can be two quite useful devices in unravelling the 'dream-thoughts' behind the 'dream-content' of a nation.

This would extend an observation of Tilley (1999) that the concept of metaphor can be a very useful tool in studying how the meeting of

49

agency and material forms takes place in everyday life, to the realm of the nation and the agency of its material forms. According to Tilley, applying the concept of metaphor can prove fruitful in unravelling the various layers of meaning attributed to a piece of material culture. Metaphors, or rather tropes in general, highlight the multiplicity of the meanings of things in the way they are perceived, used, and translated in various cultural contexts and by different agents. Thus, things are not only polysemic, but also polytropic, as 'they assume various tropic capacities – as metaphors, metonyms, synecdoches, or ironies – as actors use the symbols' (Ohnuki-Tierney 1992: 129).

Ethnographic research in Greece has already pointed out the importance of metaphors as a means to illustrate and analyse the ways in which Greeks perceive and describe issues of national politics by transferring them to an everyday discourse (Herzfeld 1992; Sutton 1998). Here I will try to illuminate the condensed character of the nation/dream, through the analysis of a site of equally condensed meaning, the Acropolis. More specifically, my aim is to demonstrate how through this material form the nation-state can evoke memories and communicate ideas which can, in turn, be transformed or reproduced by the way the Acropolis is interpreted or used by particular agents. In doing so, I will use a (limited) set of tropes, which can provide a powerful key to understanding the interrelation and interaction between the Acropolis and people who live in Athens.

The Acropolis As History

History is an essential element in the cohesion of a nation. Lacking a national history means lacking the grounds for national recognition. Antiquities and archaeology in general are the means providing evidence for history's suggested 'truths'. In several conversations I had during my research in Athens, historicity and old age appeared as major qualities or virtues, the first one featuring as a kind of record that the Greek nation can display and the second testifying the richness of this record. In her composition, a student (6th GR) explains why 'the past' is so important for a nation's life:

> As it is well-known, both the development and the survival of a culture depend on sources from which it draws its basic elements. The more solid, i.e. the more significant, these sources are, the more this culture is able to adapt to different situations and to manage not simply to survive, but also to dominate. This is the case for both European and modern

Greek civilization. Given that they both rest upon the ancient Greek
civilization, the best known and greatest civilization of its times, they
have a very stable basis, and thanks to it they survive and dominate.

In the student's words, history becomes a kind of infrastructure supply-
ing people with the necessary equipment for surviving or even dominat-
ing in the international arena. Moreover, it is a decisive, definite and
unchangeable asset, which predetermines the present and the future
of peoples. For another student of the same class, preserving the past
of a people means preserving the main characteristics of a people, con-
sequently preserving the people itself in the world. In other words, the
specific distinction of a people within the world today can be found
fossilized in the idea of a past:

> It goes without saying that each people's antiquity is a necessary pre-
> condition for the preservation of their main characteristics as well as for
> their preservation within the social and political arenas of the world.

The past thus becomes a 'symbolic capital' (Hamilakis and Yalouri 1996),
a kind of possessed wealth. Perceiving the past as a resource also leads
to the idea of the past as 'property' – a phenomenon that has been
discussed by Just (1995) and Sutton (1997; 1998). As such, the past is
attributed material qualities, such as size and physical presence.

Shanks and Tilley have discussed how 'the time of an object becomes
a property possessed, equivalent to mass and dimension' (1992: 9). The
traces of the past, they argue, 'belong to a time in the distance which
we cannot see clearly. In this way time is conceived spatially, as distance.
. . . The object *has* been, it *has* happened. . . . This "perfected" past is
opposed to the flow of the ongoing, incompleted, "imperfect" present'
(ibid.). If the past is perceived spatially, it should not be surprising
that it is sought in some physical, 'objective' evidence. The disciplines
of history and archaeology provide raw material for this physical
conceptualization and re-creation of the past. In fact, these two
disciplines' preoccupation with the production of 'facts' aiming at the
revelation of the 'historical truth' is another example of how the past
is perceived as complete and 'perfected' in space, as 'cast in stone'
(Sutton 1998).

The Acropolis, the monument of the 'national Greek past' par excel-
lence, is one of these forms of history's materialization. It is not simply
a historical monument; it is conceptualized as history itself. It is, as a
teacher put it, 'our tangible history, which awakens the feeling of

patriotism within every Greek'. Several informants were fascinated by 'how old' the Acropolis is. The infatuation with oldness was not necessarily verbalized chronologically, but rather as a physical magnitude. Thus, I came across proud statements such as: 'We have the longest history in Europe' or '[The Acropolis hill] is the only hill that bears *so much* history' (emphasis added) (student of the 6th PR) or '[The Acropolis] is one of the *most* historical monuments' (emphasis added) (taxi-driver, Athens).

For the people in the island of Kalymnos 'history', according to Sutton, 'means the disruption of routine, an event that bursts on the scene' (1998: 135). This perception of history as an event is another form of history's objectification in the sense that it particularizes and condenses the historical process in the form of a specific event. Setting off from Shanks' and Tilley's argument that time is conceived spatially, I would suggest that history is conceptualized as a disruption not only in time, (an event), but also in space (e.g. a monument). The Acropolis as a form of history's objectification is both a disruption in time, 'a golden moment [in the past]'[1] (middle-aged housewife) and a disruption in space. It creates a distinctive form of space; it constitutes, to a large extent, the physical environment of Athens. It is a *historical landmark*, a gateway between time and space.

The Acropolis As Territory

It has been argued that the nationalist conceptualization of time locating the members of a nation 'in the same temporal frame, one marked by progress' (Alonso 1994: 388), has transformed time into history (see also Anderson 1991: 24). Accordingly, the nationalist conceptualization of 'people living within a single, shared spatial frame' has transformed space into territory (Alonso 1994: 382–3). Researchers of the nationalist phenomenon not only seem to agree that 'an idea of nation is inextricably tied to a sense of history', but they also stress the importance of the concept of territory in nationalist discourses (e.g. Smith 1995). In other words, history and territory are tied up in nationalist imagining and are protagonists in the process of establishing a homogenous strong and shared feeling of national identity. In fact, the relationship between the two is so intimate that I believe that writing history is another way of drawing one's territory.

The prospect of the publication of a book under the title *Europe: A History of its Peoples* in April/May 1990 provoked a big reaction in Greece (cf. Kitromilides 1995: 1). Its editor, Jean-Baptiste Duroselle, had excluded

Greece from the history of Europe. Given that the book was expected to be partially sponsored by the EU, the issue was highly political. If time is conceived spatially, and if history is associated with territory, it should not be surprising that not including Greece in the history of Europe was also thought of as a territorial matter. It was, as some complained, 'excluding Greece from the European *map*'.

If writing history is perceived as drawing a people's territory, the reverse is also true: drawing one's territory is a way of writing history: In March 1994 the French newspaper *Le Monde* published a 'special issue' dedicated to Second World War. In the historical maps, which accompanied the texts entitled 'The War in the Balkans', there was the following caption: 'Italian Attack on Greece (October–November 1940) which was driven back by the British'. On the map, which covered the area of the Greek-Albanian border, the positions of the Italians (in Albania) and of the 'British' (in Greece) were depicted, while the Greek army was totally absent. A journalist reporting on this event wondered 'what does this . . . *rewriting of history* aim at?' (emphasis added) (Ριζοσπάστης 30/3/94). As observed by Malkki (1992: 26), the duality of nation/territory is entrenched through many ways from the multicoloured school atlas to ordinary language: the 'nation' can commonly signify the 'land', the 'country', and the 'soil', while in English as well as in many other languages 'land' is frequently a suffix in the name of countries.

In nineteenth century nation-states the criterion of greatness was largely territorial (Smith 1995: 91). In Greece, a criterion of greatness was largely historical. Since the establishment of the Greek state, Greece's strong point, as opposed to other powerful Western nation-states, was not its territory (in fact its size was not enough to contemplate using it as a criterion for greatness).[2] Although the Greek nationalist 'imagining' had territorial aspirations (see for example the concept of the 'Great Idea' outlined in Chapter 2), its strong point was its history. At the time of the establishment of the Greek state, its spatial borders were vague and negotiable. By contrast, classical antiquity provided a period in the history of the land which accommodated the new state, highly and widely appreciated by the West, therefore serving as a more solid point of reference. Moreover, this history was not claimed by anyone else, and modern Greece, which bore the same name as the country that occupied the same land during the classical times, could be considered its legitimate 'owner' (only it would have to persuade others that it was the 'rightful' heir of that history). It should, therefore, not be surprising that history acquired characteristics similar to those

of a territory: it is referred to as property (cf. Sutton 1998); it becomes measurable: the more you possess of it the better. It can become the ground on which territorial claims can be made: if history is linked with this territory, then this means that rights over this territory can be claimed as well (a claim also made within the framework of the 'Great Idea').

The Acropolis as a symbol of history legitimizes national territorial space, and it can therefore be easily transformed into a symbol of territory. The identification of the Acropolis with the Greek state's territory is evidenced in a cartoon by Stathis (Figure 3.1). It appeared in the Greek press in 1996, after Turkey's attempt to occupy the Greek islet of Imia, and it refers to this territorial occupation by comparing it with the site of the Acropolis being intruded on by a Turkish Muezzin who preaches on the Parthenon (*Τα Νέα*, 8/8/96).

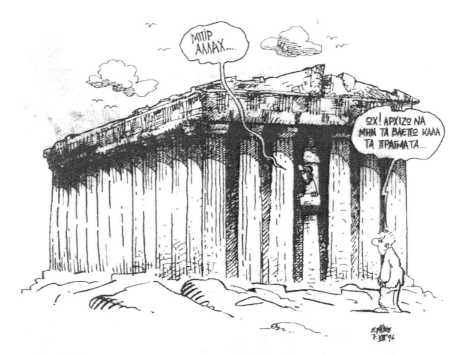

Του Στάθη

Figure 3.1 A Turkish Muezzin, who preaches on the Parthenon. The person on the right says 'oh, I can foresee things not going that well'. Cartoon by Stathis, (*Τα Νέα* 8/8/96).

The transformation of time and space into history and territory respectively is also illustrated in a series of efforts after the establishment of the Greek nation-state to demarcate the site of the Acropolis, physically and symbolically in time and in space. First of all, the Acropolis' site was declared an 'archaeological site', and an entrance fee was charged as early as 1835 (Πετράκος 1997). This definition, requiring for example the guarding of the site and the restriction of certain activities within the borders of the site, demarcated the latter and made it an entity distinct from its surroundings. The 'purification' of the Acropolis from more recent buildings, undertaken by the Archaeological Society at Athens and completed in 1874, seems to go along with the homogeneity that the concept of a nation-state requires (cf. Hamilakis and Yalouri 1999). A similar mindset led to the wide-spread use among the Greek middle-class of katharevousa (καθαρεύουσα), a purist form of Greek that insisted on the use of archaic terms.[3]

Of course the act of architectural purification of the Acropolis was a deliberate attempt to expel the memory of the times when it was not 'Greek' in the sense the new nation state wanted it to be understood.[4] Freud observed that memory loss is an active force, often intentional and desired. As Lowenthal (1999: xi–xiii) reminds us, collective oblivion is also purposeful and regulated, necessary to all societies. To use the words by the French nineteenth-century writer Ernest Renan, 'the essence of a nation is that all the individuals share a great many things in common and also they have forgotten some things' (Forty 1999: 7).

Demolishing the monuments of periods later than the classical 'golden age' reduced the Acropolis' life-span to the classical period. The monument's history was collapsed onto a moment of greatness, and it was converted into something remote and sacred. Since then, a series of actions have been aiming in the same direction. The height of the buildings in the wider area of the Acropolis is strictly regulated to ensure the visibility of the site (Μαρμαράς 1991: 44). Also the terminology used when referring to the Acropolis, e.g. the term 'holy' or 'sacred' rock which refers to the Acropolis hill, automatically places it on a higher sphere than the affairs of everyday Greek life. So does the relation the Acropolis has with the surrounding inhabited area, or the distance that it is required to keep from that which is traced much earlier than today. Hence, there were accusations and complaints provoked by the construction of Anafiotika, a small settlement that was built illegally on the slope of the Acropolis' hill by some workers from the Greek island of Anafi, in the beginning of the 1840s (for more details, see Καυταντζόγλου 2000; Caftantzoglou 2000; Φιλιππίδης 1984: 77). Similarly, in 1915 an Athenian

newspaper criticized the construction of little houses in a street close to the Acropolis:[5]

> The fumes of the kitchens of the neighbourhood will be rising up to the Parthenon as an incense of the complete administrative indifference' (*Αθήναι*, 29/11/1915, quoted in Φιλιππίδης, 1994: 284).

All the physical and symbolic boundaries we have mentioned here place the Acropolis in a reductive and generic 'monumental time' as described by Herzfeld (1991; cf. Hamilakis and Yalouri 1996; Καυταντζόγλου 2000) or 'epic time' as described by Bakhtin (Holquist 1981: 13). They signal not only its different dimension in space and time, but they also create wider boundaries differentiating Greece from the rest of the world. Consequently, those who are within the boundaries, or rather those who are represented by this 'national territory', are contrasted to all those who are outside.

An interesting example of how these boundaries can be reproduced in terms of social relations and how they inform perceptions of the national self can be drawn from one of the school visits of the Acropolis which I accompanied: I asked the class whether they would have preferred some of the more recent (mainly Turkish) buildings to still be there on the site. Only one girl said that she might have liked the idea. Later on, the same girl was almost in tears when she ran to her teacher to complain that one boy in class had called her 'χανούμισσα' – 'Turkish woman'. In her defence, she said that it was in any case mainly the Frankish buildings, and not the Turkish ones, which she would have liked to see preserved. This shows how the children have internalized the ideology of purification and demarcation discussed above, and how they apply it in the negotiations that take place between them.

The nation-state is a historical and cultural construct which, however, tries to naturalize itself through 'myths' (Barthes 1974), 'systems of knowledge/power' and 'regimes of truth' (Foucault 1980), or simply making itself part of people's 'habitus' (Bourdieu 1977). Another way of naturalizing a nation-state order is through associating it with images borrowed from nature itself, such as the earth and the soil, natural products of the homeland, or national landscapes. (For specific examples see Alonso 1994: 383.) The metonymic experiencing of the Greek national territory in the form of the Acropolis' earth and soil is illustrated in the following two examples.

Mr Sofoklis had been an officer in northern Egypt during the Second World War. A few years ago he visited the grave of his friend in a cemetery near the battlefield. Mr Sofoklis brought with him some soil

from the Acropolis and spread it over the grave of his friend. As his friend had not managed to come back home, Mr Sofoklis brought 'the homeland' to his friend. More than that, through this act he *transformed* the foreign land where his dead friend lay into Greek soil, which would receive the dead body of its child and would let it lie in peace.[6]

A similar act of symbolic repatriation of fallen soldiers, by connecting them in some way with the Acropolis, manifests itself in the design of the monument of the unknown soldier erected in 1928–30 in front of the Parliament building. The wall flanking the monument contains replicas of column drums from the Old Temple of Athena on the Acropolis, which was destroyed by the Persians in 480 BC (Papageorgiou-Venetas 1994: 386). Again it is the Acropolis' presence which is considered important in the reunion of the dead soldier with his home country.

In a different situation in the summer of 1997 a Greek mission to Cyprus called *Kimon '97* (Κίμων '97) took place, organized by the prefecture of Athens and supported by the municipality of Athens, various universities and other institutions. The name of the mission was commemorative of the mission of Kimon, the Athenian leader of the fifth century BC, who marched out against the Persians when the latter occupied the island of Cyprus. The purpose of the '97 mission was to deliver to Cyprus the Athenian flame, which burns on the Acropolis, as well as some soil from Pnyka, the hill just opposite the Acropolis linked with classical Athenian Democracy. Both the flame and the soil would be deposited on the graves of two Greek-Cypriot protesters killed by Turks or Turk-Cypriots during a protest in the Turkish zone of Nicosia, on the anniversary of the Turkish invasion in Cyprus (see *Καθημερινή*, 21/8/97).

Given that Cyprus is an island contested by Greeks and Turks and given that the two Greek-Cypriot protesters were killed while demonstrating their anti-Turkish feelings, the symbolic act of delivering Greek earth and flame to the island was highly political, also suggesting the claim for the 'Greekness' of Cyprus. What is interesting in both cases, however, is that the Greek soil and flame came from the site of the Acropolis.

Most of the students I talked to described the Acropolis as 'their monument', a monument that shows things about 'them' as a nation, as a spirit. As one of them said, the Acropolis is a 'symbol and a *creation of the Greek spirit*, it is the *symbol of the Greek civilization*, it is the *sign of Greece*' (6th GR). In other words, they made no distinction between modern Greece and ancient Greece, modern Greek and ancient Greek spirit, Greek and ancient Greek civilization. A student of the 5th GR school wrote:

> Behind the rock of the Acropolis lies the admirable course of a nation, which achieved great things in everything it undertook. The Acropolis is identified with Greece itself; it is the main and greatest national treasure of our country. The revolution of 1821, the struggles that followed it until our country acquired its boundaries of today, the war of 1940, [all these] took place for the defence of our boundaries, of our religion, of democracy, and of national and cultural heritage. The Acropolis' national importance is underlined by the blue and white flag which, from the highest point of the Greek capital, keeps our national conscience awake.

In the words of the student, the Acropolis becomes the site where past and present, ancient classical and modern Greece meet. It is not just the symbol of Athens, or even of ancient Greece. It actually transcends time, being a symbol of the Greek nation, traceable far back in history. It becomes the substantiation of the Greek homeland, the objectification of the Greek nation-state.

The Acropolis As Greek Flag

The Acropolis' dominant position on a hill in the middle of Athens gives it a communicative power inscribed in its material form. Foucault has connected visibility, or 'the gaze' with the operation of power and he has rejected the 'innocence' or 'naturalness' of 'being seen' (Rajchman 1988). One could argue that the Acropolis' dominant position is 'innocent', as it was built a long time before the modern Greek state was established. As we saw earlier, however, this position has not only been maintained, but there have been a series of efforts to enhance it since the beginning of the building of the new Greek capital. In fact the Acropolis performs a function similar to that of a national flag which actually does wave on the Acropolis. The prominent position that it occupies reinforces its conceptualization as such. The visualization of the Parthenon is often made with the Greek flag waving before it. It is raised and lowered every sunrise and sunset respectively by Greek soldiers on weekdays and the Greek national guards (εύζωνοι) on Sundays and Bank Holidays (Figure 3.2). For a student of a primary school, whose classroom has a direct view to the Acropolis, just saying the word 'Acropolis' brings the image of 'the half-ruined Parthenon with the blue and white flag waving in front of it to her mind. Another student associated the restitution of the Parthenon marbles with the flying of the Greek flag on the Acropolis, thus proving to whom the contested heritage belongs:

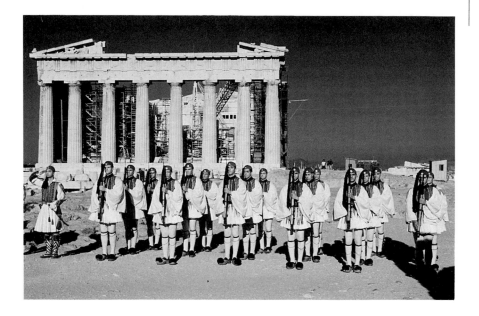

Figure 3.2 Εύζωνοι having raised the Greek flag on the Acropolis (source: Studio Kontos).

> The Parthenon marbles must come back, because they are part of our civilization. No matter what, the Acropolis will always belong to Greece and the Greek flag will always fly in front of the Parthenon (6th PR).

In 1834, one day after the arrival of the first Bavarians in the newly established Greek state, 'an old captain from Hios saw from Pireus, where he had anchored his ship, that there was no Greek flag on the Acropolis' hill. He came to the Acropolis and he asked [the Bavarians] to raise the flag in the Parthenon. The Bavarians accepted and, in a while, the captain's son with some Athenians climbed up the hill and raised the flag' (cited in Φιλιππίδης 1994). Let us not forget that the Acropolis used to be called 'the fortress' ('το κάστρο') of the city of Athens and fortresses used to be the symbols of their cities.[7] Moreover, the Acropolis was actually used as a fortress in the nineteenth century during the last years of the War of Independence until it was handed over by the Turks to the Bavarians in 1833 (Figure 3.3). As the Acropolis was already the symbol of the city of Athens, it was an easy transition to become the symbol of the Greek nation-state, especially once Athens became the capital of Greece.

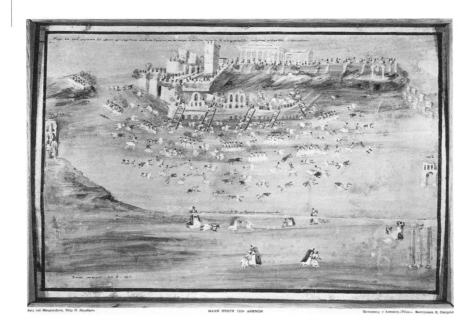

Figure 3.3 The siege of the Acropolis by the Greeks (1827–1833), highlighting the function of the Acropolis as a fortress (source: Εθνικό Ιστορικό Μουσείο της Ελλάδας 1966).

On 30 May 1941 two young men Manolis Glezos and Lakis Santas removed the German flag with the swastika from the Acropolis' hill. As one of them remembers today (*Έθνος*, 24/3/97), 'We wanted to throw it down, to tear it apart and, thus, to wash out the dirt from the Sacred Rock.' This event enjoyed wide publicity. The two young men have repeatedly been honoured for their act, which is still commemorated today as the beginning of the resistance against the German occupation in Greece (Figure 3.4) and has inspired artists both within and outside Greece (Πετράκος 1994: 111 cf. Hamilakis and Yalouri 1999). A Greek archaeologist, discussing that event, said to me:

> Why [do you think that] Glezos did not remove the flag from the Greek Parliament? In Paris he would have removed it from the Étoile. Here, it was the flag on the Acropolis that hurt the Greek [he actually used the term 'Ρωμιός' (Romios)]. This is what disturbed him. I remember my father, [although he was] a person having received German education, referring to the German flag as 'the stain'. But it was the stain on the Acropolis [that disturbed him]. A 'stain' existed also opposite [of where

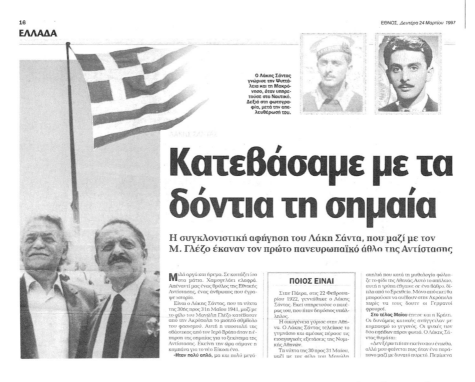

Figure 3.4 Article in the newspaper Έθνος (24/3/97) dedicated to the act of Glezos and Santas. The title quotes their words 'We took the flag down with our teeth'.

he lived], in the National Museum. He had it in front of him, but he was not disturbed; it was the other one that disturbed him. This is how things are. [The Acropolis] is a point of reference.

According to these words the Acropolis is the focal point of the nation. It becomes a field of resistance against the foreign power. It actually becomes the Greek nation's flag, which cannot possibly co-exist with the Nazi one. The idea of Greece is embodied in the site of the Acropolis. This is why it is the flag on this particular place that is considered 'polluting', an intrusion to Greek territory, and a disgrace for Greece.

Similarly, today, a middle-aged lady who used to live in the area of Anafiotika (see Chapter 6) told me that when Athens had been liberated from the Nazi occupation her father took her to the Acropolis and asked her to kick the flagpole, still flying the Nazi flag. From the way she pronounced the word 'kick' one could tell that she imagined kicking the entire Nazi army at that moment.

Other acts of patriotism are also linked with the Acropolis during the period of the Nazi occupation. There is a story which may be real or legendary (Πετράκος 1994: 110) about a young Greek soldier guarding the flag on the Acropolis. When the Nazis occupied Athens and headed towards the Acropolis in order to remove the Greek flag, the Greek soldier wrapped himself in it and jumped from the Acropolis. The soldier's suicidal sacrifice is the symbolic opposite to Glezos' and Santas' act. The Greek flag goes down with the soldier in an act of despair in the face of the German invasion.

The site of the Acropolis is also considered the most appropriate locus for the Greek nation-state to manifest and to celebrate itself every year, when the departure of the last German troops from Greece is commemorated. In this celebration the official Greek flag is carried around in a parade. A newspaper (Καθημερινή, 13/10/95), reporting on this event, wrote: 'The sacred rock was flooded in blue and white [the Greek flag's colours] . . . The Parthenon was watching [the celebrations] and was rejoicing'.

There have been a series of events that took place on the Acropolis, which associate it with the Greek flag. The flag, originally raised on the site when the Greek nation-state was established, served as its representation. However, its removal and its re-establishment, its association with acts of resistance and its celebration every year, create multiple layers of meaning and reproduce it in people's consciousness.

Billig (1995) has examined how national identity is brought home to the people on an everyday basis through routine symbols or habits of language that often operate beyond the level of conscious awareness. Referring to national flags, he argues that they can be either 'waved/ flagged/saluted' or 'unwaved/unflagged/unsaluted'. By that, he means that there are cases where a national flag can hang unnoticed outside a building, it can be stitched on officers' uniforms or stuck on commercial products to indicate their place of production. All these signs however, pass mindlessly through the everyday routine; they are 'flagging' national identity 'unflaggingly' as they form part of people's 'habitus'. On the other hand there are also flags which are consciously waved and displayed. According to Billig, the 'waved' flags call attention to themselves, as for example when a nation seeks its independence or when it feels challenged. Billig argues that symbols of nationhood start operating as 'unwaved' when a nation-state becomes established in its sovereignty, although there are cases, such as commemoration days, when the flags would be waved as well.

One can see Billig's argument illustrated very well in the case of the Acropolis. The archaeologist earlier quoted referring to the history of the Acropolis, said that the latter has always been a point of reference. I quote the dialogue that followed:

Eleana: Do you believe that the Acropolis is still a point of reference today?
Archaeologist: Oh, yes! You should have lived during the [Nazi] occupation in order to realise that.
Eleana: But I am asking about today.
Archaeologist: The points of reference are always points of reference in times of difficulty. They are never points of reference in easy moments. You don't need points of reference in easy moments.

The Acropolis is one of those signs which are so familiar that they often pass unnoticed in the everyday life of the Athenians as unwaved flags of Greek national identity. It can, however, become a waved flag when the situation requires it. For the archaeologist, the Acropolis becomes a 'flagged flag', only when Greek nationhood is challenged. At that point it is required to leave 'the enhabited national homeland' (Billig 1995: 43) and to become a potent symbol flagging Greek nationhood.[8]

The Acropolis As a Physical Body

It has been argued that the human body as a 'natural symbol' (Douglas 1970) serves as a means to perceive social relations and processes, while at the same time reflecting and representing the culture in which it was developed, and within which it moves and acts. Here I would like to demonstrate how the human body provides an analogy of the Greek nation-state as materialized in the form of the Acropolis.

The Romantic concept of nationalism viewed the nation as a living organism (Κυριακίδου-Νέστορος 1978: 37–8) which develops through time.[9] Handler (1984; 1988), for example, has shown how the Québecois nation is personified in nationalist rhetoric. Denying a nation its very specificity is, in the words of the head of the Parti Québecois, like mutilating this nation, obliging it to live 'without an arm or a leg – or perhaps a heart' therefore leading it, 'as in cases of pernicious anemia', to a slow death.

The Acropolis often appears as a body, which is violated and mutilated not only by time and air pollution, but also by the looting of Lord

Elgin. In such discussions, the removal of the sculptures from the Parthenon by Elgin often represents Western arrogance and imperialism. A lady, member of the 'Society of the Athenians', wrote a poem under the title 'The Parthenon' (*Τα Αθηναϊκά* 92: 47):

> They took the Caryatids away from you.
> They did not ask you,
> whether you felt pain.
> They did not ask you,
> whether you long for them,
> day and night.
> You cry silently
> over your wounds.
> Enemies and friends,
> opened them.
> They set your heart on fire.
> Their black stain
> has not totally disappeared

The terminology used in the discussions about preservation/restoration works undertaken on the site of the Acropolis often interprets the Acropolis as a body 'in the operating theatre, heavily ill' (*Επενδυτής*, 8–9/3/97), and the architects and conservators as 'curing it' (e.g. *Ελευθεροτυπία*, 15/10/96). For example, in an interview with a conservator of the Acropolis' monuments a journalist spoke of conservation works as open-heart surgery. To use his words 'the most important Greek monument, point of reference for all peoples on earth is ill'. The conservator adopted a similar terminology, while explaining how she and her co-workers use surgical instruments and peroxide, exactly as one would on a wound. 'These marbles', she said, 'are tired from wear, they have grown old and they are full of wounds'.

The 'illness' and 'suffering' of the Acropolis' body are often associated with a more general crisis of the Greek state. For example, the Greek architect Dimitris Filippidis comments on the destruction of the Parthenon marbles because of the pollution and their calcination:[10]

> We are talking about the symbol of Hellenism par excellence, identified with Greek society. The suffering of Greek society could be related, by some imagination, to the suffering of the paramount monument. Couldn't the contemporary 'calcination' of the monument be perfectly compared to the general crisis we go through? Can't the dead ends that

we reach [as a nation and/or state] be understood with the dead ends that our national monument reaches? (*Avtí* 1990 453: 44).

Filippidis thus associates the 'suffering' of the Acropolis' body with that of the Greek national body. As we will see in the following examples, antiquities in general, and the Acropolis in particular, have often been perceived as metaphors of the Greek national body.

The Acropolis as a National Body

Miliadis, a prestigious Greek archaeologist and former head of the Acropolis ephorate (1941–1960), wrote in the middle of the twentieth century (*ΕΔΑΕ* 5, 1989):

> Our land, the blessed land of the marble gods, is studded with antiquities . . . Temples, the columns of which appear in the blue background of the sky and of the sea; theatres, the rich echo of which convey the slightest whisper; fortresses which seem to be built by superhuman powers. And there are also whole marbled cities, full of mystery and memories from old years that founded the most glowing civilization of Europe and of the whole world . . .
>
> . . . Every spring and autumn – the seasons when the excavations take place – mother Greek land brings into light more and more of her marble, bronze, and terracotta children. Our antiquities are the most precious, rare, and invaluable products of the Greek land.
>
> . . . It looks like a fairy tale, a fisherman throwing his nets into the sea and bringing out a marble god. A European wise man said years ago that archaeology is at home in Greece. It is true that our lives have been linked to the antiquities on this divine land, studded with miracles. It is one of the most universal characteristics of our country. It is one of our most fair prides and one of our more authentic epithets. It is our wealth, which we will bequeath together with our country to our children.

What we have here is a hymn to the body of the Greek motherland, bearing invaluable children. The Greek earth is blessed because it is fertile, its fertility lying in its richness in antiquities. Antiquities are depicted as natural products of the Greek land, and Greece as the mother of these 'divine' children is raised to a divine level too. Antiquities are considered to be title and 'wealth', i.e. a cultural investment, which Greeks inherit from their mother Greece, one generation after the other.

The above-cited text is a good example of how nature and culture fuse in the conceptualization of antiquities in general. Beyond that, however, it suggests that the body of the Greek land gives birth to both people and antiquities. In other words, they both constitute a wider Greek national family, the Greek *national* body.

In the last few years there has been a plea in the anthropological literature to examine nationalism as an ideological or cultural system similar to kinship.[11] Terms such as motherland, fatherland, patria, Vaterland, πατρίδα for example, allude to metaphorical associations of the nation-state with parenthood (cf. Malkki 1992). Research has taken place in Greece which illuminates the logic of nationalism that treats the nation as a family. Kinship, it has been argued, provides the means to study nationalism from the 'bottom up' and to elucidate the 'nationalist imagining' not simply as a construction of the nation-state, but also as a practice which can either reproduce or challenge the nation-state (Herzfeld 1992; Sutton 1997, 1998). I would argue that the Acropolis, apart from being perceived as 'a national flag' representing Greek nationhood, also stands as part of the Greek national body representing the blood ties of the wider Greek family, the so-called Greek 'γένος'.[12]

In this respect, a part of the discussion I had at the 6th PR school with a ten-year-old student is also revealing. Speaking about the Acropolis, she said that 'old things provoke awe in us'. Starting from that statement, the following dialogue emerged:

> *Eleana*: Why do you say that old things provoke awe in us? We have an old thing at home and we throw it away because it has become old.
>
> *Maria*: It is not the same, because things do not have the same value. For example, you have an old shoe and you throw it away, but you never throw away the photo of your great-grandfather or a person that you love very much.

With these words, the student compares her feelings towards antiquities with her emotional attachment to her family. The suggestion is that the feelings one has towards one's personal past are comparable with and equivalent to those towards the national past. In fact, the national past is perceived in personal terms. The Acropolis is not simply an old thing, which has deteriorated physically and in meaning. On the contrary, its physical deterioration is a product of its historicity, which further increases its – what Ricoeur has termed – 'surplus of meaning', the accumulation of meanings that transcend any literary signification

(Ricoeur 1976). It has become a 'biographical object' (Kopytoff 1986; Hoskins 1998).

In 1992, the Greek government decided to send twenty-one antiquities of the fifth century BC for display at the National Gallery of Art in Washington and the Metropolitan Museum of New York. The exhibition was titled 'The Greek Miracle. Classical sculpture from the Dawn of Democracy'. This decision aroused strong reactions in Greece (see Mouliou 1996 on a discussion of the politics of Greek travelling exhibitions). The Archaeological Society at Athens (see Chapter 1) summoned a general meeting to discuss its position towards the governmental decision. In the meeting, the members' views were divided. The government's supporters based their argument on the grounds that it highlights the 'global' character of the Greek antiquities and their role as 'ambassadors of Greece abroad'. The opposition's opinion was grounded on 'the national meaning' of the antiquities, which did not allow their 'expatriation', or indeed any action that could put them in the slightest danger. The poster of Figure 3.5 advertised the opposition of the 'Panhellenic Cultural Movement', a leftist society. The head of a well-known classical statue appears with a deep crack, splitting it in two. The heading says: 'No to the uprooting. Do not let our works of art leave Greece'. The crack on the head of the statue implies not only the danger which antiquities might be subjected to in such an undertaking, but also the dismemberment, the disintegration, which would follow the 'expatriation' of the antiquities.

In discussions about the restitution of the Parthenon marbles, statements such as 'The Parthenon marbles should come back; it is as if they are stealing a part of your body' are frequent. As a 10-year-old student puts it (6th PR):

> Every single piece of the Acropolis is a part of Greece. On these pieces the Greek language, history and identity are established. These are the sources where the knowledge about the past is drawn from, where the claims for Greekness are grounded, and where the glory of the ancient inhabitants of Greece is evidenced. With this evidence every Greek will be asked to defend the Greekness of contested areas. However, this is impossible when the cultural heritage is dispersed. Therefore, the restitution of the Elgin marbles is a national demand.

This sounds very grown-up, but is likely to be an almost verbatim quote of what he may have heard from adults. According to the above, every single piece of the Acropolis not simply conveys, but actually *is* Greece.

ΟΧΙ ΣΤΟ ΞΕΡΙΖΩΜΑ

ΝΑ ΚΑΤΑΡΓΗΘΕΙ Ο ΝΟΜΟΣ 654

Νά μή φύγουν άπό τήν Έλλάδα
τά άριστουργήματα τῆς Τέχνης μας!

ΠΑΝΕΛΛΗΝΙΑ ΠΟΛΙΤΙΣΤΙΚΗ ΚΙΝΗΣΗ

Figure 3.5 Panhellenic Cultural Movement poster opposing the governmental decision to send Greek antiquities abroad for display (source: ΠΑΠΟΚ).

When these pieces are dispersed in foreign museums all over the world, Greece cannot survive as a totality. This is also why some students consider the integrity of the Acropolis so crucial.

The language used in discussions about the Parthenon marbles' restitution has many similarities with the one used when referring to expatriate members of a Greek family. For example, the Caryatid of the British Museum is often presented as crying and missing her sisters

'wanting to go back home' (an old Athenian legend which I heard reproduced several times). Students of the 6th PR school told me: '[The Parthenon marbles] must come back to their mother, to the country that gave birth to them and they should come back from the foreign lands', or 'they must come back to their brothers and sisters who are waiting for them and are lamenting for their loss', etc. For many, antiquities are able to experience the hardships of emigration exactly like all those Greeks who had left for Germany, the USA, Australia, etc (cf. Hamilakis 1999: 314).[13]

Every time I visited the Parthenon marbles' room at the British museum I met Greeks who had felt the need to visit their 'expatriated' heritage, as a Greek tourist called it. Most of them were commenting on the act of Elgin having 'stolen' the marbles and some were becoming quite sentimental as well as aggressive against Elgin and the British nation in general. One of them described her experience after her visit: 'I felt as though I would cry – they looked imprisoned in that room'. Many referred to the Greek antiquities of the British Museum as if they were living members of an extended Greek family.

The conceptualization of the Acropolis in relation to expatriate Greeks is also made by advertisements: a Greek insurance company (Figure 3.6) advertises its new offices in Cologne, and addresses the Greeks of Germany. The heading says 'Guten Morgen to our compatriots in Germany'. In the accompanying photo the Parthenon appears facing the Dome, the cathedral of Cologne. The implication is that through the new branch of the company in Cologne, Greece comes closer to its children, the Greeks of the diaspora in Germany. And the symbol chosen to incarnate Greece is the Acropolis.

The Greek diaspora or, as it is known in Greece, 'Emigrant Hellenism' (Απόδημος Ελληνισμός), is often considered by Greeks in mainland Greece as the remaining witness of so-called 'ecumenical Hellenism'. The 'ecumenical' character of Hellenism is the Greek interpretation of the phenomenon of global Hellenism. Ecumenical Hellenism refers to the whole of the Greek nation, comprising Greeks in Greece as well as Greeks outside the borders of Greece. It also refers to how the Greeks perceive the cultural influence Hellenism had in ancient times, under the empire of Alexander the Great, the Romans, and the Byzantine Empire. Moreover, it refers to the appeal classical Hellenism has had since the Renaissance to a world beyond the Greek state's borders. Throughout the history of the Greek state, great importance has been ascribed in Greece to the role of the communities of the Greek diaspora. For example, Metaxas' regime wanted to organize the Greeks of the diaspora

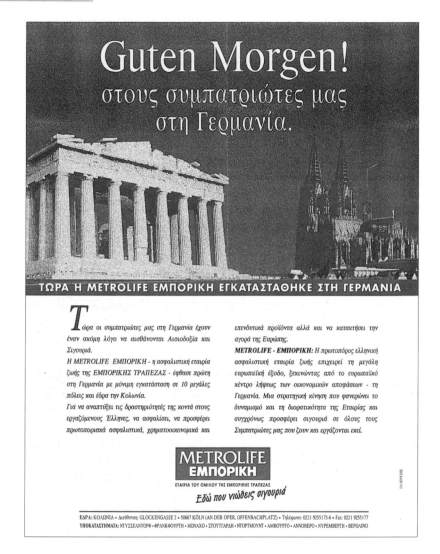

Figure 3.6 Advertisement of a Greek bank's new branch in Cologne, Germany (source: Metrolife Εμπορική).

under the strict control of the Greek state, so that they also contribute to the accomplishment of the 'mutual national destination' (Μαχαίρα 1987: 62–3). More recently, actions have been taken by the Greek government in order to found a Council of 'Emigrant Hellenism' (Συμβούλιο Απόδημου Ελληνισμού). In 1996 Christos Yannaras,[14] one of the representatives of Neoorthodoxy (Νεοορθοδοξία) criticized this governmental action in the following words:

The satisfaction deriving from the founding of the Council of Emigrant Hellenism was based on the logic of a common quest: that the dispersed powers of the Greek emigrants should be more efficiently organized; that the state of Greece should take advantage of the dynamism of the diaspora both on the level of international relationships as well as in specific problems of foreign affairs . . . This artificial state – that the Bavarians created for us and that we keep intact in its borrowed structure – has not succeeded in anything. The request, however, was common: to subordinate even the last strong support of the Greek ecumenism to the state failure. To organize the extraordinary dynamism of the Greek diaspora according to the model of the failed and miserable state provincialism . . . The ecumenical Greek diaspora does not need organization based on imitations of the state provincialism, councils and parliaments of emigrants (*Καθημερινή* 30/6/96).

For Yannaras the Greek state of today represents a shrunken Hellenism often associated with failure and inefficiency. This Hellenism constrained by borders is occasionally juxtaposed to the simmering, smouldering power and potential of ecumenical Hellenism as embodied by the Greek diaspora.

The Greek antiquities, dispersed in museums of the West, are often considered by Greeks to play a role similar to that of the Greek diaspora, namely to be the representatives of Greece abroad, or as is often said, the 'ambassadors' of Greece abroad. There are some people who express the opinion that the Parthenon marbles, being abroad, can transmit messages about the grandeur of the Greek civilization. They believe that their physical dispersion all over the world might, after all, work to Greece's advantage.

Apparently, this metaphor of the dispersed antiquities as the dispersed Greek national body is one that links the 'Emigrant Hellenism' with its metropolis. In a book about the Greeks of America, the Greek community is shown parading on 5th Avenue in New York holding a model of the Parthenon on 25 March, the day of the declaration of the Greek War of Independence (cf. Hamilakis 2000b). Figure 3.7 also shows the Greek community of a village in the south of Russia at the foot of the Caucasus dancing under a framed painting of the Parthenon.

In a similar spirit the 'Union of Hellenic (Greek) Students Societies in the UK' have occasionally taken the initiative to advocate Greek rights over the restitution of the Parthenon marbles in Britain. For example they assigned 5 December 1997 as 'Parthenon day'. The activities that were organized for that day included a mass e-mailing, through the

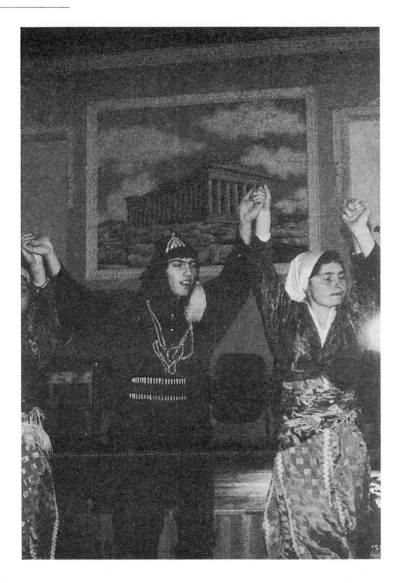

Figure 3.7 The Greek community of a village in the south of Russia dances under a framed painting of the Parthenon (*Τα Νέα* 13/5/97).

Union's 'Parthenon-day web-site', to the British government, the Labour Party, the British Museum and the British Embassy in Athens asking for renegotiation over the issue of the marbles. In addition, they organized a demonstration outside the British Museum with a big banner demanding the return of the Parthenon marbles. The demonstration was followed by a debate about the restitution of the Parthenon Marbles,

in which Stelios Papathemelis, a former Greek minister, and British journalists participated (Symposium 1998; cf. Hamilakis 1999).

Apart from collective manifestations of Greek identity enacted by the Greeks of the diaspora, more personal ones occur too. The following letter, sent by a Greek lady living in East Berlin to the magazine *Αντί* (1990 40: 65), asks the Greek state to take further steps towards the return of the Greek antiquities which are in the Pergamon museum:

'Dear *Αντί*,

I am established in East Berlin and I often visit the Pergamon Museum. When I face the imprisoned masterpieces of the ancient Greek city of Pergamon, I feel – together with the dazzling awe that they provoke in me – at the same time a pain in the chest. In a continuously rainy and depressing East Berlin, in that ungraceful huge museum without a single window, I feel that those figures have a complaint, it is as if the Ionian smile has been lost from their face. In a way I feel as if I am imprisoned in that gray building. I must apologize for the emotion I demonstrate for these statues. The truth is that I love them very much . . .'

Classical antiquities are not only used by the Greek diaspora to celebrate their national identity. The mother-country uses them as well, to demonstrate her affection for her dispersed children. In 1998, on the occasion of the commemoration of the beginning of the Greek War of Independence, the mayor of Athens sent a statue of the ancient Greek goddess Athena, two and a half metres high, to the Greeks of New York to celebrate (Figure 3.8). That statue was sent to decorate the square of Astoria, the Greek neighbourhood of New York (*Ελευθεροτυπία*, 15/3/98).

The Acropolis shows in the most explicit manner the extent to which material culture, being visible, tangible and durable, can be more expressive than language. The Acropolis contains multiple, lengthy arguments without needing any narrative. The French historian Pierre Norra (1998) introduced the idea of 'lieux de mémoire' in his wish to study national feeling not in the traditional thematic or chronological manner, but by analysing the places where the French collective heritage is 'crystallized'. Thus, lieux de mémoire are poly-referential entities drawing on a multiplicity of cultural myths that can be appropriated for different ideological or political purposes. The Acropolis is such a 'lieu de mémoire', invested with what Paul Ricoeur has called 'surplus of meaning' (1976) or 'reservoir of meanings' (Connerton 1989: 56–7), which is available for various uses and interpretations.

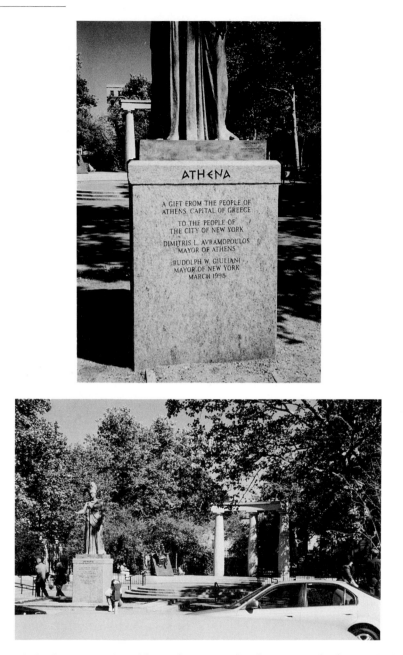

Figure 3.8 The statue of goddess Athena, sent by the mayor of Athens, Dimitris Avramopoulos, to the Greeks of Astoria, New York. The statue was placed in Athens Square Park. The inscription on the base of the statue says: 'A gift from the people of Athens, Capital of Greece, to the people of the city of New York' (photo by E. Yalouri).

In the beginning of this chapter I referred to Gourgouris's comparison of the nation to a dream. The Acropolis can be seen as a metaphor or metonymy, 'condensing' or 'displacing' Greek nationalism during the Greek national dream-work. The Acropolis is 'dense with cultural meaning and value' (Weiner 1994). It is this density and condensation that make it extremely powerful in its claims and in its negotiations. If dreams are expressions of a person's psyche and analysing the former's mechanisms is a way to explore the latter, analysing the Acropolis as a product of the Greek nation's dream-work can help us trace the Greek national 'psyche'. Alonso (1994: 382, 386) has suggested that if we are to explain how an 'imagined community' becomes second nature and lived experience, we should look at nationalism as a 'structure of feeling' (Williams 1977: 132–5), a concept that Williams uses to describe 'meanings and values as they are actively lived and felt' (ibid.: 132). In unravelling these 'structures of feelings the means of metaphors and tropes in general can prove illuminating. The Acropolis is a materialized and embodied 'structure of feeling', which brings us back to where we started: the interrelation between structure and agent, things and persons. The Acropolis, featuring on the walls of the houses or in the restaurant names of the Greeks in Alamo, Texas or in Melbourne serves as the meeting point of Hellenisms. The Acropolis as Greek earth, homeland, flag, territory, history or body becomes the ultimate symbol of Greek identity and of national identification. It unifies past and present, classical and ethnic Hellenisms by providing an 'authentic', durable, and tangible identity.

Contesting Greek Identity:
Between Local and Global

Building An Image – The 'Mission' of Antiquities Abroad

My intention here is to discuss how classical antiquities become active agents involved in the Greek efforts to establish an honourable profile and to become a dynamic presence in a changing world (cf. Mouliou 1996). For this purpose I will use a case study – a discussion that took place among the members of the Archaeological Society at Athens (hereafter ASA) regarding the 1992 governmental decision to send some antiquities of the fifth century BC – including sculptures from the Acropolis – to be exhibited in the USA (the discussion's proceedings were published in a special edition of the ASA newsletter – *O Μέντωρ* 20, 1992). As I mentioned in Chapter 3, those who supported the government's decision highlighted the global character of Greek antiquities and their role as 'ambassadors' of Greece abroad. Those against emphasized the possibility of damage or loss and focused on the national meaning of the antiquities which did not allow their 'expatriation' or indeed any action that could expose them to the slightest danger. 'The antiquities', it was said, 'are not just works of secular art, but national heirlooms' (ibid.: 29). Georgios Dontas, a classical archaeologist and former ephor of the Acropolis, was in favour of sending the antiquities abroad:

> When new, huge cultural entities are formed, among them the entity of the 'Western world', Greece not only participates, but claims by right the position of the respectful wet-nurse, and when the states of all the world are linked together with dense networks of cultural decisions, including periodic exhibitions, is it logical for Greece to refuse deliveries of antiquities, especially when such an attitude would provoke the

cessation of the reciprocal arrival of foreign works of art to our country and the cultural marginalization of the country? I believe that this action would also be extremely dangerous politically, because other neighbouring peoples would gladly take advantage of the Greek absence by undertaking the presentation of the Greek cultural heritage abroad and by completely distorting the historical truth, bearing disastrous results for our country . . . The 'offensive' presence of our ancient [ancestors] in a foreign country from which we expect certain benefits has definitely a much bigger impact for the people of this country than if they viewed the same ancient [ancestors] in our museums under the well-known, passive guided tours of people in herds (ibid.: 37–9).

According to Dontas, Greece being 'the respectful wet-nurse' of the Western world claims the position it deserves within the transformations that take place worldwide. Together with the 'exportation' of antiquities abroad, Greece re-exports at the same time its title as 'the cradle of the Western world'. In this way, it *reminds* the world that there is a 'legitimate' owner of what is considered a global heritage. Turkey has many Greek antiquities in its territory. So does Italy. The implied fear is that Turkey will undertake to represent Greek antiquities. Claims to the title-deeds of Greek antiquities by neighbouring peoples are perceived as potential territorial threats against Greece. The whole enterprise of sending the antiquities abroad then takes the form of a battle in which antiquities become the fighters, and offence is the best defence.[1]

A position similar to Dontas' was held by a professor of Prehistoric Archaeology, Spiridon Iakovidis, and member of the Greek Academy in Athens.[2] He preferred to support his arguments in favour of sending the antiquities abroad by illustrating the positive side-effects of such an exhibition, using a comparison with an exhibition organized by Egypt (ibid.: 57–58).

> The exhibition of Tutankhamun toured all over America, and Egypt found a place on the map. It didn't exist before. The Americans started discussing Egypt, Egypt's heritage, and since that day I tell you – I experienced it – the attitude of various senators in the Congress, who are average Americans, started changing towards Egypt and finally towards Israel . . .

Antiquities, according to the quotation above, are able to secure a place on the map as they situate a country in time and in space. Through the institution of the museum, an exhibition sanctifies the reality that

it presents. In other words, sending antiquities abroad is exchanging historical time, as embodied in antiquities, with political recognition. The issue of the exchange of Greek cultural capital for political support is raised repeatedly. In the following citation, the price expected in return becomes more concrete. Konstantinos Papapanos, a former high-ranking employee of the Ministry of Education, says (ibid.: 41):

> What happened with the other 49 Greek exhibitions that were organized [abroad in the past]? 29 of them took place in the USA. What is the attitude of the American government and its policy towards us? It kept helping Turkey both on the military and the financial level. Occupation of Cyprus. American archaeologists are indifferent towards the drain of Cypriot antiquities by the Turks and then Turkey demands airspace, the Aegean sea and sea-shelf, it creates the Muslim crescent around the Balkans and day after day it becomes more and more insolent and impudent. To what extent did these 29 exhibitions contribute to change in American politics regarding our national issues? You know that national politics are not designed and they are not materialized on the basis of such criteria, especially today when immorality dominates internationally. Everything is judged according to interests and not according to exhibitions and similar activities.

The negative outcome of the cultural expedition as described above is attributed to the 'immorality' of the times, wherein the love for civilization cannot beat economic or political interests. The negative attitude that confronts Greece in its efforts to establish a secure and honourable position internationally serves as an argument against the idea of sending the antiquities abroad. Vassilios Petrakos, the General Secretary of the Archaeological Society at Athens, says:

> Should twenty-one Greek masterpieces of the fifth century BC be expatriated to the USA and be displayed in a foreign land, participating in this way unwittingly in festivities which have nothing to do with the ideas they represent or inspire, in festivities which will remind us of relevant ones which took place in a neighbouring peninsula after 146 BC? (ibid.: 26–7).

The festivities to which Petrakos refers are those that followed the defeat of Greece by the Romans. General Mummius, the Roman conqueror of Greece, transferred Greek works of art to Rome, and Greek antiquities were taken around as loot demonstrating the Roman power. This characterization of the West as an expansionist force plundering Greece

is not something new. In another issue of the newsletter of ASA (*EΔAE* 8, 1989), an article signed by Hristos Petrakos criticizes J. H. Merryman's article 'The Retention of Cultural Property' (1988). According to Petrakos, Merryman advocates the opinion that humankind has a common cultural heritage. In this cultural community (πολιτισμική κοινοπολιτεία) there are two kinds of nation: the 'Source Nations' (those which provide their old heritage) and the 'Market Nations' (those which import cultural goods). According to Petrakos, Merryman, following liberal views, considers antiquities to be objects for exchange and blames the Source Nations for putting restrictions on the exportation of their heritage with the support of UNESCO. Merryman's views provoke strong feelings in Petrakos. He writes (ibid.: 18):

> Mr Merryman fails to say that the global civilization which he discusses is the Western one which was violently imposed on almost the whole planet. Many peoples neither had nor have the desire to be absorbed by it and it is a major insult, after conquering and destroying their traditional ways of lives, to loot their creations as spoils in order to increase the prestige of the winner. A winner who treats his spoils as plain bric-a-brac – I don't believe that the kouros of New York has any cultural meaning for any American. It is a good investment either as capital or as an interest-bearing object. The same goes for the development of the archaeological discipline. For the Greeks, it is a research and study of their ancestors' history, which means self-knowledge, while for most of the others it is at best a very noble career . . .

For Petrakos globalization means expansion of Western imperialism over smaller national units, resulting in the homogenization of cultures. Thus, globalization is considered as another Western colonialist exped- ition in which antiquities become the spoils of an expansionist war. As such they cannot evoke in Westerners the same genuine feelings that they evoke in the Greeks. This fits in with the discussion about the false content of 'philhellenism' by the same author in another issue of the Newsletter (*EΔAE*, 13, 1990). Philhellenism is regarded as a Western invasion, the result of which was the plundering of Greek monuments. Petrakos cannot hide his bitterness about the fact that the adoration of the ancient past by Westerners is opposed to their contempt for the Greek present. The discussion about the origins of philhellenism illum- inates the bad feelings towards the West which have accumulated in modern Greek history. It is used to argue against the concept of a global culture as we saw it earlier on:

... Any harmful actions by foreigners towards us might not be because of their hatred of Greece ... but on account of the plain pursuit of their interests. This is of no importance to us. The result is the same. Given that, in whatever internal situation, we will remain a weak country, it would be at least a delusion to be drawn by the charm of the 'world without boundaries' and give up the very few elements which distinguish us from others and give us power. And this is especially the case as far as antiquities are concerned. For better or worse the contemporary Greek state based its ideology on our special and unique relation with antiquity. If we abandon this ideology and accept that our antiquities are part of a 'common cultural heritage' of all humankind then, losing what distinguishes us, we will remain a people without a past, and with a present which does not inspire either fear or respect (ibid.: 143).

The tenor of this text is that Greece, being a weak country, draws its power from antiquities, not only because they are unique but also because the Greeks do not have a present which is valued by others. They are therefore their only weapon for political survival. The political role of archaeology and antiquity is obvious here. Antiquities are the very vehicles of Greek identity, the ones which constitute the specific distinction between the Greek and the other nations, the ones which empower the nation and provide it with the equipment that is needed to make it 'inspire fear or respect'. That is why the possibility of damage or loss of antiquities during their transportation for an exhibition abroad is equated with national loss provoking feelings of 'agony' [sic] (O Μέντωρ, 20, 1992: 36). For Fanni Drosoyanni, a Byzantine archaeologist and former ephor of Byzantine antiquities, 'the fact that Kritias' boy can end up at the bottom of the Atlantic and that this fact will be irreversible is utterly determinative and absolutely horrifying' (ibid.: 70).[3]

The whole issue of sending the antiquities abroad is epitomized in the words of the Professor of classical archaeology at the University of Athens, Vassilis Lambrinoudakis. After referring to the national and global role of Greek antiquity he concludes (ibid.: 45):

It becomes obvious that the relics of our past which are within our present day boundaries are part of our national heritage, for which we are responsible and which we must safeguard like the apples of our eye. No exportation, no concession to any other people is allowed. The direct contact of other peoples with our monuments is, however, a must ...

The national and global aspects of Greek heritage are both present and competing against each other every time the latter is involved in issues of Greek international affairs. The global aspect, however, is present only as long as it serves the local; namely, it reminds the world of its 'debts' (Σκοπετέα 1988: 211) to Greece and of the position the latter deserves in the contemporary world. Although Greek heritage needs to circulate around the world, at the same time it needs to return to reassemble the body of the nation-state that it represents.

In this section I described a discussion on 'exportation' of Hellenism. Next I will discuss a case where Hellenism asks to be imported back to Greece. As I will demonstrate, these are two processes that follow the same logic.

Request For Repatriation/Restitution of Hellenism

A number of studies on 'the politics of heritage' (to name but a few examples, Gathercole and Lowenthal 1994, Greenfield 1996, Karp and Lavine 1991; Lowenthal 1998) have shown that antiquities can become representations of contested identities, tools loaded with meanings in the negotiation of rights and interests, especially between local communities and their former colonizers. The former are becoming increasingly cynical about the concept of 'world heritage', which is used to justify foreign patronage over their heritage, and which allows artefacts to accumulate in the museums of the Western world.

Although Greece has never been colonized in the literal sense, it has experienced direct foreign interference in its political system and life since the beginning of its life as a nation-state. Statements by the British Museum, such as those implying or even explicitly stating the inability of Greece to protect its heritage and justifying the B.M.'s decision to shoulder the responsibility of keeping classical works of art, allude to older experiences of foreign intervention and reinforce already strong feelings against foreign hegemony. In the previous section we saw that antiquities can be visualised as 'spoils' when in foreign hands. In a similar way they can also become signifiers of the Greek nation-state and the medium of claims and interests. Melina Merkouri, ex-Minister of Culture and well-known for her crusade for the restitution of the Parthenon marbles, said in an interview with a British journalist (Επενδυτής, 15–16/3/97):

> I was born – and I believe all Greek children are born – thinking that in a way *we* built the Acropolis and the Parthenon. It is our heritage, our

identity. Asking for the return of its parts is a political act, an act of *independence* (emphasis added).

That is a strange thing to say about a people who have had their independence for almost two centuries now. However, the issue of the Parthenon marbles has been linked to questions of Greece's ability to take on responsibilities without foreign patronage. Note that one of the arguments of the B.M. against the return of the Parthenon marbles to Greece is that Greece in unable to protect them. This attitude may in part explain that the claim for the marbles' restitution is a political statement against any patronizing attitude by foreign powers. The claim made here is that the Greek nation-state has passed the stage of its infancy and has become mature, ready to take over its property without needing guardians any more. In a talk at a UNESCO meeting in Mexico City (29/7/82), Melina Merkouri said (Diary 1998):

> Dear friends, it was the Englishman Hobhouse, the future Lord Bronkton, on a visit to Athens in 1809, who gave us this striking illustration: an elderly Greek man approached him and in a voice trembling with bitterness says: 'You English have taken from us the work of our ancestors. Look after them well, because the day will come when the Greeks will ask for them back'.
>
> There is nothing we need to add to that. Our English friends have indeed looked after our marbles well; and now, with a very firm voice, we are asking for them back.[4]

Athenians who did not demonstrate any particular interest when they strolled among the ruins of classical antiquity were interpreted by Gibbon in the eighteenth century as 'incapable of admiring the genius of their predecessors' and therefore 'unfit guardians' (Lowenthal 1998: 243). In contrast, the Westerners were more deserving of inheriting those works, because they thought of themselves as better equipped to safeguard them, as more appreciative of the value of the items, and as permitting this heritage to become 'more accessible' and therefore truly global (Woolf, 1906 quoted in Lowenthal 1998).

One can still find such attitudes in Britain today. Consider the words of Lord Wyatt of Weeford, in a session of the House of Lords on 19 May 1997, after a proposal for the restitution of the Marbles:

> My Lords, is the Minister aware that it would be dangerous to return the marbles to Athens because they were under attack by Turkish and Greek

fire in the Parthenon when they were rescued and the volatile Greeks might easily start hurling bombs around again? (cf. Hitchens 1998: vii–viii)

In another case, Godfrey Barker in his article in Daily Telegraph (5/11/84) claimed that 'this illiterate, resigned, enfeebled race [the Greeks], for two millennia a shadow of past Periclean glories' were not fit guardians for such treasures (Just 1995: 303 note 14).

Any claim of ownership is then at the same time asking for affirmation of independence, accountability and responsibility, which Greece asks to have acknowledged internationally. The issue of the Parthenon marbles' restitution, however, is not only a matter of Greece asking for recognition that it is on a par with the other European states. It should be seen also in relation to more regional frictions that Greek politics encounters. Here I quote two students, the first from the 6th GR and the second from the 4th GR school. For them the restitution of the Parthenon marbles would serve to underline the territorial rights of Greece in the political arenas of the Balkans and the Mediterranean:

6th GR: What is most important is that the Acropolis denotes our national continuity, i.e. that the Greek people existed even from the past, as the Acropolis is a creation of the past. This is very important because this people has an asset compared to others who might have claims on some Greek territories.

4th GR: My feelings for the Acropolis are the same as those of every Greek. However, for me, as a child, it means something more: with all that war against my country by its neighbours who question even the Greekness of Macedonia, I resist by promoting the Greek monuments. I become more attached to Greece and especially to the Acropolis, the 'representative' of Greece . . . As our ancestors used to say, 'a country without a past is a country without a future'.

If the Acropolis and antiquities in general are representations of Greek identity, as demonstrated in Chapter 3, then the demand for their restitution could stand as a metaphor for Hellenism's repatriation. In the last years the Greeks have been going through many struggles for the return of their heritage. They wanted to 'bring the Olympic Games back to their homeland' and 'to bring the Parthenon marbles back home where they belong'. The claim for the restitution of Greek heritage could thus be seen both as a request to reterritorialize and to repatriate the

global, 'world' heritage to its local homeland. But here it sounds as if we encounter a paradox: on the one hand Hellenism is praised for its global/ecumenical character, transcending national borders, while on the other its (local) contenders claim it back, trying to draw borders and to retrench their territory.

In his analysis of modern day globalization, Appadurai (1990) says that deterritorialization is one of the main forces in the postmodern world, in the sense that national borders become irrelevant in the way people, money, technology, media and ideas circulate around the world. On the other hand, there is a reterritorialization in the sense that there is a 'resurgence of national, regional, ethnic and territorial attachments'. This relates directly to the 'embattled' relationship between nation and state (ibid.: 303). 'That is, while nations (or more properly groups with ideas about nationhood) seek to capture or co-opt states and state power, states simultaneously seek to capture and monopolise ideas about nationhood' (ibid.). The Greek case is similar, except that globalization of the Greek cultural and intellectual heritage is a much older phenomenon than the one described by Appadurai. On the one hand global (deterritorialized) Hellenism is praised while on the other, following the principle of nation-states, Greeks try to draw borders and entrench their territory. The building of the Acropolis Museum, which is planned to receive the 'diasporic' Parthenon marbles, can stand as a perfect metaphor of the desire to reterritorialize Hellenism. The Acropolis Museum provides a 'home' for the Parthenon marbles, reinforcing the claim that they belong to Greece: even if they do not arrive there, they will be noted through their absence.

Requesting the return of Greek heritage does not mean constraining its world-range. On the contrary, by achieving its restitution the prestige of Greece is restored, because it means acknowledgement by Europe that Greece is the legitimate owner. As another 18-year-old student puts it (5th GR):

> They must definitely come back, and if someone wants to see them then they have to come here and not to Britain. The marbles cannot be conceived without Greece and Greece cannot be conceived without them, *its cultural heritage which proves its glory* (emphasis added).

I see the request for the restitution of Greek heritage as a way for Greece to claim that Hellenism belongs *in* the West, i.e. it is global, but it belongs *to* Greece, i.e. it is local. In this procedure of Greece negotiating its identity and trying to create its space, not just physically but also

symbolically, the request for the repatriation of Greek heritage stands as a request for reterritorialization of a glory that global Hellenism has appropriated.

The Olympic Games are also an example of a 'local' heritage which has become global, but which Greece now asks to have repatriated, exactly as in the case of the Parthenon marbles. Greece has been applying to host the Olympic Games for several years now, but this has been refused because of a lack of infrastructure and logistical capabilities. This reinforces the Greeks' image of Greece as a country trying to catch up and being passed over repeatedly. The national humiliation that followed the refusal of the global community to grant to Greece what the latter considers its legitimate heritage has been repeatedly revealed either in Greek libels against the powerful countries or in extended outbursts of self-criticism.

Figure 4.1 is a cutout of the first page of a newspaper (*To Βήμα* 14/7/96) on the occasion of Greece having lost the competition to stage the 1996 centennial Olympic Games to Atlanta. Billy Paine, one of the major protagonists of the Atlanta campaign features in this photo, which is accompanied by the title: 'He is the one who "stole" the 1996 Olympic Games from us'. The choice of this photo to illustrate the act of the Olympic Games 'robbery' is not coincidental. In a powerful, almost arrogant way, Billy Paine makes Olympic rings of smoke with his cigar, looking as if he has complete rule over the ring. With just one hand, he manages to raise his armchair from the ground, implying his literal and metaphorical power. This image reflects the Greek feeling that the Olympic Games are in the hands of the powerful, where the Greeks do not belong.

Finally, in 1997 Greece was granted the right to host the Olympic Games of the year 2004. The Olympic Committee's decision was received triumphantly in Greece. In fact, since then there has been a wide mobilization to have the new Acropolis Museum ready to accommodate the expatriated Parthenon marbles by the year 2004. The idea is that Hellenism will thus be celebrated in its complete restitution. However, even before Greece was granted the organization of the Olympic Games, there were moments when it was felt that Hellenism was already starting to be reterritorialized to Greece. An event illustrates this: two years before Atlanta was named as the venue for the 1996 Games, Voula Patoulidou, a Greek athlete, won a gold medal in 1992 in sprint. She is a figure who has made history in Greece, not just because she won a gold medal, but because when she won it she exclaimed 'Για την Ελλάδα, ρε γαμώτο', 'For Greece, for fuck's sake!' Although it might sound strange,

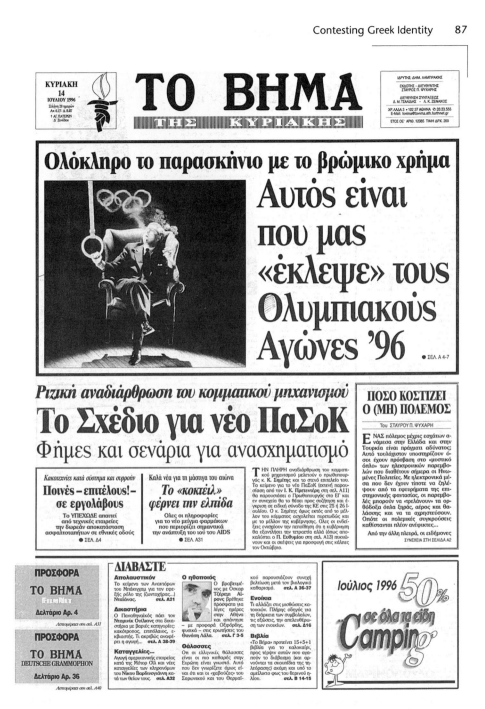

Figure 4.1 *Το Βήμα της Κυριακής* (14/7/96) comments on Billy Paine's role in Atlanta's successful application to host the 1996 Olympiad with the words: 'All the backstage with the dirty money. He is the one who "stole" the 1996 Olympics from us'.

this phrase made thousands of Greeks smile and cry at the same time at the night of her victory. The gloss of Patoulidou's cry cannot render its full meaning in English. It encompasses a folk, unpretentious warmth, which implies a grudge against the image of Greece as a country which history always leaves behind and a determination to prove its worth. The glory which the global community had refused Greece, namely the right to celebrate the restitution of the Olympics in Athens on the occasion of their centenary, was now being taken back by Greece in the form of a gold medal.

Apart from Patoulidou, some of the other Greek Olympic medallists had similar reactions. Pirros Dimas, a Greek from a Greek village in South Albania, who won a gold medal in weight-lifting in 1992, 1996, and 2000, is also a figure treated with great affection within Greece. What moved many Greeks was that a young man who was brought up under the regime of Enver Hodja, outside the borders of the Greek state, turned out to be so devoted to Greece and so keen in granting it a medal. In fact, in 1992 while he was lifting the weight that finally granted him the medal, he cried 'για την Ελλάδα' – 'For Greece', another moment for Greeks to remember. In the Greeks' feelings, crying 'for Greece' at that particular moment was like forcing the globe to turn eyes towards Greece at the moment of its victory. At that moment Greece became the weight that Pirros Dimas lifted and placed on the pedestal of victory. I believe that through their exclamations, both Voula Patoulidou and Pirros Dimas *re*territorialized Hellenism after Atlanta had been named as the host of the centennial games. And that was even more important, as the victories took place in the contested field of the Olympic Games.

In the case of the 'exportation' of antiquities to exhibit them abroad as well as in the claim for the repatriation of Greek cultural heritage, we encounter the same situation: Hellenism tries to remain both local and global. The need for the circulation of Hellenism is felt, while at the same time the need for its national reassembly is required. Even the terminology used is similar in the two cases: it is believed that the Greek national body cannot survive as a totality when its expatriate members are abroad, while at the same time being abroad means manifesting Hellenism all over the world.

I will end with an example which offers a perfect synopsis of the interplay between the local and the global in the Greek case described here. On the Euro-coins, one side will be the European one – the same for all member countries. The reverse side will be a national one, bearing a sign chosen by each member-country separately. Originally it was suggested in Greece that the Parthenon marbles should be depicted

on the national side of the Greek Euro coin. According to the Greek member of the European Parliament, Alekos Alavanos:

> Every coin will be a proclamation. It will be carrying the electric charge in support of the repatriation of the Parthenon sculptures . . . Europe is being unified into a common coin. Berlin was unified years ago. Only the Parthenon remains divided with a wall of shame that Lord Elgin created and which is sustained today by the British government' (*Καθημερινή* 5/4/98).

The above suggestion was not materialized in the end. Its realization, however, would be a manifestation of the local-global contest. By depicting the Parthenon marbles on the national side of the Greek Euro-coin, Greece would put an advertisement of a local claim into global circulation. It would reproduce the global image of the Greek heritage, in an effort to project its local Greek identity.[5]

Revival – Restoration – Regeneration

I would like to show another kind of repatriation, a repatriation in time: the revival of aspects of ancient Greek civilization in the modern Greek state.

With the establishment of the new nation-state the belief that Hellenism was *reborn* and *regenerated* was cultivated. The nation-building process which started with the War of Independence was referred to as Παλιγγενεσία (regeneration-renaissance), implying that ancient Greeks were resurrected and were re-inhabiting the Greek soil (Σκοπετέα 1988: 207). In fact, the centennial celebrations in 1933 of the liberation of Athens took place on the Acropolis on Easter Day, chosen for the symbolic connotations of the Resurrection (Papageorgiou Venetas 1994: 390).

It is interesting how this revival was conceived in its materialization. If classical antiquity was one of the new nation-state's representations, then it should not be surprising that together with the *revival* of the Hellenic people, the *restoration* of Greek antiquities was among the first priorities of the state. The Greek nation was disinterred from the soil where it had been buried for years and years, and it was resurrected.

Together with the restoration, the *renaming* of the Christian population living on the Greek peninsula took place. Earlier regional names, such as 'Ρωμιοί', 'Χριστιανοί' (Christians), or 'Κρητικοί' (Cretans), 'Μοραΐτες' (people from the Peloponnese), etc., which were used before the Greek

War of Independence, were all replaced by the name 'Ἕλληνες' (Hellenes), which evoked the name of classical Greeks, very soon after the War broke out (e.g. Πολίτης 1993: 33–5). Similarly, classical Greek personal names became extremely fashionable at the beginning of the nineteenth century, in many cases replacing a tradition of giving Christian names (Δημαράς 1989).

It is within this spirit that the revival of the Olympic Games (1896) should be seen.[6] The idea behind the restored Panathenaic Stadium in the 1890s was to accommodate the revival of the Olympic Games on Greek soil, to be expanded into a global competition for all nations, under the auspices of Greece. The Stadium was rebuilt virtually from scratch at great expense, although its oblong shape was from the beginning considered unsuitable for modern athletic games.

Performances of ancient drama in ancient settings are another aspect of the same desire for the revival of ancient Greek civilization, and they occurred as early as 1867. For the purposes of reviving ancient drama, many ancient Greek open-air theatres were put into use again (e.g. Epidaurus, Dodona, Philippi, and Athens) (Papageorgiou-Venetas 1994: 378–80).[7]

There are several examples that illustrate Greek efforts to revive Classical Greek antiquity but need not be cited here. What I should note, however, is that rendering life to Ancient Greece in a contemporary setting is a way to reterritorialize (regain) the glory that it represents to contemporary Greece. Through performing the past (e.g. in ancient drama) the Greeks activate their national identities. Moreover, they make this past theirs again because they revive it on its local modern Greek ground. Reviving is a mimesis, and mimesis is 'a metonymy of presence' (Bhabha 1994), reminding everyone that ancient classical civilization is still here, in the place where it was first born in flesh and blood.

As Leach (1961, cited in Bloch and Parry 1982: 9) has argued, religious ideology uses the promise of rebirth to negate the finality of death. It merges the experience of birth and death, thus entangling them in a cyclical process whereby the one follows the other, establishing a continuity of life. Bloch (1982), on the other hand, has emphasized the political nature of this cyclical process of renewal. He associates duration and contingency of events with the efforts of an authority to establish itself as belonging to an eternal and unchanging order. The nation-state cultivates the idea that it was reborn after a long period of Ottoman 'slavery'. It thus establishes the conviction of continuity in the life of the Greek nation-state since the classical ages.

The concept of continuity thus becomes intimately linked with the notion of immortality. The Acropolis is a monument commemorating the glorious past, and epitomizing the Greek nation's continuity throughout the centuries. As we saw in Chapter 3, since the establishment of the Greek state there has been a series of efforts to revive the Acropolis' former glory (e.g. restoring the archaeological site and 'cleaning' it from elements linked with its 'dark ages' that negate this idea of continuity). The claim for the restitution of the Parthenon marbles not only illustrates the effort to keep the Acropolis immortal throughout the centuries, but also evidences the intimate relationship between reterritorialization and revival: in Greece, emigration is often perceived as a symbolic death. The restitution of the expatriated Parthenon marbles is thus both a reterritorialization as well as a revival.

I would now like to compare claims over antiquities with claims over names. I suggest that they work in very similar ways and that names are also used in the process of reviving and reterritorializing ancient Greece. They are potent symbols for establishing a connection between time and space.

Names, Power and the Claims of Identity

Naming systems work to establish continuity between the present and the past, not only at the level of family linkages, but also at the level of national history. Sutton (1997; 1998: 181–93) has shown how nationalist ideologies become important to people, as the latter perceive them through local-level practices such as kinship. He also stresses the relationship between naming practices and property rights in both systems of kinship and nationalism. He thus brings up the analogy between two discourses: the one referring to the Greek custom whereby a child together with the name of a relative inherits also the relative's property, and the one accompanying the national 'battle' that Greece fought over the name of Macedonia, based on the argument that 'Macedonia is a Greek property by right', since the name signifies a Greek region.

Apart from the well-known Greek objection to allow FYROM to be called 'Republic of Macedonia', which has already been discussed in anthropological works (Danforth 1984; 1993; 1995, Karakasidou 1993; 1994, Sutton 1997; 1998), there is a series of other examples illustrating the ideological significance of conferral and use of names in Greece (e.g. Herzfeld 1982b). As Herzfeld notes, through naming systems one can study the interplay between identity and power as well as the ways

in which social relationships are constructed and experienced. Although Herzfeld's study refers to Greek baptismal names, following Sutton we could extend his argument to the domain of national names and names in general. Here I will discuss two cases: the first one is the Greek request for changing the name 'Greece' to 'Hellas'. The second is the claim that the sculptures that Lord Elgin removed from the Acropolis should not be called 'Elgin', but 'Parthenon marbles' (Figure 4.2).

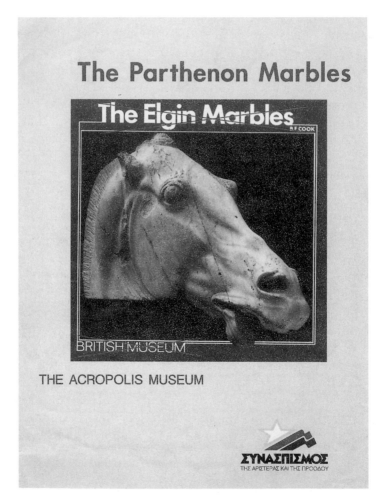

Figure 4.2 An election leaflet of the *Left Alliance* party (*Συνασπισμός*), circulated before the 1994 European parliamentary elections. The party announces its intention to fight for the return of the Parthenon marbles by crossing out the names 'Elgin marbles' and 'British Museum' and substituting for them 'The Parthenon marbles' and 'The Acropolis Museum' (Source: Συνασπισμός).

Recently several Greek voices have suggested that the international
names *Greece* and *Greeks* should be abolished and the names *Hellas*
and *Hellenes* should take their place. *Hellas* (Ελλάς) is the ancient Greek
name for Greece. It is also the name modern Greeks have chosen to
refer to their country. In 1980 the philosophy professor and General
Secretary of the Academy of Athens, Ioannis Theodorakopoulos, had
requested linguistic research of this issue (*Avtí*, 576 (1995): 38). In the
following years the matter was discussed sporadically until a programme
of the Piraeus Church radio station (10 March 1995) brought up the
issue again. The programme's editor suggested that the name *Greece*
should be changed to *Hellas*. Since then many individuals have expressed
their desire for the name-change.

An illustrative example is that of a professor of clinical surgery who
sent five letters to the newspaper *Καθημερινή* (24 and 26/6/1981, 2/8/
83, 6/7/91, 7/2/98) complaining about the names Ρωμιός (Romios) and
Γραικός (Graecos) and asking to ban them from the Greek vocabulary,
replacing them by the name Έλληνας (Hellene). The first one, he
claimed, recalls the Roman domination and it has a degrading meaning.
The Turks, he argued, used the name *Rum* by fraud in order to estrange
the Greeks from their glorious past. The second, he continued, must
be banned because it is connected to the Latin *Graeci, Graecia, Graecus*
and, the worst, to *Graeculus,* which was used to mean a decadent Roman
citizen. In any case, all these names – according to him – are more recent
and have been used only occasionally and in short periods of the Greek
national life. The professor then tried to prove historically that it is
'the name Έλληνας that was the first and more dominant name of the
Greeks' and that 'this is the one expressing the continuity of the Greek
race throughout centuries'.[8]

In a similar vein, an anonymous reader of an economics magazine
(*Οικονομικός Ταχυδρόμος*, 16/9/93) complains because foreigners, instead
of using the names 'Hellenes' and 'Hellas', use the names 'Greeks' and
'Greece', which are of Turkish origin (γκιαούρης).[9]

Herzfeld (1982b: 299) maintains that claims about identity can some-
times be made by shifting the category ascription of a particular name,
e.g. by treating a baptismal or a surname as a nickname (παρατσούκλι).
I suggest that in the words of the two people quoted above the names
Greece and Hellas seem to belong to two different categories. The name
Hellas is conceived as the formal and official name of Greece (something
like a surname), while 'Greece' is considered to be a 'παρατσούκλι', i.e. a
name *attributed* to the original 'Hellas' in a later period referring to the
inferior position of the Greeks under the Ottoman empire, i.e. something

like a nickname. Thus, 'Greece' is not a name conveyed through gener-
ations, like a surname, or conferred by the family and sanctified through
a religious practice, like a baptismal name. Herzfeld says that 'when the
nickname becomes a surname, the bearer is thereby registered (γράφεται,
written) as a bureaucratic category token'. In this respect, the 'nickname'
Greece has been registered as a surname and the restitution of the
'authentic' and 'original' 'Hellas' is requested.

Several people, including intellectuals, have expressed the opinion
that changing the name 'Greece' is pointless. Many of them do not
base this argument on the insignificance of the whole matter, but on
the name's authenticity. Thus some (among them the former president
of Greece, Christos Sartzetakis, *Αντί*, 16/9/93), in an effort to restore the
validity of the name *Greece*, have tried to prove in historical terms that
the names *Greece* and *Greeks* are not only Greek in origin, but that
they are even older than the name 'Hellas' (compare a similar view of
an archaeologist, *Καθημερινή*, 7/7/96).

The request to change the name 'Greece' into 'Hellas' meant in a way
bringing 'Hellas', with all its connotations, back to Greece. Although
'Greece' is the name used by the international community, it is the
name 'Hellas' that represents the global character of Hellenism. 'Hellas'
was the name of ancient Greece which has travelled around the world
to designate the cradle of classicism and it is 'Hellas' (the vision of
ancient Greece) that foreign travellers from the seventeenth century
onwards were after. 'Greece', on the other hand, is a very localized name,
as it refers to the contemporary Greek state, rather than the 'diachronic'
and 'dispersed' Hellenism.

As we saw earlier, Greek antiquities and Greeks of the diaspora are
often seen as representatives of Greece abroad. Thus, it is not surprising
that the issue of the name of Greece abroad also aggravated several
Greeks of the diaspora. A common Greek expression referring to the
need of people to insist on their dignity is 'Για ένα όνομα ζούμε' ('It is for
a name that we live'). Staining one's name (αμαύρωση του ονόματος) is
staining one's dignity. The use of a 'wrong' name for Greece abroad
also affected the image of Greeks abroad, who protested for this reason
on several occasions.

An American Greek sent a letter to the newspaper *To Βήμα* (24/11/
96) complaining that official organizations, such as the State Post Office
of the USA, do not recognize the term 'Hellas'. He concludes: 'I wonder
why we do not decide to inform the international society that we are
Hellenes'. Similar rhetorical questions, e.g. 'So, [will we be] Έλληνες or
Γραικοί in our international appearance?' (*To Βήμα*, 3/12/95) are often

addressed. They display an urge to persuade the international society that 'we are Έλληνες' and to remind it of the intimate links between ancestors and their descendants.

This urge has its roots much earlier in Greek history, in the first days of Greece as a new nation-state: in 1830 the Austrian historian Jakob Philipp Fallmerayer put forward his theories questioning the origins of modern Greeks from the ancient Greeks. These views reflected a more general predisposition of 'the West' towards the Greeks of the newly established Greek state. As the Greek historian Αλέξης Πολίτης writes (1993: 26):

> The modern Greeks were not corresponding to the idyllic image the Western Europeans had created: they were short, ugly, with crooked noses – nothing to do with those all-white, vigorous statues! They had neither Plato's wisdom, nor Socrates' resignation, nor Aristides' unblemished patriotism . . . Those uneducated orientals might be picturesque, but they could not possibly claim the right to the heritage from classical Greece, which was the very ideal of every European middle-class society.

Fallmerayer's views obviously turned the cosmology of modern Greeks upside-down. The most valuable aspect of their national existence, namely their origin from the ancient Greeks, had been questioned on the grounds of historical arguments (Πολίτης 1993: 25). Fallmerayer was not the only one. Others, too, had contrasted the ('real') ancient Greeks with their barbarian modern copies 'who had parodied the speech and pilfered the name of the great' (Woolf 1906: 979, quoted in Lowenthal 1998: 200). More than a hundred years after Fallmerayer a British Foreign Affairs spokesman commented on Melina Merkouri's referring to her classical origins: 'If Miss Merkouri is descended from Plato then Omar Sharif is descended from Rameses II' and argued that since Greece's modern inhabitants 'are not descended from the race of Pericles, modern Greece has very little in common with the nation and the people who carved the Marbles' (Lowenthal 1998: 200).

This is the framework within which we should also look at complaints such as the following, expressed by a journalist attending the Olympic Games in Atlanta (*Καθημερινή*, 28/7/96):

> The Americans did not know our flag . . . One called us Argentineans, another one Finns, and another one Uruguayans. And when you were telling them 'Hellas', they were asking what that was. Unfortunately,

you had to say 'Greece' in order for them to understand. Even on the athletes' T-shirts Hellas is not Hellas, but Greece! I wonder why.

The journalist implies that although the international community knows the meaning and the importance of the Olympic Games as well as the spirit of Hellenism that gave birth to them, it seems that it doesn't know who the contemporary Hellenes are. As a matter of fact English-speakers in general (apart from classicists) refer to 'ancient Greece' and not 'Hellas'. They only know the adjective 'Hellenic', but not the noun underlying it. This is a linguistic reality, which in Greece is perceived as a refusal to accept that Greece is no different from Hellas and that Greeks *are* Hellenes. In other words, it is a refusal that Hellenism of today is the most respected and well-praised global classical Hellenism.

In a paper of Καθημερινή (20/1/98) a journalist reports the opinion of a Greek of the diaspora who, while watching a polo match between Greece and Canada, brought up the question of why Greece should be called 'Greece' and not 'Hellas': 'It is not right' he said 'for a country with such a history to allow the distortion of its name.' When someone in the group remarked that it is difficult for a country to change its name within the international organizations, the Greek of the diaspora revolted: 'But this is impossible! When African countries impose their new name in record time, can't Greece simply *restitute* its proper name?' (emphasis added). Names thus acquire materiality like history and become 'heritage' similar to antiquities and are treated like a property, which is claimed back especially in moments and in fields of internat-ional contest, such as the polo game between Greece and Canada or the Olympic Games.

If names, as Sutton argued, establish property rights, then foreign products cannot bear the name Hellas, as that belongs to Greece. On 3 December 1995, a text in the Greek newspaper To Βήμα reported:

> The National Society 'Hellas', which was founded by shipowners of London as well as intellectuals and artists, will apply for the change of the international name of the country from Greece, as established during the last centuries, into Hellas. The reasons are several. The following argument, however, is impressive: according to international legislation it is prohibited that commercial goods bear the name of a country. There is, however, evidence that commercial directors of foreign companies have started using the classical glamour of the name 'Hellas'. In Northern Europe, the Finnish chocolate 'Hellas' already circulates, while God knows what other products our ancient splendour can name (To Βήμα, 3/12/95).

Appropriating the name 'Hellas' means keeping it protected from foreign 'abuse'. The issue of the commodification and consumption of Greek heritage will be examined in more detail in Chapter 5. Here I only use the above-cited example to show how a name can be a tool for contesting Hellenism.

It is within a similar framework that we should look at the claim over another name: in both private and public discussions about the restitution of the Parthenon marbles in Greece, I often heard people complaining that the marbles should not be called 'Elgin', but 'Parthenon'. There are many cases where a collective noun becomes a name specifying only a subset of the objects the literal noun denominates. Similarly the Parthenon marbles are known among Greeks as simply 'the marbles' – a fact that leads to mocking comments of the British of the type 'they lost their marbles'. Such names can afford to be shortened without losing the uniqueness that they denote. The term 'marbles' in its generality can evoke the qualities each person wants to ascribe to them. A further specification can either add nothing to its meaning or only emphasize a particular aspect of it. Thus, the adjectival 'Elgin' can be considered 'obtrusive' as it highlights the importance of this person in the shaping of the history of the contested marbles. When a BBC journalist asked Melina Merkouri whether Greece was able to protect the Elgin marbles she answered:

> My sweet boy, I only happen to know the Parthenon marbles. Elgin, your ancestor, I only know him as a thief. Therefore we cannot possibly be referring to the same thing. In any case, if what you refer to are the Parthenon marbles I will answer to you: no, my sweet boy, we cannot protect them. We Greeks are primitive. We still live in caves and we eat raw meat with our hands . . .

The identification of Elgin with a 'thief' has become almost idiomatic: In one of the schools I visited, one boy who thought that another one had taken food from his lunchbox exclaimed: 'You couldn't even be Elgin' (Ούτε ο Έλγιν να ήσουνα!).

Several informants also protested when I used the term 'Elgin' rather than 'Parthenon' marbles. A middle-class lady explained to me: 'We cannot possibly name the marbles 'Elgin', after the thief!' In other words, calling the Parthenon marbles 'Elgin' means for them attributing the negative, polluting qualities of Elgin to the marbles. Herzfeld says that 'name conferral makes a statement about the recipient's identity, while the subsequent use of the name in address and reference implies the degree to which that identity is acknowledged or challenged by

others' (1982b: 288). Accepting and using the name 'Elgin' rather than 'Parthenon' is equated by that lady with acknowledging that the contested marbles' identity is defined by Elgin. Moreover, as Stewart notes (1991: 55), (personal) names on Naxos (as well as in several other places in Greece) link an individual with a nuclear family, a larger lineage and the community. Similarly, the name 'Parthenon marbles' creates an intentional link with the perceived identity as belonging to the Parthenon, Hellas and modern Greece. Calling them 'Elgin' marbles denies this link and replaces it with incompatible associations.

As we know from Stewart's research in Naxos (1991: 215), if you can find out the name of the demon possessing you and you are able to address it by name then *ipso facto* you control it and can exorcize it. In other words, knowledge of a name means possession and subordination of the spirit. Calling the marbles 'Elgin' is a similar act of possession and subordination. For example, a Greek archaeologist, referring to the name of the 'marbles', exclaimed: 'This is ridiculous! The marbles are not Elgin's, but the Parthenon's'. In other words, the issue of the name becomes a question of where the antiquities belong. It conveys the seal of the owner, the certificate of the marbles' origin, which cannot be other than Greek. Names thus attain a certain materiality as they become linked to a particular bodily or social self. The conveyor of the marbles' name is the one entitled to enjoy the rights of succession. A little girl in a private school of Athens said: '[The marbles] should not be named "Elgin", because it is not right for the Louvre [sic] to take advantage of the Greek sites.' According to this mentality it is not fair for a foreign people to become famous or rich through the manipulation of somebody else's property (cf. Sutton 1997; 1998).

Marilyn Strathern (1979), discussing body decorations in Mount Hagen, has criticized the tendency to draw 'a contrast between body and soul, between physical appearance and individuality, between an outer shell and an inner identity'. She suggests that decorating the body is a way to manifest the inner self, the body becoming the medium for making the self apparent. Decorations on the actor's body, she says, 'are symbols of himself turned inside out'. Setting out from Greek sayings during the 'battle' over the name of Macedonia, e.g. 'the Name is our soul' (Sutton 1998: 186), I suggest that use of names could be seen as analogous to the way in which Strathern approaches the body decorations. A name is not only an external attribute, but it also associates with the inner self. Extending Strathern's argument, I would apply this relationship between body and self to the relationship between national bodies and national selves. The name therefore not

only constitutes the image of the national body, but it actually defines its content, the substance of the national self. As with the body decorations in Mount Hagen, displaying the name demonstrates the strength, the power and certain qualities of the group which conveys this name, and it submerges the individual in group identity. Names are evocative. 'They make habitable or believable the place that they clothe with a word; they recall or suggest phantoms that still move about' (De Certeau 1986: 105). Hellas for example stands for certain qualities, and by using the name 'Hellas' these qualities are evoked. This is why a distortion of a name seems to equate to the distortion of what it represents. By insisting on the use of a name on a global level one essentially seeks to establish certain qualities on this global level. The skin, Strathern says, 'is the point of contact between the person and the world'. So, I would argue, is the name: it embodies history and it recalls it every time it is pronounced. It is evident that in the situations described above, a name is not simply a referential marker. It is a representation; it constitutes an identity. De Certeau (1986: 94), discussing the meaning that names attribute to space, argues that 'a proper name provides a way of conceiving and constructing space on the basis of a finite number of stable, isolatable and interconnected properties'. The Greek journalist in one of the above cited texts wonders: 'So will we be Hellenes (Ἕλληνες) or Graeci (Γραικοί) in our international appearance?' That is, will we represent the qualities of the global and diachronic Hellas or those of a temporally specific Greece, constrained by borders? Herzfeld says (1982b: 289) that 'naming is an associative act: it projects a hoped-for similarity as though it were virtual sameness'. Naming contemporary Greece after Hellas means also attributing to it the laurels the latter has acquired. Names then, as Sutton has shown, ascertain continuity between past and present. As a Greek teacher of the diaspora said, referring to a list with the names of all Greeks who lived in his village in Russia since it was first established, 'A person dies, not when his heart stops beating, but when he is forgotten. That is why we never forget anyone' (Τα Νέα, 13/5/97). 'Names', de Certeau says (1986: 104), 'carve out meanings' and 'create a nowhere in places'. Naming Greece after the ancient name 'Hellas' is stating that the same Hellas as the one of the ancient times is here in the same place, still alive. It also gives ancient Hellas a place in the contemporary world. It renders Greece the rightful home for the deterritorialized Hellenism.

In this chapter I have introduced some of the ways in which the Greeks deal with the paradox of Hellenism being both 'local' and 'global'. By

following an at-first-sight equally paradoxical tactic, they 'export' their heritage on the one hand, thus reinforcing its global character, while at the same time they claim it back on the grounds that it is local. On reflection this tactic is not so paradoxical, because global Hellenism does not substitute for or even contradict local Hellenism. On the contrary, global Hellenism is used to reinforce local Hellenism. Local Hellenism actively uses the rhetoric developed about Hellenism's 'global' features in order to create its space and, in some cases, to resist what it considers as global.

Antiquities, just like names in the cases discussed here, do not simply constitute images of Hellenism, images of Greek identity. The detachment of the Parthenon marbles from the Acropolis by Elgin was considered as 'a plundering of the Greek soul' ('Η λεηλασία της ψυχής μας' – Ελεύθερος Τύπος, 3/4/94), in the same way as Greeks claimed during the Macedonian conflict that 'the name is our soul' (Sutton 1998: 186). Thus, antiquities become mobile manifestations of Greek identity internationally, able to circulate beyond the borders of the Greek state. In their materiality, antiquities evoke the entire process of their biographies: their production in ancient Greece, their detachment from the Greek land and their appropriation by foreign hands. Their return to Greece is seen as the closing of a cycle, which will generate for Greece the reputation and the value that antiquities acquired throughout their 'outward movement' (cf. Munn 1977). 'Exporting' Hellenism is therefore a way of eventually getting it back in the form of reputation, which has been produced while Hellenism was in the hands of others. When the Greeks ask for repatriation of their heritage they want to make sure that this cycle is completed, that the reputation, and more generally, the power embodied in antiquities, will eventually come back to where they originated.

Claims both over names and over antiquities are a way of writing history, of establishing certain 'truths': the 'truths' of Greece being Hellas, of the marbles belonging to the Parthenon rather than to Elgin, of Macedonia being part of Greece and not FYROM. Such claims over history are means for Greece to write its history as it sees it and to draw its territory in the map of the world.

Consuming Inalienable Wealth

I had two excellent statues, a woman and a prince, both solid – their veins showed, that's how perfect they were. When Poros was destroyed, some soldiers took them and were ready to sell them to some Europeans at Arta: they wanted 1000 tálara [monetary unit]. I ended up there, I happened to be passing by; I grabbed the soldiers, I spoke to them. 'Even if they give you 10,000 tálara for these, don't stoop to letting them out of your patrída [fatherland]; these are what we fought for (I take out and give them 350 tálara); and when I see the governor (since we eat together), I'll give them to him and he'll give you whatever you ask for to keep them up there in the patrída'. And I hid them. Then through my reference I offered them to the king to make them of use to the patrída (Makriyannis cited in Leontis 1995: 58–9).[1]

In Chapter 4 I discussed the relationship between the local and global meanings of Hellenism and gave some examples of how the idea of Hellenism is exported and re-imported back to Greece, how it is put into international circulation while at the same time being bound within the Greek borders. In this chapter I intend to examine further an aspect of this local-global relationship, namely the Greek response to the global commodification of Greek heritage.

Weiner (1985; 1992; 1994) has introduced a new way of approaching the issue of exchange systems by examining the ways in which objects acquire a value that keeps them untradable, out of circulation. Such objects, Weiner argues, constitute inalienable wealth and are inherited within the same family or descent group. These objects are more than economic resources. Their inalienability derives from their ability to concentrate multiple cultural meanings and values and their power 'to define who one is in a historical sense' (1985: 210). Keeping an inalienable object, according to Weiner, makes the past a 'powerful resource for the present and the future' not only expressing a person's

or group's identity, but concentrating this identity into a symbol of immortality (1985: 224). In earlier chapters, we saw the reaction with which the governmental decision to send antiquities abroad was met. Although there were some who agreed with the governmental undertaking, believing that 'the world' should have a share in Greek heritage, others considered Greek antiquities national treasures, 'inalienable wealth', which could not be given away or loaned to anyone. The campaigns for the return of the Parthenon marbles and for the hosting of the Olympic Games are other examples revealing the extent to which classical antiquity is considered irreplaceable, nationally indispensable and non-transferable wealth.

Even stronger reactions have been voiced in relation to thoughts of selling antiquities. Classical antiquities have been declared 'national heritage' and 'state property' since the first archaeological law in the early years of the Greek state (1834), and in Greek people's minds they are not tradable (cf. Hamilakis and Yalouri 1996). There are many examples in Greek history when suggestions of selling antiquities were met with indignation (Petrakos 1982). For example, after the Second World War the sale of some antiquities was suggested for the economic relief from the difficult situation created by the war. The suggestion fuelled public uproar, and finally the plan was abandoned (ibid.: 30–5). Suggestions to display Greek antiquities abroad in exchange for commercial benefits have always met strong opposition from both archaeologists and the wider public. In 1924 Americans proposed the travelling on show around American and European cities of the statue of Hermes made by Praxiteles in order to collect money for the repayment of the 'Refugee Loan' of the Greek state.[2] Again, strong feelings resulted in the cancellation of the plan (ibid.: 80–1; ΕΔΑΕ, 4 [1989]: 24). Similar reactions followed the proposal of the Greek ambassador to the USA to display Hermes at the International Commercial Exhibition of New York in 1963 (Πετράκος 1982: 81–4). Protests, however, did not always prevent the exportation of antiquities. In 1970, uproar against the export of a female statue from the Acropolis was ignored and the statue was finally displayed at the commercial exhibition EXPO '70 in Osaka, Japan (ibid.: 85).[3]

As Parry and Bloch (1989: 6) note, it is often argued that 'the impersonality and anonymity of money lends itself to the impersonal and inconsequential relationships characteristic of the market-place and even to a complete anonymity in exchange . . . Anonymous and impersonal, money measures everything with the same yardstick and thereby – it is reasoned – reduces differences of quality to those of

quantity'. In the case of Greek heritage, however, it is not only monetary transactions that are avoided if they involve antiquities, but any kind of open exchange. In the discussion of the ASA concerning the exhibition 'The Greek Miracle' discussed in Chapters 3 and 4, the main argument against the governmental undertaking was that antiquities were national treasures, which could not be exchanged or loaned to anyone. Antiquities, as many said, should be above any material profits, and any kind of trade-off would be against the values they represent. Angelos Vlahos, a member of the Academy of Athens, historian, former diplomat and ambassador, said (*O Μέντωρ*, 1992 (20): 64):

> Those who signed the request for the calling of this special meeting report three points. The first one is that the antiquities will be exposed to danger. I totally agree . . . I believe that this is the only reason which should be promoted by the archaeologists. Because the second reason, that the compensatory advantages are not enough, is a position very difficult for me to accept. We either have the perception that the [ancient] Greek works are unique or we do not. If we do, then there is no currency. Greece radiates without asking for radiance. Gentlemen, apart from Egypt with its treasures, Italy, France and maybe England because of its museums, which other countries could in return offer an equivalent which would not be poles apart from ours? I, therefore, think that we trivialize our [antiquities] if we ask something in return and we come to some kind of exchange, some kind of trade.

Vlahos touches the heart of the issue: for the Greeks, antiquities should not be exchangeable goods. Their exchangeability would mean their replaceability, negating their uniqueness. If exchange is based on reciprocity, asking for some works from abroad *to exchange* would be engaging Greek antiquities in an economic logic and thus admitting that there is a price for them as well.

Even though Greek antiquities cannot be considered 'saleable', this does not prevent them from being capitalized on, even for economic profit. However, such transactions are veiled. An example is a campaign during the Second World War, which called for financial assistance for Greece. In the campaign poster (Figure 5.1) the Acropolis is depicted between a fourth-century BC statue of Hermes and a contemporary Greek woman with her child. The Acropolis is thus shown to link symbolically the classical Greek past with the Greek present. On the top of the poster the imperative 'Help Greece now!' reminds the Western world in bold capital letters of the 'responsibility' it has toward the 'cradle of

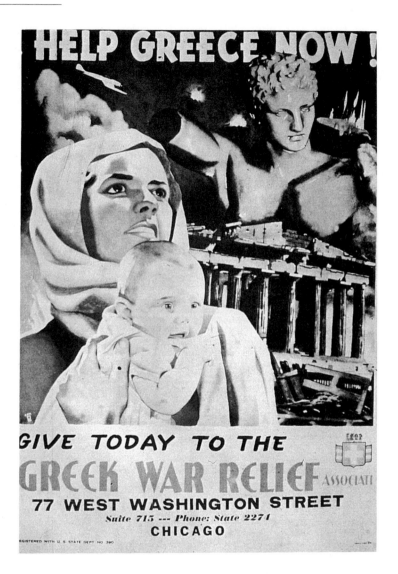

Figure 5.1 A Second World War poster, part of a campaign calling for financial assistance to Greece (source: *Σύγχρονα Θέματα*, 1978 (1): 96).

civilization'. The economic transaction attempted here takes a different form to that of selling and buying. It is 'euphemized' (Bourdieu 1977: 191). Bourdieu, in his discussion of 'symbolic violence', says that a way of 'getting and keeping a lasting hold over someone' is through gifts or debts which create 'moral', 'affective' obligations (ibid.). In fact, a belief held by both Greek official bodies and ordinary people since the

establishment of the Greek state (Σκοπετέα 1988: 211) considers Greek heritage as a *gift* to the world, which should therefore be indebted to the country that gave birth to it. This conviction allows the exchange of Greek heritage without creating commodifying connotations for it. By reminding the Western world of its valuable gift, Greece takes the right to ask for financial help without turning its heritage into a saleable item.

It has been noted (Parry and Bloch 1989: 9) that 'while those who write in the Marxian tradition stress the mystification which accompanies commodity exchange, they tend by antithesis to treat the world of gift exchange as non-exploitative, innocent and even transparent'. By contrast, Parry and Bloch argue that non-commodity exchanges are not politically innocent and that in some cases 'it is not commodity exchange which is ideologically problematic but rather the exchange of gifts'. Moreover, depending on different contexts and situations, things may move in and out of the commodity phase as they are subjected to forces of both commodification and singularization (Kopytoff 1986: 88 cf. Hamilakis 1999: 313).

Some monies are considered more 'polluting' than others. For example, no funding apart from that by UNESCO has been accepted for the restoration works on the Acropolis. As an archaeologist said:

> Any kind of funding for the Acropolis, apart from UNESCO, has been denied. It should be supported only through national funds. If we cannot support at least the Acropolis by our own funds, then, what the hell! What will we make out of the Acropolis? Acropolis Renault, Heineken, etc.?

If the Acropolis is considered to be a gift to the world, then it should not be surprising that the only money considered acceptable is that which comes as a sign of gratitude and responsibility of the world toward the monument. UNESCO, as an international organization working for the sake of 'civilization', apparently meets these criteria. By contrast, the money of Renault or Heineken would only serve the advertising ends of these companies and would therefore transform the monument into another product, which could be bought and sold according to commercial interests. Although in practice the economic transaction does take place, for the archaeologist quoted above it is the intention and the spirit in which the money is given and accepted that defines the character of, and legitimizes, the exchange.

Although much effort has been made to keep classical antiquity out of a strictly economic interchange, it has not managed to escape

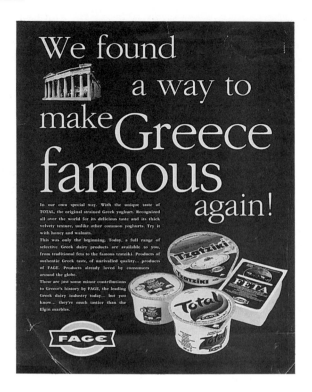

Figure 5.2 Advertisement of the dairy industry
FAGE (source: FAGE).

commodification through its increased use in advertising. Commercial advertising of consumer goods using symbols of classical heritage has taken place in Greece since the beginning of the twentieth century, the first pioneering phase of industrial development in Athens. Large-scale advertising, however, appeared in Greece after the Second World War, and since then images extracted from ancient works of art have played an increasing role in commercial advertising (Figure 5.2). This trend is, to some extent, certainly due to the general public having become increasingly aware of ancient culture through mass tourism and exhibitions (Papageorgiou-Venetas 1994: 391). Although the commodification of antiquities is most often met with criticism, it is frequently accepted as a necessary evil, in step with our times. It is also tolerated to the extent that it allows the circulation of the Acropolis' reputation without moving it away from its 'home'. There have been occasions, however, when commodification has provoked uproar and it has generated long discussions concerning the limits of the commercial use

of antiquities. I will discuss three examples, which will illuminate further the co-existence of the alienable and inalienable properties of Greek heritage.

Coca-Cola Versus the Acropolis: The Clash of the Titans

In 1970, the Greek Nobel laureate George Seferis narrated his 'nightmare on the Acropolis' in an essay on Artemidoros Daldianos[4] (Σεφέρης 1981 [1970]: 312–332). In Seferis' nightmare the Acropolis was auctioned to an American toothpaste company which would give the Parthenon Doric columns the shape of toothpaste tubes. Seferis wrote this essay during the colonels' dictatorship in Greece, when the spirit of tourism and Americanism was at its peak.

Twenty years later a version of Seferis's nightmare was to come true. In 1992 an advertisement caused an outcry and generated much discussion in the Greek press (cf. Hamilakis and Yalouri 1996). The advertisement was produced by Coca-Cola and showed Coca-Cola bottles replacing the columns of the Parthenon (Figure 5.3). As some pointed out, many Greek companies had repeatedly used the Parthenon and other 'national' symbols in advertisements (see Μπουλττης 1988), a fact that made that reaction unjustifiable. A text in a left-wing magazine writes (*Αντί*, 591 (1992): 45):

> While the nightmare of the Acropolis consisting of casts seems to be coming true, the Greek intellectuals – with the support of most of the media, which are after the ephemeral news – keep complete silence. Only one truly outrageous slogan by the multinational Coca-Cola company was enough to awaken the entire political and intellectual world and to cause unanimous condemnation of the barbarians in an effusion of nationalist fever. They overlook, deliberately or not, the fact that a Greek company was the first one to 'throw' the Acropolis' monuments into mass consumption by using the Caryatids in a sandals advertisement. But in this case there were no reactions following the modern Greek [assumption] 'they are ours, we do anything we want with them'. The ex-minister Melina Merkouri was a pioneer in the wider outcry by placing the usurpation of the monument on the same scale with the undertaking of the Olympic Games party by Atlanta.[5]

However, what was widely felt was that the symbol of the Acropolis had been internationally humiliated. I quote some of the reactions of students from the 6th PR and the 5th GR respectively, when I showed them the advertisement:

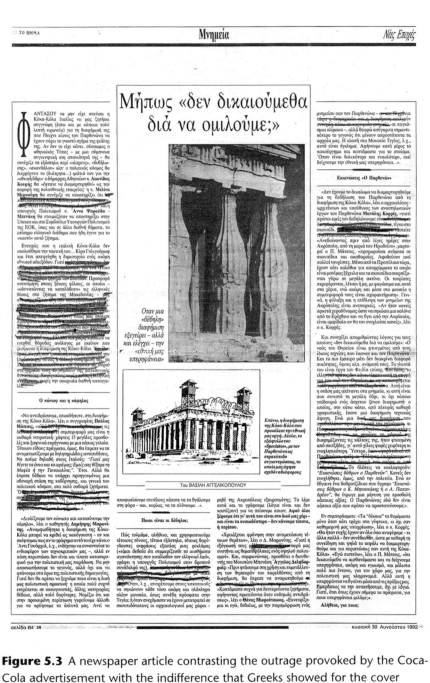

Figure 5.3 A newspaper article contrasting the outrage provoked by the Coca-Cola advertisement with the indifference that Greeks showed for the cover design of an issue of '*Spectator*', showing the Parthenon as a concentration camp (source: *Το Βήμα της Κυριακής*, 30/8/92).

6th PR:
Eleana: What do you think of this advertisement?
Maria: On the one hand, the fact that foreign peoples put the Parthenon
 in the advertisement shows that they too consider it as some-
 thing important, but on the other . . .
Vassilis: It shows that Coca-Cola conquered Greece even more!
Anna: I didn't like it, because they are ridiculing the Parthenon, they
 present it as if it was something very simple.
Eleana: But we, too, use the Parthenon everywhere: if you walk around
 Plaka you will see 'Hotel Acropolis', 'souvlaki the Parthenon',
 etc.
Eva: Souvlaki is sacred too!
Andonis: Coca-Cola and Atlanta stole the Olympic Games from us!

5th GR:
Manolis: I don't like it. It is ridiculous, it is degrading to the Acropolis.
Eleana: But when we see a sewer maintenance company called ' the
 Parthenon' or souvlaki 'the Acropolis', isn't that degrading?
Manolis: It is.
Eleana: Then why was it this particular photo that provoked protests
 and not the others?
Spiros: Probably because the company is universally known and it
 degraded us universally.
Kostas: I don't agree with that advertisement, because what would they
 think if we had depicted the Statue of Liberty holding a feta
 cheese?

The dialogue above raises several issues concerning the 'keeping-while-
giving' (Weiner 1985) of the Greek heritage and the dilemmas accomp-
anying it: Maria is happy that the company chose a Greek symbol for
its advertisement: it shows that the Parthenon is still a meaningful
symbol internationally and proves that even the economic giant Coca-
Cola considers it powerful enough to benefit from it. On the other
hand, the same student feels uncomfortable with the act of using the
Parthenon as an advertising logo. According to Anna (6th PR), Manolis
and Spiros (5th GR), it is degrading for the Acropolis to lend its name
and its form to commodities. Coca-Cola as an international company
manifests the Acropolis' commodification universally while, as we said,
it has to be distant from economic connotations. Vassilis and Andonis
(6th PR) also see in this advertisement the threat of American hege-
mony, which 'robbed' Greece of the Olympic Games and then of its

other prominent symbolic capital, the Acropolis. Another issue raised, but not only by the students, is the distortion of the form of the Acropolis by Coca-Cola. For many it was unacceptable that what was put into worldwide circulation was not the Greek Acropolis and the ideals that it represents, but a distorted one which displaced the original. A Cretan left-wing activist asserted:

> It is absurd and unacceptable. And don't tell me what Yiorgos [a mutual friend] told me, i.e. that since the Greeks, the Greek society, the Greek state treats the antiquities with disregard, why should we be disturbed when the foreigners do it. Both are wrong. You can't treat a monument as a means of advertising. There are certain limits in advertising. My personal opinion is that there should be no advertising. Advertising creates passive consumers and, following this logic, it does not have any qualms or limits. As far as I know, the use of a monument to such an extent and in such a way has never occurred before. OK, you see 'dolmas Aristotle', or 'feta cheese the Parthenon'. Surely this is ridiculous. But in the case of feta cheese, you have at least the photo of the Parthenon – they have not put pieces of cheese on the column.

Alexandros, an archaeologist in his late 50s (see also his views on p. 161), also brought up the 'difference between an advertisement which takes the Parthenon as a whole and an advertisement that deforms it'. Drawing his argument further, and while we were going through some VIP photos taken on the Acropolis, he commented that 'all these are inevitable photos, taken by journalists because these people are VIPs or in memory of the moment'. However, he found some photos 'provocative and disturbing', such as one of the American actress Jane Mansfield posing in front of the Parthenon (Figure 5.4), because he believed that she used the Parthenon as the background of her portrait. '*She* is the background, not the Parthenon' he exclaimed, disturbed.

The Coca-Cola advertisement did the same thing, namely it placed the Parthenon to the background and brought Coca-Cola to the fore. Coca-Cola became the main subject, while the Parthenon served as a trick to promote it. Daniel Miller (1998) uses the term 'meta-symbol' to describe Coca-Cola. 'Coca-Cola', he argues, does not simply represent the dark sweet American drink. On the contrary, it is a much more generalized and 'dense' sign, concentrating multiple discussions and evoking associations which relate to the nature of commodities in general. Similarly, the Acropolis is more than a set of ancient ruins on the hill dominating the city of Athens. The term 'Acropolis' can be

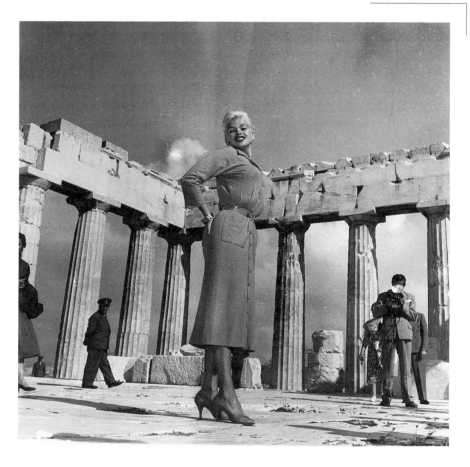

Figure 5.4 Jane Mansfield posing in the Parthenon (source: Megaloconomou archive).

filled with any feelings, ideas, ideals or values relating to the idea of 'civilization' as praised by classicism. Under this perspective, the case of the Coca-Cola advertisement can be seen as a clash between two meta-symbols. The meta-symbol of Coca-Cola appropriates the title of 'civilization', offering a new interpretation of it. This would mean that civilization is not derived from the spirit of Hellenism, but from commodification, materialism and Americanization. The Parthenon thus fades away and gives its place to Coca-Cola. It is transformed, and its Doric columns, product of 'the measure and harmony' of the golden Classical era, become mass-produced Coca-Cola bottles. An archaeologist who participated in a conference in Paris on the occasion of the centennial of the revival of the Olympic Games, shook his head with grief,

while quoting to me the words by the head of public relations of Coca-Cola, 'democratization is commercialization'. Democracy, the well-known child of the Hellenic spirit, had finally been put into the service of money and advertising.

In the case of the Coca-Cola advertisement, the authority and the power of the unique, original, and authentic Acropolis was at stake because of the polluting connotations of a non-Greek, mass-produced product. The Acropolis is a cultural product not only of the fifth century BC, but of millennia, as it has been reproduced through use/abuse. In this continuous reproduction, its appropriation through visual represent-ations has been crucial. The unique work of art has been substituted by multiple copies, part of today's mass culture. This means that the Acropolis has become more accessible both literally and metaphorically: not only can it be made known to anybody, but it can also be appro-priated by several people and on many levels. Does this mean, however, that the mass-reproduction of classical antiquity in general and the Acropolis in particular has affected the aura of these national Greek symbols, as Walter Benjamin has suggested in relation to art in the era of mechanical reproduction (1992 [1955])? As I argued in Chapter 4, the global character of Greek heritage is not denied as long as it does not undermine the local. Greek heritage, Greeks say, belongs *in* the world, but *to* Greece. It is alienable in the sense that it circulates around the world and its image is exchanged on several levels, but at the same time it does remain inalienable, a valuable treasure of the Greek nation. Its mechanical reproduction does not deprive it of its aura for the Greeks. On the contrary, its circulation around the world can be an asset: it makes it known all over the world and increases its popularity (cf. Hamilakis 2001: 6). In that respect, it is not the Acropolis that loses its aura and its authority; it is Greece that may lose the power to control it. The Greek Acropolis situated in Greece is challenged by the global, deterritorialized Acropolis, which moves around the world through its reproductions. Later I will quote a journalist blaming the 'era of virtual reality' which creates artificial settings. Virtual reality encourages the creation of imaginary places by using elements from reality. In this respect, it could constitute a danger for a work of art like the Acropolis. It threatens to dismember it and to use it in pieces rather than as a whole. It *uses* it as a décor, a simple setting, where the action is undertaken by other protagonists.

Lash and Urry (1994: 13–15), discussing the mobility that character-izes the postmodern world, have argued that the increased circulation of objects progressively empties their material content, increases their

sign value and transforms them into images. Lash and Urry believe that through this process objects are also emptied of meaning. Deterritorialization is for them equated with emptying out. Abstractedness, however, does not necessarily imply emptying. On the contrary, deterritorialization makes objects more elastic and absorptive, and it allows them to be filled up with more than one meaning. The more the Acropolis travels around the more its local Greek meaning becomes relative and easily displaced by others.

Traditionally part of the canon of Western European upper-class 'high art' and a marker distinguishing the taste of the 'court' from popular taste, ancient classical art eventually passed into the hands of the bourgeoisie, became commodified and mechanically reproduced, communicated and accessible to a mass audience. Factors such as distance, costs and difficult access, which used to make the acquisition and consumption of these prestige-generating objects a marker of distinction, were eliminated when their mass-reproduction became possible. Thus, other ways had to be invented in order to preserve their uniqueness and exclusivity. One of the ways in which the upper classes tried to retain the exclusivity of this 'cultural capital' was through developing the discourse of authenticity and originality. In a similar way the discourse of authenticity has also been adopted by the Greeks in order to protect the singularity of their national heritage against mass-production and to keep its uniqueness in relation to other nation-states. In the meeting of the ASA discussed earlier, many suggested sending copies instead of the original works of art to the exhibition in New York (e.g. *O Μέντωρ*: 23). I quote the words of Vassilios Petrakos, the General Secretary of the ASA:

> I remind you that antiquities are absolute values; they are not movies in many copies. It is as if we had Thucydides or Homer in a unique unpublished manuscript. I believe that this is how we look at Poseidon, Hegeso and Dexileos. Unless there are archaeologists or art lovers for whom the antiquities' photos are enough; I hope not for the Greeks[6] (ibid.: 28).

In the same spirit a professor of classical archaeology in the ASA meeting dreads what will happen if the antiquities are damaged during their transportation to or from the exhibition in New York (ibid.: 53): 'If something happens, God forbid, what will we put in its place in the Acropolis Museum? Its replica or its photo?' According to the two speakers above, a replica may represent the ancestral heritage of the Greeks, but only the authentic artefact embodies it. Antiquities appear as vehicles of invested emotion and the Greeks, for whom antiquities represent their

ancestral heritage, should be especially sensitized to their authenticity. Authenticity then becomes another means of negotiation between (local) original works of art and the (global) easily replaceable replicas.

While the mass-reproduced copies of antiquities are intended for global consumption, the original ones remain the inalienable wealth of the local. As such, they cannot be appropriated by any non-Greek organization. Thus, claims to ancient Greek heritage by non-Greek agents can only ignite the reaction of the Greeks and eventually lead to extended conflict between the two. The question of hosting the 1996 Olympic Games can serve as an indicative case study for exploring these politics further.

The Olympics in Atlanta – How the 'Golden' Olympiad Turned Into 'Plastic'

On 4 September 1997, members of the 'Citizens' Initiative Against the Olympic Games 2004' organized a protest demonstration on the Acropolis. They tried to hoist a banner saying 'No to the 2004 Olympiad, no to the commercialization of the ancient spirit' (*Καθημερινή* 5/8/97). It was a reaction following the fears of the negative results that the staging of the Olympic Games in Athens might have for the city. The Greek intellectual Christos Yannaras (see also pp. 70–71), referring to Seferis's nightmare mentioned earlier (p. 107), argued that:

> If Greece accepted and tolerated on its soil the monstrous Olympiads' adulteration of today, it would amount to the allotment of the Parthenon for the conversion of its columns to toothpaste tubes for the advertisement of a multinational product (*Καθημερινή* 17/8/97).

For Yannaras, Greece's hosting of the Olympic Games in the 'distorted' (commodified) form that it had acquired while in foreign hands would amount to Greece's blessing of the adulteration of the Olympic spirit. It would be equal to selling off the Acropolis to a multinational company.

It is important to see how the two sides of the contest over the Olympic Games were presented in Greece. On the one hand was Greece, the land that 'gave birth' to the Olympic Games and thus its 'legitimate owner', and on the other the USA, powerful but 'foreign' to the spirit of the Games. Through such a juxtaposition, comparisons between the USA and Greece, Athens and Atlanta, North American culture and Greek culture were sought.

The general discourse that accompanied discussions about the hosting of the Olympic Games revolved around the idea that the Olympics

have become prey to the law of the powerful, a field of advertising and of rivalries between superpowers. Whole pages in newspapers were dedicated to describing the means by which Atlanta succeeded in becoming the host and to outlining the profile of those involved.[7] Economic giants such as Coca-Cola or CNN, which both have Atlanta as their home base, were contrasted to the comparatively powerless position of Greece. Nikitas Gavalas, a journalist, reports in Καθημερινή, (14/7/96):

> The only superpower left in the world is the one that deprived Greece from the rightful organization of the Games on the occasion of the centennial since its revival. It is the one which keeps for itself the exclusive right to undertake the Olympic Games every time it thinks that this is in accord with its interests, thus applying a very singular, anti-democratic order in the bosom of the International Olympic Committee. What kind of service to the Olympic Games' spirit can one talk about, when before and during the Games the basic aim is the advertising of power and of wealth as well as the obtaining of all kinds of profit by the renowned multinational companies of the state of Georgia? Only four years before the year 2000, we will become witnesses to the adulteration of the nature of the oldest institution, which has now become giantized and commodified.

Dimitris Kapranos, another journalist, describes his experience of 'the multinational companies' feast' and laments the 'degradation of the Olympic spirit, which has been transformed into a plastic Coca-Cola glass or sold as a 'memorabilium sticker' (Καθημερινή 4/8/96) (Figure 5.5):

> While Cassius Clay or Mohamed Ali was lighting up the torch in the Olympic stadium of Atlanta, a blond American with a ponytail and a handlebar moustache was crying his wares. 'Cold Bud[weiser], quench your thirst'. In the next seat, a well-fed lady was enjoying a piece of pizza and was brandishing the plastic cup of Coca-Cola. She was wearing a hat with the sign of Panasonic and a T-shirt with the badge of IBM and on her socks, there appeared the initials of another company.

The journalist's words reveal a belief shared by many Greeks that Greek heritage in foreign hands can not but be treated as another commodity. In general, a widespread perception in Greece was that the Olympic Games of Atlanta were a kitsch commercial show and Atlanta itself a hectic city worse than Athens, where everybody either sells or buys, a city linked with racism and counter-democratic values (Figure 5.6).

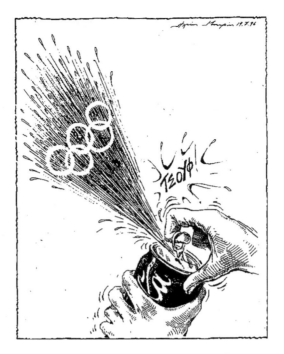

Figure 5.5 Cartoon by Ilias Makris, commenting on the commodification of the Olympics by Coca-Cola (source: *Καθημερινή*, 21/7/96).

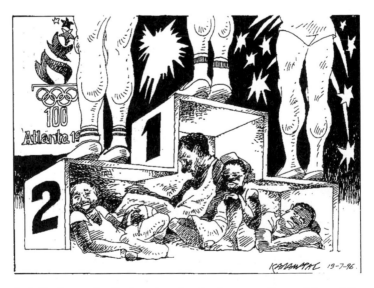

Figure 5.6 Black people displaced under the heavy podium of the white Olympic winners in Atlanta. Comment on the racist features of the city accommodating the Olympic Games of 1996 (source: *Καθημερινή*, 21/7/96).

To the size and ethos of the adulterated Olympic Games, the presence of Greece was juxtaposed:

> The Greek team, larger than any other time, and perhaps with more hopes for some medals than at any other time, will give its own difficult and, in many cases, unequal athletic battle. What is important is that our representatives participate with passion and self-denial, certain that in every appearance of theirs they will be reminding many lovers of the unadulterated Olympianism that they are coming from a country which keeps its traditions alive and which can serve as a shelter of the institution (*Καθημερινή*, 28/7/96).

Yannis Melissanidis is a gold medallist of 1996 from Thessaloniki. He became very popular in the Greek press not only for his athletic achievement, but also because of his command of the Greek language and his eloquent expression of his patriotic feeling. The following words are his, recollecting the moment of victory:

> Maybe the body was mine, Melissanidis' body, who had to do his duty; Greece, however, was contesting at that moment, thus the medal belongs to Greece . . . It is grandiose to enclose Greece inside you. In order to achieve that, I closed my eyes and I felt I acquired a tremendous strength . . . I must be perfect for Greece. I was not Melissanidis, I was Greece.
>
> (*Ta Νέα*, 14/11/1998)

In a journalist's question as to what he expects from Greece he answered: 'What would I expect from Greece? The love of everyone and the honour that the Greeks wept [with my victory] is enough for me'. To another question on how he felt when he won, he answered: 'In a word, Greek' (All are quotes from *Καθημερινή*, 4/8/96).

Not only did Melissanidis feel his body was one with the Greek national body, the Greeks themselves felt that the Olympic medallists were performing as if they were the whole Greece. This is why all those who wept with Melissanidis' and Voula Patoulidou's victories felt that they had a share in the honour. The medallists' victory was also a personal victory for them. The 'small and, compared to the USA, poor and not as well equipped Greece' was identified with the promising bodies of those young people who, against all odds, became champions of world fame. The attendance in the welcoming ceremony of the medallists in Athens in 1996 was massive, and the national emotion

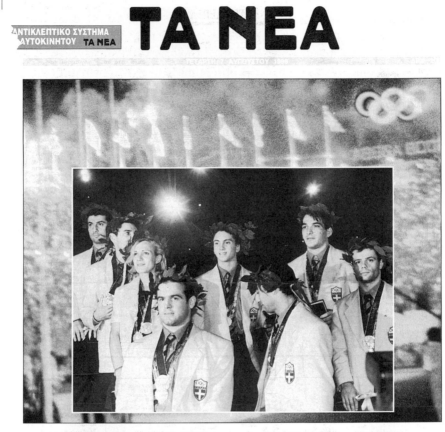

Figure 5.7 Front page in the newspaper *Τα Νέα* (7/8/96) dedicated to the return of the Olympic winners from Atlanta to Greece. The title says 'Hello to you, proud Greeks'.

this event provoked in Greece was stunning (Figure 5.7). Also Greek Macedonia, the place of origin of many of the athletes, an area which has been particularly sensitive to issues of national character in recent years, put on an extremely enthusiastic welcome for them.

Although, on an international level, the Greeks promoted their claim to organize the games, they often privately expressed scepticism. There were many who voiced their objections to the idea of Athens accommodating the Olympic Games. Most of the arguments were that such an undertaking would be a burden on the already weak Greek economy. It would aggravate the existing architectural congestion and environmental pollution of the city (Figure 5.8), which was not ready to afford such an enterprise technologically and logistically. Finally, some were horrified at the prospect of 'Helleno-Christian' kitsch demonstrations which might accompany such a venture (e.g. *Αντί*, 610 (1996): 44).

This fear was also related to the opening celebrations of the Athletics World Championships held in the summer of 1998 in Athens. These were considered crucial to prove to the Olympic Committee the capability of Athens to hold the Olympic Games in the year 2004. What

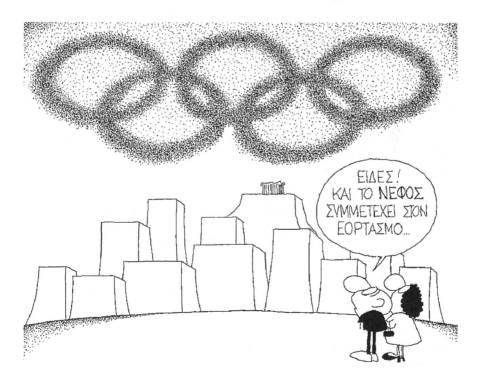

Figure 5.8 Cartoon by KYR, after Greece was granted the right to host the Olympic games of 2004. One of the figures on the right says 'You see, even the νέφος (the pollution-cloud hanging over Athens) participates in the celebrations' (source: *Ελευθεροτυπία*, 21/9/97).

became the object of discussion was the construction of an archaic gate at the entrance of the stadium that accommodated the champion-ships in Athens. The gate was constructed out of some artificial material and it had some ancient representations assembled arbitrarily. Appar-ently, the construction's aim was to make the whole event look more spectacular on TV. Many were particularly disturbed by the aesthetics of this fake gate, which were compared to those dominant during the two dictatorships in Greece and to fascist constructions by Hitler and Mussolini. Above all, however, the comments that the gate provoked were of the type 'a product of a globalized taste'; 'a product of the greed for easy profit'; 'monstrous and sacrilegious'; 'a Hollywood setting' adopted by the Greeks themselves.

The forthcoming Olympic Games were foreseen to become a game of public relations and personal promotion, a market of athletic ideals, a circus. The paradox of the fake construction trying to 'retouch' the authentic stadium was repeatedly stressed. It must be noted, though, that the stadium is not ancient, although in many people's minds it is, maybe because it is situated in the place where the ancient one was, or because it looks ancient. Many Greeks expressed the view that, instead of trying to produce replicas, Greece should rather look after the auth-entic products of its civilization. At the same time it was suggested with bitterness that this construction was the gloss which aimed to mask all the things Athenians are ashamed of, foremost among them the sorry state of the city of Athens. Others viewed it as one of the disastrous effects of globalization:

> Antiquities, too, demand respect . . . rather than putting make-up on them so shamelessly, it would be better to leave them to what time does to them. Time is merciless, but it will still look after them better. It will not violate them. Because what is happening here now, without shame, is something like a libation to the globalized taste. The leveled taste, which is the result of the aesthetics of the restaurant owner in Hong Kong, the caretaker in Marseilles, the hairdresser in Sri Lanka, the taxi driver in LA, the receptionist in Beijing. Aesthetics under the direction of CNN . . . [The organizers of the ceremony] admit with an unanswerable lowness that the way the Kallimarmaro[8] stadium looked could not 'sell'. For the foreign TV to be interested, they said, 'magnets' were needed, an 'imagery intervention' was needed (*Καθημερινή*, 23/7/97).

The act of adding the artificial gate on the 'authentic' site is perceived here as a violation: it is imposing a foreign body on the site, transgressing

its identity. This is a belief reminiscent of the one arguing that form is the mirror of the soul. The fake gate, like the Coca-Cola bottles replacing the columns of the Parthenon, is believed to have the power to transform the ancient spirit and everything that this represents. This idea comes up again in a later issue of *Καθημερινή* (1/8/97), where another journalist laments the departed, real, ancient glory:

> Late tonight, when the last spectator leaves the Kallimarmaro, the Discus thrower[9] will be there, alone, to recollect the years of his real, and not his television, glory. And we, his descendants, with our eyes turned toward the Olympic stadium, we will be enjoying the athletes' efforts, trying perhaps to imagine them stripped of the tunics of advertising.

Many described the gate, as well as the opening ceremony, as a Hollywood setting, reminiscent of movies such as *Ben Hur* and *Hercules*, reopening the discussion of the use/abuse of the monuments. A columnist under the pseudonym 'Paratiritis' writes in *Καθημερινή* (23/7/97):

> There is much ado about the use and the abuse of monuments. And while the use or the abuse takes place for the indigenous or for living people, like the performances of ancient tragedies or musical performances, it is fine. Now, however, we have to deal with an international television show. An overproduction of a Hollywood type which will be transmitted to millions of people all over the world . . . So can we use monuments as a [performance] setting? . . . We live in the era of settings, of virtual reality . . . This is why all those who refer to the revival of the Olympic spirit either consider *us* stupid or they cannot suggest that *they* are famous for their intellectual abilities. In simple words they are all . . . actors.

It becomes obvious that we are coming across a series of oppositions which derive from the comparison between the two cultures, the local 'original' and the global 'commodified' reproduction. On the one hand appears the American, 'glossy, rich and powerful' and on the other the Greek, 'plain and simple'. The American reproduction of the Olympic Games for example was considered as only hiding its fakeness behind demonstrations of affluence and luxury, while the Greek was thought to possess the authentic already. To the power of the US linked with material growth, Greece was seen to respond with the power of the spirit. Following a strategy similar to that of religion, which promises another level where power can be defeated, the juxtaposition between

material riches and the power of 'spirit' manages to subvert the normal rules of power. The material riches associated with capitalism and commodification become irrelevant compared to the power of spirit, and poverty becomes an asset.

The term πνεύμα (spirit) in Greek, apart from religious meanings, can also have intellectual and cultural connotations. Therefore, praising 'the spirit' of the Acropolis or the Olympic Games is praising both the intellectual as well as the Greek cultural force which gave them form. This spirit, usually coined as 'Το Ελληνικό πνεύμα' (the Greek spirit), is no other than the Greek *Volksgeist*, which carries intellectual, cultural and religious connotations.

The driving force behind the dynamics of 'keeping while giving' is, for Weiner (1985), the 'hau', the spirit which resides in things and defines their inalienability. Weiner writes (ibid.: 223):

> Mauss was correct: 'The thing given is not inert. It is alive and often personified' (1954: 10). For *taonga* are to some extent parts of persons in the sense that they are the material document of its owner's past and are themselves the carriers of the hau. The stone and cloth valuables believed to contain the same life force, the hau, as do humans, are not only the agents of individuals, but through their collective histories, the valuables become the proof of a group's immortality. To lose a taonga forever is a material admission of one's own mortality and a sign of the weakening of a tribe's identity and power.

Inalienable wealth for Weiner is a concept not restricted to the 'taonga' of the Maori. It can appear in the Western or Eastern world, in the developing or developed societies. The 'hau' on the other hand is a quality of objects, such as the Australian Aboriginal tjurunga boards and Maori feather cloaks, as well as the British crown jewels or the Parthenon marbles.

In the age of nationalism the romantic *Volksgeist*, the soul of a nation sought in various pieces of material culture, could be seen as a concept similar to that of the hau. Classical Greek heritage, the Parthenon marbles or the Olympic Games are all inalienable wealth and conveyors of the 'Greek spirit', defining it in a historical sense. Greek antiquities thus serve as a means for bringing the past into the present and for establishing the status of Greek identity within the international ranking. Getting back the contested Greek heritage is, to use Weiner's words, 'attesting to one's power to hold oneself or one's group intact. For to give up these objects is to lose one's claim to the past as a working

part of one's identity in the present'. In the search for national distinction, for national authenticity and for signs representing the very Greek soul, any appropriation of classical Greek antiquities by foreign agents can only be seen as a distortion and an abuse of the essence of national treasures.

From the Saloon to the Herodeion: Blue Jeans and Classical Heritage

So far I have examined some cases where Greek inalienable wealth was felt to be expatriated and deterritorialized by foreign institutions, as in the examples of the Coca-Cola advertisement and the hosting of the Olympic Games in Atlanta. Contestation of Greek inalienable wealth by the forces of globalization, however, can be felt even in cases where it has not been literally moved away from the Greek territory. Here, I intend to discuss such a case.

Every summer the Athens festival takes place and fuels discussions as to what cultural events are considered suitable to be staged in ancient theatres. The idea of a festival reviving the ancient Greek theatres originated in the early 1950s and gradually developed into a grand cultural event hosting Greek and non-Greek artists under the auspices of the Greek Tourist Organization. Herodeion, a theatre of Roman times named after its sponsor Herodes Atticus, lies on the south foot of the Acropolis hill and is the main ancient theatre inside Athens that stages these cultural events.

In the summer of 1998 the company of the American fashion designer Calvin Klein (hereafter CK) requested to present a new jeans series in a show of 'artistic character' involving music and dancing. The receipts from the performance would be donated for the building of the new Acropolis Museum (*Καθημερινή*, 18/8/98). The request, like all requests, reached the Central Archaeological Council (hereafter CAC), but was rejected. The issue was forwarded to the Minister of Culture in order to sign off the rejection. Although the minister normally agrees with the CAC, this time he disagreed.

The possibility of a fashion show at the Herodeion fuelled several public and private discussions (Figure 5.9). Although the Herodeion is a Roman and not a Greek classical theatre, its vicinity to the Acropolis gives it an importance which other Roman sites or antiquities do not enjoy in Greece. This was another example of a non-Greek company attempting to use Greek wealth for its own interests and for economic profit. Many felt that such a performance would be an atrocity against the ideals

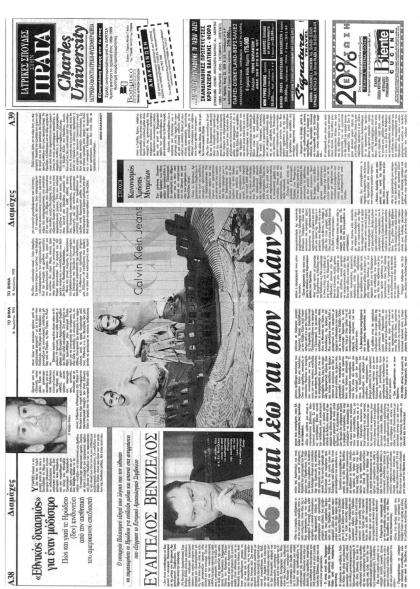

Figure 5.9 A newspaper article (*Το Βήμα της Κυριακής*, 16/8/98) discussing the impending Calvin Klein show in Herodeion.

that the site represents, a sign of the corruption that the bourgeois world brought about (Καθημερινή, 18/8/98). Others thought that a bad start would be made and all fashion designers would start asking to stage their fashion shows at the Herodeion. The show was meant to mainly concentrate on the new jeans collection of CK. However, as the CK underwear had become very trendy in Greece at that time, soon many started associating the planned show with an underwear fashion performance, shameful and improper for the site of the Herodeion. Others, on the other hand, felt that such a reaction was undue and typical of those 'who suffer from an arterio-sclerotic conservatism and a pompous provincialism' (Καθημερινή, 16/8/98). It was argued that such an attitude was indicative of the 'confusion between culture and tourism which led the festivals in populist choices shutting out the new, the imaginative, the experimental as non-profitable' (ibid.). In fact some remembered that a year earlier the Greeks had allowed the staging of a concert by a popular Greek singer in the Herodeion thus transforming the site into a 'bouzouki place'. Therefore they believed that the fury against the idea of transforming the Herodeion into a catwalk was at least hypocritical (ibid.).

If in the case of the Parthenon marbles or the Olympic Games it was felt that a stolen property had to be restored, in the case of CK it was felt that the Greeks had to protect their cultural dignity against a new 'intrusion' that was about to take place. Only this time it was taking place under the blessing of the Greek state. In the previous section, I discussed the spirit of the nation as embodied in Greek heritage. This same spirit, however, is also thought to reside in sites which are therefore considered as 'sacred' (see Chapter 6). The idea behind staging cultural events in ancient Greek theatres was to revive this spirit, which was served by performances of classical or other recognized forms of art. No matter how spectacular such performances are, they still manage to project the ancient site without overshadowing it, because they are aligned with the ideals that it represents. In contrast, the character of the flashy fashion show of CK was not considered compatible with a site which requires modesty and respect for the ancient spirit. The show threatened to introduce the reproducible world of commodities into a site which praises the original and the unique, and to transform it into a medium in the hands of another protagonist, namely CK and his products. Fashion shows, it was argued, were not art but advertising of commodities.

It is revealing that even the Greek minister of culture, who argued that fashion is an art form and that 'fashion is one of the definitive features of aesthetics and of everyday culture (πολιτισμός)', actually

backed this decision to disagree with the CAC on the basis that Klein's proposal was not an *'ordinary* fashion show', thus implicitly agreeing with the opinion that fashion is not really art. On the contrary, he said, it was 'a complex spectacle with *original* choreography, *original* music and, I imagine, of aesthetic interest, *respecting* the rules of the site's use' (emphasis added). As an answer to those who detested the idea of a product advertising at the Herodeion he argued that:

> Most of the times various music, theatrical or dance performances in monuments are directly linked with the projection of artistic products of new record producers, new movies, new theatrical schemes, or with the projection of art perceptions, or people yielding in their turn an important surplus value.

All those who protested against that event had turned to the rhetoric about the sacredness of ancient sites and heritage. They also felt from Greek Orthodoxy that once sites become sacred, they can never be deconsecrated again. Now, however, the Greek state itself was attempting to secularize the site of the Herodeion through a 'degrading performance'. Degrading, not only because of the 'polluting' and 'frivolous' connotations of the half-naked bodies of fashion shows, but also because of the shows' tendency to transform everything but the products into a décor, a background for the advertisement of an enterprise with commercial ends. CK represented for many the same forces as Coca-Cola, i.e. the American hegemony and the power of the giant and commodification, which tend to devour the culturally unique.

Nikos Mouzelis, professor of sociology at the London School of Economics, argued that the use of the Herodeion by the Klein company was 'a loud example of the colonization of "the artistic" by "the commercial"', a case in which the economic capital does not simply buy cultural capital, but a case in which the ultimate aim is to accumulate economic rather than cultural capital. He writes (*To Βήμα*, 23/8/98):

> When companies, such as Klein, Cartier or Toyota go beyond sponsorship, aiming at the transformation of the artistic advertising into 'high art', then the already frail autonomy of cultural space is totally destroyed. Then, from the advertising pornography (in which, by the way, Calvin Klein has a spectacular performance) up to the 'conscription' of artistic celebrities, the use of television and the mass media, all means lie in the service of the sales promotion. Then, in the bottom line, the world of art and civilization becomes in practice a huge syncretic mosaic where

everything is levelled and where the only common denominator, the only link is the market mechanism.

I would like to end this section with the words of the Greek historian Andonis Liakos, who foresees the danger of the 'gigantic' eliminating the personal evocations and readings of a monument and levelling its identity (*To Βήμα*, 23/8/98):

> Monuments are tangible, but everyone sees them and perceives them through his or her imagination. And this imagination is fed by several sources, among which are of course the national education and its symbolisms, but also the personal experience and the individual readings . . . The new era, the new cultural industry is characterized by the giantized image and the monopolization of the imaginative [φαντασιακό]. A monument, any monument, landscape or event, is a dwarf devoured by the giant-company. Its image becomes an element of another image. It is inscribed in its style and acquires its nuances. It enters the imaginative exactly through this style, through this industrially produced image. If Coca-Cola made an advertisement on the Parthenon, its restoration's economic problems would certainly be solved. We would certainly win the public opinion for the return of the marbles. Greek tourism would definitely gain from the gigantic and priceless project. I would not want, however, to think of the Parthenon, or of any other monument inside or outside Greece, as the background of an advertisement, such as the rocks of Monument Valley as the background of Marlborough, the Eskimos as people of Fujitsu and so on. Also, I don't care whether the Herodeion was built by Greeks or Romans, and therefore is a first or second quality monument. There are heavy and light uses of monuments and this has to do with the power of the users to monopolize the imaginative or not. It does not have to do with whether the uses are the traditional ones of high culture or the postmodern ones of mass culture. The question is whether the individual autonomy in the conceptualization of monuments is threatened. The imaginative is not air. If it has a price in the market, and indeed a high one, this does not mean that we should sell it.

Tourism in Greece: The 'Double-decker' and the Fate of the Acropolis

My intention here is not to undertake an 'anthropology of Greek tourism'. This would need many more pages and extended fieldwork

on this issue. I believe, however, that in a discussion concerning the commodification of Greek heritage, the issue of tourism should not be overlooked.[10] Moreover, tourism is a meeting point of the local with the global, a sphere where the local directly experiences the local-global relationship through the immediate and personal contact of the local people with the tourists, a 'contact-zone' and a 'site of identity-making and transculturation' (Clifford 1997).

Mass tourism appeared in Greece after the Second World War. Konstandinos Karamanlis, during his term as minister of public works (1950–52, 1954–55), minister of transportation (1953–54) and as prime minister (1955–1963), became engaged in the application of an economic development scheme which also involved infrastructure works for the attraction of more tourism. Despite its economic orientation, in its first years Greek tourism was conceptualized in a romantic and idealistic way and followed the desire to project Greek cultural capital. The ancient Greek spirit was to be revived, and with it the idea of φιλοξενία – 'the age-old Greek hospitality'. The Greeks undertook the role of the hosts who also had the responsibility to introduce the foreign pilgrims to both past and present Hellenism. The Greek Tourist Organization (hereafter GTO) was established in this spirit in 1950. As part of the infrastructure which was created for the materialization of this project, the foundation of the 'School of Guides' staffed with the offspring of 'the best' (upper-middle-class) Athenian families took place. The 'educational experience' of travellers to Greece thus passed into the hands of professionals who were trained for that mission.

In its realization, however, this enterprise was not always met with enthusiasm. Many described Karamanlis' 'modernizing' period with the darkest colours. For example, two art magazines, Ζυγός and Επιθετρηση Τέχνης repeatedly sounded a note of warning as early as the 1950s. They believed that the development which 'modernization' involved knew no bounds and that it had destructive effects on the landscape and the archaeological sites (Ζυγός, Δ 1958–59, 43–4: 4; Επιθετρηση Τέχνης, ΚΑ (1965) 121–6). Tourism was seen as an orgiastic activity humiliating Greek heritage, which had become victim to exploitation and self-interests (Ζυγός 1957–58: 14). The GTO itself often became a target of bitter criticism since its inception. One issue of Ζυγός (Δ 1958–59, 41: 4) levels strong criticism against 'the servility' that the GTO displays toward foreign tourists at the expense of ancient as well as of modern Greek sites. It accuses the 'aesthetes' of the GTO, who every now and then compose directives and send them off to the various ministries:

'The shoeblacks must leave from Amalia Avenue!' And the very nice toilers for a living, who not only didn't disturb anybody, indigenous or foreign, but they were also a picturesque note on the city's life, took their well-shined and spotlessly clean cases and disappeared. A while later, the enterprisers of GTO took it out on the chestnut-sellers, and lately they turned their fire against whom? . . . The marble carvers of Alexandra's Avenue! 'The marble-workshops must go', they cry. 'It is embarassing, the foreigners see them'. You see, it is fashionable to weigh and estimate everything according to the 'tourist' interest. Is it comfort the foreigner wants? We gladly build a hotel inside the archaeological site of Sounio for him. Does the foreigner get tired walking up to the Acropolis? Let us put up a lift for him. Does the tourist want streets to walk on around the antiquities? Let us dig up Castalia and let us open up streets in Delphi.[11] How many, however, of the travellers who visit us have the attitude that the GTO wants to impose on us? How many want a lift to get to the Parthenon? How many look for a rock-n-roll floor after their visit to Sounio? How many are those who will not prefer the grandiose view of Delphi in order not to be deprived of their limousine's comfort? And how many are those who do not perceive that inside the 'inelegant' workshops of the marble carvers, those which the GTO wants so fervently to demolish, resides the flame of a national tradition out of which Pheidiases [Φειδίες], Halepases [Χαλεπάδες], and the whole of Kerameikos originated.[12] We believe that the foreigners who belong to that category are a negligible quantity. They are the spoiled ones and the uncivil ones. We also think that a foreigner who is cultivated and has taste will be more disturbed by the horrific façades of certain central buildings or from the various kiosks selling 'souvenirs', which have appeared under the blessing of the GTO outside every archaeological site, even on the Acropolis, rather than from the humble, invisible workshops of the marble-carvers in Alexandra's Avenue. But even if this is not the case and if the GTO is right, is it right to expropriate our consciousness, our history, and our traditions for some thousands of dollars? What is our ideal then? To become a people of bellboys and valets? Because following such a tactic, having such people governing us, this is where we will inevitably end . . .

The fear of exploitation by foreigners and the 'Greek servility' which might lead the Greeks to renounce their cultural identity is something that has been preoccupying Greeks until today and has found its expression in statements like that of the ex-minister of culture Melina Merkouri: when she became minister of culture in 1981, and while announcing

her intentions to contribute toward Greece's keeping of its cultural uniqueness, she declared that 'the Greeks will not become the waiters of Europe'.[13] As already mentioned, since its very beginning as a nation-state, Greece has felt a direct foreign interference, both in its political system and its life, often conceived as 'foreign hegemony'. In the text quoted above the general rhetoric about this unbalanced relationship is reflected in the haste the GTO displayed to transform and to adjust the Greek living space to the needs and expectations of foreign visitors.[14]

Until the 1950s tourism in Greece had been mainly 'cultural', consisting of 'travellers' continuing, in a way, the tradition of the eighteenth and nineteenth centuries. Their voyages to Greece were more like 'pilgrimages', paying homage to the countries that 'gave birth to civilization'. That elitist character of travelling fitted more with the concept of ancient Greek heritage as a unique, irreplaceable and irreproducible work of art. It also served the circulation of the fame of Greek heritage, while it kept it attached to its land of origin and not easily accessible to the masses. By contrast, the idea of mass consumption as represented by mass tourism contradicts the 'impregnable uniqueness' of archaeological sites. It makes them prey to 'the tourist gaze' (Urry 1990). As Walter Benjamin says (1992 [1955]: 232), 'The greatly increased mass of participants has produced a change in the mode of participation. Distraction and concentration form polar opposites, which may be stated as follows: a man who concentrates before a work of art is absorbed by it . . . In contrast, the distracted mass absorbs the work of art'. A common bitter joke between Greek tourist guides is what by now has become a slogan: 'It is Tuesday, so we are in Athens' (see also Graburn 1989: 21). It refers to their experience of tourists realizing where they are because of the timetable which they have been given by the agent. Mass tourism transforms monuments from being privileged sites to being parts of an itinerary routine. It makes them 'easy'. It is not the tourists who have to go through difficulties and sacrifices in order to reach the sites any more. On the contrary, the sites must be adjusted to the needs of the tourists.

The writer of the text quoted above complaining about the ill effects of tourism could not have expected the dimensions tourism was destined to acquire in Greece. Especially after the colonels' dictatorship (1967–1974), mass-tourism went out of control and got drawn into the vortex of the international market and international economic interests. Today, big international tour operators tend to eliminate the Greek operators, and tourism slips more and more from Greek hands. The

Greeks, rather than being hosts, now experience themselves as becoming subjected to the logic of 'globalization', often perceived as a 'market hegemony', and they feel that those who once were 'guests' have simply become 'customers', and the educational tours commodities for consumption.

Leontis (1995: 46) has mentioned the complaints expressed by Western travellers about '[mass] tourism as a phenomenon incongruous with the sacredness of the Acropolis', which does not allow them 'to see Hellas through Plato's eyes'. For them, mass tourism disrupts aesthetic appreciation of the Acropolis. In Greece, however, mass tourism today is often perceived as a threat to the local Greek identity and it is often accused of distorting the landscape, the history, and the people. I quote the words of Mihalis Tiverios, professor of archaeology (*To Βήμα*, 7/9/97), who refers to the inefficiency of the Greek tourist policy and expresses his fears that the 'national industry' might turn out to be a boomerang for the Greek national identity:

> Let those in charge mention in their annual report – apart from the amount of the foreign currency that poured into Greece, and the other economic profits that our tourist policy produced – also the extent of the maltreatment of the Greek landscape and the adulteration of the people of this country which took place because of it, how violently our history, our aesthetics and our pride have been injured, how much our manners and customs have been alienated and how much less Greek we have become.

The reaction to mass tourism as an aspect of globalization is not confined solely to statements and aphorisms by political figures, such as Melina Merkouri or the Archbishop of Greece Christodoulos (Figures 5.10 and 5.11). A 6th GR student expressed her strong complaints about the Acropolis 'being insulted' by the fact that, 'when you visit the Acropolis, which is a Greek place, all labels giving information about the monuments are written in English and not in Greek'.[15] This is how the student experiences the rhetoric about the unequal relationship between Greece and 'the world'.

According to Greek tourist guides and archaeologists, when tourists visit the Acropolis they repeatedly ask why there isn't any escalator to facilitate the ascent to and the descent from the archaeological site. The reaction of both Greek tourist guides and archaeologists to such a request is strong:

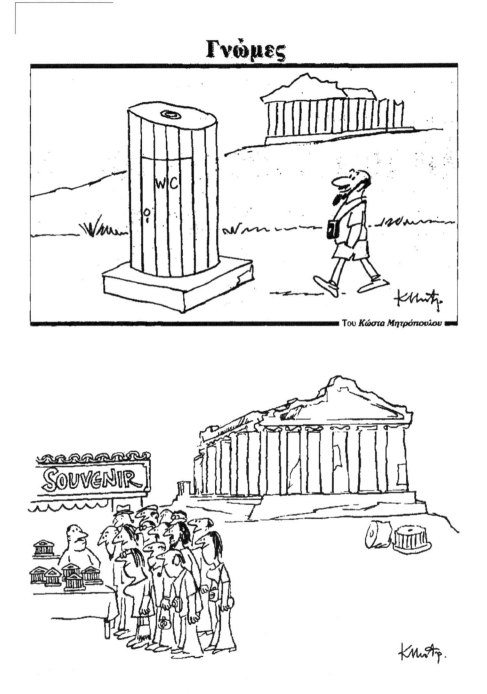

Figure 5.10 Cartoons by Mitropoulos, criticizing the ill effects of mass tourism. (source: Mitropoulos).

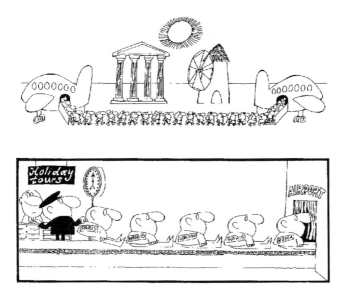

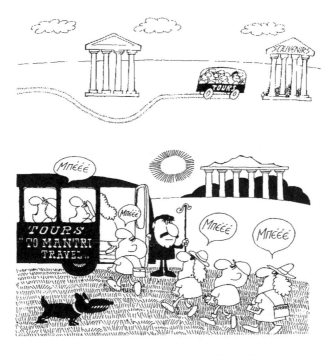

Figure 5.11 Cartoons by KYR, criticizing the levelling effects of mass tourism. In the last cartoon tourists are represented as sheep, baaing, and led by the tourist guide/shepherd into a tourist bus labelled *To Μαντρι* (The sheepfold) (source: KYR).

> When will they realize that ascending to the Acropolis hill is not like visiting a supermarket? This is the essential difference between a traveller-pilgrim and a tourist. The first one knows that visiting the Acropolis is a process. The second one wants to reach the top with the least effort and sacrifice. The Acropolis, however, *does* require effort (archaeologist) (emphasis in the original).

Greek tourist guides also complain that, while 'travellers' used to come with the desire to *discover* Greek culture, 'tourists' come and go without really having left their country at all, as they do not bother to understand or to even feel a reality different than theirs. As a tourist guide said:

> They take nothing else back home but photos which they then show to their friends and relatives. In the same way as they demonstrate their new video camera they display the places they have visited. This is what *I* call consumption (emphasis in the original).

The 'consumption' of sites such as the Acropolis is seen in a metaphorical way as a consequence of the giganticness of mass tourism, which 'swallows up' cultural uniqueness. Consumption, however, can also be literal: especially during the high season, when sites such as the Acropolis are unbearably crowded, the monuments become worn out and endangered. This is how an archaeologist commented on the wearing-out of the monuments by the thousands of tourists who step on them:

> This place [the archaeological site of the Acropolis] was made for a specific reason. The fact that we change its function as time passes by does not mean that the place can withstand it. When I worked in Olympia, I was allocated the job to see what the condition of the temple of Hera is. Well, the doorstep had lost four centimetres. This means that if you leave the temple open to the tourists you do not serve its function, i.e. you do not make it known to people. You consume it in its most literal sense. You devour it, you swallow it up. In some years there will be no temple. And I do not know whether our interest in letting people [ironically] see it and all these nice things counts more than it being there for my grand-children to see. The monument will not be there when it is trampled. It will not be there physically. What I can do is to constrain it, to close it, to make it difficult, to lose money if I have to. Yes, it does sound elitist, but it does not matter. I am sorry.

What is thus clear from the above is that tourism is directly involved in the paradoxical relationship of local and global Hellenism as discussed

in Chapter 4: as we have already seen, the projection of the global character of Greek heritage entails the danger of negating its local uniqueness. In a similar way, tourism on the one hand accomplishes the 'national mission' of promoting Greek heritage internationally, while on the other it puts Greek heritage in danger through exposing it to global consumption. The only way out of this paradox is to develop a discourse which allows the reconciliation and the co-existence of the local and the global. Hence the distinction between travellers and tourists, travelling as pilgrimage and travelling as consumption. Such a distinction permits the existence of tourism as long as it is practiced by 'travellers' seeking cultural uniqueness, rather than by 'tourists' destroying it.

In Chapter 4, I situated the Greek discourse about Greek classical heritage in the framework of the relationship between the global and the local. In this chapter, I discussed further this relationship by examining how features considered 'typical' of globalization, such as homogenization, mass consumption and commodification, are incorporated in this local-global negotiation. Mass production or consumption are juxtaposed with authenticity, commodification with inalienability, materialism with spirit. These contrasts, however, only stand as metaphors of the Greek versus foreign contestation and they serve the projection of the uniqueness of Greek identity. Issues such as the importance of the spirit against materiality, the disdain of money and of individual interests, the search for the real against the fake, and the efforts for classical antiquity's resurrection, create a kind of aesthetics which seems pervaded by a Christian ethic. As a response to commodification and mass consumption, the Greeks project the 'sacredness' of archaeological sites. This is the question I will try to explore further in the Chapter 6.

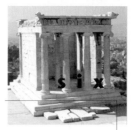

The Aesthetics of Sacredness

Introduction

> Respectable governor! . . . I dedicate to this museum the two statues which
> I discovered on my island's soil. As soon as I found them I transferred
> them to my house and I not only safeguarded them like the apples of
> my eyes, but in my enthusiasm I even incensed them [τα εθυμίαζον].
>
> (Levantis Oikonomos, quoted in Πρωτοψάλτης 1967: 126–7)

The above text, written in December 1829, is addressed to Kapodistrias,
the first governor of Greece, by a man from the island of Egina (the
first capital of Greece). The writer goes on in his letter explaining that,
although several travellers asked him for the statues and offered him
respectable amounts of money and promised to send one of his sons
to study in Europe at their own expense, he did not bear to give away
these national heirlooms. Instead, he waited until his Nation was in
good hands and 'headed back to its former glory' in order to hand his
valuable possessions over to the 'respectable' government, asking only
for its favour in return. Incensing religious icons is a common practice
in the Orthodox Church, performed either by priests in church or wor-
shippers at home. Regardless of whether the writer of the above letter
genuinely felt like incensing the ancient statues or whether that was
an official ideology that he reproduced in his letter in his eagerness to
gain the favour of the governor, in one way or another this religious
practice is nonetheless applied to the (pagan) statues here.

As early as the beginning of the nineteenth century classical antiquities
became sacred symbols of the Greek nation. Official rhetoric often describes
them as 'sacred heirlooms of antiquity', and the Athenian Acropolis,
the ultimate specimen of classical antiquity, is today known in Greece
as the 'sacred rock'. Various authors have pointed out the similarities
between nationalist imagining and religious ideology (e.g. Herzfeld 1992:

137

34–9; Kapferer 1988; Eriksen 1993: 107–8; Gellner 1983: 56), and national heritage has been seen as built on the prerogative of a certain faith functioning in similar ways to religious beliefs (Lowenthal 1998: 1–2). Anderson (1991: 12) has underlined the need to consider both religion and nationalism as cultural systems, the latter following the former. He suggests that the dawn of nationalist ideology in eighteenth century Europe coincided with the dusk of religious systems of thought. The new group identity, the 'imagined community of the nation', had to absorb and incorporate many religious concepts and ritual practices. Drawing on Anderson's argument, it has been discussed elsewhere (Hamilakis and Yalouri 1999) how classical antiquities, being considered national heirlooms, have acquired religious connotations since the establishment of the Greek state. There, we have also explored the ways in which – with the establishment of the Greek state – Greek nationalism followed and incorporated many elements of Orthodoxy. The sacredness of antiquities has emerged in different contexts throughout this book. In Chapter 5 we saw how the idea of the sacredness of antiquities arose as a reaction to their commodification and the appropriation of Greek heritage by 'the others'. In this chapter, I will explore further the nature of this concept of 'sacredness' with which the Acropolis has been attributed, and will discuss the ways in which people perceive it, make use of it, and reproduce it. My aim is to demonstrate how this sacredness is enmeshed with other social values and how, together with consideration of the Acropolis as a work of 'high art', it constitutes a certain aesthetic: the aesthetic of sacredness.

Greek Syncretism

Orthodoxy is the official religion of the Greek state (Greek Constitution of 1975, Article 3). Church and state lend authority to each other.[1] Their close relationship is also evidenced by the fact that two important celebrations of the Greek Orthodox Church, namely the Annunciation of the Virgin (25 March) and the Dormition of the Virgin (15 August) are also significant celebrations of the Greek state. The first one is the day on which Greeks celebrate the beginning of the War of Independence in 1821, and the second is the day honouring the Greek Military Forces. Another striking piece of evidence for the connection between religious and political sentiments is the *Akathistos Hymn* (Ακάθιστος Ύμνος), sung in honour of the Virgin by a standing congregation every Friday from the seventh to the third Friday before Easter. It is a recollection of the all-night vigil during which, according to tradition,

the hymn was first sung in thanksgiving for the protection against the Avar siege of Constantinople in AD 626. This hymn, apart from its religious character, also has a triumphal political side. The joint celebration of religion and the nation is not coincidental. It alludes to the difficult moments in which, according to Greek tradition, the Virgin has intervened to help the Greek nation from Byzantine times until today (cf. *Καθημερινή*, 18/8/96). Thus the Virgin Mary (Παναγία), the mother of Jesus, becomes the mother of the Greek nation (το γένος), coming to its aid in its hour of need.

As mentioned in Chapter 1, Herzfeld (1987: 111) has described Greek identity as consisting of two parallel sets of representations – that of classical Hellenism and that of Byzantine Christian Orthodoxy. The oscillation between these two parallel traditions he termed 'disemia'. Stewart (1994) has explored this disemia and the synthesis of these two facets of the Greek national identity under the lens of syncretism, the synthesis of two different religions. He notes that, in the beginning, the Church found it very difficult to accept that its congregation, the contemporary Greeks, had affinities with their pagan polytheistic ancestors. However, he also finds that 'with the passage of time many of these local practices simply became naturalised as parts of the accepted Christian tradition of a particular place, region or country' (1994: 134).

As mentioned in Chapter 4, in Byzantine and Ottoman periods the Greek name for Greeks, 'Έλληνες', was connected to a large extent with paganism. 'Ελληνικά' (the 'Hellenic' language) was the ancient Greek language and 'Ελληνικό' (Hellenic) was also the name of sites with ruins or ancient graves (Κακριδής 1989: 41ff). Some intellectuals had advocated adopting the names Hellenes for modern Greeks, but these names were not prevalent. Such names as Graecos, Graecia and Romios dominated (Πολίτης 1993).

After the declaration of the autocephaly (administrative independence) of the Church of the Greek state from the Patriarchate of Constantinople, however, 'the church of Greece spearheaded all nationalist initiatives in the later part of the nineteenth and throughout the twentieth century' (Kitromilides 1989: 166). Today it plays a leading part as the guardian of the Greek national interests, together with the state (Figures 6.1, 6.2).[2]

The ambivalence of a Christian Orthodox nation embracing the ideals of a pagan past was overcome through the finding of 'survivals'. This process was undertaken by Greek folklorists, especially Nikolaos Politis, the founder of the discipline of folklore studies in Greece and the first folklore professor, and was meant to reconcile these two originally

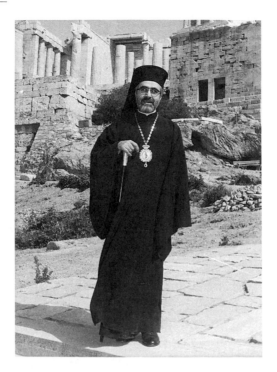

Figure 6.1 The Archbishop of the Greek Orthodox Church of North America, Iakovos, visiting the Acropolis (source: Megaloconomou archive).

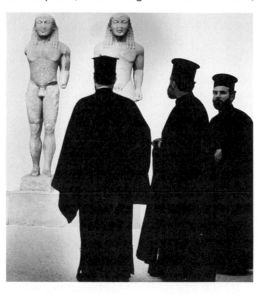

Figure 6.2 Three priests in front of the statues of Dioskouroi at the museum of Delphi (source: N. Kontos).

conflicting aspects in Greek national identity (Herzfeld 1982a). As Herzfeld has noted (ibid.: 104), 'Politis was revising Tylor's use of survivals – which referred to retentions from primitive phases of human evolutionary development – and refashioning it to suit the Greek situation where the survivals were relics from highly developed ancient forebears' (ibid.: 102ff).

According to that logic, the two pillars of Greek identity, the Parthenon and St Sophia, did not express two contradicting ideologies. On the contrary, they were considered products of the same spirit, conveyed by a uniform and homogeneous nation throughout centuries, and could therefore appear close together when it came to the definition of Greekness. The nineteenth century historian Konstandinos Paparrigopoulos, who tried to bridge the gap between ancient and modern Greece by projecting the importance of the Byzantine period, considered St Sophia as a 'half-brother of the Parthenon'. He wrote: '. . . is the Parthenon anything else than the national temple of the divine wisdom? Maybe the art of Anthemios and Isidoros was different from that of Iktinos,[3] but the impression they both evoked is the same' (Δημαράς 1970: 146). For Paparrigopoulos, St Sophia stands for the missing link of Byzantium in a chain of continuity comprising the timeless Glory of the Greek nation. A few years later Periklis Yannopoulos, in his quest to prove the cultural continuity of Hellenism, writes: 'In the domes of temples the head of Zeus dominates; Zeus and the young Pantocrator have in essence one [and the same] head. The Virgin Mary is a blood sister of the ancient Greek marble goddesses' (Γιαννόπουλος 1938 [1902]: 77).[4] Even today, the Parthenon and St Sophia appear as two features of Greek identity, equally meaningful, interconnected, and widely recognized.

In his inaugural lecture in April 1998, the new archbishop of Athens and of all Greece, Christodoulos, called Mount Athos – a monastic society intimately linked with the history and the meaning of Orthodoxy – 'the Acropolis of our Orthodox Faith'. On the same occasion, he emphasized the interrelation of classical antiquity and Orthodoxy:

In the same way as it is inconceivable that a young Greek might complete his or her general education without learning which metaphysics gave birth to the Parthenon and the ancient Greek democracy, it is equally inconceivable that he or she might not know which theology built St Sophia . . . With its loaded ancient history, Athens, conveyor of a world with a universal range, was renowned both as a city and as a spirit. Its Parthenon, a work of faith of its, in all respects, pious[5] inhabitants, remained a specimen of genuine devoutness of our ancestors throughout

the centuries. It is the same Parthenon, the ecumenical symbol of our city's civilization, that remained a converted temple of the Virgin of Athens [Παναγία Αθηνίττισα] for a thousand years when the new faith followed the old one, continuing the worship of the real God inside the same building, the structure of which it respected. It continues to be a universal and unique object of respect for all humankind until today and until the end of the world.

Orthodoxy comes out as a specific distinction of Greek identity and together with classical antiquity defines Greekness today. The syncretism of Orthodoxy and classicism, however, does not simply remain on the level of an official discourse. On the contrary, it becomes accommodated in people's attitudes. It is translated into an embodied practice. The concept of 'sacredness', a term referring as much to churches as to classical ancient sites such as the Acropolis, is one that serves this end. Through the concept of sacredness, religious and nationalist connotations fuse the two facets of Greek identity. But how has this sacredness been validated by people who follow the Christian traditions and how is it expressed?

'Worshipping' the Acropolis

In her book about modern Greek votives (τάματα), the architect Καρδαμίτση-Αδάμη (n.d.: 22) presents two such votives depicting the Parthenon (see Figure 6.3). As she notes, 'obviously, the faithful did not offer the votive of the Parthenon as part of a request to obtain it. It is very likely that it is a votive of some immigrant, symbolizing his return home, or it might have been made during the period of the German occupation and might symbolize the liberation of Athens, or it might remind the faithful of some event that took place in this site'.[6] Whatever this votive is meant to provide to the faithful, it does remain a materialization of Greek identity's syncretism. Except that here it is no deliberate intellectual association of classicism and Orthodoxy, but a genuine expression of a personalized and internalized idea of the way the two facets of Greek identity are bound in one.

Several case studies have demonstrated how the sacred places of the past retain their cultural and religious significance and how they become incorporated in new religions or cultural systems and beliefs. Cooney (1994), for example, argued in his study of Neolithic tombs in Ireland that some of them have continued to be the focus of burials. They have become accommodated in folk beliefs and have retained

Figure 6.3 A modern Greek votive (τάμα) depicting the Pathenon (source: Nikos Papageorgiou collection. Photo by Stephanos Alexandrou).

their cultural significance. There are other examples, such as the temple of Athena in Syracuse (440–420 BC), which in the Christian era became a temple dedicated to the Madonna. The temple of Madonna con melograno (the Virgin with the pomegranate) in Paestum was built on a temple of a deity depicted holding a pomegranate.

In Greece several sacred sites have become naturalized as parts of the Christian tradition. Apart from all Palaeochristian basilicas built over or next to major ancient temples such as Olympia, Delphi or Dodona during the first years of the Christian era, there are also many examples of churches still celebrating mass today. To name just a few, consider the little church of Άγιος Νικόλαος (St Nicholas), the patron saint of seafarers, built on the foot of the hill where the temple of Poseidon (the ancient god of the sea) in Sounio lies, or Αγία Μονή, dedicated to the Virgin and built in Nafplio next to Canathus, the sacred ancient fountain where the goddess Hera used to bathe. In Athens, the little church of Άγιος Γιάννης της Κολόνας (St John of the Column) is built on an earlier temple dedicated to Ianiskos, a healer deity (Figure 6.4), while the temple of Hephaistos (Theseion) functioned for a long time as a church dedicated to St George.

Figure 6.4 The little church of Ἅγιος Γιάννης της Κολόνας (St John of the Column) in Athens. The Corinthian column belongs to an earlier temple dedicated to Ianiskos (photo by E. Yalouri).

The Acropolis' sacredness has been reproduced under different forms for centuries. Ever since ancient Greek gods were worshipped on the hill of the Acropolis, there has been a long tradition of the site being perceived as sacred. The Parthenon, first conceived as the temple of goddess Athena, became successively an Orthodox Christian church, a Roman Catholic church and, under the Ottoman Empire, a mosque (see Chapter 2). The small church of Zoodohos Pigi was founded in one of the caves of the south slope of the Acropolis hill next to the temple of Asklepios (the ancient god of healing) (Figure 6.5). The water of its fountain is still believed to have healing properties.

Figure 6.5 The small church of Zoodohos Pigi (source: Studio Kontos).

Hubert, discussing the reactions of indigenous peoples to the desecr-
ation of their sacred sites, attributes the difficulty archaeologists and
developers face in understanding these reactions to the fact that it is
possible within the Western Christian religion to deconsecrate sacred
sites. 'A church', she says, 'can be deconsecrated, by the carrying out
of rituals, so that it becomes a secular site, an ordinary building that can
then be used for any purpose' (Hubert 1994: 13–14). This is not the
case, however, for Orthodox Christianity (cf. Stewart 1998: 8–9). Once
a place is sacred it remains so and its sacredness cannot be undone.
Thus, the long tradition of the Acropolis as a site of cult is not erased
in people's minds and consciousness.

The site of the Acropolis itself is linked with miracles. Καμπούρογλου (1922: 83) recounts that during the War of Independence the olive tree next to the Erechtheion was burnt. During the following years, however, the tree revived, which was considered a miracle.[7] Among other miracles associated with the site of the Acropolis is that of a Turk who, after shooting an icon of the Virgin inside the Parthenon-Church, had his hand paralysed. In yet another one, a Turk died after attempting to open two big vestries on the walls of the temple, hoping that he would find a treasure (ibid.: 77). The most well-known legend associated with the Acropolis is that of the marbled princesses – the Caryatids of the Erechtheion – who were revived after the abduction of their sister by Lord Elgin, so that one could hear them lamenting every night for her loss (ibid.: 82). It is difficult to situate the exact periods of these legends' origin. Καμπούρογλου,[8] writing at the beginning of the twentieth century, had been exposed to the new ideology of the sacredness of ancient sites, and so probably have those who recounted the stories to him. Therefore, we cannot really distinguish to what extent these stories represent concepts of pre-revolutionary Orthodox people living around the Acropolis or modern Greeks, citizens of the capital of the new state. This in itself, however, reveals sacredness with which ancient sites are vested, representing a fusion of practices and perceptions related to these sites, and always adjusting to new sets of needs.

During my research in Greece, I encountered various examples of fusion between antiquity and modern religious beliefs and practices. An old Athenian, who has lived on the slopes of the Acropolis for all her life, was talking to me about her mother: 'Kira-Thodora was making the sign of the cross every time she went to the top of the Acropolis'. And she went on explaining:

> The Acropolis lives, it pulsates, it has spirit. It has sacredness, this is why they call it 'sacred rock'. This is why they constructed all these little churches on the slopes of the hill. Kira-Thodïra founded the little church of Zoodïhos Piyi. She took the icon of Zoodohos Piyi to the church and she left it there for 40 days . . . [She goes on explaining the customary procedure Kira-Thodora followed in order to consecrate the place].

Nobody knows whether Kira-Thodora decided to found the little church on the Acropolis hill because she considered it sacred or whether she considered the hill sacred because of all these little churches that already existed on the slope of the Acropolis. Also, one cannot know whether her perception of sacredness was the same as the perception of all those who live in Athens and who call the hill of the Acropolis 'sacred', some

of them without even knowing of the existence of the little churches. What is true, however, is that the site has been linked with cults of various periods and cultures, including that of the 'secular religion of nationalism' (Hamilakis and Yalouri 1999).

On a different occasion, I was present in a chat between a deeply religious lady and her gay son who was teasing her, for every time she moved into a new flat she would first have to make sure that she would have a view to the Acropolis. 'How come you, such a religious person, can be fascinated with a product of paganism?' he asked her. To that remark she replied promptly: 'The Parthenon accommodated the worship of both goddess Athena and Jesus' mother, as they both celebrated virginity'. 'Virginity' was the ideal that for her reconciliated paganistic and Christian ethic, and at the same time it provided her with a means to subtly comment on what she thought of as the 'dissolute' lifestyle of her son.

Yorgos, a geologist and owner of a small business, told me that he feels magic on the Acropolis. He likes to be at the site on Good Friday and to listen from up there to all the Athenian church bells ringing together. 'At that moment, I feel that the two civilizations [πολιτισμοί – the Byzantine and the ancient classical] meet', he said. Yorgos's perception of the Acropolis' sacredness, promoted also through education, mass media and state rhetoric to which he is exposed on an everyday basis, is, however, shaped through his very personal experiences of what the sacred means in relation to his religion. The sacredness of antiquity is internalized through the sacredness of Orthodoxy. It is a concept which manages to link two different 'civilizations' and create 'the magic' of a nation with a 'long, continuous history'.

After the War of Independence, there was a much wider awareness of the ancient world and its links with the contemporary, rebel Greek nation. This awareness among the intellectuals and politicians of the time, as well as among ordinary, uneducated people (Κακριδής 1981: 62), was the result of an interest in education as part of the wider reconstruction of the nation (see Κουλούρη 1988: 13–15). I do not believe, however, that education and the secular religion of nationalism divested the ancient Greek past from its miraculous connotations. If the pre-revolutionary image of the past wanted the Acropolis site linked with miracles and the Hellenes vested with supernatural powers, the situation did not change radically in the state period. The pre-revolutionary Hellenes/giants became accommodated in the ideology of the nation-state and they became metaphorical giants. Their gigantic physical qualities were replaced by a 'gigantic' cultural aura.

Visualizing the Acropolis

Another element linked with the construction of the Acropolis' sacredness is its aesthetic appreciation and its praise as a work of high art. The Acropolis is systematically praised for being the 'most outstanding architectural monument in the world', a 'masterpiece', 'the jewel not only of Athens, but of the whole of Greece', as 'adorning Greek history'. Even today, the Acropolis cannot be seen divested from its high artistic value. Walter Benjamin (1992 [1955]: 217–18) wrote:

> We know that the earliest art works originated in the service of a ritual – first the magical, then the religious kind. It is significant that the existence of the work of art with reference to its aura is never entirely separated from its ritual function. In other words, the unique value of the 'authentic' work of art has its basis in ritual, the location of its original use value. This ritualistic basis, however remote, is still recognizable as secularised ritual, even in the most profane forms of the cult of beauty.

Shanks and Tilley argue that 'by approaching something "aesthetically", we divest it from the trivia of oppression, of conflict, of everything social' (1992: 73). In other words we raise it onto another sphere, we make it absolute and unreachable. In that respect art is similar to religion. Although both religious and aesthetic values are socially and ideologically located, religion and art are often considered non-political categories, and this fact can make them even more powerful ideological tools. For the present study it is interesting to witness such power in relation to the way sacredness and aesthetics work to legitimize the authority of the Greek nation state.

Leontis (1995: 40–66) has shown how the classical education of Western travellers to Greece formed their perception of the Acropolis and of Greece in general as a holy ground. She highlighted how much the 'pilgrimage' sentiment they took to Greece was associated with their wish to see the aesthetic values and styles of classicism resurrected.

'The Prayer' of Ernest Renan on the Acropolis in 1865 was a prayer not simply to the ancient Greek gods, but a praise to the beauty and the ideals of classical Hellenism. He addressed the goddess Athena: 'O noble! O simple and true beauty! Goddess whose creed signifies reason and wisdom, thou whose temple is an eternal lesson of conscience and sincerity' (Renan [1865] 1993: 8), and he continues:

> Thou alone art young, O Kora! Thou alone art pure, O Virgin! Thou alone art strong, O Victory! Thou alone art sane, O Hygeia. The cities, thou

guardest them, O Promachos! Thou hast the valor of Mars, O Areia! Peace is thy end, O Pacific One, Legislatrice, source of just constitutions! Democracy, thou whose fundamental dogma is that everything good comes from the people, and that, when there is nothing to inspire genius in a race, all is lost, teach us to extract the diamond from the dull herd! Providence of Zeus, divine artisan, mother of all industry, protectrice of labor, O Ergane, thou who makest noble the civilized toiler and givest him a place far above the lazy Skythian; Wisdom, thou to whom Zeus gave birth . . . (ibid.: 10).

In Renan's verses beauty is nothing but absolute sincerity, rationality, wisdom and conscience. The temple of Athena is a temple of Peace, Democracy and Labour. It is a temple of Civilization. Similarly, the art of the Acropolis monuments is often admired in Greece, because it is identified with democracy. The Parthenon for example is attributed 'spirituality', 'humanity', 'plainness', 'nobleness' in its lines, and 'peacefulness in its surfaces' (Μηλιάδης n.d.), and it is considered as 'everything high and noble' (Φιλαδελφέας 1928: 139). The praise to the beauty of the Acropolis monuments can, at the same time, be praise to the social and religious values this beauty represents. Aesthetic values can be translated into religious or social terms such as sincerity, plainness, respect and vice versa. High aesthetics reflect high values, all of them intermingling to provide evidence for the existence of a high civilization. Although for Renan this high civilization was probably identified with what we have so far termed 'global Hellenism', for the Greeks it is part of a much more personal Hellenism. The association between religion, art and civilization and their association with modern Greece becomes evident in the following statements by 6th PR students, also illuminating their understanding of what a 'high civilization' consists of:

The Acropolis was the evidence for the great cultural development that *we* had in Athens. The building [sic] of the Acropolis being the most perfect and expensive one, the various statues, as well as the most important achievement, namely democracy, made the Athenians proud of their homeland (emphasis added).

The Acropolis shows how much *our* ancestors were developed and interested in good taste, art, sculpture, architecture, faith and worship of the gods [sic] (emphasis added).

However, not only can a 'sacred' monument of high artistic value stand as a representation of Greek identity, but this relationship can be reversed,

and Greekness often becomes an aesthetic value. In various discussions about Greekness in art, for example, Greekness is often identified with values, such as harmony, light, and moderation. This close relationship is evident in the wider quest of Greekness in art in the 1930s, which urge painters such as Hatzikiriakos-Gikas (1906–1998) to seek elements of 'higher civilization' in all aspects of Greek life. He finds that 'the structure and the proportions of the ancient Doric temple exist in a primitive form in most of the shacks of the Greek countryside' (cited in Φιλιππίδης 1984: 196).

This aesthetization of Greekness is very much a product of the establishment of the Greek state. The privileged position that modern Western culture gives to 'vision' compared to other senses has led to an 'aesthetization' of everyday life. The mythologies of '"objectivity", "pure vision", "bias-freedom" and the "naked eye" ' (Jenks 1995: 11), products of an 'ocularcentric' society pervaded by Cartesian perspectivalism (Jay 1992), have generated an equivalent attitude in the way we perceive our surrounding world. This has led Susan Buck-Morss (1992: 6–7) to note that, while the 'original field of aesthetics is not art but reality – corporeal, material nature . . . within the course of the modern era, the term "aesthetics" underwent a reversal of meaning so that in Benjamin's time it was applied first and foremost to art – to cultural forms rather than sensible experience, to the imaginary rather than the empirical, to the illusory rather than the real'. Thus, Buck-Morss argues that aesthetic experience has ended up as an 'anaesthetic', numbing the human sensorium. I would now like to show how, with the establishment of the Greek state, an 'aesthetic' look prioritized an 'anaesthetic' conception of the site of the Acropolis, emphasizing its experiencing as an image rather than a site associated with everyday practices and felt with senses other than vision.

As already mentioned in Chapter 2, when the question of which city should claim the right to become the capital of the new state arose, the choice was made because of Athens's link with the glory of the classical world (Πολίτης 1993: 75). The Acropolis was the monument epitomizing that glory. It became the image of Greece, which the new state would project all over the world.

Even in the words of people of that time one can see how the Acropolis features as a vision rather than an actual physical existence. Especially revealing are the words of the British wife of Alexandros Rizos Rangavis, an intellectual of nineteenth century Athens: 'The new buildings, expanded on the slopes and the foot of the Acropolis, seemed as if they were kneeling before the Parthenon which crowned them' (ibid.: 85)

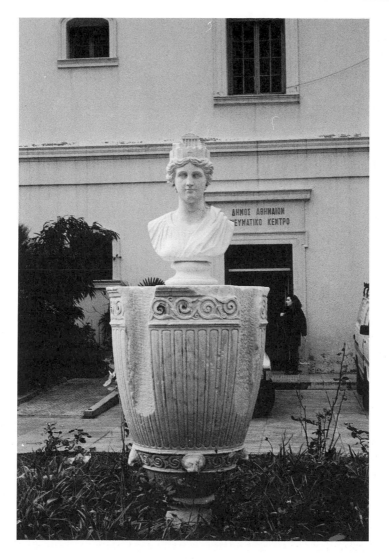

Figure 6.6 A bust of the personification of Athens, crowned by the Acropolis, in front of the cultural centre of the municipality of Athens (photo by E. Yalouri).

(Figure 6.6). When, in 1853, in an article in the periodical *Νέα Πανδῶρα*, Athens claims the title of the Sovereign from Constantinople, it appears 'wearing the Acropolis, with its outstanding architectural miracles, as a royal crown on its head' (*Νέα Πανδῶρα*, 67, 1/1/1835: 441). In 1857 the road around the Acropolis hill was under construction. At the time, a columnist in the newspaper *Αθηνά* imagined the hill to be planted over with trees, and 'the city of Athens, wearing the unique and

incomparable antiquities from the Pendelic marble, which provoke the admiration of all the civilized world, as a glorious and valuable crown on its head' (*Αθηνά*, 2511, 3/1/1857).

Before the establishment of the Greek state, the Acropolis and its vicinity were inhabited and intimately linked with the everyday life of the Athenians. Soon afterwards, however, the first attempts of an expropriation and entrenchment of the area took place. The 'purification' of the Acropolis from the more recent buildings was completed with the demolition of the Frankish tower in the Propylaea by the Archaeological Society in 1874. The removal of relics of more recent years from the environment deprived the space from its historicity and reduced it to an eclectic and isolated world. It made it frozen in time and space; it transformed it into a landscape, an image of Greece.[9] This perception is also manifested in the lighting of the Acropolis, as early as the nineteenth century during visits of distinguished guests in Athens (see Φιλιππίδης 1994) and later on in the 'Son et Lumière' shows (see below, p. 177).[10]

The viewing of the Acropolis as a landscape does not allow anything to interrupt or to spoil the high aesthetics that it represents, exactly as in a beautiful art-painting. In fact, the otherwise anarchic build-up of the city of Athens has always followed rules regarding the unobstructed viewing of the sacred site, thus creating physical and symbolic boundaries between the area of the Acropolis and the rest of the city (see also Chapter 3). A revealing example is the discussion about the position of the Law Megaron built by Alexandros Nikoloudis in 1931 in the area of the military hospital of Makriyannis. The dome of the planned building, with its height of 60 metres, would obstruct the view to the Acropolis. During discussions about the construction, an article by Erneste Hebrard, professor at the School of Architecture at the Technical University of Athens and director of the studies of school buildings in the Greek Ministry of Education, is indicative. Hebrard imagines with repulsion 'the transit of many cars, the smell of benzene, and the general disturbance from traffic directly next to the Acropolis' (Μπίρης 1995: 307–8). The issue even raised international concern, which finally led to the withdrawal of the original plans (ibid.: 306–8). Similar reactions were provoked by the building of a block of flats in Dionisiou Areopagitou Street in 1955. Not only was the interruption of the building works proposed, but also the demolition of the already constructed parts of the building (*Ελευθερία*, 3433, 13/11/1955). In the discussion of the reconstruction of the Stoa of Attalos in 1949, the architect Κτστας Μπίρης (1995: 386–7) feared that 'the size of the

building might harm the view to the Acropolis and to the Areios Pagos. This would be more obvious once the Stoa of Attalos would be isolated in the wider area of the archaeological landscape, when the excavations would be continued further towards the east'. Μπίρης claimed that 'such a risk is understandable only for the monuments of the classical era, whose beauty is unequalled, whose finesse is inconceivable, and whose purity must be protected from any modern interference'.

I have already argued (Chapter 3) that the Acropolis is being elevated into a 'monumental time' (Herzfeld 1991; Hamilakis and Yalouri 1996 cf. Καυταντζόγλου 2000) and space. It is exactly the position the Acropolis occupies in monumental time and space that allows it to watch upon the behaviour of Athenian society. In 1907, a note was published in the newspaper *To Άστυ* (12/1/1907), commenting on a fight over the owner-ship of land in Athens: 'The day before yesterday several Greeks slaughtered each other under the eyes of the king of Greeks and [under the eyes] of the Parthenon'. In this context, the Parthenon is portrayed as the omnipresent spectator similar to the proverbial 'eye of God' from which no inappropriate behaviour escapes. In a research about the every-day details of the colonizing project in Egypt, Timothy Mitchell (1988) showed the impact of the 'Western gaze' over the Muslim country, like the Benthamite Panopticon which ordered and controlled space and people through its systematic yet unseen surveillance (cf. Foucault 1977). In Greece as early as the eighteenth century, Western European travellers juxtaposed ancient Greeks, the ancestors of Europe, to modern Greeks, the oriental 'curios' who for them had nothing in common with their idealized ancestors. The landscaping of the Acropolis that coincided with the establishment of the Greek state was objected to and ordered according to that colonizing ideology which wanted it cleaned from any element that could evidence the least relation with those 'polluting' descendants who were simply 'matter out of place' (Douglas 1966). The Acropolis, by the authority of an idealized past introduced by a colonizing ideology, became in some ways an internalized and self-operating Panopticon in the consciousness of Greek subjects (Δοξιαδης 1994). It does not 'observe' them in the same way in which prisoners, students, and patients are controlled by the institutionalized spaces they inhabit, but it becomes a point of reference, a yardstick for cultural behaviour, an eye that dictates what is wrong and what is right. Its moral authority, however, is not only subordinating, but also empowering and enabling.

The presence of the Acropolis similarly defines and dictates the aesthetics of the rest of the Athenian landscape: during the first decade

of the twentieth century, when some expressions of Art Nouveau in architecture appeared in Athens, a contemporary newspaper wrote the following: 'On the foot of the Acropolis, opposite the Parthenon one can see the deplorable view of the newly appeared and obscene Art Nouveau with its crazy lines and its mad curves' (*Αθήναι*, 17.4.1903).

The wide disapproval of the building of the Hilton hotel (built in the 1960s) was also characteristic. Its construction was considered a blow to the aesthetics of Athens and especially to the Acropolis causing criticism even outside Greece. Indicative of this is the critique of the professor of history of architecture at Yale University, Vincent Scully (1963: 101, 102):

> It is peculiarly bitter and instructive to watch, in a landscape once regarded as holy. This is the story of a single, but rather pointed aspect of the whole problem: the solid blow just received by the Acropolis [. . .] In fact, if one takes a position in the Parthenon where Pheidias' ivory and gold statue of Athena once stood, it will be seen that the temple was orientated directly and rightly toward its appropriate sunrise over the mountain is now oriented toward the sun and the Hilton, whose egg-crate façade leers up on axis between the two central columns.[11] [. . .] it seriously injures its site, which happens to be Athens, whose Acropolis it rivals in size [. . .].

The 'purifying' ideology as described so far, which requires the Acropolis to be elevated in a splendid remoteness and space above the trivia of Athens' everyday life, has not been left unchallenged. A case in point is Caftantzoglou's research in Anafiotika (Caftantzoglou 2000; Καυταντζόγλου 2000), a small settlement built by migrant workers from the island of Anafi on the north slope of the Acropolis hill in the 1860s (see also p. 55). Those workers specialized in construction and masonry were attracted to Athens by the reconstruction works of the new capital of Greece. Their settlement, built as it was within the grounds of a declared 'archaeological site', was considered illegal from the very beginning and has experienced threats and acts of demolition ever since. Today its forty-five (middle-aged to elderly) inhabitants, most of them descendants of the original builders, experience the weight of being co-tenants with the classical monuments through the constant interference of the Archaeological Service, which must give its permission prior to any repair or restoration carried out in the settlement. In her research Caftanzoglou shows how the inhabitants of Anafiotika challenge the official rhetoric of the state about their settlement as being 'matter

out of place' incompatible with, if not polluting, the archaeological site. The Anafiot version of the story of the building of their settlement claims that when master builder Loudaros' sister viewed the Acropolis hill for the first time, she was reminded of and longed for her island which had a similar amphitheatric hill. In an effort to keep the valuable master builder Loudaros in Athens, King Otto gave him permission to built the first house of the settlement on the Acropolis hill. Through such stories, the settlement of Anafiotika is legitimized by Otto himself and the Acropolis is valued not because of its glorious fifth-century BC history, but because of its resemblance to the homeland of the workers from Anafi. Following a discourse of counter-hegemony, Anafiots project the admiration that foreigners show for their settlement and present their community as the real embodiment of Greek tradition. To an attitude that purifies and distances the 'Sacred Rock', Anafiots contrast their own warm relationship with the place. They tell of their childhood when they helped archaeologists in their job – stressing that they knew the place better than the archaeologists themselves. They also used to dress up as ancient Greeks and play games on the Acropolis hill (ibid).

In an autobiographical account, Τατιάνα Γκρίτση-Μιλλιέξ (1995), who grew up on the foot of the Acropolis in the area of Theseio, describes how the neighbouring archaeological sites haunted and inspired her as a child. The 'Stoa of the Giants' made her believe in the existence of real giants whose shadows scared her when she used to come home late as a kid.[12] Figures from ancient history and myths became her companions in her imagination. Statues had once been real people whom a curse condemned to become marble. Cyclop and Hercules gave their names to her games with other children. 'Statues' became a game in which they were competing for the best posture imitating ancient statues. In these stories the Acropolis and all the myths surrounding it became integrated in the child's life. The monuments themselves became a means of her experiencing seasonal change: 'I used to count the seasons on the columns. The sun moved from one column to another every season'.

This book is a good example of how children may internalize the presence of ancient sites, integrate them into their everyday lives and to their construction of reality. Even though some of the stories that Γκρίτση-Μιλλιέξ narrates may be an idealized or even invented description of her childhood, this book does now circulate among Greek children, both constructing and maybe to some extent reflecting their experiences of the remnants of the ancient world.[13]

Although I only talked to a few people who live in the vicinity of the Acropolis (Makriyanni, Theseio and Plaka), it occurred to me that while other Athenians used the term 'Acropolis' to refer either to the group of monuments on the summit of the hill or in fact only to the Parthenon, they used the term to refer to the hill as a whole, or in some cases even to the wider area surrounding it. It is revealing that the first time I realized this was when one of them, a sixty-year-old lady, mentioned that as kids she and her friends used to play on the Acropolis. I was confused and asked her how they could play in a fenced and guarded place, thinking that she referred to the archaeological site on the top of the hill. She then explained that they played in the caves of the hill and near the theatre of Dionysus (in the south slope of the Acropolis). It is possible that through their close engagement with the site on an everyday basis people who live next to the Acropolis experience it not visually, as a landscape, or a postcard sold on the street corner featuring the hill with the ancient monuments on the top, but through their everyday engagement with the place of which they also form part.

'Manners out of Place': Offending the Sacred

As in religious systems of thought, perceptions of purity and pollution dominate the behaviour towards 'sacred' sites (Douglas 1966) and define the urge to keep the landscape surrounding the Acropolis 'clean' and 'humble'. Nothing is permitted to disrupt the view to the Acropolis, which must remain dominant in the Athenian landscape. There are several main streets, whose axes are aligned so as to provide a view of the Acropolis along most of their stretch (Figures 6.7, 6.8). Cartoons criticizing the sorry state of the city of Athens often do so in relation to the Acropolis (Figures 6.9–6.12). Practices or things which violate the classification of the Acropolis as the unique, eternal, and dominant sacred Greek symbol are considered somehow impure, incompatible with the site itself (cf. Hamilakis and Yalouri 1999: 118). An example illustrating this point took place in 1925. A prominent Greek photographer, known as Nelly, took a series of photos of a naked female dancer, Mona Paiva, on the Athenian Acropolis (Figure 6.13). Originally, the plan was to take some ordinary photos of her. Nelly describes the event (Κάσδαγλης 1989: 100):

> They offered us the guardian's kiosk for the dancer to get changed. As she was getting undressed I saw her naked body and I was stunned. The sun was falling on it sideways, her skin was rosy and transparent and it

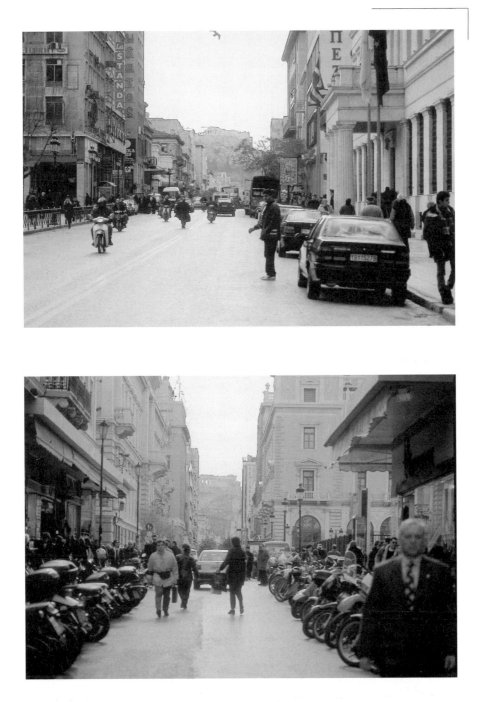

Figures 6.7 and 6.8 Photos of main Athenian streets (Eolou, Athinas) whose axes are aligned to provide a view to the Acropolis (source: Studio Kontos).

Figures 6.9 and 6.10 Cartoons by Mitropoulos, using the Acropolis as a reference to criticize the sorry state of the city of Athens (source: Mitropoulos).

Figures 6.11 and 6.12 Cartoons by KYR and Mitropoulos, criticizing the sorry state of the city of Athens in relation to the Acropolis (sources: KYR and Mitropoulos respectively).

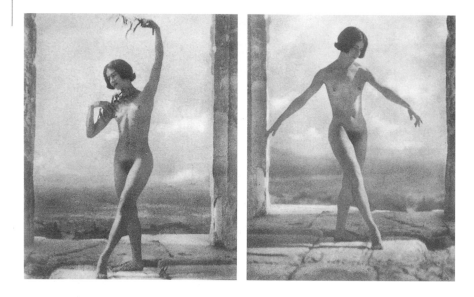

Figure 6.13 The dancer Mona Paiva on the Acropolis, photographed by Nelly in 1927 (source: The Photographic Archive of the Benaki Museum).

> looked like a Saxony bibelot.[14] Oh, madam, I said to her, would you allow me to take some naked photos inside those sacred marbles? Your body is asking for it . . .

This incident fuelled a row among archaeologists and journalists.[15] The 'most sacred monument could not possibly co-exist even temporarily with what in modern Western thought is often attributed immoral and frivolous connotations, the naked female body (Hamilakis and Yalouri 1999). It is interesting that both Nelly and her critics acknowledge the sacredness of the Acropolis, although they appreciate it in opposing aesthetic terms.

When I started fieldwork I was certain that the consideration of the above incident as an offence to the monument was linked with the morals of that particular era, and that sentiment would be long gone today. I was surprised to find that this was only true to some extent. Although there were people who were not offended by the photos, but on the contrary liked them, there were many who were still very disturbed by them. When I showed Nelly's photos (Figures 6.13 and 6.14) to some students and asked them whether they found it reasonable that they provoked so many protests in their time, the students' reactions were mixed. Some of them thought it was not reasonable.

Many of them, however, were disturbed. In fact, one particular boy
(5th GR) was most assertive. I cite our dialogue below:

Student: Did she go [to take naked photos on the Acropolis] just like that,
without rhyme or reason?

Eleana: She went to have some photos taken and as she was changing,
Nelly saw her, admired her body and asked her whether she
could take some photos of her.

Student: She was changing on the Acropolis? And what is the Parthenon,
a changing room?

Eleana: Don't you think that an artistic naked photograph should be
taken on the Acropolis?

Student: Of course not; the Acropolis is a monument, it is not a strip-
tease club!

Eleana: Does this mean that you don't find this photo artistic?

Student: It is of course artistic, and the Parthenon is a beautiful place with
the Acropolis nearby [sic], but on the other hand many photos
have been taken on the Acropolis – only Koromila has not gone
there to make a TV programme, but this is not the issue.[16]

Although the student does not state explicitly what 'the issue is' about
Nelly's photos, he believes that the naked photos have degraded the
site to the level of a strip-tease club. The paradox is that, although he
does accept that the photo of a naked body can be artistic, he cannot
accept this might be compatible with the sacred site. Could it be that a
naked body linked with more secular connotations of everyday life
cannot be seen in a sacred context, whatever its artistic value might be?
Or maybe he sees it as part of a phenomenon whereby anything is perm-
issible in connection with the Acropolis and people can do whatever
they want. If the Acropolis belongs to another sphere, as argued earlier,
it cannot be associated with everyday mass activities such as second-
rate TV programmes.

I encountered a similar attitude by two archaeologists (we have already
heard the views of one of them on page 110). Their words reveal that
the perception of sacredness is actually translated into practice in the
way one is allowed to behave, to act, to be dressed etc. The dialogue
goes as follows:

Eleana: You don't like Nelly's photos on the Acropolis?

Alexandros: The one where she dances naked [τσίτσιδη] on the Acropolis?
No, I don't.

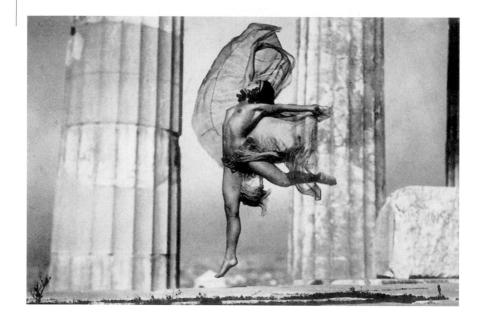

Figure 6.14 The dancer Nikolska, photographed by Nelly in 1929 (source: The Photographic Archive of the Benaki Museum).

Eleana: Does it disturb you because she is naked?

Alexandros: No, what disturbs me is that she thought that she can make a décor out of the Parthenon. The Parthenon is not a décor. She is the décor.

Lydia: Officially, it is forbidden. In the labels we have in the guard-room, there is a paragraph which says that taking indecent photos or photos for advertising reasons in front of, or next to, monuments is not allowed (Figure 6.15). This is because several times we have seen completely naked men taking a photo, or an American who took off his pants and made indecent gestures in front of the statues (Figure 6.16).[17] I consider these monuments heirlooms. We don't allow them to just wear the upper part of their swimming suit. This would never happen in the Louvre or a cathedral.

Alexandros: Once I told one of them so and she answered 'But the Louvre and here are not the same'. And I answered 'of course it is not the same: here we have nothing stolen'. We must realize that there are certain things made for a particular reason. The Acropolis is not a public place. It is not Syndagma Square.

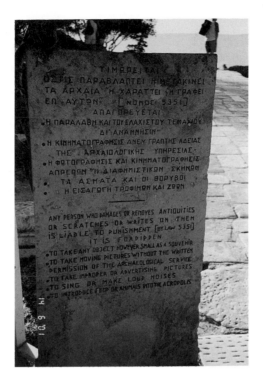

Figure 6.15 Inscription at the entrance of the Acropolis site, forbidding 'improper or advertising pictures, singing or making loud noises', etc. (photo by E. Yalouri).

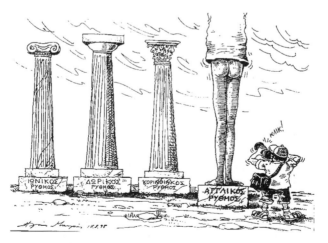

Figure 6.16 Cartoon by Ilias Makris which appeared in *Καθημερινή* (18/8/98) after an English tourist in Knossos pulled his pants down in front of the antiquities in order to have a picture taken. The inscriptions of the columns from the left are 'Ionic style', 'Doric style', 'Corinthian style', and 'English style'.

It is a place which was made for worship. You cannot ignore this. It also has a character of worship as a reference point for Hellenism today. It is the same as if you told me that one visited the Daphni Church or Saint Lefteris church naked. Of course the custodian will throw him out.

Eleana: But the churches represent a living religion, they are used as such today.

Alexandros: What does 'living' mean? A religion never dies, it changes form, but it doesn't die. There are no dead religions. This is a blessed place and this does not change, just because we do not make sacrifices to goddess Athena any more. Not to mention the destructive results on the monuments when, for example they spread their suntan lotions. When you hear that there are certain churches in which services have been taking place every Sunday since the sixth century AD, even their walls know how to say the 'Lord's Prayer'!

Eleana: You see, you tell me that even the walls say prayers, however you said that you would demolish the Turkish minaret.

Alexandros: The mosque existed partially, and was almost destroyed due to the bombardment. The Acropolis was used as a fortress during the War of Independence, not as a monumental site. The Acropolis fought. This is what Pittakis experienced.[18] Pittakis had experienced a nine-year war against the Turks, which coincided with the best years of his life. Would you expect him to leave the mosque because you have the theoretical perceptions of 1996?

Apart from the issue of syncretism discussed earlier, other issues encountered in previous chapters occur in the dialogue above: the reluctance to make the Parthenon a décor, or allow it to become merely background. Most importantly, the issue of respect for the monument arises. It emerges as a reaction to something that contradicts it or refutes it, namely the tourist who does not mind visiting the Acropolis dressed in her swimming costume, while she accepts that she would not do so if she were in the Louvre. Although the discussion is triggered by the artistic value of Nelly's nude photos, the issue of nudity as lack of respect for the monument is discussed by Alexandros as completely irrelevant to its artistic value. Consequently, Mona Paiva's nudity is considered equal to the nudity of any tourist who visits the Acropolis wearing only his or her swimming costume. Moreover, the issue acquires a wider dimension and becomes a matter of confrontation between two cultures, the Greek

and the French/foreign. For Alexandros, the arrogance displayed by the tourist might reflect the imperialist power displayed by the West having 'stolen' the Greek heritage, and this arrogance is represented by the tourist at that particular moment. The request for 'respect' or 'seriousness' is a matter that Alexandros takes personally, both as an archaeologist and a Greek, because it means acknowledging the importance of his culture, as represented by the Acropolis, on an international level. This is underlined even further by the sympathy he expresses towards Pittakis, an archaeologist famed for his reverence and sentimental attachment towards antiquities and his patriotic role protecting them, during and after the War of Independence.

The same request for respect and 'seriousness' linked with the monumentality and authority of the Acropolis site was evident in the prompt reaction of the 6th PR students to an idea I brought up of small tables being situated next to the Parthenon, where one could sit and drink one's refreshments. 'This is a place that requires some seriousness' one of them said. 'If you drink your orange juice, you will not pay any attention to it. We should respect those people who created such a great work'. And another one stated: 'You can go to the coffee shop to drink your orange juice – in Plaka for example. You go to the Acropolis for another reason, to see the monument. I feel this place is sacred, because it is an old site, where our ancestors fought'. When I reminded them of what they had told me earlier, that when they were at the site for the first time with school, they were having fun and games playing and jumping around the site, the answer came instantly: 'Well, we were younger at that time . . .'

The urge to keep the Acropolis untouched and 'clean' is not restricted to activities which can be associated with vulgar or inappropriate behaviour, such as nudity. It can also refer to activities normally considered natural and generally accepted like that of playing. The student feels the need to justify a natural behaviour for a child, namely running and playing with his fellow-students, by saying that he was younger at that time. He prefers to accept that his behaviour was not right and to try to find an excuse for it rather than to admit that someone can play at the 'sacred site' without offending the monuments. The negative reaction to the idea of a coffee shop on the Acropolis might also concern its association with mass tourism as described in Chapter 5, another 'polluting' element from which the Acropolis suffers.

It is possible that my presence, which the students knew was specifically for the reason of talking about the Acropolis, biased their answers in that they gave them a more 'serious' tone than they might have

had otherwise. It is possible that if they went there again with their school they might still run around and have fun.[19] It is important, however, that they have adopted official discourse about the 'sacredness' of the Acropolis and they are able to reproduce it on demand. No matter what is the drive that leads the children's reaction, the contrast drawn between Plaka, the tourist area of the old city of Athens where one can eat, drink and have fun, and the archaeological site proves that the children are very much aware of the boundaries between the site of the Acropolis and the rest of Athens.

If the site of the Acropolis is considered a 'sacred' place it is not surprising that it demands a formalized behaviour.[20] As we have seen it is not only foreign tourists' behaviour that is criticized when considered inappropriate and incompatible with the sacredness of the archaeological site. On the contrary, Greeks can be reproached even more sharply, as it is felt that they should be able to tell right from wrong when it comes to their national responsibilities. One such example follows.

Safeguarding a Legacy

When the guards' union decides to go on strike, one of its tactics is to keep the site of the Acropolis closed. One such case took place in February 1997. The minister declared these strikes illegal and excessive. Antiquities were being characterized as hostages (e.g. *Ta Νέα*, 14/2/97) and the whole guards' initiative as a 'siege'. Much discussion was generated concerning the issue of 'who owns the Acropolis'. The guards were condemned under the logic that the Acropolis does not belong to them, but to all humankind. This event also generated much discussion about the rights guards have over the archaeological sites they guard.

The guards were also accused of ridiculing the country and affecting tourism. Also, the issue of whether modern Greeks are worthy of their heritage was raised again. The arrival of a group of French students only made things worse. They were accompanied by a French teacher of ancient Greek. The group of French students were seen with a lot of sympathy by the Greek press, which started praising the teacher's and the students' zeal for the ancient Greek heritage, and juxtaposing it to the shameful face Greeks – in this case the guards – showed internationally. When, after some days, the guards gave way and opened the site for the students the newspapers responded in a festive, triumphal way. Paraskevi Katimertzi, a journalist in the newspaper *Ta Νέα*, quoted

the positive remarks of the students and their teacher, e.g. 'They would not open the Louvre for the students. But in Greece you do not work against tourism' or 'I had hoped the site would open, because in general Greeks have a big heart. I have known Greece for thirty-two years. I adore it. I struggle for Greece'. Katimertzi closes her article with the following words.

Outside the fence of the site the students are gathered around [the teacher] Mr De Neville, who takes a paper out of his file and starts reciting: it is the 'Prayer on the Acropolis' of Ernest Renan (*Ta Néa* 24/2/97).

This is one of the cases where local attitudes towards Greek heritage are compared to global ones. The guards are heavily criticized when they close the site of the Acropolis. But they also carry the blame for the improper behaviour of Greeks in general towards their antiquities. The guards are the ones with whom foreign tourists come into direct contact and who represent part of Greek reality for them. The guards are thus not simply considered as employees paid by the hour, but, being Greeks themselves, they are also thought of as guardians of the contested Greek heritage in its encounter with the global. When they decided to open the site for the students, the positive aspects of the Greeks were praised: the French would have never opened the Louvre for the students, an insight which proves that deep inside the Greeks have a big heart and above all moral and social obligation (φιλότιμο).[21] By opening the Acropolis they allow their gods to rise again and to be adored, through a prayer conceived by a Frenchman in the past and addressed by some of his descendants – the French group – today.

An archaeologist blamed the fact that, while it used to be archaeologists who decided who should be allowed to become a guard, now it is the Ministry [of Culture] that decides. This has made the guardian's job part of the civil service. In fact, as the same archaeologist explained, 'today guards are simply people who want to find a placement *any*where, *any* job. Through the politics of favouritism, they are promised to be transferred into another job inside the ministry at some later stage, so they use the guard's position as a stepping stone to a better job'. As further evidence for her argument, the archaeologist mentioned that – although guards are offered seminars aiming at instructing them how to guard antiquities and of their meaning – they still display total indifference, as do many public workers in Greece. For another archaeologist, guarding antiquities is 'a national responsibility'. It is a job that requires general care and love, free from union interests and

syndicalism. 'In the past,' he said, 'guards used to really love the sites they guarded. They associated themselves with them, therefore demonstrating the responsibility required for the guarding of national treasures.'

If guards are conceived also as 'guardians' of the Greek heritage, it is not surprising that they were often criticized by the people I talked to, for not doing their job properly, for the inappropriate ways they behave and stand while on duty. A historian once complained to me that the guards are too fierce and they scare him – and not just him. 'They are the front-men, when one goes to see the antiquities,' he said, 'and what visitors see is unshaved people, aggressive, not at all smiling . . .' Another archaeologist was describing a photo of a female guard at the museum of Rhodes, in front of the grave stele of Krito and Timarista, slumped on the chair with her shoes thrown to one side.[22] The archaeologist did not fail to point out that it was a tourist who had taken that photo. This indicates the fear of the bad image that Greeks might give abroad, especially in relation to their ideal ancestors (see for example the contrast between Krito, Timarista and the female guard). The juxtaposition between modern and ancient Greeks as well as between the treating of classical antiquity on a local and global level is an issue that often arises. In a column of *Καθημερινή* (9/6/96), the journalist Maria Karavia writes:

> Many guesses have been made about the relationship between museum guards and the treasures they look after, about the hours of loneliness and silence, and mostly, about the magic radiance of the antiquities, especially when you live with them for eight whole hours a day. There has been no clear answer. It is unknown if some mystic addiction is added to the plain responsibility of the guards. This view, however, is supported by the ecstatic look of guards in foreign museums, who reply in a low voice like in a church, with an expression of recollection and deep devoutness, always with a hint of pride and tender intimacy for the ancient works when you ask them for some information. Greek reality dissolves such spells. It intrudes sweepingly in the form of a loud political chat, jokes, stretching and boredom, accompanied with hanging around which has nothing to do with the necessary discreet watching of visitors, but with the [Greek] national sport of killing time.

Karavia here juxtaposes the superior meaning of classical antiquities with the inferior behaviour of modern Greek guards, the magic radiance of the ancient masterpieces with the dry modern Greek reality. The

focus of criticism is the public workers' attitude in Greece ('δημοσιο-υπαλληλισμός').[23] It is widely known that many public workers have got their posts through political bribery and that they have chosen the public sector as a secure post not requiring any initiative or creativity. Thus, it is the ideal field for exercising what Karavia terms the 'national sport of killing time'. For her, not only is the worst face of modern Greece contrasted to the grandeur of classical antiquity, but it comes as an irony that representatives of this face are called to guard antiquities. It seems to her that these are two separate worlds and that the only link between them is the authority the second has over the first. The situation is once more viewed within a framework of comparison between the ways Greek heritage is treated on a local and on a global level. She suggests, that foreigners prove to be more able to receive the almost metaphysical messages that antiquities transmit, while the Greek guards treat them through the prism of an ordinary job.

Despite the above generalizations, it is possible that what is regarded as 'disrespectful behaviour' of the guards is not caused by actual disrespect for the antiquities, but by the guards' indifference toward how the anonymous public perceives them. It would be interesting for example to know how a guard's behaviour adapts to the presence of his children visiting the museum or to similar situations. In fact one could say that the guards do not deny or question the national importance of antiquities. The nature of their job obliges them to carry the load of classical heritage on their backs, even as they want the right to treat their work as an ordinary job. As one of them complains (ibid.), 'don't you talk and laugh in your jobs? When we are on strike, you accuse us. When we work here overtime, you criticize us. You are obsessed with guards. On the top of that, we are lowly paid. But you say nothing about the sorry state of the museum. You are afraid to go against archaeologists.'

The 'indifference' of the guards may be translated in terms of the inappropriate way they are often dressed. 'Indecent' dressing is seen exactly like the nudity of Nelly's photos and of foreign tourists. They both lack 'respect': 'In earlier times', an archaeologist said,

> guards used to wear their uniforms. Men used to wear a gray-blue suit and so did women. Now, however, they do not want to wear it anymore. Also they refuse to wear identity disks, like they do in museums all over the world, because they say that various people might use their name to blackmail them or to sue them for not having behaved decently, etc.

They also say it is a matter of personality, which is offended by wearing a uniform. And you see them being dressed awfully . . . how can the visitor then distinguish them or even respect them?

Bourdieu (1977), in his exploration of the relationship between structures and the 'habitus', discusses the role of 'bodily hexis'. It is through their bodies that people embody the structures around them and make themselves part of the world in which they belong. The values of their cultures are 'given body', are '*made* body' through 'injunctions such as "stand up straight" or "don't hold your knife in your left hand"' (ibid.: 94). According to Bourdieu 'bodily hexis is political mythology realised, *embodied*, turned into a permanent disposition, a durable manner of standing, speaking, and thereby of *feeling* and *thinking*'. The encounter with classical antiquities requires a certain attitude also translated in terms of behaviour and dress code. In the guards' case their behaviour and way of dressing is interpreted as evidence for their indifference and, thus, their unsuitability for something that is not an ordinary job but a patriotic service.

What we have here, however, should be seen under the prism of a more general identity problem. Herzfeld's discussion of Greek identity as one consisting of Hellenism and Romiossini is not only a distinction between the Classical and Byzantine pasts. As he has explained (1987), although Romiossini might be a mark of intimacy, it can also mark a 'polluted' vision of modern Greece linked with Turkishness and the stereotypes of the Oriental as lacking organization and self-control. It can also be a metaphor of the Greek state's bureaucracy and inefficiency. The discussion of the guards' behaviour and their attitude in general is seen as such an example. The distinction between the 'polluted' Oriental and the 'pure' Hellene should be seen as part of the contest between local and global Hellenism as appropriated by non-Greeks. The obsession with the idea that 'the others' show a greater appreciation of 'our' heritage is driven by the fear that 'we' are running the danger of losing 'our' rights over it. This fear reflects the feeling Greeks have towards the foreign presence in their country as a presence which decided even the very existence of the Greek state and which also decided and decides on what is 'clean' and what is 'polluted' Greek culture.

Viron Polidoras, a press representative of the former right-wing government (*Νέα Δημοκρατία*) and a member of the Greek Parliament today, writes about the 1st of May when he decided to go with his kids to the Acropolis and found it closed (*Απογευματινή*, 2/5/96):

In the entrance a very unpleasant surprise was waiting for us. A cold
shower. A disappointment. *The door was closed*. Something broke, cracked
inside. We froze. We were looking at each other. The eyes of my kids, a
huge '*why*'. And I *was feeling guilty* before those eyes. I looked around.
Then I saw hundreds of faces, mirrors of the same feelings. *Disappointment,
indignation, anger, fury, disgust* against those who *had stolen from them*
what was most valuable: *the dream* . . . I could see *British* phlegmatically
shaking their heads with justified contempt. *Germans* talking – swearing
loudly. *Italians* laughing with sarcasm and swearing with gestures. *Japanese*
went into a huddle . . . in order to explain the phenomenon. They
probably failed. *Americans* saying in all tones the 'F-word' followed by
the word Greeks and another four-letter word (s . . t). Two *Africans* in
their traditional gowns were (in vain) seeking a policeman . . . Inside the
guardhouse I see three employees. One of them recognizes me. I ask:
why is it closed? He replies: because it is. I ask him to explain why what
the label says, namely that on bank holidays the site is open from 10.00
until 2.30, is not adhered to. He says something like 'The 1st of May is
not a bank holiday. It is a strike'. I was looking at him and I was feeling
sorry for his political education . . . An *Albanian* (as he introduced himself)
with a little girl, *Anna-Maria*, recognized me and he asked me to take a
picture with me. His wife from *Northern* Epirus was crying because the
Acropolis was closed . . . I looked up at *the Parthenon: 'Our goddess Athena,
give us some of your wisdom', I prayed*. Further down, Protopapas of GGCL
[Greek General Confederation of Labour – ΓΣΕΕ][24] were having a speech
to some 500 supporters of the guards [εργατοπατέρες] about the Labour
Day and Greek society . . . *Under the closed Acropolis* (emphases in the
original).

It is not clear to what extent the strong emotions expressed in Polidoras'
words are personal, or whether the article was also politically motivated
as it might have been intended to increase the public's disappointment
with the government's handling of the strike. Nevertheless, even in the
latter case, he would have been playing to existing public sentiment.
However, the same rhetoric could have been employed by the gov-
ernment itself with a different aim, namely to increase pressure on the
striking guards.

Although I have based this section on interpretations of the guards'
behaviour, it would have helped to hear the guards' point of view – a
discourse that this research has left out. I did not talk to any guards,
but I found very revealing the response of the head of the guards'

syndicate regarding their tactic to close first of all the Acropolis site for contesting their claims (Ελευθεροτυπία, 14/2/97):

> Do not think that we close down the Acropolis light-heartedly. The criticism we receive [should] have two recipients. It is us, who do not have any other way to react, and the government that does not want to hear.

Through his rather apologetic tone he accepts the discourse about the high importance of the Acropolis, only he tries to use it in a way to attack the government and achieve his claims. All the public agents are therefore able to use the same discourse accepting the importance of the accessibility of the Acropolis to the public. The only difference is whom they blame for the strike.

Honour and shame, 'φιλότιμο' (see note 18) and 'ντροπή', or the more general concepts of display and concealment are, it is argued, a 'key to the front and back door of Greek culture' (Herzfeld 1991: 40; cf. Herzfeld 1997). One could view all this criticism against the guards' behaviour as an example of such distinctions, whereby the national honour and display requires the concealment of the 'dirty laundry' of the guides' behaviour. Honour and shame, however, are not always in tension with each other. Shame may be displayed rather than concealed and exposure is not always considered an offence as the example that follows demonstrates. In February 1999 Ocalan, the leader of PKK was arrested by the Turkish Secret Forces in Nairobi, Kenya on his way from the House of the Greek ambassador to the airport. The Greek scenarios that followed Ocalan's arrest saw the Greeks either as 'traitors', conspiring with the US and Turkish Forces or as inefficient and incapable of helping Ocalan to get away safely. In this spirit of 'national embarrassment' dispersed all over Athens, the NGO of 'Hymetos citizens' went to the Acropolis and unravelled a banner asking for the Kurds' forgiveness (Figure 6.17). Through such an action, the Acropolis which is normally the major site through which Greeks project their pride became a site where they purposefully displayed their shame. At the same time, however, their action was a display of 'φιλότιμο', without which no such embarrassment would have taken place in the first place.

The use of the dominant discourse about the Acropolis in a counter-hegemonic way is an issue that will occupy us in greater detail in the following section.

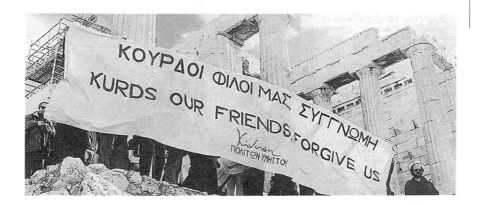

Figure 6.17 Members of the Hymetos movement unravelling a banner on the Acropolis (source: *Τα Νέα*, 23/2/99).

Official Discourse Turned on its Head

Peter Ucko (1994: xviii) has noted that sacred places can at any moment be vested with an identity which involves not only the supernatural sphere, but also 'the power of social self-definition and personal self-identity'. In fact, sacredness is a discourse which can arise as part of an effort to differentiate oneself, as an urge to project one's identity in relation or in reaction to 'the other'.

In an article entitled 'The Acropolis/Greece is in danger', the leftist intellectual magazine *Επιθετρηση Τέχνης* (ΙΔ: 132) denounces the establishment of NATO bases in Greece:

> Before entering any sacred site, ancient Greeks used to leave their weapons outside the entrance. War, disaster, or any armed threat had to remain outside the gates of the temples. But in the sacred site called Greece this principle is not kept anymore. Weapons pollute the immunity of the sacred Acropolises. The danger is great and immediate. It is not focused on the specific Acropolis of Athens and it was not created recently. It was born at the moment the first foreign base intruded upon the sacred site of our country . . . It does not matter whether the bases are outside the limited site of the Acropolis. Yes, they may not be on the Acropolis, but they are in Crete and in other parts of mainland Greece and Greek islands. And in this land, no matter where you build a base, you will find an Acropolis right next to it.

The Acropolis is presented as Greece writ small and the range of its sacredness covers all Greece. The Acropolis *is* Greece, therefore its sacredness transcends the particular limited site and expands to every corner of the Greek land. The Acropolises in the above quote are not the Acropolises of other ancient sites, but a metaphorical vessel for everything Greek. It seems that the discourse of sacredness is activated by foreign intrusion. It is the obtrusive NATO military bases in Greece that provoke the writer's reaction and the juxtaposition of ideals, such as the sacredness of the site, which coincides with Greekness per se. It is this reasoning that allows the writer to use the ancient custom of leaving one's arms outside sacred sites exclusively against the foreign military presence. Greek weapons do not seem to violate the Acropolis' sacredness as they do not violate Greek territory. We have encountered similar reactions throughout this book, whereby the sacredness of the Acropolis gives rise to resistance against foreign elements. For example, the 'purification programme' that took place on the Acropolis, or the removal of the swastika from the Acropolis. Both activities were part of the effort to emphasize or to maintain the sacredness of the site in the face of the threat of the foreign 'polluting' presence. The concept of sacredness, however, is not necessarily only a reaction to foreign presence or authority. It can be a form of resistance from within against official ideologies.

A case in point is the reaction of inhabitants of areas around the Acropolis to the environmental and traffic problems in these areas. In August 1996, the cultural environmental society *Acropolis* submitted a petition, signed by the inhabitants of the areas, asking for a curfew on heavy vehicles in the area and for the placement of relevant traffic signs. The problem remained unresolved. Thus, in the summer of the same year, the society threatened that, if their requests were not satisfied by 25 August, they would proceed with other actions: they would address the Public Prosecutor, and inform all international organizations (the EU, the Office of Citizens Protection of the EU, UNESCO, etc.) (*Απογευματινή της Κυριακής*, 18/8/96; *Απογευματινή*, 8/8/96). The head of the society complained that

> Twenty-four hours a day, hundreds of heavy vehicles . . . as well as count-less passenger cars, taxis, motorbikes, etc. have made the lives of the people who live around the Acropolis unbearable. And of course, the thick air pollution injures the ancient marbles of the sacred rock in a criminal way (*Απογευματινή της Κυριακής*, 18/8/1996).

Similar reactions were voiced also by several others, who treated the specific problem of the inhabitants of the area always together with the moral issue of pollution of the Acropolis. Spiros Karalis, a columnist of *Καθημερινή* writes:

> [This fact], apart from insulting the aesthetics of the unique [Acropolis'] landscape, provokes a severe traffic problem. Above all, it creates serious problems – because of the pollution and the vibrations – for the monument as well as for other archaeological sites. The inhabitants of the area complain. However, for months now bureaucracy sends them from one person in charge to another. (*Καθημερινή*, 9/8/96).

The issue brought up by the inhabitants of the area around the Acropolis also provoked discussions about the traffic and air pollution of Athens. This ignited several accusations and complaints against Greek state bureaucracy and inefficiency. The inhabitants of the area, basing their claims on the official discourse about the uniqueness and the importance of the Acropolis, got more attention and found more supporters because they associated their demands with the monument.

Such claims by protesters using the official discourse around the Acropolis and turning it to their advantage in making claims against the state do not just appear in organized form. They can even be made on an individual level, as we see in the following example. On 9 September 1996, a 22-year-old man climbed on the walls of the Acropolis and threatened to jump if the state refused to listen to his claims. The young man – a drug addict according to the journalists who covered the event – accused the police of having beaten him in the past and he asked, among other things, for compensation from the state (*Απογευματινή*, 10/9/96). A few days later a 37-year-old man climbed the scaffoldings set up for the restoration of the Parthenon and threatened to commit suicide.[25] It was the second time in two years that he had done that in order to protest against the hypocrisy of the state. He complained that although the state allowed him to live in an illegally built house on the slopes of the mountain Hymettos, it did not do anything to help him when the house had been swept away by a torrent. Now the man was expecting the state to help him find a new place to live and to be sent to a detoxification programme, as he was also a drug addict. The newspaper in both cases underlined the men's threatening and swearing behaviour, which made the marbles 'turn red out of embarrassment' – one of them pulled down his pants in front of the cameras. The paper concluded that 'we have ridiculed ourselves in front of the tourists'.

The two young men obviously wanted to provoke the state. It was no coincidence that they chose to do so on the Acropolis, knowing that their reaction would be heard from there better than from anywhere else. They were two disempowered individuals who empowered themselves by using a highly charged monument. In Chapter 3, I mentioned another act of suicide, a Greek soldier who wrapped himself in the Greek flag and jumped from the rock when the German troops invaded Athens. That was considered a heroic act, glorifying the Acropolis' rock, as it was an act of resistance in the name of the Greek nation and compatible with the idea of the Acropolis as embodying the spirit of the nation. In contrast, the acts of the two young men were considered 'polluting' and exposing, as they were blackmailing and motivated by self-interest.

As Herzfeld has noted (1991: 227), 'once the rhetoric of national heritage has entered the protesters' vocabulary, it can be turned to their advantage'. In all three cases discussed above (the reaction to the establishment of NATO bases in Greece, the response to the environmental and traffic problems of the Acropolis area and the suicide threats), the discourse about the Acropolis' sacredness becomes a political tool incorporated in a wider framework of negotiation of power and resistance to support group or individual claims. These claims become more powerful once addressed in the name of the Acropolis or from the site of the Acropolis.

White – The Colour of Purity

So far we have seen examples of how concepts of sacredness are expressed in relation to the Acropolis site and how they are translated in aesthetic terms. Here I will examine one aspect of the aesthetics of sacredness and purity, the whiteness of the marbles.

Whiteness was an integral part of the nineteenth-century aesthetics of classical sculpture and architecture, in tune with the ideals of austerity and simplicity associated with classical Greek art and life. The 'whiteness' of the marbles is repeatedly praised, even today, as being in character with the ideals classical antiquity represents. In the following section, I discuss how white, as a colour signifying purity, is associated with a series of efforts to keep the Acropolis 'clean' from any alien elements.

The verse of a resistance song, released during the Colonels' dictatorship in 1967–1974, says: 'In these very marbles, bad rust cannot sit'. The verse implies that in a place like Greece, with all its connotations as a cradle of Democracy and Civilization, a dictatorship is a foreign element and therefore cannot last. It is significant that the imposition

of the dictatorship is perceived in aesthetic terms, namely as dark filthy rust, staining the white pure marbles.[26]

The urge to see the Acropolis restituted in its former glory – and stripped of any elements which distort what it represents – is epitomized in the desire of a 10-year-old student (6th PR):

> The Elgin marbles should come back, so that we see the Acropolis richer, as it used to be. I would like to see the Acropolis all white and illuminated as I imagine it.

The student perceives the glory of the Acropolis by imagining it all white and illuminated. This is how he imagines the Acropolis' restituted form.

Given this ideal of whiteness I was not surprised by the mostly negative reactions of the students of all schools, when I told them that the buildings on the Acropolis used to be colourful and I asked them whether they would have liked to see the Acropolis in colours: One of the students said:

> The Acropolis multi-coloured [ironically]? It loses all its essence. I think that with the colours it loses its value. Because, the way it looks now, it shows that it is an old monument (6th PR).

Another student thought that a coloured Acropolis would look 'kitsch and banal' while yet another one thought that 'it might be nicer in colours, but we have linked all old things with not being that cheerful' (6th PR). Finally, one (5th GR) exclaimed: 'Will we make a clown [φλούφλη] out of our history?'

Colours are not only considered motley (cf. also the Greek expression 'χρτματα κι αρτματα' – 'colours and perfumes' – normally used to imply frivolity), but an alien skin, an artificial body, added to the original, which masks rather than projects the spirit of the Acropolis (see also Chapter 5). As a young Greek lecturer in artificial intelligence, who found the idea of an Acropolis in colours excessive, phrased it: 'It would be as if you had a nice dessert and you added other things on the top, more whipped cream, more cherries, etc.'

Similar reactions have also been caused by the 'Son et Lumière' (Sound and Light) system which has been adopted by the National Tourist Organization since 1959 and is on show during the tourist months in Greece (June–September). The 'Sound and Light' is an event based on lighting effects co-ordinated with a narration and music, which aim to

evoke moments of a monument's history. Sound and light performances have been staged in a wide variety of historic settings including Giza, Versailles, etc. (Papageorgiou-Venetas 1994: 377–378). From the very beginning, the Acropolis as a subject for Son et Lumière has been quite controversial.

In 1959, an art magazine (Ζυγός, 42: 4) criticized the Sound and Light as 'The phantasmagoric glow of the Acropolis bathed in red, yellow and green glows like the scene of Folies Bergères' and it grieved:

> If Pericles was on the Pnyx hill on the evening of the 28th of May and if he saw the deplorable sight of the Acropolis, this is what he would cry: 'Since everything is condemned to decline, at least, let future centuries say about us that whatever beautiful things we built in this city and whatever remained erect after time's passing and after the enemy's rage, we ourselves destroyed through foreign hands'.

In the same year, a left-oriented intellectual magazine made a similar critique (Επιθετρηση Τέχνης, 53–54 (1959): 242):

> The motley light and the sounds of Mr Pavlos Melas – and, unfortunately, of others as well – make the Acropolis and her monuments 'productive' for the last one month . . . for the benefit of a French company which produces records, radios, vacuum cleaners and shaving machines. The instigators of this spectacle apparently thought that the Parthenon and the temple of Apteros Nike do not look so great under the light of the sun and the sky of Attica, or under the moonlight. On the contrary, they thought that, with the motley colours of the footlights, it would become pretty, more imposing, almost like the badly painted settings of a revue. And, indeed, the Parthenon under the caressing of the coloured projectors sometimes reminds of Karagiozis' hut,[27] sometimes of a block of flats and sometimes of an apocalyptic monster which breathes fire out of its nostrils.

According to the magazine a *foreign* company of *mass-produced* goods aspires to beautify the Acropolis. In its efforts to do so it only manages to reproduce an artificial Acropolis which is not in tune with 'the appropriate' aesthetics, but is ugly like the Athenian blocks of flats, poor and miserable like Karagiozis' hut, and scary like an apocalyptic monster.

The critiques developed today, 40 years later, toward the 'Sound and Light' effects do not vary significantly from those expressed in the first

year of its establishment. An undergraduate student in economics who went to watch the spectacle with some foreign friends of hers commented:

> What a mumbo jumbo that was! I felt embarrassed. It was excessive, not at all modest, and not at all informative either. All that verbal pomposity made the actors' voices weigh with all the glory of ancient Greece, while at the same time motley red, yellow, and blue lights illuminated the marbles.

For an archaeologist who has worked on the Acropolis the show aggravates the site aesthetically, while for several tourist guides the Sound and Light show is simply 'a tragedy'. A tourist guide (in her 50s today) explained:

> I believe that the Sound and Light show does not befit the Greek monuments. The Greek monuments have a clarity, a rationality; this romantic thing – because the Sound and Light show is clearly romantic with all these contrasts . . . voices, music, etc. – does not fit. In general the Greek reality does not take romanticism. You see the Palace in Rhodes: because it is Medieval or pseudo-Medieval it fits with the Sound and Light show; it fits in Egypt, because it has this mysticism, the unknown, the dark . . . The Greek landscape, however, does not take it. It is out of date and out of place. It is the monument itself that resists.

The aesthetics of the Acropolis is conceived as plain, austere, clear and white, unable to withstand the 'weight' of polychromy. There is, however, a case in which the whiteness of the marbles was not praised at all. The story is the following.

A Contest Over 'Cleanliness'

In the summer of 1998, William St Clair, a British historian and intellectual, brought up the issue of the proper guarding of the marbles by the British Museum through his newly published book (1998) about the acquisition of the Elgin marbles. He came up with evidence that the technicians of the BM had removed a considerable layer from the marble of the sculptures in their effort to 'clean up' the marbles in the 1930s. Apparently, that had happened at the request of Sir Joseph Duveen, the donor of the gallery in which the marbles are exhibited, and was dictated by the aesthetics of that period, praising the whiteness of the marbles. Given that one of the major arguments of the British

Museum in its refusal to return the marbles to Greece is the supposed inefficiency of the Greek Archaeological Service in maintaining and guarding them properly, the evidence St Clair brought to light rekindled in the Greek press the issue of the return of the Parthenon marbles to Greece.[28] The reddish-brown patina of age, formed by the action of iron oxides on the surface of the marble, was considered 'natural' and, therefore, improper to remove (e.g. *Τα Νέα*, 9/6/98). Eleni Bistika, a journalist of the newspaper *Καθημερινή*, who showed special interest in the issue, wrote that by scraping and rubbing the brownish colour of the marbles, the BM technicians were 'extinguishing forever the traces of the artist's burin on the sculpture'.[29] That, according to her, was a sign that it was time for Greece to claim back the Parthenon sculptures which, quoting her words, 'wait inside the gallery of the ludicrous Duveen, pale and having been deprived of the mantle of time which accompanied them for over 2000 years' (*Καθημερινή*, 14/6/98).

The brownish colour of the patina here represents time and the original artist's hand, both qualities of the originality of the work of art. The marbles, being deprived of these two qualities, seem to lose their authenticity. In their effort to achieve the ideal whiteness of the Pendelic marble, the British thus destroyed the marbles' nature. Bistika (*Καθημερινή*, 11/6/98) also quotes the words of St Clair who regrets that one cannot find the familiar brown anymore after the cleaning: 'Nobody can find a trace of brown [colour] in many sculptures with bare eyes. Only the gray, the pale, [the colour] with no glow'. And, Bistika adds: 'The gray of sorrow, the pale of expatriation, which demands the glow of truth . . .' She also associates the 'dull' colours of London with the colour of the marbles in the BM. This idea goes along with the words of the Greek Minister of Culture when he stated that a scientifically documented conservation programme for the marbles is only possible when one bears in mind what the sky of Attica is like, what the colour of the marble of Attica means (*Τα Νέα*, 10/6/98).

The whiteness of the marbles in the BM featured as an artificial creation by the British in their eagerness to imitate the original Greek white colour which, however, could not be conceived outside Greece.[30] Moreover, it was believed to be an imposition of the foreign element which destroys the very nature of the marbles. In the same way as Turner paintings at the Getty Museum of New York are 'pale in the Pacific glare' and the London Bridge in Arizona is nothing but a 'tawdry joke' to the English eye, the Parthenon marbles look dull and inauthentic in the British Museum (Lowenthal 1998: 232). In a cartoon (Figure 6.18), an antiquities' guard standing next to ruined ancient columns which

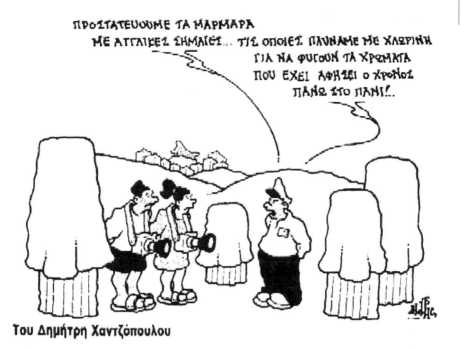

ΠΡΟΣΤΑΤΕΥΟΥΜΕ ΤΑ ΜΑΡΜΑΡΑ
ΜΕ ΑΓΓΛΙΚΕΣ ΣΗΜΑΙΕΣ... ΤΙΣ ΟΠΟΙΕΣ ΠΛΥΝΑΜΕ ΜΕ ΧΛΩΡΙΝΗ
ΓΙΑ ΝΑ ΦΥΓΟΥΝ ΤΑ ΧΡΩΜΑΤΑ
ΠΟΥ ΕΧΕΙ ΑΦΗΣΕΙ ο ΧΡΟΝΟΣ
ΠΑΝΩ ΣΤΟ ΠΑΝΙ!..

Του Δημήτρη Χαντζόπουλου

Figure 6.18 Cartoon by Dimitris on the occasion of 'the cleaning' of the Parthenon marbles by the BM. It appeared in *Τα Νέα* (10/6/98).

are covered with white cloths appears, saying to a tourist: 'We protect the marbles with British flags, which we washed with bleach in order to wash off the colour that time has printed on the cloth'. Again, the role of a flag is compared with the role of the marbles: by trying to remove the colours that time has imprinted on the British flag we turn it into white, i.e. we deprive it of its very meaning as symbol of Britain; we make it an ordinary white cloth. It is implied that, in the same way, the 'cleaning' of the marbles took off 'their skin' – the brownish-red colour – which represented their historicity and their authenticity/ originality, i.e. the traces that (a) the artist's hand left on them and (b) the traces that the past left on them.

Dimitris Kastriotis, columnist in *Καθημερινή* (14/11/99), associated the marbles' cleaning by the BM with another issue that provoked a similarly big outrage in Greece when it became public, namely the receptions that the BM organizes occasionally in the room of the Parthenon marbles. He commented, with sarcasm:

[The British Museum] could not possibly allow the distinguished revellers to hang about around shabby statues. They had to shine them as much as the floors. What would a well-respected British gentleman think of ancient Greece, if he saw that the famous Pendelic marble does not retain even its colour and if he compared it to the endless shine of the good quality whisky in his glass? As Mr Hamilton, who apart from a genius must also be a communist, said: 'Not anyone attends receptions: the clients who prefer the room of the Greek antiquities are major companies, big banks, law companies. The fact that they agree to pay such large amounts of money to rent the room shows their respect for the marbles. We are talking about a certain class of people who know how to behave'.

It becomes obvious that we encounter here a case of a politics of colour and aesthetics deciding what is 'dirty white' and what is 'clean white'. Kastriotis, referring to the verse of the resistance song mentioned earlier, wrote (ibid.): 'As is well known, in these marbles "bad rust" does not sit. It seems, however, that once these very marbles leave the country, their decay begins'. The question of the marbles' ownership then becomes a feature of their form. When the marbles leave the country of their origin, they lose their original colour, they become – in a way – fake. What is normally considered as dirty and clean is reversed here. People quoted earlier in this text thought the ideal aesthetic of the marbles was their 'whiteness'. The insistence that the 'real' ancient marbles should be 'dull' brown plainly contradicts the normal views. The removal of the marbles' surface was described as a removal of its very skin. In the same article Kastriotis notes that 'the BM rubbed the marbles in order to make them white with a passion bigger than the one they demonstrated as world-rulers . . . in whitening up the peoples and the cultures of half of the entire globe'. Race then comes up as an issue in this debate even if in the form of a metaphor. For the West, classical Greece was 'white and pure' (cf. Bernal 1987). Modern Greeks, however, could not fit this picture. If they were to meet these ideals they would need to follow the 'whitening' ideology of the West and indeed they did absorb the 'Western Hellenic view'. Here, in a situation of counter-hegemony, the dark skin of the marbles becomes an asset, the valuable mantle of time, and what used to constitute 'Western' aesthetics becomes an aesthetics of resistance in the hands of Greek protesters.

The whole debate over colour here fits right within the local-global debate. Local resistance to the global involves disavowing earlier 'local' positions that were in fact influenced by global pronouncements. Once

more, the issue of the Parthenon marbles and the protests against their
'cleansing' rekindled the wider political and historical issues that they
always do: the involvement of foreign powers in Greek matters and
matters of national honour. Even in this case, Western discourse becomes
localized and provides argumentation against the West: Bistika for
example, as well as many other journalists or non-journalists, repeatedly
quote St Clair's words to back their argument.[31] An archaeologist com-
plained to me that the 1930s cleaning of the marbles was well-known
– he himself had made it known to the Greek Ministry of Culture, but
it was St Clair who had to bring up the issue for the Greek world to
revolt. If this is true, it should not be surprising: a British discourse against
the British Museum is considered more powerful because it is British.
It is a discourse originating from the 'enemy's camp', which is appropr-
iated and used by the protesters.

The Pursuit of Authenticity and the Reunion of *Telos* and Origin

The discussion about the cleaning of the marbles that took place in
the Greek newspapers illustrates some perceptions about what constit-
utes the particular qualities of a work of art, such as the Acropolis. Both
materiality of ancient artefacts and the seal of authenticity they convey
render them able to offer immediate and tangible contact with the
past. Authenticity is a major factor in the aesthetic appreciation of a
work of art. The case of the marbles' cleaning makes clear that it is not
only subsequent additions that make something inauthentic, but also
removals (e.g. the patina of age). The authenticity of the experience of
contacting the 'glorious' national past cannot allow any interference
which might 'pollute' the result. The aesthetic appreciation of the
Acropolis derives, to a great degree, from its 'purity' which is reversed
when it is 'polluted' by elements considered as alien (e.g. the Nazi flag
or the more recent buildings mentioned earlier). Given the association
between high art and high civilization, it is evident that any influence
on the first will affect the second. Therefore, any interference which
might 'stain' the high aesthetics of the Acropolis and, as a consequence,
the values that it represents, is condemned.

As we saw earlier, authenticity is a concept that helps one make state-
ments about who one is in relation to others not only in social, but
also in national terms. In Chapter 5, we saw that the 'authentic'
Acropolis is defined in relation to its 'inauthentic' commodified copies.
Authenticity, however, is not necessarily only linked with the appearance

of mechanically produced commodities which forced the distinction between the unique and the replaceable. In the case described above, it is defined in relation to the forgery the British committed on the authentic monument itself in their effort to achieve a whiteness which was, in fact, fake. It was suggested that in their hands even the original became inauthentic, because they tried to impose on it an 'alien' authenticity. The 'real' whiteness of the marbles could only be found under the 'Greek sun' and the 'landscape of Attica'. Once removed from their real context, the marbles could not display the same whiteness, which could only be imitated but never achieved. The issue of authenticity, both in this case as well as in the case of commodification, is clearly linked with the issue of 'legitimate' ownership. By trying to make the Parthenon marbles real and authentic the British only managed to make them fake and inauthentic.

In contrast to other archaeological schools of thought, the dominant policy of Greek archaeologists regarding restoration works on archaeological monuments is traditionally that of minimal intervention. As early as 1956, *Επιθετρηση Τέχνης* (Δ (1956) 22: 323) quoted a text by Anastasios Orlandos (architect and archaeologist, professor at the University at Athens and at the National Technical University of Athens, and director of the ancient and historical monuments restoration programme between 1917 and 1958), referring to the restoration of the Stoa of Attalos by the American Archaeological School at Athens:

> I wonder whether I should call it restoration or reconstruction; Because here in Greece what we consider restoration of a monument is placing back to their original place all its pieces without exception – even the smallest ones – adding only a few new ones which are necessary to structurally support the placing of the old ones . . .

The archaeologists to whom I talked during fieldwork had similar beliefs about the restoration of monuments. Those beliefs were held also by non-archaeologists. Most of those whom I asked whether they would have liked the Parthenon fully restored said either that they like it in its present form or that they would only like it fully restored if (a) they were absolutely sure that it is only authentic pieces that have been used and (b) the pieces are in exactly the right place. 'The Acropolis can not withstand any fake elements', a business employee stated. Keeping the site authentic is very important. Any recent addition is alien to the monument and adulterates its meaning. As we saw in Chapter 5, any intervention on the original form is considered menacing to the spirit of the site.

Hence the reactions against a project proposed by Swiss architects in the 1970s, when a more systematic conservation and restoration programme was put into practice on the Acropolis. The proposal suggested covering the Acropolis monuments with a transparent dome 500 metres in diameter for a more effective protection of the archaeological site. The dome, which was mockingly termed 'cheese bell' (τυριέρα), met many objections and it was eventually rejected. While in the case of the 'cleaning' of the Parthenon marbles the British Museum was condemned because it removed the skin of the marbles in this case, the proposed project was accused for creating a 'new skin' separating the Acropolis from its surroundings and deforming the original way of experiencing of the monuments (Απογευματινή, 26/2/77).

Rajan (1985: 4), comparing the idea of 'ruin' to the (originally Romantic) idea of 'the unfinished', argues that while the unfinished does not invite completion, the aspiration when viewing a ruin is 'the union of telos and origin'. He also argues that 'the relation of the part to the whole, the consciousness of loss, and the endeavour of retrieval which characterize our contemplation of survivals are singularly prominent in the way the ruin is viewed' (ibid.). In fact all these elements do exist in the way the Acropolis is viewed. The Acropolis is indeed linked with the origin and *telos* of the Greek nation, with its losses, and its aspirations for regeneration. The restoration works on the Acropolis could thus be seen as a metonymy for the Greek nation's efforts to restore its ancient glory. This longing towards 'the union of telos and origin' sounds very similar to the (Orthodox) religious quest of the union with the divine, which is both *telos* and origin, as God made Man according to his own image. Viewing ruins entails something transcendental. It is like a religious situation, where you have to imagine a God whom you cannot see. 'Imagination', McFarland (1981) says, 'transcends reality'. He notes that thrusting aside the barriers of the sensible world 'gives it a feeling of being unbounded; and that removal is thus a presentation of the infinite' (ibid.: 45). 'The logic of incompleteness is thus ultimately the logic of infinity' (ibid.: 28), inherent also in religion. The association between ruin and the divine is well-depicted in the words of Mme de Stael who writes in the spirit of the Romantic 'sentiment des ruines': 'A broken column, a bas-relief half ruined, some stones linked in the indestructible workmanship of ancient architects, reminds you that there is an eternal power, a divine spark in man' (ibid.: 14).

It is this feeling of 'eternal power', deriving from the traces of centuries cast in the ancient marble, that renders the Acropolis a powerful

metaphor for the imagining of the Greek nation's history. The damage done to the monuments, which is not only the outcome of natural wear through time, but the result of violent interference (e.g. the sawing off of the sculptures by Elgin or the destruction of the Parthenon by Morosini's bomb) stands as a real wound on the 'sorely-tried' Greek national body. It is associated with historical moments and experiences, such as the foreign hegemony or the long Ottoman occupation. The Acropolis' persistence throughout the centuries comes as a promise that the Greek spirit remains intact throughout history. The young 6th PR student said that he likes 'to imagine the Acropolis all white and illuminated' (p. 177). It is a vision of the Acropolis in past and future times that the half-ruined form of the Acropolis allows him to picture. On the other hand, the concept of sacredness, linked with the Parthenon as a temple where the Greek soul resides, does not define only local and global relationships. It is also one that brings together the two facets of Greek identity, Hellenism and Romiossini, as described by Herzfeld. It becomes, as Yorgos said, the magical world where the Byzantine and the classical civilizations meet. It is where the Greeks see a glorious past and envisage a promising future.

Conclusions

I woke with this marble head in my hands;
It exhausts my elbows and I don't know where to put it down.
It was falling into the dream as I was coming out of the dream
so our life became one and it will be very difficult for it to disunite again.

I look at the eyes: neither open nor closed
I speak to the mouth, which keeps trying to speak
I hold the cheeks, which have broken through the skin.
I don't have any more strength.

My hands disappear and come toward me mutilated.

George Seferis, *Mithistorima*
Translated by Keeley and Sherrard (1967).

In Greece it is often said that the Greek nation had been asleep during the entire Ottoman occupation, waking up again in the early nineteenth century, with the War of Independence and the consequent establishment of the Greek state. When the Greek nation 'woke up', however, it found itself carrying the weight of a heritage valued highly by 'the West'. The classical Greek heritage became a blessing and a curse at the same time: on the one hand, it rendered modern Greeks what the nineteenth-century historian Zambelios has termed 'les enfants gâtés de l'histoire' ('the spoiled children of history') (Σκοπετέα 1988: 11). Modern Greece became the heir of ancient Greece, and classical heritage became the means through which the Greeks could come closer to their European counterparts. On the other hand, it was this same heritage that reminded the West of how different contemporary Greeks were from their classical ancestors. Classical antiquity was considered as the distinctive mark of Western identity; a measure of cultural difference

and superiority over the 'barbarian' peoples of the New World and of the Orient which Western civilization 'discovered' and, consequently, tried to 'civilize'. The Greek people was considered as one of those and it is well known how 'civilizers' repeatedly expressed their discontent for Greece not being its 'real' self, not corresponding to the idealized image they had shaped for it (Ανδρεάδης 1989: 60; Σιμόπουλος 1984). There is a tale about a poor man who suddenly found himself in possession of fabulous riches. He had always dreamt of that moment and, although the gift was beyond his expectations, it eventually became an unbearable load under the constant fear of its potential loss. The heritage with which the Greek state was endowed has been accompanied by the anxiety that modern Greeks have to keep it and, most importantly, to prove themselves worthy of it. It represents a perfected 'civilization', a yardstick which has always been there reminding them of what they *should* be.

Seferis' nightmare about the exhausting weight of the marble head expresses the unease which the weight of classical heritage creates, and which has resided in the Greek national consciousness, burdening the Greeks' present lives.[1]

An equally pessimistic spirit is conveyed in a cartoon by Stathis described by *Καθημερινή* (4/1/00) as 'the Man loaded with the mythical time that he himself created' (Figure 7.1). I am not aware of whether Stathis specifically refers to the relationship of the Greeks with their classical past, although this is very likely, given his recurrent engagement with the issue. In any case, if we read his cartoon from this perspective, we will find that he introduces a new dimension into this relationship. Although the cartoon indicates the oppressive role of classical heritage by depicting the Greek nation kneeling on all fours in order to carry this heritage on its back, it also suggests that classical heritage is not simply a foreign body imposed on the Greeks from the outside, but that it has become an integral part of the Greek national body – its back and its hind legs in the cartoon. It does not mutilate their hands as Seferis suggested in the above-cited poem, but it enables them to walk.

Although the classical past can undeniably be oppressive for modern Greece, it can also be empowering, a *telos* to aspire to. It can be both a burden and a weapon in negotiations of power, within Greece and on an international level. The Acropolis is a case in point. The shadow it casts over Athens and Greece has an animistic power, a spirit that haunts and guards them at the same time.[2] In the last years of Otto's reign, one of the fighters in the War of Independence narrated his dream to

Figure 7.1 Cartoon by Stathis. According to *Καθημερινή* it should be interpreted as 'The Man loaded with the mythical time that he himself created' (source: *Καθημερινή*, 4/1/00).

General Makriyannis: an old man revealed to him that Makriyannis must go to a church. In the church's foundations he would find an [ancient] stone with engraved capital letters (γράμματα κεφαλιακά). As long as the Greeks held on to this stone and the foreigners did not take it from them, the country had nothing to fear (Ανδρεάδης 1989: 13).[3] In the fighter's dream, classical antiquity thus played the role of a talisman for Greece. As we have seen throughout this book, this view is not exclusively Makriyannis'. The Acropolis occurs repeatedly as an asset, inalienable wealth that Greeks possess, a point of reference from which they can draw strength in difficult times.

The Acropolis site does not simply represent a specific period of a remote past, detached from the Greeks' present lives. On the contrary, it relates also to more recent and more personal experiences, which create a familiarity not exclusively linked with an archaeological or historical knowledge of the classical past. In fact, the Acropolis plays a primordial

role in domesticating historical experience. It is, as we saw, a metaphor of Hellenism's history in time and space. Thus, foreign occupation or hegemony, national losses and sufferings, but also national reinstatement and restitution find their expression in the form of the Acropolis' history, as for example in its mutilation or occupation, but also in its restoration and above all its 'timelessness'. The 'timelessness' of the ancient ruins represents the Acropolis' – and by extension the Greek nation-state's – existence despite history's vicissitudes. It signifies their continuity in time, as well as their unity in space.

The Acropolis also merges opposing aspects of Greek identity, such as those of Hellenism and Romiossini as described by Herzfeld. The transformation of the caves on the Acropolis' slopes into little churches, Kira-Thodora who made the sign of the cross in front of the Parthenon, or Yorgos who went to the Acropolis on Good Fridays to listen to the churches' bells are all examples of how the Acropolis accommodates those features of Romiossini related to Byzantine Orthodox Christianity. On the other hand, the calcination of the monuments' marbles associated with the air-pollution or the 'general crisis' of the Greek state alludes to those features of Romiossini related to backwardness and lack of progress. In one of the issues of *Τα Αθηναϊκά* one of the members of 'The Society of the Athenians', in her praise of the 'beauty of Greece' (literal and metaphorical), considered the Acropolis as the place where 'one greets Romiossini' (Κωνσταντινίδου 1973: 44). Κωνσταντινίδου does not explain why 'one greets Romiossini' on the Acropolis. Maybe she refers to the site's association also with more recent events in Greek history, such as the War of Independence. What is interesting, however, is that the monument of classicism par excellence is also considered to be a site where Romiossini resides.

Thus, evoking the Acropolis does not simply mean evoking the classical past, the one introduced into Greece 'from outside', but a familiar and common national past and present, including a reservoir of values, meanings and memories.

An argument often made against Greek claims for the restitution of the Parthenon marbles is that Greek laymen's knowledge of the ancient Acropolis is not such as to render them responsible enough for the safeguarding of a monument of universal importance. In fact, some of the students I talked to were pretty confused as to what the Acropolis used to be in classical times. For one the Acropolis was 'the capital of the Athenian nation-state' and for another it was 'something like our churches of today'. Others confused it with other parts of ancient Athens, e.g. the Athenian Agora ('The Acropolis was the public market,

a place of everyday gathering, a site of public announcements, a site where politicians and philosophers delivered their speeches'), and others made up stories which they felt were in tune or adding to its 'mythical' profile, e.g. 'The Acropolis was built with marble from Pendeli that the Athenians transferred with their hands'. Others identified the Acropolis, not with the whole hill or with the group of monuments on its summit, but just with the Parthenon: 'The buildings [on the top of the hill] were fabulous, the Acropolis being the most perfect, biggest and most expensive'; 'The Acropolis was a temple for the Athenians'.

Maybe some Greeks do not actually know what the different stages in the construction of the Acropolis monuments are; they might not even know whether they are of Ionian or Doric style. However, it is not only through archaeological knowledge that a place becomes meaningful and appreciated. For several people the Acropolis could not be identified with its archaeological interpretation, but it was recognized as the landmark par excellence of their city and, above all, as representing the history and fate of Hellenism. Experiencing the Acropolis by taking a date there for a romantic moment or by kicking the flag pole where the swastika used to fly (Chapter 3) is no less important than experiencing it as an archaeologist involved in its restoration works.

Drawing from Gourgouris' comparison of nation-building with dream-work, I described the elision and layering of the cultural meanings of the Acropolis as similar to the dream-work's mechanisms of condensation and displacement. For Freud, a consequence of the work of condensation in dreams is 'over-determination': not only are the elements of a dream determined by the dream-thoughts many times over, but the individual dream-thoughts are represented in the dream by several elements. Similarly the Acropolis' multiple meanings are redetermined many times in relation to various 'national dream-thoughts' on various levels throughout Greek history. As is the case with dreams, associative paths lead from one meaning of the Acropolis to several 'national dream-thoughts', and from one 'national dream-thought' to several meanings of the Acropolis.

Through its material form the Acropolis is *there*, in its wholeness conveying all its attributed meanings simultaneously. In the process of the Acropolis' evocation, use, and contestation, its materiality is crucial, as is the fact that it condenses the spirit of Hellenism per se. It sums up Hellenism's multiple meanings and projects them in a tangible way. Elsewhere, General Makriyannis argued fervently that 'statues and icons and manuscripts and sacred vessels are not objects for display, but the garment of this country (το ρούχο του τόπου)' (Ανδρεάδης 1989:

270). In this sense, classical antiquities, among other highly valued heritage objects in Greece, play the role of 'another skin', the visible form of Greek identity. All specific features of the materiality of antiquities and the Acropolis in particular, such as authenticity, oldness, wear, and whiteness are important insofar as they project the otherwise invisible, intangible spirit of Hellenism. As Gell (1998: 231) has noted with regard to the 'kula' arm-shell or necklace:

> It does not 'stand for' someone important, in a symbolic way; to all intents and purposes it is an important person in that age, influence, and something like 'wisdom' inheres in its physical substance, in its smooth and patinated surfaces, just as they do in the mind and body of the man of renown to whom it was attached, and from whom it has flown away as an idol of distributed personhood.

The materiality of the Acropolis should under no circumstances be a reason to view it as a wealth external to the Greek self, as its plain signifier. On the contrary, it is a defining constituent of it. Thus others cannot appropriate it without provoking a feeling of violation of the Greek self's integrity.

Ortner (1973), in her article on 'key-symbols', puts symbols into two categories, 'summarizing' and 'elaborating'. The former sum up what 'the system' means to agents, as in the examples of a flag or the cross of Christianity. For Ortner, such symbols 'synthesize or "collapse" complex experience, and relate the respondent to the grounds of the system as a whole' (ibid.: 1344). 'Elaborating' symbols, on the other hand, contribute to the ordering of experience, they are 'good to think' with. Apart from 'conceptual elaborating power', these symbols may also have 'action elaborating power', 'that is they are valued as implying mechanisms for successful social action' (ibid.: 1340). The example of the Acropolis shows us how arbitrary a distinction between summarizing and elaborating symbols can be (cf. Tilley 1999: 32). Symbols may have both summarizing and elaborating power and the Acropolis is certainly a case in point. It condenses understandings about Greek identity, while at the same time it is a means through which experiences, feelings, ideas, and actions are ordered.

One of the people I talked to during fieldwork (Greek lecturer of Artificial Intelligence in Britain) said that even if the Acropolis was bombarded, burnt, totally destroyed, it would still be there, equally powerful and influential even if only in the form of a memory or an idea.[4] This statement is indicative of the fact that in the process of objectification materiality is alternated with dematerialization and that

physical things are generated from and generative of mental represent-
ations, memories, feelings and values.

In fact, part of the Parthenon's communicative power is for what it is
today – a robbed and dismembered ruin – and not for what it used to
be as a building of the fifth century BC.

The fact that the absence of something can be a signifier or a powerful
symbol is not unknown: The eighteenth-century Frauenkirche in
Dresden became a powerful Second World War memorial after the air
raid of 13 February 1945 which transformed it into a pile of rubble;
The empty pedestals that were left after the removal of statues of Lenin
in Moscow after 1989 made their absent presence more noticeable and
thus more memorable than before (Forty 1999).[5]

This is not a new idea in material culture studies. A case in point are
the elaborate Malangan wooden carvings of New Ireland, Papua New
Guinea, which are produced and used during death rituals, while they
are left out to rot in the forest just after the mortuary ceremonies are
over. It has been argued that the Malangan carvings aim at providing
the 'skin' for the 'life-force' (Küchler 1987) or 'social effectiveness' (Gell
1998) of the deceased as well as the parchment on which past and
future social relationships are inscribed. In other words, the (non-
material) 'life-force' of the deceased along with the outcome of his
participation in political and productive life is objectified in the material
form of the wooden carvings. Through these carvings it is internalized
by the participants in the ceremony in order to shape and legitimize
future social relationships. The rotting wooden carvings are a material
manifestation of the death, while their odour serves to transform
material imagery into (non-material) memory.

Another example is the 'spatio-temporal transformation of Gawa
Canoes' as described by Munn (1977) seen as 'spatio-temporal transform-
ation of social identities' (Tilley 1999). Munn describes 'the biography'
of these canoes from the moment of their construction through to
their exchange with yams (inside Gawa) and Kula shell valuables
(outside Gawa) highlighting the ways in which material goods are
converted into non-material fields of influence.

In its dialectic with the Greeks, the Acropolis is internalized by various
agents who redeploy, reproduce or transform it. Through this process of
reproduction and redeployment Greeks give shape to their own identities,
thus converting materiality to abstract concepts, such as identity and
power, and vice versa.

Simon Harrison (1999) has noted that processes of ethnic opposition
and boundary formation may be accompanied by perceptions not only

of dissimilarity, but also of resemblance. Drawing on Weiner's discussion of inalienable wealth he mentions several cases in which the imitation or appropriation of ethnic identity symbols is perceived as piracy of identity. While Weiner discusses objects needing to be kept out of circulation, Harrison focuses on practices which need to be protected from unauthorized copying or reproduction. In fact, in the last decade the idea of expanding the notion of copyright to defend indigenous cultures has been proposed by an increasing number of legal scholars, anthropologists and native activists (Brown 1998). According to Brown, advocates of this idea argue that indigenous people should be permitted to copyright not only objects but ideas, and such protection should exist in perpetuity. Native American tribes, as well as peoples from Australia and the Pacific, declare in manifestos their claims to control their cultural property, which is defined in broad terms. We live in an 'era of cultures', whereby we experience the resurgence of nationalities and multiculturalism, rather than an 'era of civilizations', which is mostly seen as a feature of the colonizing West. The appeal of ancient Greek heritage and classical studies progressively declines as part of the wider rejection of Western civilization and its heritage. Within this framework, Greece has found itself in a paradoxical situation, carrying the load of a heritage which is both 'civilization' and 'culture'. Brown, in the article cited above, illustrates 'the problem of literalist notions of cultural property' with an example originally used by Philippe Descola (n.d.): 'We commonly regard Greek civilization' he says 'as the source of a mode of formal reasoning known as the syllogism. Does that mean that the Greek people therefore "own" syllogistic logic? Should they be compensated by American or British or Israeli software companies for their collective cultural contribution to modern programming?' Although Brown uses this example as an extreme and unrealistic case to highlight what he considers as the absurdity of institutionalizing cultural copyright, throughout this book we have seen that this is a very real situation that Greeks confront – only in a much wider sense: although their problem is not foreign software companies benefiting from their ancestors' 'invention' of syllogism, they do try to cope with these dual culture/civilization, local/global features of their heritage which make it both familiar and foreign to them. As Brown himself notes, 'calls for the return of land and resources have a way of intertwining themselves with demands for religious freedom and other basic rights to such an extent that it is sometimes difficult to distinguish culture from its material expression'. Negotiation of heritage is a way of peoples making political or cultural statements and claiming the

right to be recognized as a political and cultural entity. Although the Greeks never raised the question of 'copyrighting their heritage' in a literal sense, they often ask for the world to remember that modern Greece is the descendant and thus the 'rightful' heir of that global heritage.

Greek discourses about the Acropolis are developed in dialogue with – and become structurally equivalent to – global discourses about it. Silberman (1995: 257) has already stressed that 'even if modern national identities are in conflict, they are nonetheless made vivid and politically potent by structurally similar narratives'. 'It is important', he argues, 'not to overlook a subtle universalist dimension that exists side-by-side with the nationalist particularism in the new nations of the post-colonial world'. As Wilk suggests in his discussion of the future of the local in an era of globalization 'we are not all becoming the same, but we are portraying, dramatizing and communicating our differences to each other in ways that are more widely intelligible' (Wilk 1995: 124). In a similar way, Greece uses a widely intelligible 'global' discourse about the Acropolis and turns it around to project its own claims and difference.

The same can be observed within Greece in the ways social agents build upon and reformulate official discourses about the Acropolis in the pursuit of their own interests. Official idioms about the Acropolis are not necessarily suppressive and rigid, and they are transformed and readjusted in the hands of different interest groups, through different practices and with different purposes, ascribing them different meanings. The Acropolis is used as a point of reference for groups of conflicting ideologies to develop their criticism against each other. For example, the condemnation of the political prisoners at Makronisos to build up Parthenons (see Chapter 2) did not result in their dismission of the Acropolis as a symbol but in its appropriation in their attempts to resist the oppression by the dominant regime who forced them to build Parthenons (Hamilakis 2000). As Hamilakis argues, 'at times it seems that the issue becomes which side represents the true values of the classical past best, which side should be considered as the real descendants of classical Greeks' (ibid.). Thus, although this hegemonic aspect of the classical past might derive from the context of the nation-state, it is not only constructed 'from above'. Non-élites are also engaged in the formation and reproduction of attitudes and perceptions about the classical past. They appropriate easily either the classical past or the habituated official discourse about this past whenever it suits their agendas. They give their own interpretations and make their own use of it.

Throughout Greece's existence as a nation-state, values and meanings have been changing in Greek society. All national identities are in the process of change, and the Greek is no exception. However, its rhetoric about classical antiquity presents many similarities today with that of the nineteenth century, and its importance as a representation of Greek identity seems to persist and adjust under different circumstances.[6] Greece's integration into Europe does not yet seem to have diminished the power of the rhetoric about the Acropolis and classical antiquity. If anything, the opposite seems to be happening, and Greece attempts to remember and to remind the world of its contribution to Western civilization. Is it likely that other factors might change the situation, for example the large number of immigrants who have entered Greece since the 1980s, transforming the society from a mono-cultural to a multi-cultural one? Will the Acropolis be flexible enough to accommodate these other cultures under its roof or will it become a representation of a certain group of Greeks who perceive themselves as the 'real' ones? Will the second generation of these new cultures somehow internalize and adopt the Acropolis or will they attempt to dismiss it totally? Time will show.

In the meanwhile, more than one-and-a-half centuries after the opening ceremonies for the restoration works on the Acropolis in the early nineteenth century, which were a celebration of the restitution of the modern Greek state, Greece met the year 2000 under the Acropolis. For the international television broadcast of the New Year's celebrations, its monuments were illuminated in red and orange colours, while the main fireworks display was also centred around the Acropolis. (Figure 7.2). It seems that Greece's ruins of the past are not only a centrepiece of Greece's image in the present, but also the focus of the country's celebrations of its future.

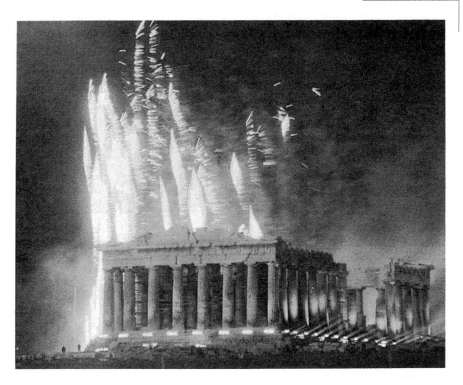

Figure 7.2 The Acropolis under the fireworks of the 2000 celebrations (source: *Τα Νέα*, 3/6/00).

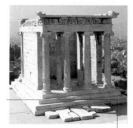

Notes

Preface

1. As an example, consider the words of Paul Theroux (1996: 330): 'Still it was possible to see the Parthenon, as white as though it had been carved from salt, glittering and elegant, and towering over the dismal city of congested traffic and badly-built tenements. Apart from what remained of its ancient ruins, and the treasures in its museums, Athens had to be one of the ugliest cities on earth, indeed ugly and deranged enough to be used as the setting for yet another variation on the Heart of Darkness theme, perhaps to be called Acropolis Now'.

Chapter 1 Introduction

1. For the relationship between Western travellers and Hellenism see Leontis 1995.

2. The Parthenon in particular has been systematically and very widely used in the name of international values and ideas; See Τουρνικιώτης (1994b) for extended research on the imitation and reproduction of the Parthenon's architectural lines in national monuments, public or private buildings. Some examples are: the Walhalla in Bavaria, conceived by Ludwig of Bavaria in 1807, at the peak of Napoleonic domination, to symbolize and revoke the German union; The 'Parthenon' on Calton Hill of Edinburgh built in Scotland in 1822 based on plans by Cockerell and Playfair. It would function as a Christian church. The construction of the building stopped, due to financial problems. After the successful battle in Waterloo there were also plans for a national monument following the architectural lines of the Parthenon; The mausoleum of Antonio Canova by the architect Giovanni Antonio Selva which was designed and built in Possagno (near Genova) between 1819 and 1833; The second bank

of the USA in Philadelphia by William Strickland in 1818–1824; The Capitolium of Indiana in Indianapolis by Ithiel Town and Alexander Jackson Davis (1831–1835); The Custom House, Wall Street, New York by Ithiel Town and Alexander Jackson Davis (1833–1842); the Custom House in Boston by Amni Young (1837–1847). There have also been copies and maquettes of the Parthenon, such as for example the one in Nashville, Tennessee (1897) for the International centennial exhibition of Tennessee. To the above imitations and reproductions we should also add the copying of certain architectural elements of the Parthenon (e.g. its propylon, its friezes, its columns, etc.). However, monuments of the Acropolis are copied not only within the Western world. A replica of the Parthenon exists also in Sodo Shima, a small island in Japan, and it was built as a peace symbol after the tragedies in Hiroshima and Nagasaki (1973) (Χατζηγιαννάκη 1993–1994).

3. In an autograph of his to the Greek journalist Thanassis Lalas published in *Το Βημα της Κυριακης*, 16/5/99, Salman Rushdie writes: 'to Thanassis Lalas, whose Greek heritage is also mine'.

4. For an extended review and a historical background of material culture studies see Tilley (forthcoming).

5. In fact a new periodical, the *Journal of Material Culture*, was established in 1996 in order to promote this approach, as set out in its editorial article in its first issue (Miller and Tilley 1996).

6. See Gefou-Madianou 1993; Γκέφου-Μαδιανού 1998; Bakalaki 1997 for a discussion of Greek anthropologists conducting their fieldwork in Greece, as well as the issue of 'anthropology at home' in general.

7. The situation described here is illustrated very well in the words of one of my informants, a Cretan left-wing activist: 'On a political level I believe that Europe looks at us like a third world country in its periphery. It thinks that we are a small dependent country, a naughty child, a black sheep, which always wants to profit without offering [anything]. This is the general image. On a cultural level, it depends on whom we are talking about. There are certain European countries with which Greece has a tradition of cultural and social relations and which see us with more understanding, e.g. France, maybe Italy, Spain. There are others, like the British, who see us like Arabs wearing trousers. There are others with classical education who see us in a romantic way and see our relationship with our ancestors in a more direct way. I don't believe, however, that this is so much the case nowadays as it used to be, say, in the 60s and 70s. Classical studies were more popular in those times, they were also supported by their countries, and they used to have a different glamour. Now there are different tendencies, multiculturalism. For example, Mexicans say 'why should we consider the classical Greek civilization as a point of reference, when it was also worshipped by Hitler? Now there are historians

who do not even refer to us when they say 'Europe'. By 'Europe' they mean mainly the central European countries, i.e. France, Germany, and Italy.'

8. In primary school fourth-year history (*In Ancient Times*); in secondary school first-year history (*History of Ancient Times until 30 BC*); and in secondary fourth-year history (*Thematic History [Ancient and Byzantine]*).

9. These are: the sixth-year class of an Athenian primary, privately managed and funded school (hereafter 6th PR), the fifth-year class of an Athenian, government-run secondary school (hereafter 5th GR), the fourth-year and the sixth-year classes of a secondary school in a village of Northern Greece (hereafter 4th and 6th GR respectively).

10. The Archaeological Service falls under the authority of the Ministry of Culture and is the main body of the Greek archaeological management.

11. 'Εφορίες' (ephorates) are the different departments in which the management of antiquities is organized in Greece.

12. In its first years (1989–1991) the newsletter was called 'Informative Bulletin of the Archaeological Society' (Ενημερωτικό Δελτίο της Αρχαιολογικής Εταιρείας – ΕΔΑΕ). It is only since April 1991 (19) that its name was changed into *Ο Μέντωρ*.

13. When the Society was established, its aim was 'to contribute to the recovery, the restoration and the completion of the antiquities in Greece' (Κόκκου 1977: 99). At that initial point of the ASA's history, its members were intellectuals, including foreigners, who were considered friends of Greece and of antiquities. Most of them had considerable political power. For example Iakovos Rizos Neroulos, the first president of the Society (1837–1841), was the minister of education. Alexandros Rizos Rangavis, the secretary of the Society, was the head of a department in the Ministry of Education. Ioannis Koletis, the second president of the Society (1843–1846), was also the Prime Minister of Greece, etc.

14. See Καλπαξής (1997a) for an extended discussion on the ideological profile of *Επιθετρηση Τέχνης* in relation to classical antiquity.

Chapter 2 The Acropolis Past and Present

1. The political circumstances were favourable for Britain, as after the defeat of the French fleet by Lord Nelson in the battle of the Nile in August 1798 the Sultan looked to Britain to protect the Ottoman Empire against the French. The conquest of Egypt by Napoleon Bonaparte had serious consequences on the French-Turkish relationships. The battle of the Nile and the subsequent Turkish declaration of war against France gave Britain the chance to replace France as the primary ally of Turkey (Hitchens 1987: 23–4).

2. However, protests by inhabitants of the area, and especially by chieftains who had played a leading part in the War of Independence and who had bought land in that area, did not permit the appropriation of the land for archaeological research.

3. The 'Great Idea' is a multifaceted concept. It was a term introduced by the Greek Prime Minister Koletis in 1844. The term acquired various meanings and dimensions. It could refer either to territorial expansion of Greece, or to its cultural regeneration and domination in the East, or to the Greek state's reorganization (Πολίτης 1993: 62–3; Σκοπετέα 1988).

4. The 'generation of the '80s' consisted of those intellectuals and artists who encapsulated and fully absorbed Paparrigopoulos's three-age scheme bridging the gap between ancient and present times and favouring also the Byzantine era.

5. After the completion of the large-scale excavations on the Acropolis between 1885 and 1890, the excavation director P. Kavvadias made the following statement reflecting the dominant purist preservation approach: 'Thus Hellas renders to the civilised world the Acropolis, as a noble monument of Greek genius, cleansed of every barbaric addition, as a venerable and unique treasure-house of the sublime creations of ancient art' (Papageorgiou-Venetas 1994: 218).

6. I thank Fotos Lambrinos for providing access to this history documentary series.

7. Roger Milliex was vice-director of the French Institute of Athens, and in 1959 he was appointed cultural attaché in the French Embassy of Cyprus. He is married to the Greek writer Τατιάνα Γκρίτση-Milliex (see p. 40).

Chapter 3 Greece Condensed: Materializing National Identity

1. This is probably a reference to what she has learnt from school-books about 'the golden age of Pericles'.

2. cf. Σκοπετέα (1988) and Τζιόβας (1989) on the contrast between the small size of the 1827 (1834) nation-state vis-à-vis the territories under Ottoman rule comprising Greek-speaking populations and populations that had participated in the War of Independence.

3. This connection between the preservation of ancient language and the preservation of ancient monuments is frequently made by proponents of either tendency, for example by Aristotelis Constantinidis, who criticizes the governmental decision to abolish the accent marks from the Greek language. 'Let us suppose that a team of archaeologists supported also by a team of other specialists . . . argue that the NW part of the Parthenon for example is of bad taste, badly constructed and that it needs to be demolished for some serious reason . . . Who has the right to operate such a sacrilege for any reason at all? Something analogous happened also with the imposition of the one-accent system and we have not realized yet what consequences this will have for our language' (*Καθημερινή* 26/1/97) (cf. Hamilakis 2001: note 41).

4. Although the demolition of more recent buildings did cause some negative reactions (Hamilakis 2001).

5. 'Scents had no room in the shiny temple of perfect order modernity set out to erect' (Bauman 1993: 24). In nineteenth-century Western cities, smell had become a planning concern, and played a key role in the construction of class-relations (Stallybrass and White 1986; cf. Rojek and Urry 1997). The Acropolis could not be exposed to the rank smells of the masses.

6. Malkki (1992: 27) (cf. Balibar 1990: 285–6) provides us with an example from France illustrating the metonymic experiencing of a nation with the soil which it inhabits. On the night of 9 May 1990, the body of a newly buried man in a Jewish cemetery was disinterred and impaled with an umbrella in Carpentas, Southern France. Being a Jew, 'his membership in the French nation was denied'. While in the Greek case it was felt that the body of the Greek soldier had to be included in the Greek soil, in the case described by Malkki the buried man was perceived as 'a person in the "wrong" soil, and was therefore taken out of the soil'.

7. The Acropolis used to be called 'το κάστρο' (the fortress) during the Frankish and Ottoman occupation of the Acropolis, but as I already mentioned it did function as a fortress as early as the Neolithic period.

8. By the term 'enhabited' Billig alludes to Bourdieu's 'habitus'. To quote his words: 'Thoughts, reactions and symbols become turned into routine habits and, thus, they become *enhabited*' (1995: 42) (emphasis in the original).

9. Fascist discourses have also made extensive use of this metaphor. For example, the colonels' dictatorship aspired to the healing of 'the ill body of the Greek nation' ('το στμα που νοσεί') and for that reason they aimed at 'wrapping it in plaster of Paris' ('το έθνος που μπαίνει στο γύψο'). The opponents of the dictatorship, in their turn, adopted the same terminology to resist the authoritarian regime. For them the Greek nation was indeed ill, but because of the junta – and the plaster of Paris in which the nation found itself was not therapeutic material but the rigid mould of the junta's despotism.

10. Filippidis, professor of architecture at the National Technical University of Athens, is an important figure in the area of modern Greek architecture. He is interested not simply in the historical or morphological features of architecture, but also in the social/ideological parameters that created them.

11. The authoritarian regimes of the twentieth century also made extensive use of such analogies between nation and family as part of the mystification of their oppressive nature. For example, Metaxas and Stalin identified themselves as the fathers of their nations (Μαχαίρα 1987: 181–96).

12. The word 'γένος' could be translated by the words nation, people, race (Latin genus) (Leontis 1995: 69).

13. Emigration in Greece throughout the twentieth century has happened in large waves, to escape extreme poverty or – in some cases – for political reasons.

14. Christos Yannaras is a Greek intellectual and a representative of the so-called 'Neo-orthodox' movement ('Νεοορθοδοξία') in Greece. 'Νεοορθοδοξία' in its variations generally projects Orthodox Christianity as a feature as important as classical antiquity in the shaping of Greek identity. It also tends to draw a line between Hellenism as a cultural concept and the Greek nation-state as a political entity emphasizing the superiority of the former over the latter. Representatives of 'Νεοορθοδοξία' feel that with the Greek Independence the body of the Orthodox Church split for the sake of the creation of a secular inefficient state (Λιάκος, *Το Βήμα* 2/3/97).

Chapter 4 Contesting Greek Identity Between Local and Global

1. Viewing antiquities as a means to increase international awareness of people's identity is not something new. When the New Zealand government had the option to have certain historical relics returned, some New Zealand Maoris advised to leave them abroad so as to enhance international awareness of Maori identity. Israel, too, has demonstrated a readiness to sell or make gifts of antiquities as symbolic expressions of Israel's identity, such as for example the Bronze Age Canaanite scimitar and Iron Age oil jar given to the former Prime Minister of Britain Margaret Thatcher (Silberman 1989: 129–130). Increased circulation of one's heritage may actually enhance its value instead of diluting it (Lowenthal 1998: 247).

2. The Greek Academy is an institution equivalent to the French Académie des Lettres et des Beaux Arts, consisting of pre-eminent representatives of

disciplines, sciences and arts aiming at the encouragement and the enhancement of their areas.

3. Kritias' boy is an early fifth-century BC statue (Acropolis Museum).

4. cf. the words by the Greek novelist Γρηγόριος Ξενόπουλος (1867–1951) (1930: 378–81): 'There is no reason for Britain to guard [the Elgin marbles] for us any more. We are free and strong enough to guard them'.

5. Another means of promoting widespread circulation of national claims are stamps and banknotes. The banknotes of Croatia, which were designed in 1994, are another example of how the circulation of money is used to aid the circulation of political claims to justify 'historical truths'. The 20 kuna note bears an image of an old palace and a copper-age pot from Vukovar, a town which fell to the Serb forces in 1991. The act of placing these images on *their* banknote enforces a deliberate message: That Vukovar is Croatian and has been so for a very long time (Kaiser 1995: 118). For another example of how Greek national identity is projected through a global means, the internet, see Hamilakis 2000b.

6. For the national importance of the Olympic Games revival in 1896 see Κουλούρη 1997.

7. I should also mention the Delphic celebrations of 1927 and 1930, which involved not only performances of ancient drama, but also performances of ancient dances, torch-races, as well as performances of Greek folk dances and songs.

8. It is widely accepted that the Greeks who inhabited the area of ancient Dodona were called 'Γραικοί' by their Illyrian neighbours until the name ''Ελληνες' was established. A few centuries after Christianity arrived, the name ''Ελληνες' was linked with paganism, and thus the names 'Γραικοί' and 'Ρωμιοί' prevailed until the establishment of the Greek state (Μπαμπινιώτης 1998). The question of what the national name of Greeks would be after the establishment of the Greek state was raised as early as the eighteenth century. The alternatives were: ''Ελληνες', 'Γραικοί,' 'Ρωμαίοι' (Romans). The Patriarchate preferred the name Ρωμαίοι which was reminiscent of Byzantium, rather than the ''Ελληνες' which had paganistic connotations (Τζιόβας 1989: 43). On the other hand, the representatives of the Greek Enlightenment wanted to break the links with the obscurantist Byzantium and they rejected the name 'Ρωμαίοι'. According to Τζιόβας the name 'Γραικοί' was a compromise between the name 'Ρωμαίοι' preferred by the Patriarchate and the ''Ελληνες' advocated by the representatives of the Greek Enlightenment. Finally, in the first national assembly of Epidaurus in 1822, the name 'Ελληνες' prevailed (ibid.: 44).

9. As I said, the names Greece and Greeks do not derive from the word 'γκιαούρης', which is of Turkish origin. This is an incorrect etymology, often mistakenly reproduced by Greeks.

Chapter 5 Consuming Inalienable Wealth

1. Makriyannis was a general of the Greek army in the War of Independence.

2. A loan provided by the League of Nations for the needs of the refugees who fled to Greece as a result of the exchange of Greek and Turkish populations after the Greek-Turkish confrontation in Asia Minor (1920–1922).

3. Let us not forget that in 1970 the military dictatorship ruled, and thus it was not a very favourable time for any kind of protest.

4. Artemidoros Daldianos was born in Ephesos in the late second century AD. He wrote a five-volume work on the interpretation of dreams, the 'Ονειροκριτικά'.

5. In fact, the inconsistency of the Greek reactions was brought up several times, e.g. in another issue of the same magazine (*Αντί*, 610 1996: 44) referring to the fact that in the new Greek committee for the 'claiming' of the Olympic Games 2004, the participation of the representative of Coca-Cola in Greece was welcomed. The writer comments: 'Anti-cocacolism is over; long live the glorious coca-colaphilia'.

6. The speaker here refers to Poseidon, the fifth-century BC bronze statue (National Museum of Greece), to the fifth-century BC grave stele featuring Hegeso (National Museum of Greece), and to the fourth-century BC grave stele featuring Dexileos (Museum of Kerameikos).

7. Long before the appearance of the Coca-Cola advertisement and the candidacy of Atlanta as a host of the Olympic Games, Greek cartoonists used images of the classical past as a means to comment on what they considered to be 'American hegemony'.

8. Kallimarmaro (Καλλιμάρμαρο) is the name after which this stadium is known. Its literal meaning is 'beautifully marbled'.

9. A statue situated opposite the entrance to the Kallimarmaro stadium in 1927, made by the sculptor Konstandinos Dimitriadis inspired by a classical statue known to us from its Roman copies.

10. A Greek tourist guide that I met distinguished the various periods in the history of tourism in Greece by reference to the successive means of mass transport: 'When Boeing appeared, the tourist buses became fifty-seaters. When the aeroplanes became double-deckers the buses became double-deckers too, and mass tourism was already there in all its 'greatness'.

11. Castalia is the famous fountain in Delphi used for the purification of ancient pilgrims before they entered the sanctuary.

12. Pheidias is the famous sculptor and supervisor of the Periklean project on the Acropolis. Halepas (1854–1938) is a modern Greek sculptor and Kerameikos is the cemetery of ancient Athens.

13. A similar statement was made in 1999 by the Archbishop of Greece, Christodoulos, who, when referring to the reality of globalization, said that 'the Greeks will not become the waiters of the foreigners'.

14. See Nash 1989 for an approach to tourism as a form of imperialism.

15. This is not true information though.

Chapter 6 The Aesthetics of Sacredness

1. Stewart 1994, see below.

2. The relationship between the Church and the State has not been always a harmonious one (see for example Stewart 1998). Recently, the new archbishop has displayed a tendency to compete with the state for the favour of the Greek *ethnos*. With his regular appearance in the mass media and his vivid engagement in discussions of a vast range of political and national issues and topics such as cloning and premarital sex, he has shown his eagerness to involve the Church dynamically in Greek public life, and he has been accused by the state, and by others, of being involved in issues outside the Church's jurisdiction. (for more details, see Alivizatos 1999.)

3. Anthemios and Isidoros were the architects of St Sophia, while Iktinos – together with Kallikrates – was one of the architects of the Parthenon.

4. Periklis Yannopoulos (1869–1910) is considered to be one of those who introduced the integration of Greek culture, Greek nature, and Greek people by arguing that the basis of the Greek aesthetics is the Greek earth and that 'all the beauty and nobleness that exists in it also exists in [the Greeks]. To quote his own words (Γιαννόπουλος 1965 [1903]: 41), '. . . It is a paradox that the idea of the curved lines of the Parthenon are so much admired, as it is obvious that a real artist, having to erect lines on an Attica hill, could not possibly consider anything else than to keep these lines in tune with the surrounding harmonic curve . . . And it is the [same] line which we see in all ancient statues and artworks in Byzantine Virgins and saints, in folklore songs, in . . . the contemporary young villager . . .'

5. The Greek word δεισιδαίμων can have two meanings, 'pious' and 'superstitious'. I choose to translate it in its first meaning, as it is more in tune with what Christodoulos says later about the Athenians' devoutness.

6. I would even suggest that, if the votives are old enough, they might have requested the protection of the Parthenon as a representation of Athens or Greece from the German invasion of the Second World War.

7. Herodotus (VIII.55) and Pausanias (I.27.2) refer to a similar story. After the plundering of the Acropolis hill by the Persians the sacred olive-tree, which had been burnt, showed life again when the first worshippers arrived to make their sacrifices.

8. Καμπούρογλου (1852–1942) was a literary figure very much interested in Athens' history, literature and folklore.

9. As has been noted (e.g. Cosgrove 1989; Cosgrove and Daniels 1988; Tilley 1994), the term 'landscape', as opposed to the terms 'place' or 'space', signifies a particular conception of space, which presupposes its distancing and object-ification by the people who now become its observers.

10. In 1834, on the day of the national celebration of the arrival of king Otto, the first king of the Greek state, John Hill, an American missionary who built the first school in the capital of the new Greek state, wrote in his diary: 'The town was partially illuminated – and as a novelty, the Acropolis, with pine knots placed on the turrets of the ramparts and the embrasures' (John Hill, personal diary – I thank Mrs Panayotopoulou for giving me access to the diary).

11. The statue stood inside the Parthenon temple. We know its appearance from ancient descriptions and from later copies of it or of parts of it.

12. The Stoa of the Giants is a monumental façade of a large building complex (c. AD 400) which probably served as the seat of a governor or the like. It has got its name from the statues of giants (and tritons) of the façade.

13. For a research on the ways antiquity has inspired Greek toy-makers see Gougoulis 1999.

14. Here Nelly compares the dancer's body with the porcelain or alabaster small statues produced in Saxonia, an area in northern Germany.

15. Of great interest is a letter in a newspaper column by the early twentieth-century writer Pavlos Nirvanas criticizing the attack Nelly had received (Κάσδαγλης 1989: 103–4)): '. . . Sacrilege! I rack my brain to discover what kind of sacrilege it is that the dear respectful gentlemen refer to. It would be a sacrilege if, in a moment of archaeological enthusiasm over the "Parthenon" marbles, they themselves threw away their veils and pretended to be Hermes by Praxiteles, in his current age. This would indeed be a sacrilege, enough to provoke the intervention not only of the Archaeological but also of the Palaeontological Society. What is a sacrilege is the romantic orgies which take place on every full moon with the permission of the Ministry of Education, in the vicinity of the Temple of Wisdom. What is a sacrilege is the tumbles of those who are despaired from life, and who transform every now and then the sacred rock into a suicide place. What is a sacrilege is the fireworks which incense the statue of Athena on the official days – fortunately, she is not there any more to sneeze. [What is a sacrilege is] the broken bottles of Καμπανίτης

[champagne], which once covered the floor of her temple after an official meal. All these are sacrileges. But how can the sacred nudity of the rising Aphrodite, whom even gods desire, be a sacrilege? I protest on behalf of the Olympian gods, who, as it is known, not only walked naked, both male and female, but they were also worshipped naked in their temples . . .'

16. Popular Greek TV presenter.

17. Such an episode took also place in the archaeological site of Knossos in 1998. It was much discussed and caricatured, e.g. Figure 6.15.

18. Pittakis is considered the first Greek archaeologist in the history of the Greek state.

19. That was more or less the case with the students of the fourth-year class of a primary, privately run school, when I accompanied them for their visit to the Acropolis.

20. In a discussion I had with eight tourist guides, they criticized the clothing of the tourists who visit the Acropolis. One of them said that 'Since this is a kind of pilgrimage, they cannot visit it dressed "like that"'. Another one felt her civilization was being insulted. Most of them were extremely disturbed by the fact that Greek pupils were visiting the site with their stereos on. 'This is not an excursion', they said. It is significant though that those kids *did* apparently consider their school visit to the site an excursion.

21. I adopt here Herzfeld's interpretation of φιλότιμο (1991).

22. Krito and Timarista are two female figures that appear on a gravestone from Rhodes (c.410 BC) embracing each other before death separates them.

23. 'Δημοσιο-υπαλληλισμός' and patronage are well-known and much discussed aspects of the Greek bureaucratic state and Greek politics (Herzfeld 1992; Campbell 1964; Παπαταξιάρχης 1990; Κομνηνού 1990; see Gilmore 1982 for a comparative approach).

24. Πρωτόπαπας was the then president of ΓΣΕΕ.

25. Committing suicide from the rock of the Acropolis has a long history, beginning with the legendary suicide of Mary, the young German governess of King George (then heir to the Greek throne), in 1893. Since then several other suicides have followed with a quite notable number around 1925 (e.g. Ελεύθερον Βήμα, 1/8/1925; 3/8/1925 – I thank Prof. George Margaritis for providing me the relevant newspaper clippings).

26. The Greek word for rust σκουριά comes from the ancient Greek σκωρία, itself deriving from the word σκωρ meaning excrement.

27. Karagiozis is a poor, bold and hunch-backed Greek shadow theatre protagonist who embodies what are considered as virtues and vices of the Greek folk (see Danforth 1976; 1983; Leigh Fermor 1966; Herzfeld 1987). The way he is used here, however, underlines rather the motley form that the Acropolis acquired through the various colours of the 'Son et Lumière').

28. In a later rekindling of the issue, Victoria Solomonidis of the Greek embassy described the British comment about severe methods employed by the Greeks themselves for the cleaning of the marbles as 'a reflection of long-running British arrogance about whether the Greeks are fit to look after their own heritage' (*The Independent*, 6/11/99).

29. One could compare with the case of the Sistine Chapel for similar complaints concerning the cleaning of the Michelangelo paintings. The bright colours that the cleaning set off were seen as incompatible with what was considered until then as the 'typical palette' of Michelangelo, and the cleaning was believed to be an intrusion to the works of art extinguishing the artist's brush.

30. Petridon (2001) has shown that the same rhetoric involving 'whiteness' also appears with reference to feta cheese.

31. Even the comparison of the colour the Parthenon marbles have acquired, while in British hands, with the British weather and colours has formed part of another Western European discourse. Καλπαξής (1997) refers to an article under the title 'From the Acropolis to the British Museum. The abduction of the Parthenon frieze by Lord Elgin' published in the German newspaper *Frankfurter Zeitung* on 23/7/1939. The columnist, after having described the story of the removal of the Parthenon marbles by Elgin, also describes the destruction of the surface of some sculptures resulting from the inept cleaning with caustic acid in the beginning of 1939. The columnist criticizes the display of the sculptures in a room with 'dirty-red' walls, where the sculptures have attained the brownish colour of the London fog. On the contrary, she says, the Pergamon museum in Berlin is bright and the display of its antiquities perfect. 'Those who worked on the Pentelic marble, the surface of which is so thin and so vulnerable, surely did not destine it for London's smog.' As Καλπαξής notes (ibid.: 64) the conclusion of the columnist is far from suggesting the removal of the sculptures from London. In the end of the article Elgin is exculpated from the charge as 'an honest day-dreamer, who was on a soul-quest for the land of the Greeks'. So is the British museum, as the whole event is described as 'an accident for which the BM cannot be reproached'. The defence of a mutually accepted ideology, the one which nominates the Powers of the West as the only legal heirs of the ancient world, prevails even over the sharp disputes which occur among its conveyors.

Chapter 7 Conclusions

1. Compare Marx's statement: 'Men make their own history, but they do not make it just as they please; they do not make it under circumstances chosen by themselves, but under circumstances directly encountered, given and transmitted from the past. The tradition of all the dead generations weighs like a nightmare on the brain of the living (Die Tradition aller toten Geschlechter lastet wie ein Alp auf dem Gehirne der Lebenden).

2. In that respect, the beginning of the anthem of a school in the Makriyanni area (on the south foot of the Acropolis) is revealing: The students sang the anthem until 1963 and in the first verses they addressed their school: 'My school, under the light of the Parthenon . . .' (I thank the architect Ms Julia Kostaki for the information.) A more personal example is that of a friend who was brought up in the same area. After his success in entering the University his father, in his enthusiasm, exclaimed 'It could not have been otherwise, given that you were conceived under the shadow of the Parthenon'.

3. Many ancient Greek cities used to have a sacred object in their possession, which they believed to have the power to keep them safe in moments of danger. This object was kept secret, out of fear that it might fall into the hands of an enemy, and the city would then be destroyed. For example, the temple of Athena in Tegea was kept closed, because this is where its secret, sacred object, the head of Medusa, was held. It was on that object that Tegea's existence depended (Pausanias VIII, 47.5–6).

4. Compare the answer of the Greek Prime Minister Konstantinos Karamanlis to Khrushchev when the latter threatened to destroy the Parthenon with nuclear bombs in case of a world war: 'Mr Khrushchev may have the power to destroy the Acropolis, but he cannot destroy the ideals that our Sacred Rock symbolises, that are stronger than any missile'.

5. Another example from antiquity is the following. After the battle at Salamis, in 480 BC, the Persians burnt and plundered the temple on the Acropolis hill. When the Greeks won the final battle at Plataia one year later, they swore never to rebuild the destroyed monuments, as a reminder of the 'barbarians' disrespect' (Dio. Sic. XI.29.2).

6. Φραγκουδάκη and Δραγτνα (1997) reach a similar conclusion in relation to Greek school textbooks: 'The discourse of textbooks referring to the [Greek] nation, culture, cultural homogeneity, and national continuity from classical antiquity seems to remain hemmed in the myths and the contradictions of a nineteenth-century nationalism'.

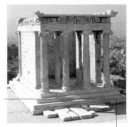

Bibliography

English Titles

Alivizatos, N.C. (1999), A New Role for the Greek Church?, *Journal of Modern Greek Studies Special Issue: Greek Constitutional law and practice,* 17 (1): 23–40.

Alonso, A-M. (1994), The politics of space, time and substance: State formation, nationalism, and ethnicity, *Annual Review of Anthropology,* 23: 379–405.

Anderson, B. (1991), *Imagined Communities,* New York: Verso.

Appadurai, A. (1986), Introduction: commodities and the politics of value, in A. Appadurai (ed.), *The Social Life of Things: Commodities in Cultural Perspective,* Cambridge: Cambridge University Press, 3–63.

—— (1990), Disjuncture and difference in the global cultural economy, *Public Culture,* 2: 1–24.

Bakalaki, A. (1997), Students, Natives, Colleagues: Encounters in Academia and in the Field, *Cultural Anthropology,* 12 (4): 502–26.

Balibar, E. (1990), Paradoxes of universality, in D.T. Goldberg (ed.), *Anatomy of Racism,* Minneapolis: University of Minnesota Press.

Barber, B.R. (1995), *Jihad VS Mc World,* New York: Times Books.

Barthes, R. (1974), *Mythologies,* London: Jonathan Cape.

Bauman, Z. (1993) *Postmodern Ethics.* Oxford: Blackwell.

Bender, B. (1993a), Introduction. Landscape – meaning and action, in B. Bender (ed.), *Landscape: Politics and Perspectives,* Oxford: Berg, 1–17.

—— (1993b), Stonehenge – contested landscapes (Medieval to present day), in B. Bender (ed.), *Landscape: Politics and Perspectives,* Oxford: Berg, 245–79.

Benjamin, W. (1992) [1955], *Illuminations,* London: Fontana Press.

Berger, P.L. and Luckman, T. (1976), *The Social Construction of Reality,* Harmondsworth: Penguin.

Bernal, M. (1987), *Black Athena: The Afroasiatic Roots of Classical Civilization*, New Jersey: Rutgers University Press.

Bertrand, L. (1908), *La Grèce du soleil et des paysages*, Fasquelle.

Bhabha, H. (1994), Of mimicry and man. The ambivalence of colonial discourse, in H. Bhabha (ed.), *The Location of Culture*, London: Routledge, 85–92.

Billig, M. (1995), *Banal Nationalism*, London: Sage.

Bloch, M. (1982), Death, Women and Power, in M. Bloch and J. Parry (eds), *Death and the Regeneration of Life*, Cambridge: Cambridge University Press, 211–30.

Bloch, M and Parry, J. (1982), *Death and the Regeneration of Life*, Cambridge: Cambridge University Press.

Bourdieu, P. (1977), *Outline of a Theory of Practice*, Cambridge: Cambridge University Press.

Brown, M.F. (1998), Can culture be copyrighted?, *Current Anthropology* 39 (2): 193–222.

Buck-Morss, S. (1992), Aesthetics and anaesthetics: Walter Benjamin's artwork essay reconsidered, *October*, 62: 3–41.

Caftanzoglou, R. (2000), Profane Settlement: Place, memory and identity under the Acropolis, *Oral History*, 28 (1): 43–51.

Campbell, J.K. (1964), *Honour, Family and Patronage: A Study of Institutions and Moral Values in a Greek Mountain Community*, Oxford: Clarendon Press.

Clifford, J. (1997), *Routes: Travel and Translation in the Late Twentieth Century*, Cambridge, Mass.: Harvard University Press.

Clogg, R. (1992), *A Concise History of Greece*, Cambridge: Cambridge University Press.

Connerton, P. (1989), *How Societies Remember*, Cambridge: Cambridge University Press.

Cooney, G. (1994), Sacred and secular neolithic landscapes in Ireland, in D.L. Carmichael, J. Hubert, B. Reeves and A. Schanche (eds), *Sacred Sites, Sacred Places*, London: Routledge, 32–43.

Cosgrove, D. (1989), Geography is everywhere: Culture and symbolism in human landscapes, in Gregory, D. and Walford, R. (eds), *Horizons in Human Geography*, London: Macmillan, 118–35.

Cosgrove, D. and Daniels, S. (1988), Introduction: iconography and landscape, in D. Cosgrove and S. Daniels (eds), *The Iconography of the Landscape*, Cambridge: Cambridge University Press, 1–10.

Crang, Ph. (1999), Local-global, in P. Cloke, Ph. Crang and M. Goodwin (eds), *Introducing Human Geographies*, London: Arnold.

Daily Telegraph: British liberal newspaper.

Danforth, L.M. (1976), Humour and status reversal in Greek shadow theatre, *Byzantine and Modern Greek Studies*, 2: 99–111.

—— (1983), Tradition and change in Greek shadow theater, *Journal of American Folklore* 96: 281–309.

—— (1984), The Ideological context of the search for continuities in Greek culture, *Journal of Modern Greek Studies* 2: 53–85.

—— (1993), Claims to Macedonian Identity, *Anthropology Today* 9: 3–10.

—— (1995), *The Macedonian Conflict: Ethnic Nationalism in a Transnational World*, Princeton: Princeton University Press.

De Certeau, M. (1986), *The Practice of Everyday Life*, Berkeley: University of California Press.

Descola, P. (n.d.), Exploitable knowledge belongs to the creators of it: A debate, *Social Anthropology*, 6 (1): 109–26.

Diary 1998. *Dedication to the Parthenon Marbles*, Athens: Elix.

Douglas, M. (1966), *Purity and Danger: An Analysis of Concepts of Pollution and Taboo*, London: Penguin.

—— (1970), *Natural Symbols*, Harmondsworth: Penguin.

Eriksen, T.H. (1993), *Ethnicity and Nationalism: Anthropological Perspectives*, Chicago: Pluto Press.

Featherstone, M. (ed.) (1990), *Global Culture: Nationalism, Globalisation and Modernity*, London: Sage.

Fanelli, F. (1707), *Atene Attica Descritta da suoi Principii sino all' Acquisto Fatto dall' Armi Venete nel 1687*. Venezia.

Forty, A. (1999), Introduction, in A. Forty and S. Kuschler (eds), *The Art of Forgetting*, Oxford: Berg.

Foucault, M. (1977) [1975], *Discipline and Punish*, New York: Vintage.

—— (1980), *Power/Knowledge*, Brighton: Harvester.

—— (1984), Truth and Power, in P. Rabinow (ed.), *The Foucault Reader: An Introduction to Foucault's Thought*, London: Penguin, 51–75.

Fowler, R. (1991), *Language in the News. Discourse and Ideology in the Press*, London: Routledge.

Gathercole, P. and Lowenthal, D. (eds) (1994) [1990], *The Politics of the Past*, London: Routledge.

Gefou-Madianou, D. (1993), Mirroring ourselves through western texts: The limits of an indigenous anthropology, in H. Driessen (ed.), *The Politics of Ethnographic Reading and Writing: Confrontations of Western and Indigenous Views*, Verlag Breitenbach Publishers, The Netherlands.

Gell, A. (1998), *Art and Agency: An Anthropological Theory*, Oxford: Clarendon Press.

Gellner, E. (1983), *Nations and Nationalism*, Oxford: Blackwell.

Giddens, A. (1984), *The Constitution of Society*, Cambridge: Polity Press.
—— (1990), *The Consequences of Modernity*, Cambridge: Polity.
Gilmore, D.D. (1982), Anthropology and the Mediterranean Area, *Annual Review of Anthropology*, 11: 175–205.
Gougoulis, C. (1999), Toys as Greekness: The Search for Cultural Continuities in Greek Folk-Play Studies. *2nd International Toy Conference*, Halmstad, Sweden, 14–18 June 1999.
Gourgouris, S. (1993), Notes on the nation's dream-work, *Qui Parle* 7: 81–101.
—— (1996), *Dream Nation: Enlightenment Colonisation and the Institution of Modern Greece*, Stanford: Stanford University Press.
Graburn, N.H.H. (1989), Tourism: The sacred journey, in V. Smith (ed.), *Hosts and Guests: The Anthropology of Tourism*, Philadelphia: University of Pennsylvania Press, 21–35.
Greenfield, J. (1996), *The Return of Cultural Treasures*, Cambridge: Cambridge University Press.
Hall, S. (1978), The social production of news, in S. Hall, C. Critcher, T. Jefferson, J. Clarke and B. Roberts (eds), *Policing the Crisis: Mugging, the State and Law and Order*, London: Macmillan, 53–77.
Hamilakis, Y. (1999), Stories from exile: fragments from the cultural biography of the Parthenon (or 'Elgin') marbles, *World Archaeology*, 31 (2): 303–20.
—— (2000a), Cyberspace/cyberpast/cybernation: Constructing Hellenism in hyperreality, *European Journal of Archaeology* 3(2), 241–64.
—— (2000b), The 'other Parthenon': Antiquity and national memory at Makronisos, Paper presented at the Symposium *'Intersecting times: the work of memory in South East Europe'*, Clyne Castle, Swansea, 25–28 June 2000.
—— (2001), Monument Visions: Bonfils, Classical Antiquity and Nineteenth-Century Athenian Society, *History of Photography*, 25 (1): 1–8.
Hamilakis, Y. and E. Yalouri (1996), Antiquities as symbolic capital in modern Greece, *Antiquity*, 70: 117–29.
—— (1999), Sacralising the Past: Cults of archaeology in modern Greece, *Archaeological Dialogues*, 6 (2): 115–59.
Handler, R. (1984), On sociocultural discontinuity: Nationalism and cultural objectification in Quebec, *Current Anthropology*, 25 (1): 55–64.
—— (1988), *Nationalism and the Politics of Culture in Quebec*, Madison: University of Wisconsin Press.
Harrison, S. (1999), Identity as a scarce resource, *Social Anthropology*, 7 (3): 239–51.

Harvey, D. (1989), *The Condition of Postmodernity*, Oxford: Blackwell.

Herzfeld, M. (1982a), *Ours Once More: Folklore, Ideology and the Making of Modern Greece*, Austin (TX): Texas University Press.

—— (1982b), When exceptions define the rules: Greek baptismal names and the negotiation of identity, *Journal of Anthropological Research*, 38: 288–302.

—— (1987), *Anthropology Through the Looking-Glass*, Cambridge: Cambridge University Press.

—— (1991), *A Place in History: Social and Monumental in a Cretan Town*, Princeton: Princeton University Press.

—— (1992), *The Social Production of Indifference: Exploring the Symbolic Roots of Western Bureaucracy*, New York: Berg.

—— (1997), *Cultural Intimacy: Social Poetics in the Nation-State*, New York and London: Routledge.

Hirsch E. and M. O'Hanlon (eds) (1995), *The Anthropology of Landscape*, Oxford: Clarendon Press.

Hitchens, C. (1987), *The Elgin Marbles. Should they be returned to Greece?*, London: Chatto and Windus.

—— (1998), *The Elgin Marbles: Should they be returned to Greece?*, London: Verso.

Holquist, M. (ed.) (1981), *The Dialogic Imagination: Four essays by M.M. Bakhtin*, Austin: University of Texas Press.

Hoskins, J. (1998), *Biographical Objects*, London: Routledge.

Hubert, J. (1994), Sacred beliefs and beliefs of sacredness, in D.L. Carmichael, J. Hubert, B. Reeves and A. Schanche (eds), *Sacred Sites, Sacred Places*, London: Routledge, 9–19.

Hurwit, J.M. (1999), *The Athenian Acropolis: History, Mythology, and Archaeology from the Neolithic Era to the Present*, Cambridge: Cambridge University Press.

Jakobson, R. (1975), The metaphoric and metonymic poles, in R. Jakobson and M. Hall (eds), *Fundamentals of Language*, Paris: Mouton, 90 6.

Jay, M. (1992), Scopic regimes of modernity, in S. Lash and J. Friedman (eds), *Modernity and Identity*, Oxford: Blackwell, 178–95.

Jenks, C. (1995), The centrality of the eye in Western culture: An introduction, in C. Jenks (ed.), *Visual Culture*, London, New York: Routledge.

Just, R. (1995), Cultural Certainties, Private Doubts, in W. James (ed.), *The Pursuit of Certainty: Religious and Cultural Formulation*, London and New York: Routledge, 285–308.

Kaiser, T. (1995), Archaeology and Ideology in Southeast Europe, in Ph.L. Kohl and C. Fawcett (eds), *Nationalism, Politics, and the Practice of Archaeology*, Cambridge: Cambridge University Press, 99–119.

Kapferer, B. (1988), *Legends of People, Myths of State*, Washington and London: Smithsonian Institution Press.

Karakasidou, A. (1993), Politicizing Culture: Negating Ethnic Identity in Greek Macedonia, *Journal of Modern Greek Studies*, 11: 1–28.

—— (1994), Sacred scholars, Profane advocates: Intellectuals molding national conscience in Greece, *Identities*, 1: 35–62.

Karp, I. and Lavine, S. (eds) (1991), *Exhibiting Cultures: The Poetics and Politics of Museum Display*, Washington DC: Smithsonian Institution Press.

Keeley, E. and Sherrard, Ph. (1967), *George Seferis, Collected Poems*, Princeton: Princeton University Press.

Kessel, D. (1994), Ελλάδα του '44, [Greece in '44], Athens: Άμμος.

Kitromilides, P.M. (1989), 'Imagined Communities' and the origins of the national question in the Balkans, *European History Quarterly*, 19: 149–94.

—— (1995), Europe and the dilemmas of Greek conscience, in P. Carabott (ed.), *Greece and Europe in the Modern Period: Aspects of a Troubled Relationship*, London: School of Humanities, King's College.

Kopytoff, I. (1986), The cultural biography of things: commoditisation as a process, in A. Appadurai (ed.), *The Social Life of Things: Commodities in Cultural Perspective*, Cambridge: Cambridge University Press, 64–91.

Küchler, S. (1987), Malangan: Art and memory in a Melanesian society, *Man*, 22 (2): 238–55.

Lash, S. and Friedman, J. (eds) (1992), *Modernity and Identity*, Oxford: Blackwell.

Lash, S. and Urry, J. (1994), *Economies of Signs and Space*, London: Sage.

Leach, E.R. (1961), Two essays concerning the symbolic representation of time, in E.R. Leach (ed.), *Rethinking Anthropology*, London: Athlone Press, 124–43.

Leigh Fermor, P. (1966), *Roumeli: Travels in Northern Greece*, New York: Harper and Row.

Leontis, A. (1995), *Topographies of Hellenism: Mapping the Homeland*, Ithaca and London: Cornell University Press.

Lovell, N. (ed.) (1998), *Locality and Belonging*, London and New York: Routledge.

Lowenthal, D. (1988), Classical antiquities as national and global heritage, *Antiquity*, 62: 726–35.

—— (1998), *The Heritage Crusade and the Spoils of History*, Cambridge: Cambridge University Press.

—— (1999), Preface, in A. Forty, and S. Kuschler (eds), *The Art of Forgetting*, Oxford: Berg.

Mackenzie, M. (1992, *Turkish Athens: The Forgotten Centuries, 1456–1832*, Reading: Ithaca.

Malkki, L. (1992), National Geographic: The Rooting of Peoples and the Territorialization of National Identity Among Scholars and Refugees, *Cultural Anthropology*, 7: 24–44.

Mallouchou-Tufano, F.X. (1994), The history of interventions on the Acropolis, in R. Economakis (ed.), *Acropolis Restoration: The CCAM Interventions*, London: Academy Editions, 68–191.

Marx, K. (1978), *The 18th Brumaire of Louis Bonaparte*, Peking: Foreign Languages Press.

Mauss, M. (1954) [1925], *The Gift*, Glencoe: Free press.

McFarland, T. (1981), *Romanticism and the Forms of Ruin*, Princeton: Princeton University Press.

McNeal, R.A. (1991), Archaeology and the destruction of the later Athenian acropolis, *Antiquity*, 65: 49–63.

Merryman, J.H. (1988), The retention of cultural property, *University of California Davis Law Review 21*, 447–513.

Miller, D. (1987), *Material Culture and Mass Consumption*, Oxford: Blackwell.

—— (1992), The young and the restless in Trinidad: A case study of the local and the global in mass consumption, in R. Silverstone and E. Hirsch (eds), *Consuming Technologies*, London: Routledge.

—— (1998), Coca Cola: A black sweet drink from Trinidad, in D. Miller (ed.) *Material Cultures: Why some Things Matter*, London: University College London Press, 169–87.

Miller, D. and Tilley, C. (1996), Editorial, *Journal of Material Culture*, 1 (1): 5–14.

Milliex, R. (1946), *A l'École du Peuple Grec, 1940–1944*, Du Beffroi.

Mitchell, T. (1988), *Colonising Egypt*, Berkley, Los Angeles, London: University of California Press.

Morphy, H. (1995), Aboriginal art in a global context, in D. Miller (ed.), *Worlds Apart: Modernity through the Prism of the Local*, London: Routledge, 211–39.

Mouliou, M. (1996), Ancient Greece, its classical heritage and the modern Greeks: aspects of nationalism in museum exhibitions, in Atkins, J. A. et al. (eds) *Nationalism and Archaeology*, Glasgow: Cruithne Press.

Munn, N. (1977), The Spatio-temporal transformation of Gawa canoes, *Journal de la Société des Océanistes*, 33: 39–53.

—— (1986), *The Fame of Gawa*, Cambridge: Cambridge University Press.

Nash, D. (1989), Tourism as a form of imperialism, in V. Smith (ed.). *Hosts and Guests: The Anthropology of Tourism*, Philadelphia: University of Pennsylvania Press: 37–52.

Nora, P. (1998), From Lieux de mémoire to realms of memory, in P. Nora and L.D. Kritzman (eds), *Realms of Memory: The Construction of the French Past*, New York: Columbia University Press.

O' Hanlon, M. (1993), *Paradise: Portraying the New Guinea Highlands*, London: British Museum.

Ohnuki-Tierney, E. (1991), Embedding and transforming polytrope: The monkey as self in Japanese culture, in J.W. Fernandez (ed.), *Beyond Metaphor: The Theory of Tropes in Anthropology*, Stanford: Stanford University Press.

—— (1992), *Rice as Self*, Princeton: Princeton University Press.

Ortner, S.B. (1973) On key symbols, *American Anthropologist*, 75: 1338–46.

—— (1984), Theory in anthropology since the sixties, *Comparative Studies in Society and History*, 26: 126–66.

Papageorgiou-Venetas, A. (1994), *Athens: The Ancient Heritage and the Historic City-Scape in a Modern Metropolis*, Athens: Vivliothíki tis en Athines Arheologikís Eterías, no. 140.

Parry, J. and Bloch, M. (1989), *Money and the Morality of Exchange*, Cambridge: Cambridge University Press.

Petridou, E. (2001), *Milk Ties: A Commodity Chain Approach to Greek Culture*, PhD Thesis, University College London.

Philo, G. (1983), Bias in the media, in D. Coates and G. Johnston (eds), *Socialist Arguments*, Oxford: Martin Robertson, 130–45.

Photographic Album of Makronisos 1949, Athens: Privately published.

Plenel, E. (1990), 'Words are Weapons' and Le Pen's army knows how to pull the trigger, *Manchester Guardian Weekly*, 142(21): 16.

Price, S. (1989), *Primitive Art in Civilized Places*, Chicago and London: University of Chicago Press.

Rajan, B. (1985), *The Form of the Unfinished*, Princeton: Princeton University Press.

Rajchman, J. (1988), Foucault's Art of Seeing, *October*, 44 (Spring): 89–117.

Renan, E. (1993) [1865], *Prayer on the Acropolis* (Transl.by John Myers O'Hara), USA: Roots, Vision and Memory.

Ricoeur, P. (1976), *Interpretation Theory: Discourse and the Surplus of Meaning*, Forth Worth: Texas Christian University Press.

Robertson, R. (1992), *Globalisation*, London: Sage.

Rodocanachi, C.P. (1949), *A Great Work of Civic Readaptation in Greece*, Athens: Privately published.

Rojek, C. and Urry, J. (1997), Transformations of travel and theory, in C. Rojek and J. Urry (eds), *Touring Cultures: Transformations of Travel and Theory*, London and New York: Routledge, 1–19.

Ross, L. 1976 [1863], *Αναμνήσεις και Ανταποκρίσεις από την Ελλάδα (1832–1833)* [Memories and Communications from Greece (1832–1833)]. Athens: Τολίδη.

Scully, V. (1963), The Athens Hilton: A study in vandalism. *Architectural Forum* July, 100–103.

Shanks, M. and Tilley, C. (1992), *Re-constructing Archaeology. Theory and Practice*, London and New York: Routledge.

Shelley, P.B. (1934), *The Complete Poetical Works*, London: Oxford University Press.

Silberman, N.A. (1989), *Between Past and Present: Archaeology, Ideology, and Nationalism in the Modern Middle East*, New York: Henry Holt.

—— (1995), The Politics and Poetics of archaeological narrative, in P.L. Kohl and C. Fawcett (eds), *Nationalism, Politics and the Practice of Archaeology*, Cambridge: Cambridge University Press.

Smith, A.D. (1991), *National Identity*, London: Penguin.

—— (1995), *Nations and Nationalism in a Global Era*, Cambridge: Polity Press.

Spivey, N. (1997), *Greek Art*, London: Phaidon Press.

Staiger, E. (1996), *Der Briefwechsel zwischen Schiller und Goethe*, Frankfurt am Main: Insel.

Stallybrass, P. and White, A. (1986), *The Politics and Poetics of Transgression*, Ithaca, N.Y.: Cornell University Press.

St Clair, W. (1998), *Lord Elgin and the Marbles: The Controversial History of the Parthenon Sculptures*, Oxford: Oxford University Press.

Steiner, C. (1995), The art of the trade: on the creation of value and authenticity in the African art market, in G. Marcus and F. Myers (eds), *The Traffic in Culture: Refiguring Art and Anthropology*. Berkeley: University of California Press, 151–66.

Stewart, C. (1991), *Demons and the Devil*, Princeton: Princeton University Press.

—— (1994), Syncretism as a dimension of nationalist discourse in modern Greece, in C. Stewart and R. Shaw (eds), *Syncretism/Anti-Syncretism: The Politics of Religious Synthesis*, London and New York: Routledge, 127–43.

—— (1998), Who Owns the Rotonda? Church vs. State in Greece, *Anthropology Today*, 14 (5): 3–9.

Strathern, M. (1979), The self-decoration, *Oceania*, 49 (4): 241–56.

Sutton, D.E. (1997), Local names, foreign claims: Family inheritance and national heritage on a Greek island, *American Ethnologist*, 24 (2): 415–37.

—— (1998), *Memories Cast in Stone: The Relevance of the Past in Everyday Life*, Oxford and New York: Berg.

Symposium 1998 (1.3): Quarterly Journal by Hellenic Students.

The Independent: British liberal newspaper.

Theroux, P. (1996), *The Pillars of Hercules: A Grand Tour of the Mediterranean*, London: Penguin.

Tilley, C. (1990), Towards an Archaeology of Archaeology, in C. Tilley (ed.), *Reading Material Culture*, Oxford: Blackwell.

—— (1994), *A Phenomenology of Landscape: Places, Paths and Monuments*, Oxford: Berg.

—— (1999), *Metaphor and Material Culture*, Oxford: Blackwell.

—— (forthcoming), Ethnography and material culture, in P. Atkinson et al. (eds) *The Sage Handbook of Ethnography*, London: Sage.

Tsigakou, F.M. (1981), *The Rediscovery of Greece*, London: Thames and Hudson.

Ucko, P. (1994), Forward, in D.L. Carmichael, J. Hubert, B. Reeves and A. Schanche (eds), *Sacred Sites, Sacred Places*, London: Routledge, xiii–xxiii.

Urry, J. (1990), *The Tourist Gaze*, London: Sage.

Vitti, M. (1977), *Η Γενιά του Τριάντα. Ιδεολογία και Μορφή*, [The Generation of the Thirties. Ideology and Form], Αθήνα: Ερμής.

Watson, J.L. (1997), *Golden Arches East: McDonald's in East Asia*, Stanford: Stanford University Press.

Weiner, A. (1985), Inalienable wealth, *American Ethnologist*, 12: 210–27.

—— (1992), *Inalienable Possessions*, Berkeley. University of California Press.

—— (1994), Cultural difference and the density of objects, *American Ethnologist*, 21: 391–403.

Wilk, R. (1995), The local and the global in the political economy of beauty: from Miss Belize to Miss World, *Review of International Political Economy*, 2 (1): 117–34.

Williams, R. (1977), *Marxism and Literature*, Oxford: Oxford University Press.

Woolf, V. (1987) [1906], A dialogue upon Mount Pentelicos, *Times Literary Supplement*, 11–17 September.

Greek Titles

Αβδελά, Ε. (1997), Η συγκρότηση της εθνικής ταυτότητας στο ελληνικό σχολείο: Εμείς και οι άλλοι, [The constitution of national identity: Us and the others], in Α. Φραγκουδάκη and Θ. Δραγτνα (eds), *Τι είναι η Πατρίδα μας; Εθνοκεντρισμός στην Εκπαίδευση* [What is our Country? Ethnocentrism in Education], Αθήνα: Αλεξάνδρεια, 27–45.

Αθηνά: Greek newspaper (13/2/1832–4/7/1864).

Αθήναι: Greek newspaper (19/10/1902–30/9/1927).

Ανδρεάδης, Γ. (1989), *Τα παιδιά της Αντιγόνης. Μνήμη και Ιδεολογία στη Νεότερη Ελλάδα*, [Antigone's children. Memory and Ideology in Modern Greece], Αθήνα: Καστανιττης.

Αντί: Monthly leftist magazine.

Απογευματινή: Right-wing daily newspaper.

Αργυρίου, Α. (1994), Ο Παρθεντνας στη συνείδηση των νέων Ελλήνων ποιητν και στοχασττν [The Parthenon in the conscience of modern Greek poets and intellectuals], in Π. Τουρνικιττης (ed.), *Ο Παρθεντνας και η Ακτινοβολία του στα Νεττερα Χρόνια* [The Parthenon and its Aura in Modern Times], Αθήνα: Μέλισσα, 340–66.

Βαλέτας, Κ. (1975), Πρόλογος [Introduction], in Γ. Πικρός (επιμ), *Το Χρονικό της Μακρονήσου* [The Chronicle of Makronisos], Αθήνα.

Γεννάδιος, Ι. (1930), *Ο Λόρδος Έλγιν και οι προ αυτού ανά την Ελλάδα και τας Αθήνας ιδίως αρχαιολογίσαντες επιδρομείς, 1440–1837* [Lord Elgin and the Antiquarians who Invaded Greece and especially Athens Before him], Αθήνα: Εν Αθήναις Αρχαιολογική Εταιρία

Γιαννόπουλος, Π. (1938) [1902], Η σύγχρονος ζωγραφική [Contemporary Painting], *Τα Νέα Γράμματα* Δ: 41–95.

—— (1965) [1903], Η Ελληνική Γραμμή [The Greek line], in Π. Χάρη (επιμ), *Ο Κόσμος και οι Έλληνες* [The World and the Greeks], Αθήνα, 39–41.

Γκέφου-Μαδιανού, Δ. (1998), Αναστοχασμός, ετερότητα και ανθρωπολογία οίκει: Διλήμματα και αντιπαραθέσεις [Reflexivity, otherness and anthropology at home: dilemmas and contradictions], in Γκέφου-Μαδιανού, Δ. (ed.), *Ανθρωπολογική Θεωρία και Εθνογραφία. Σύγχρονες Τάσεις* [Anthropological Theory and Ethnography: Current Trends], Αθήνα: Ελληνικά Γράμματα, 365–435.

Γκρίτση-Μιλιέξ, Τ. (1995), *Φεγγάρι στην Ακρόπολη* [Moon on the Acropolis], Αθήνα: Καστανιττης.

Δημαράς, Κ.Θ. (1970), *Κ. Παπαρρηγόπουλος – Προλεγόμενα* [K. Paparrigopoulos – Forward], Αθήνα: Ερμής.

Δοξιαδης, Κ. (1994), Για την ιδεολογια τουηθνικιςμου [On the ideology of nationalism], in *Έδνος Κρατος Εθνικισνος* [Nation-State-Nationalism],

Αθηνα: Εταιρεια Σπουδων Νεοελληνικου Πολιτιςμου Και Γενικης Παιδειας, 41–52.

—— (1989), *Νεοελληνικός Διαφωτισμός* [Modern Greek Enlightenment], Αθήνα: Ερμής.

ΕΔΑΕ: Newsletter of the Athens Archaeological Society (from No 19: *Ο Μέντωρ*).

Εθνικό Ιστορικό Μουσείο της Ελλάδας (1996), *Εικόνες του Αγτνα Μακρυγιάννη-Ζωγράφου* [Images of the War by Makriyannis-Zografou], Αθήνα.

Έθνος: Liberal daily newspaper.

Ελευθερία: Greek newspaper (25/8/1944–20/4/1967).

Ελεύθερο Βήμα: Greek newspaper (1922–1944) (since 1944 *Το Βήμα*).

Ελεύθερος Τύπος: Right-wing daily newspaper.

Ελευθεροτυπία: Daily liberal newspaper.

Επενδυτής: Mostly financial weekly newspaper.

Επιθετρηση Τέχνης: Wide-ranging, intellectual, left-oriented periodical.

Ζυγός: Periodical interested especially in the arts addressed mostly to an intellectual readership.

ICOMOS 1991. *Μακρόνησος Ιστορικός Τόπος* [The Historical Place Makronisos], Αθήνα: ICOMOS.

Ιωαννίδης, Α. (1988), Το ιδεολογικό περιεχόμενο στις αναφορές στην αρχαία Ελλάδα στα φασιστικά καθεσττα [The ideological content in references to ancient Greece in facist regimes], *Δελτίο Εταιρείας Σπουδτν*, 11: 37–8.

Καθημερινή: Daily newspaper addressed to a right-wing mostly intellectual readership.

Κακριδής, Ι.Θ. (1981), *Η Ελληνική Παράδοση* [The Greek Tradition], Αθήνα: Ευθύνη.

—— (1989), *Οι Αρχαίοι Έλληνες στη Νεοελληνική Λαϊκή Παράδοση* [The Ancient Greeks in Modern Greek Folk Tradition], Αθήνα: Μορφωτικό Ίδρυμα Εθνικής Τραπέζης.

Καλπαξής, Θ. (1997), Μαζί δεν κάνουμε και χτρια δεν μπορούμε [We can't live with or without each other], *Σύγχρονα Θέματα*, 64: 62–6.

—— (1997a), Η τυρρανία του αρχαιοελληνικού μεγαλείου [The tyranny of the ancient Greek grandeur], in Εταιρεία Νεοελληνικού Πολιτισμού. *Επιθετρηση Τέχνης. Μια Κρίσιμη Δωδεκαετία* [The crucial twelve years], Αθήνα: Εταιρεία Σπουδτν Σχολής Μωραΐτη, 201–7.

Καμπούρογλου, Δ.Γ. (1922), *Αι παλαιαί Αθήναι* [The Old Athens], Αθήνα: Βιβλιοθήκη Ιστορικτν Μελεττν.

Καραχρήστος, Σ. (εκδ.) (1984), *Ελληνικές Αφίσες* [Greek Posters], Αθήνα: Κέδρος.

Καρδαμίτση-Αδάμη, Μ. (χ. η.), *Η Κατοικία μέσα από τα Νεοελληνικά Τάματα* [Representations of Homes in Modern Greek Votives], Αθήνα: Συλλογές.

Κάσδαγλης, Ε.Η. (επιμ) (1989), *Nelly's Αυτοπροσωπογραφία* [Nelly's Self-Portrait], Αθήνα: Έκδοση του συγγραφέα.

Καυταντζόγλου, P. (2000), Το μνημείο, ο βράχος και ο οικισμός: τα Αναφιττικα [The monument, the rock and the settlemement: Anafiotika], in P. Καυταντζόγλου and M. Πετρονττη (eds), *Όρια και Περιθτρια: Εντάξεις και Αποκλεισμοί* [Borders and Margins: Inclusions and Exclusions], Αθήνα: Εθνικό Κέντρο Κοινωνικτν Ερευντν.

Κόκκου, A. (1977), *Η Μέριμνα για τις Αρχαιότητες και τα Πρττα Μουσεία* [The Care for Antiquities and the First Museums], Αθήνα: Ερμής.

Κομνηνού, M. (1990), Η τοπική διάσταση στο πελατειακό σύστημα [The local dimension of the clientele system], in M. Κομνηνού and E. Παπαταξιάρχης (eds), *Κοινότητα Κοινωνία και ιδεολογία. Ο Κωνσταντίνος Καραβίδας και η Προβληματική των Κοινωνικτν Επιστημτν* [Community, Society and Ideology. Konstantinos Karavidas and the Problematic of Social Sciences], Αθήνα: Παπαζήσης, 302–31.

Κονταράτος, Σ. (1994), Ο Παρθεντνας ως πολιτισμικό ίνδαλμα. Το χρονικό της ανάδειξής του σε κορυφαίο μνημείο αιτνιας ακτινοβολίας [The Parthenon as a cultural model: the chronicle of its elevation in a top monument of global aura], in Π. Τουρνικιττης (ed.), *Ο Παρθεντνας και η Ακτινοβολία του στα Νεττερα Χρόνια* [The Parthenon and its Aura in Modern Times], Αθήνα: Μέλισσα, 18–53.

Κορρές, M. (1994), Ο Παρθεντνας από την αρχαία εποχή μέχρι το 19ο αιτνα [The Parthenon from the ancient times until the nineteenth century], in Π. Τουρνικιττης (ed.), *Ο Παρθεντνας και η Ακτινοβολία του στα Νεττερα Χρόνια* [The Parthenon and its Aura in Modern Times], Αθήνα: Μέλισσα, 136–61.

Κοτιόνης, Ζ. (1994), Μιά θραυσματική αφήγηση κάτω από την Ακρόπολη [A fragmented narration under the Acropolis], *Καθημερινή*, 16/10/94.

Κουλούρη, X. (1988), *Ιστορία και Γεωγραφία στα Ελληνικά Σχολεία (1834–1914)* [History and Geography in Greek Schools (1834–1914)], Αθήνα: Ιστορικό Αρχείο Ελληνικής Νεολαίας.

—— (1997), *Αθλητισμός και Όψεις της Αστικής Κοινωνικότητας. Γυμναστικά και Αθλητικά Σωματεία 1870–1922* [Athletism and Aspects of Middle-Class Sociability. Gymnastic and Athletic Societies 1870–1922], Αθήνα: Κέντρο Νεοελληνικτν Ερευντν.

Κούτσικου, Δ. (ed.) (1984), *Κάτι το Ωραίον. Μια Περιήγηση στη Νεοελληνική Κακογουστιά* [Something Beautiful: A Tour around Modern Greek Bad Taste], Αθήνα: Οι Φίλοι του Περιοδικού Αντί.

Κρεμμύδας, Κ. (1998), Η αρχαία κληρονομιά μέσα από ένα περιοδικό της αριστεράς [The ancient heritage through a left-wing magazine], in Πρακτικά του Συνεδρίου: *Η Αρχαία Ελλάδα και ο Σύγχρονος Κόσμος* [Proceedings of the Conference: Ancient Greece and the Modern World], Ολυμπία, Αύγουστος 1997, Πάτρα: Εκδόσεις Πανεπιστημίου Πατρτν.

Κυριακίδου-Νέστορος, Α. (1978), *Η Θεωρία της Ελληνικής Λαογραφίας: Κριτική Ανάλυση* [The Theory of Greek Folklore: A Critical Analysis], Αθήνα: Εταιρεία Σπουδτν Σχολής Μωραΐτη.

Κωνσταντινίδου, Λ. (1973), Ελληνική Επιφάνεια [Greek Epiphany], *Τα Αθηναϊκά*, 44–5.

Λυδάκης, Σ. (1994), Η επίδραση των γλυπττν του Παρθεντνα στη γλυπτική και τη ζωγραφική του 19ου και 20ου αιτνα. Ιδεολογικές αντιπαραθέσεις [The influence of the Parthenon's sculptures in 19th and 20th century sculpture and painting. Ideological juxtapositions], in Π. Τουρνικιττης (ed.), *Ο Παρθεντνας και η Ακτινοβολία του στα Νεττερα Χρόνια* [The Parthenon and its Aura in Modern Times], Αθήνα: Μέλισσα, 230–57.

Μαλλούχου-Tufano, Φ. (2000), Η αποκατάσταση των Μνημείων στην Ελλάδα: 1834–2000 [The restoration of monuments in Greece: 1834–2000], *Καθημερινή*, 20/2/2000.

Μαρμαράς, Μ. (1991), *Η Αστική Πολυκατοικία της Μεσοπολεμική Αθήνας. Η Αρχή της Εντατικής Εκμετάλλευσης του Αστικού Εδάφους* [The Middle-Class Block of Flats in Inter-War Athens. The Beginning of Intensive Exploitation of Middle-class Territory], Αθήνα: Πολιτιστικό Τεχνολογικό Ίδρυμα ΕΤΒΑ.

Μαχαίρα, Ε. (1987), *Η Νεολαία της Τετάρτης Αυγούστου* [The Youth of the Fourth of August], Αθήνα: Ιστορικό Αρχείο Ελληνικής Νεολαίας.

Μηλιάδης, Γ. (χ.η.), *Ακρόπολη* [Acropolis], Αθήνα: Πεχλιβανίδης.

Μηλιαράκης, Α. (1994) [1888], *Περί των Ελγινείων Μαρμάρων* [On the subject of the Elgin Marbles], Αθήνα: Εταιρία Φίλων του Λαού.

Μπαλαφούτης, Β. (1948), *Έλληνες της Αμερικής* [Greeks of America], Νέα Υόρκη.

Μπαμπινιττης, Γ. (1998), *Λεξικό της Νέας Ελληνικής Γλτσσας* [Lexicon of Modern Greek Language], Αθήνα: Κέντρο Λεξικολογίας.

Μπίρης, Κ. (1995) [1996], *Αι Αθήναι από του 19ου εις τον 20ον αιτνα* [Athens throughout the 19th and 20th centuries], Αθήνα: Μέλισσα.

Μπουλττης, Χ. (1988), Η αρχαιότητα στη διαφήμιση [Antiquity in advertising], *Αρχαιολογία*, 27: 22–9.

Μπούρας, Χ. (1994), Οι εργασίες αποκαταστάσεως στον Παρθεντνα και η μετατόπιση των αντιλήψεων για την διατήρηση των μνημείων [The restoration works in the Parthenon and the transformation of perceptions about the restoration of monuments], in Π. Τουρνικιττης (ed.), *Ο Παρθεντνας και η Ακτινοβολία του στα Νεττερα Χρόνια* [The Parthenon and its Aura in Modern Times], Αθήνα: Μέλισσα, 310–39.

Μπρούσκαρη, Μ. (1996), *Τα Μνημεία της Ακρόπολης* [The Monuments of the Acropolis], Αθήνα: ΤΑΠΑ.

Νέα Πανδτρα: 19th century periodical (1850–1872).

Ξενόπουλος, Γ. (1930), Τα Ελγίνεια Μάρμαρα [The Elgin Marbles], *Αθηναϊκές Επιστολές:* 378–81.

Οικονομικός Ταχυδρόμος: Weekly political and economics magazine.

Ο Μέντωρ: ASA newsletter (until issue 19 called ΕΔΑΕ).

Πανόραμα του Αιτνα: Historical documentary series on Greek national television.

Παπαταξιάρχης, Ε. (1990), Πολιτική και αγροτικός σχηματισμός στη νεοελληνική κατοικία [Politics and agriculural formation in modern Greek society], in Μ. Κομνηνού and Ε. Παπαταξιάρχης (eds), *Κοινότητα, Κοινωνία και Ιδεολογία. Ο Κωνσταντίνος Καραβίδας και η Προβληματική των Κοινωνικτν Επιστημτν* [Community, Society and Ideology. Konstantinos Karavidas and the Problematic of Social Sciences], Αθήνα: Παπαζήσης, 135–69.

Πετράκος, Β.Η. (1982), *Δοκίμιο για την Αρχαιολογική Νομοθεσία* [Essay on the [Greek] Archaeological Legislation], Αθήνα: Υπουργείο Πολιτισμού.

—— (επιμ) (1994), *Τα Αρχαία της Ελλάδος κατά τον Πόλεμο 1940–44* [The Antiquities of Greece during the War 1940–44], Αθήνα: Βιβλιοθήκη της εν Αθήναις Αρχαιολογικής Εταιρείας, No. 144.

—— (1997), Η Απττατη Αρχή του Ταμείου Αρχαιολογικτν Πόρων [The Very Beginning of the Treasury of Archaeological Resources], *Ο Μέντωρ*, 44: 92–7.

Πολίτης, Α. (1993), *Ρομαντικά Χρόνια: Ιδεολογίες και Νοοτροπίες στην Ελλάδα του 1830–1880* [Romantic Years: Ideologies and Attitudes in Greece of 1830–1880], Αθήνα Εταιρεία Μελέτης Νέου Ελληνισμού-Μνήμων.

Πρωτοψάλτης, Ε.Γ. (1967), *Ιστορικά έγγραφα περί Αρχαιοτήτων και Λοιπτν Μνημείων της Ιστορίας κατά του Χρόνους της Επανάστασης και του Καποδίστρια* [Historical Texts About Antiquities and the Rest of Historical Monuments During the Years of Revolution and Kapodistrias], Αθήνα: Βιβλιοθήκη της εν Αθήναις Αρχαιολογικής Εταιρείας, No. 59.

Ριζοσπάστης: Left-wing daily newspaper.

Ρος, Λ. (1976) [1863], Αναμνήσεις κωι Ανακοιντσεις από την Ελλάδα (1832–1833) [Memories and Reports from Greece (1932–1833)], translation from German: Α. Σπήλιου, Αθήνα: Τολίδη

Σβορτνος, Ν.Γ. (1994), *Επισκόπηση της Νεοελληνικής Ιστορίας* [Overview of Modern Greek History], Αθήνα: Θεμέλιο.

Σεφέρης, Γ. (1981) [1970], *Δοκιμές* Τόμος 2 [Dokimes], vol. 2, Αθήνα: Ίκαρος.

Σιμόπουλος, Κ. (1984), *Πτς Είδαν οι Ξένοι την Ελλάδα του 1821* [How Foreigners Saw Greece in 1821], Αθήνα: Εκδόσεις του συγγραφέα.

—— (1993), *Η Λεηλασία και η Καταστροφή των Ελληνικτν Αρχαιοτήτων* [The Looting and Destruction of Greek Antiquities], Αθήνα: Εκδόσεις του συγγραφέα.

Σκοπετέα, Ε. (1988), *Το Πρότυπο Βασίλειο και η Μεγάλη Ιδέα: Όψεις του Εθνικού Προβλήματος στην Ελλάδα του 1830–1880* [The Model Kingdom and the 'Great Idea': Aspects of the National Problem in Greece of 1830–1880], Αθήνα: Πολύτυπο.

—— (1992), *Η Δύση της Ανατολής. Εικόνες από το Τέλος της Οθωμανικής Αυτοκρατορίας* [The Setting of the East. Images From the End of the Ottoman Empire], Αθήνα: Γντση.

Σύγχρονα Θέματα: Left-wing quarterly periodical addressed to an intellectual readership.

Τα Αθηναϊκά: Periodical of the Athenians' Society.

Τα Νέα: Daily liberal Greek newspaper.

Τζιόβας, Δ. (1989), *Η Μεταμόρφωση του Ελληνισμού και το Ιδεολόγημα της Ελληνικότητας στο Μεσοπόλεμο* [The Transformation of Hellenism and the Ideological Construction of Greekness in the Middle-War Period], Αθήνα: Οδυσσέας.

Το Άστυ: Greek newspaper (6/10/1885–1909).

Το Βήμα: Daily and Sunday liberal newspaper.

Τουρνικιττης, Π. (ed.) (1994a), *Ο Παρθεντνας και η Ακτινοβολία του στα Νεττερα Χρόνια* [The Parthenon and its Aura in Modern Times], Αθήνα: Μέλισσα.

—— (1994b), Η παρουσία του Παρθεντνα στην ιστορία και τη θεωρία της νεττερης αρχιτεκτονικής [The presence of the Parthenon in the history and theory of modern architecture], in Π. Τουρνικιττης (ed.), *Ο Παρθεντνας και η Ακτινοβολία του στα Νεττερα Χρόνια* [The Parthenon and its Aura in Modern Times], Αθήνα: Μέλισσα, 200–29.

Υπουργείο Εθνικής Παιδείας και Θρησκευμάτων (1995–96), *Οδηγίες για τη Διδακτέα Ύλη και τη Διδασκαλία των Μαθημάτων στο Γυμνάσιο και το Λύκειο* [Instructions for the Content and the Teaching of the Subjects for the Gymnasiums and Lyceums], Οργανισμός Εκδόσεων Διδακτικτ ν Βιβλίων.

Φιλαδελφέας, Α. (1928), *Μνημεία Αθηντν* [Monuments of Athens], Αθήνα: Σακελλάριος.

Φιλιππίδης, Δ. (1984), *Νεοελληνική Αρχιτεκτονική. Αρχιτεκτονική Θεωρία και Πράξη (1830–1980) σαν αντανάκλαση των Ιδεολογικτν Επιλογτν της Νεοελληνικής Κουλτούρας* [Modern Greek Architecture. Architectural Theory and Practice (1830–1980) as a Reflection of the Ideological Choices of Modern Greek Culture], Αθήνα: Μέλισσα.

—— (1994), Ο αποθαυμασμός του Παρθεντνα από την ελληνική κοινωνία [The admiration of the Parthenon in Greek society], in Π. Τουρνικιττης (ed.), *Ο Παρθεντνας και η Ακτινοβολία του στα Νεττερα Χρόνια* [The Parthenon and its Aura in Modern Times], Αθήνα: Μέλισσα, 278–309.

Φραγκουδάκη, Α. and Δραγτνα, Θ. (1997), *Τι είναι η Πατρίδα μας; Εθνοκεντρισμός στην Εκπαίδευση*, [What is our Country? Ethnocentrism in Education], Αθήνα: Αλεξάνδρεια.

Χατζηγιαννάκη, Α. (1993–1994), Ένα κομμάτι της Ελλάδας στην Ιαπωνία [A piece of Greece in Japan], *Κίνηση/Motion. The Magazine of the Olympic Airways*, 54–70.

Index

Acropolis
 aesthetics, 5, 35, 138, 148 50
 agency, *see* material culture:
 agency
 as familiarization of the past,
 155–6, 190–1
 Athens' and Attica's landmark, 17,
 52, 191
 see also perspectivalism
 Christian churches on site, 32,
 145–7, 190
 demarcation, 46, 55–6, 152, 166
 fortress, 40, 59–60, 164
 landscape, *see* material culture:
 landscape
 means of resistance
 resistance against the official
 discourse, 25, 173–6, 182, 195
 see also German occupation:
 resistance
 see also Colonels' dictatorship:
 resistance
 museum, 19, 47, 85–6, 113, 123
 offending the sacredness, 160–6
 guards, 166–72
 see also Nelly
 see also Coca-Cola: advertisements
 see also Herodeion
 see also Orthodoxy:
 deconsecration

pollution, 47, 63–4, 174–5, 190
 smell, 56
 visual, 152–6, 175
 see also Anafiotika
 see also pollution
popular interpretations, 190–1
preservation, 47, 64
 see also archaeology: minimal
 intervention
 see also Parthenon marbles:
 cleaning
purification, 38n5, 55–6, 91, 152,
 154–5, 174
sacredness, 25, 55, 131, 142–7,
 176, 186
 see also antiquities: sacredness
 see also Acropolis: offending the
 sacredness
 see also flag
 see also Hellenism: local and global
 see also material culture: agency:
 Acropolis as panopticon /
 watching
 see also material culture: landscape:
 Acropolis
 see also suicides
advertisements, 15, 69–70, 105–11,
 121
 see also Coca-Cola
 see also Herodeion: Calvin Klein

agency, *see* material culture
Agora of Athens, 37, 190
Anafiotika, 18, 55, 61, 154–5
anthropology at home, 18
antiquities
 as national body, 65–7, 75, 82, 189
 emotional value, 66, 113
 expatriation, 25, 67–82 passim.,
 88, 94, 100, 102–3
 guarding, *see* Acropolis: offending
 the sacredness: guards
 inalienability, 101–5, 112, 123,
 135, 194
 and international values, 6
 mass reproduction, *see* material
 culture: mobility and mass
 reproduction
 mobility, *see* material culture:
 mobility and mass reproduction
 plundering by the West, 79–83
 passim.
 repatriation, 7, 25, 82, 85, 100
 see also Parthenon Marbles
 restoration, 89
 sacredness, 125–6, 135, 137–8,
 148–65 passim.
 see also syncretism
 see also Acropolis: offending the
 sacredness
 symbolic capital, 49–51, 82
 whiteness, 1, 95, 176–9, 182, 192
 see also Parthenon Marbles:
 cleaning by the British Museum
antiquity
 politics, 81
 and Western identity 187–8
 revival, 25, 33, 128, 135
 ancient drama and theatres, 90,
 121, 125
 political renaissance of Greece,
 35, 89–91, 196

 see also War of Independence
 see also names: national names
 survival, 4
 as territory, 53, 78, 85
Appadurai, A., 14, 16, 85
archaeology
 Archaeological Society at Athens,
 23, 34, 67, 77, 79, 103, 113
 Central Archaeological Council,
 123, 126
 formation of national identity
 and, 22–3, 35, 81
 Greek Archaeological Service, 23,
 34, 47
 minimal intervention, 184
Asia Minor, 11, 19, 38–9

Balanos, N., 38
Benjamin, W., 112, 130, 148, 150
Billig, M., 62–3
British government, 34, 72, 89, 95
British Museum, 72, 82–3
 see also Parthenon Marbles
Bourdieu, P., 4, 17, 56, 63n8, 104,
 170
Byzantine empire, 11, 69
 see also syncretism

Caftantzoglou, R., 55, 153–5
cartoons, 24
 Makris, I., *see* Makris
 KYR, *see* KYR
 Stathis, *see* Stathis
Christian churches on ancient sites,
 143–4
 see also Acropolis: Christian
 Churches on the site
Christodoulos, Archbishop of
 Greece, 130n13, 131, 141
civilizations vs. cultures, 194
 see also colonialism

classical studies
 global spread of, 6
classicism, 6
 and fascism, 63n9
 see also Colonels' dictatorship
 decline of, 19, 39
 revival, *see* antiquity
Coca-Cola
 advertisements, 107–12, 115–16,
 121, 126
 Trinidad, 14–5
Colonels' dictatorship, 19, 44–6,
 130
 resistance 63n9, 176
colonialism, 7–8, 80, 82, 182, 194
Committee for the Preservation of
 the Acropolis' Monuments, 47
commodification, 127
 see Greek heritage:
 commodification
 see also Olympic Games:
 commodification
 see also tourism: mass tourism in
 Greece
cultural capital, 79, 113, 126, 128
 versus economic capital, 126
 see also exchange systems
cultural specificity, 14
 copyright and protection of
 cultural specificity and cultural
 property, 194
 Greek, *see* Greek identity

deterritorialization, 85, 112–13
 see also Hellenism: deterritorialised
diaspora, *see* Hellenism: diasporic
dictatorship,
 dictatorship of Metaxas
 see Metaxas
 see also Olympic Games
 see also Colonels' dictatorship

differentiation
 Greekness, 12, 25, 187
 globalization and national
 differentiation, 8, 195
 see also cultural specificity
 see also Greek identity
 see also reterritorialization
disemia, 139

education
 national education system and
 national identity, 21–2
 fieldwork at Greek schools, 22
Elgin, *see* Parthenon Marbles
Enlightenment, 14, 37
Erechtheion, 10, 27, 30–31, 43
 Caryatids, 10, 68, 146
European Union, 46, 53
 Greek attitudes, 19
Euros
 design of coins, 88–9
exchange systems, 101–5
expatriate Greeks, *see* Hellenism:
 diasporic

Fallmerayer, J.P., 37, 95
fascism, 66n11
 see also classicism and fascism
flag
 Acropolis as, 25, 58–63, 181
 Nazi flag on Acropolis, 40, 60–2,
 174
 see also German occupation:
 resistance
 see also nation: flag
Foucault, M., 4, 21, 58, 153
Frankish period, 32
 buildings of, 56, 152
Freud, S., 49, 55
FYROM, *see* Macedonia: Former
 Yugoslav Republic of

Gell, A., 16, 192–3
Generation of the 1880s, 34, 38n4
Generation of the 1930s, 12, 38–9,
 44
German occupation, 40–1
 liberation, 40, 142
 commemoration of, 62
 resistance, 40, 60–2, 174, 176
global
 dialectic between local and, 4,
 13–14, 121
 global discourses, 195
 see also globalization
globalization, 14, 80–1, 85, 120, 123
 indigenization, 14–15
 see also deterritorialization
 see also tourism
Gourgouris, S., 49, 75, 191
Graecos, 93
Great Idea, 36, 38–9, 53–4
Greek civil war, 19, 40
Greek communities
 New York, 71, 73–4
 Russia, 70–1
Greek diaspora, see Hellenism:
 diasporic
Greek heritage, 9, 12, 85
 burden of, 181, 187–8
 commodification, 101, 106, 109 –
 10, 127–8, 135
 see also antiquities: mobility and
 mass reproduction
 see also exchange systems,
 antiquities: inalienability
 see also Olympic Games:
 commodification
 see also tourism: mass tourism in
 Greece
 local and global importance, 25,
 81–2, 89, 187–9, 195
 see also cultural specificity

repatriation, 100
 see also Olympic Games
 see also antiquities
 see also Parthenon Marbles
 revival, see antiquity
Greek identity, 12, 75, 77 ff, 190–2,
 196
 continuity, 95–6
 see also antiquities: as national
 body
 see also Fallmerayer
 see also names: continuity
Greek National Liberation Front, see
 EAM
Greekness, see cultural specificity
Greek state
 establishment of, 14, 36, 89–91,
 95, 187–8, 196
Greek Tourist Organization , 123,
 128–30, 177

hau, 122
Hellas, see names: national names
Hellenism
 classical, 69, 75
 continuity of, see Greek identity
 deterritorialised, 99
 diachronic, 94, 192
 diasporic, 25, 68–9, 71, 73, 85
 ethnic, 75
 European, 12, 85
 Greek Hellenism, 12
 Hellene, 9, 13, 90, 170
 see also names: national names
 Helleno-Christian ideals, 44, 119
 local and global, 12–14, 18, 69,
 85–6, 88, 94–101 passim.,
 187–9
 see also Acropolis: aesthetics
 see also cultural specificity
 see also travellers

mainland Hellenism, 25
neo-Hellenism, 12
repatriation of, 84–6, 88
 see also Parthenon Marbles
 see also Olympic Games
revival, see antiquity: revival
heritage
national, 7–8
plundering by the West, see
 antiquities
politics of, 82, 187–8
world heritage, 6, 12, 81–2, 85
see also Greek heritage
Herodeion
Calvin Klein fashion show, 123–6
Herzfeld, M., 2, 50, 66, 137, 141,
 167n21, 169n23, 176
on Hellenism and Romiossini, 9,
 11, 139, 170, 186, 190
monumental time, 56, 153
on naming systems, 91–9 passim.
history
history and territory, 53
objectifiction of, 52, 75
homeland, see nation: homeland

Imia, islet of, 19, 54
imperialism, 64, 80
inalienablility, see antiquities:
 inalienability
indigenization, see globalization

Just, R., 12–3, 18, 51, 84

Kallimarmaro stadium, 119 –21
Karamanlis, K., 46, 128, 192n4
Kavvadias, P., 38
kinship, see nationalism
KYR, 119, 133, 159

landscape, see material culture

language
fieldwork, 24
and national identity, 53, 62,
 67–8, 139
katharevousa, 55
see also names
Leigh Fermor, P., 9, 178n27
Leontis, A., 6n1, 12, 44, 66n12, 101,
 131, 148
lieu de mémoire, 73
local
dialectic between global and, see
 global
Lowenthal, D., 8, 55, 78n1, 82, 95,
 138, 180
classical Greek heritage as national
 and global heritage, 6, 12, 83

McDonald's, see indigenization
Macedonia, 31, 84, 118
Former Yugoslav Repulic of, 19,
 91, 98, 100
Makris, I., 116, 163
Makronisos, 43–3, 195
Malangan carvings, 193
material culture, 15–17, 73, 194
agency, 16–17, 50
Acropolis as panopticon/
 watching, 62, 153
authenticity and originality,
 113–14, 126, 192
 see also archaeology: minimal
 intervention
 see also commodification
 see also Parthenon Marbles:
 cleaning
coins, stamps and banknotes,
 89n5
 see also Euros
discourse and, 21
landscape, 17

landscape and mass tourism,
 131
 of Acropolis, 44, 152–3
 nation, 56
 metaphors and the meaning of
 things, 25, 49–50, 75
 mobility and mass reproduction,
 112–14
 objectification, 17, 51–2, 58, 192
 practice, 16
 symbols, 192
 time, 51–2
Merkouri, M., 47, 82, 95, 107, 129,
 131
metaphors, see material culture
Metaxas, I., 39, 69
millenium celebrations, 196–7
Miller, D., 14–15, 110
miracles, see syncretism
Mitropoulos, K., 132, 158–9
Morosini, 33
multi-culturalism, 7, 194
Munn, N., 17, 100, 193

names
 and the construction of space, 99
 continuity, 98–9
 names and claims over antiquities,
 91
 'Elgin' vs. 'Parthenon' Marbles,
 97–8
 naming, kinship and nationalism,
 66, 91
 see also Macedonia
 national names, Hellas (Ελλάς) vs.
 Greece, 92–7, 99
 nicknames, 93–4
nation
 as dream-work, 49–50, 75, 191
 flag, 62–3, 75
 homeland, 12, 56–8, 65, 75, 85

homogeneity, 55
landscape, see material culture:
 landscape
material forms, see material
 culture: agency: agency of
 material forms of a nation
motherland, see nation: homeland
myths, 56
national body, 63–7, 88, 117
 see also antiquities
national identity
 see archaeology
 see also education
 see also language
 see also material culture: coins,
 stamps and banknotes
national imagery, 49
 objectification of, 58
 soil, 56–7, 75
 and state, 85
 territory 52–8, 75, 100
 see also deterritorialization
 see also reterritorialization
nationalism, 14, 66, 85, 91, 194
 Greek, 75, 138
 nationalism and religion, 122,
 137–9, 147
 romantic, 63, 122
National Liberation Front, 41
National Tourist Organisation, see
 Greek Tourist Organisation
NATO, 173–4
Nelly 156, 160–2
Neo-orthodoxy, 70

objectification, see material culture
Olympia, 134
Olympic Games
 Atlanta 1996, 86–7, 95, 107,
 114–16
 commodification, 120–22

see also CNN
see also Coca-Cola
see also Greek heritage:
 commodification
dictatorship of Ioannis Metaxas,
 39–40
Greece 2004, 86, 119
 Citizens' Initiative Against the
 Olympic Games 2004, 114,
 119
 Greek athletes, 86, 88, 117–18
 restitution of, 19, 47, 84, 86, 88,
 90, 102, 122
Orthodoxy, 139
 deconsecration, 126, 145
 see also syncretism
Ortner, S.B., 16, 192
Ottoman empire, 11, 32, 90, 93,
 152n10
Otto, 35–6, 155, 188, 208

paganism, *see* syncretism
Panathenaic stadium, 40, 44, 90
Papandreou, A., 46
Papandreou, G., 40
Paparrigopoulos, K., 37, 38n4, 141
Parthenon
 building of, 27
 copies of, 6n2, 7–10
 New Parthenon, *see* Makronisos
Parthenon Marbles, 71, 92, 122
 British Museum room, 69, 181–2
 cleaning, 179–85
 removal by Elgin, 33–4, 63–4, 97,
 183n30
 restitution, 19, 47, 59, 67–9, 72,
 82–6, 102
 see also Euros
 see also reterritorialization
Pericles, 29–30
Persian Wars, 28–34, 57, 193n5

Pheidias, 30, 129, 154
philhellenism, 80
Pikionis, D., 44
Politis, N., 139, 141
pollution
 Athens, 1, 20, 119–20
 see also Acropolis: pollution
postmodernity, 85, 112, 127
Propylaea
 building of, 27, 30
purity, 25, 153–4, 156, 170, 176, 183
 see also Acropolis: offending the
 sacredness
 see also antiquities: whiteness
 see also Parthenon Marbles:
 cleaning

restitution
 see antiquities
 see also Olympic Games
 see also Parthenon Marbles
Renan, E., 2, 39–40, 55, 148–9, 167
renaissance, 69
repatriation
 see antiquities: repatriation
 see also Hellenism: repatriation
 see also Olympic Games:
 restitution
reterritorialization, 85–6,
 reterritorialization and revival,
 89–1
Roman occupation, 32, 69, 79, 93
romanticism, 6
Romiossini, 9, 11, 13, 170
 and Classicism, 190
 Romios, 89, 93

St Clair, W., *see* Parthenon Marbles:
 cleaning
St Sofia, 37, 43, 141
Schinkel, K.F., 35

Second World War, 40, 102–3
Seferis, G., 12, 107, 114, 187–8
soil, *see* nation: soil
Son et Lumière, 152, 177–9
Stathis, 54, 188–9
Stewart, Ch., 98, 138n1, 139, 139n2, 145
Strathern, M., 98
structuralism, 15–16
suicides, 175–6
 see also flag
survivals, 139, 141
Sutton, D., 50–2, 54, 98, 100
 kinship and naming systems, 66, 91–2, 96, 99
symbolic capital, *see* antiquities
syncretism, 138–47, 164, 190
 miracles on classical sites, 146

territorial disputes
 Balkans, 19, 84
 see also Macedonia
 see also Turkey
theatres
 see antiquity: revival
 see also Herodeion
Theotokas, G., 12, 39
Tilley, Ch., 16–17, 21, 49–50, 152n9, 192–3
 Shanks, M. and Tilley, Ch., 51–2, 148
time, *see* material culture
tourism, 127ff, 133, 163
 cultural tourism, *see* travellers
 mass tourism in Greece, 44, 128, 130–5

damaging monuments, 135
 mass consumption, 130–5
 School of Guides, 128
 traditional art and tourist art, 15
 see also Greek Tourist Organization
 see also Hellenism: local and global
travellers
 Western travellers, 6n1, 12, 128, 130–5, 148
 see also Hellenism: local and global
Trikoupis, H., 37–8
Turkey
 territorial disputes with, 19
 see also Imia

UNESCO, 6, 80, 83, 105
Union of Hellenic (Greek) Students Societies in the UK, 71

values
 cultural values, 16
 international values, *see* antiquities
Virgin Mary, 18, 138
 see also syncretism
von Klenze, L., 35–6

War of Independence, 34–5, 53n2, 138, 147, 189–90
 see also Greek state: establishment of
Weiner, A., 101, 109, 122, 175, 194
Westernization 11
Western travellers, *see* travellers

Yannaras, Ch., 70, 114
Yannopoulos, P., 141n4